JAPONISME IN ART

An International Symposium

General Editor: Yamada Chisaburō
Assistant Editor: Ōmori Tatsuji

JAPONISME IN ART

An International Symposium

Edited by
The Society for the Study of Japonisme

COMMITTEE FOR THE YEAR 2001
and
KODANSHA INTERNATIONAL LTD.

CONTENTS

FOREWORD

The Committee for the Year 2001 takes great pleasure in presenting this volume of essays which were compiled from the papers heard at an international symposium held December 18–22, 1979 under the sponsorship of the Committee, entitled "The Mutual Influences between Japanese and Occidental Arts."

The five-day symposium convened in Tokyo brought together fifteen scholars from the United States, Great Britain, France, the Netherlands and Switzerland, and seven specialists from Japan, providing a valuable opportunity for them to exchange ideas and present the results of their research. The contributions of the participants were diverse both in focus and approach, reflecting the breadth of the symposium's theme. We hope that through publication of this book, the stimulating experience of the twenty-two scholars who participated can be shared with a wide readership.

The Committee for the Year 2001 is a private, non-profit foundation established in September 1977 and devoted to the support of activities to study and plan for an ideal society for the twenty-first century. The symposium and this publication, as well as the art exhibition *"Ukiyo-e* Prints and the Impressionist Painters" held in Japan from December 1979 to April 1980, are all part of its efforts to stimulate interchange among countries around the world in this endeavor. Another event co-sponsored by the Committee was the Festival d'Automne à Paris in 1978, which included the art exhibition on the theme "Ma" organized by Isozaki Arata and the exhibit and concert series on "Space-Time in Japan" supervised by Takemitsu Tōru.

The Committee would like to express its sincere gratitude to the many persons who made the symposium possible and who devoted their time and effort subsequently to the preparation of this follow-up publication. We would like to thank the individual authors for their valuable contributions and especially to mention Dr. Gabriel P. Weisberg and Dr. Yamada Chisaburō, who served as co-chairmen of the symposium. We would also like to thank the Japan Shipbuilding Industry Foundation, without whose generous support the symposium would not have been possible. A special word of appreciation goes to Mr. Kamon Yasuo and Mr. Ōshima Seiji of the Society for the Study of Japonisme, M. Christian Polak and Mme Peggy Polak, and Mr. Ōmori Tatsuji and Mr. Abe Nobuo of the Bridgestone Museum of Art, and Mr. Miyake Riichi, all of whom deserve recognition for their faithful efforts behind the scenes which contributed so much to the success of the symposium and the preparation of this volume.

We also wish to thank Dentsu P. R. Center and the staff of Kodansha International for their cooperation and efforts.

Okamura Ryōichi
General Administrator
Committee for the Year 2001

PREFACE

Much has been said, since Ernest Chesneau wrote "Le Japon à Paris" in 1878, about the enthusiasm for Japanese art in Paris in the second half of the nineteenth century where most of the important movements of modern art began. Much has also been written about Japanese influences on the Impressionists and the Post-Impressionists. However, it is only in the last fifteen years that, except for a few pioneer works, serious, specific studies about Japonisme and Japanese influences on modern European art have been made.

It is often very difficult to determine in what respect and how far Japanese influence extended, for the great artists did not imitate, but looked to Japanese art to provide clues to the solutions of problems inherent in their own art, and showed great skill in adopting for their own purposes the special type of beauty they found in Japanese works. There is still much left to study in this field, many materials to explore, and many problems to investigate and reconsider. It was therefore gratifying that the Committee for the Year 2001 sponsored the exibition *"Ukiyo-e* Prints and the Impressionist Painters" held successively in Tokyo, Osaka and Fukuoka from December 15, 1979 through April 10, 1980, providing the valuable opportunity to study the works in this field at first hand.

The members of the Society for the Study of Japonisme felt extremely fortunate to be able to co-sponsor, together with the Committee for the Year 2001, a symposium on Japonisme, convened in Tokyo on the occasion of the opening of the exhibition mentioned above. Scholars from the United States and Europe as well as from Japan outstanding for their distinguished achievements in this field, who had helped to arrange the exhibition, came together for a five-day symposium. It is a great pleasure for us to be able to present to the public in book form the many valuable papers given at that time. We would like to express our sincere gratitude to our co-sponsor, the Committee for the Year 2001, through whose generosity these events and the present publication have been made possible.

Yamada Chisaburō
President
The Society for the Study
of Japonisme
November 15, 1980

EXCHANGE OF INFLUENCES IN THE FINE ARTS
BETWEEN JAPAN AND EUROPE

Yamada Chisaburō

The first encounter between Japanese and European art occurred in the middle of the sixteenth century. Since then, both Japan and Europe had labored under restrictions on freedom and the capacity to accept the art or culture of the other as a result of a variety of social circumstances and of the intellectual climate of the times. Consequently, each period differed in the ways Japan interpreted the art and culture of Europe and vice versa.

The influence of European art on Japanese art can be divided into three periods. The first period began in the mid-sixteenth century when Portuguese and Spanish missionaries arrived in Japan to propagate Catholicism. It lasted until the middle of the nineteenth century and may be divided into two phases. The first phase extends to the beginning of the seventeenth century when Christianity was banned and the second begins in the early seventeenth century, lasting until the middle of the nineteenth.

The second period begins at the end of the Tokugawa period, in other words, from the mid-nineteenth century when Japan opened to trade with the West and began its enthusiastic importation of occidental civilization, until the outbreak of World War II. The third period is from 1941 until the present time.

Japanese influence on European art commenced from the mid-seventeenth century and can also be divided into three periods. The first begins in the middle of the seventeenth century when Japanese lacquered articles and Arita porcelain were exported to Europe by the Dutch East India Company and lasts until the beginning of the nineteenth century; this period corresponds to the so-called Chinoiserie period. The next period stretches between the mid-nineteenth century and World War II. The most important phase of this second period was from around 1860 until 1910, the period which is the focus of this symposium.

When Europe and Japan first came to know each other around the middle of the sixteenth century, European culture was already well-developed. At that time Japan also had a highly developed culture, but of an entirely different type, based on the traditions of the Far East. It was a dramatic encounter of two different cultures, and the principals were almost opposite in character. It is fascinating to study and observe how they reacted to each other, to what extent they could understand and evaluate each other's art and culture, how and in what respects they learned one from the other and were enriched thereby.

Let us look at what happened in Japan first. When Catholic missionaries brought European paintings to Japan in the second half of the sixteenth century, a small group of Japanese painters studied them very carefully. At that time, however, only a limited number of painters were effected; no influence can be observed among painters in general during this period. We can adduce this by studying the so-called *Nanban-ga* paintings (paintings on European themes). Most of the European paintings brought into Japan at that time were religious and therefore figurative paintings. The figures were represented three-dimensionally by the use of shading techniques. Some *Nanban-ga* painters adopted this shading technique, but they were so few in number that when Christianity was banned, all trace of such influence quickly faded. This suggests that Japanese artists were not prepared at that time to accept European realism. They apparently did not feel in need of the techniques of realism found in European painting in order to represent the beauty they perceived in nature.

In the eighteenth century Dutch prints were imported to Japan, and some Japanese artists learned European realism through these Dutch prints as well as through a certain school of Chinese painting which had been influenced by European techniques. At this time, because of the rise of the merchant class with its pragmatic outlook on life, Japan was much more open to acceptance of European realism than it had been in the sixteenth century. As was true of their counterparts in seventeenth century Europe, the citizens of the merchant class had a realistic view of life and preferred painting that reflected their daily lives and the things around them as they actually were. Although their outlook and attitude toward the world was still basically traditional, there were artists who were prepared to learn European realistic methods of representation using shading and perspective. Some progressive painters produced pictures called *uki-e* which represented scenes with European perspective with shading. The art of Maruyama Ōkyo, which is comparatively realistic within the Japanese artistic tradition, reflects the bourgeois view of life mentioned above. In the early nineteenth century some *ukiyo-e* artists painted landscapes which adopted European perspective to a certain extent. The landscapes of Hokusai and Hiroshige, which later influenced the Impressionists, show some European influence in perspective, and would therefore have been easier for Europeans of the nineteenth century to understand than more traditional Japanese paintings.

Around the middle of the nineteenth century, which is the beginning of our second stage, European civilization was beginning to dominate the entire world, with an industrial technology developed on the basis of rationalism and scientific attitudes of study nurtured since the Renaissance behind them and aided by strong economic and political systems. In order to survive in such a world, Japan was forced to absorb European civilization. Other Asian countries resisted European civilization, but Japan strived hard to adopt Western natural sciences, industrial technology, and economic and political systems. Simultaneously, it emulated European art, in the belief that the literature and the fine arts of European civilization were more advanced, and that in order to achieve "modernization" of the country, Western civilization and culture must be acquired as soon as possible.

In the early Meiji era, the Japanese studied European painting, less for artistic reasons than for its utilitarian value, as a means of portraying objects faithfully. At least at the beginning I do not think the Japanese studied the European style of painting because they needed a realistic method of esthetic representation. From this time on, it is extremely interesting to study the influence of European arts on Japanese arts. How did Japanese, who had had a view of the world entirely different from Europeans, learn about their civilization? In what ways did they adopt the realistic style of European painting, and how were Japanese traditional paintings influenced by European realism? How did the traditional Japanese way of "seeing" gradually change under the influence of European natural science and realistic painting?

It would perhaps be well to explain here briefly that in Japan since the Meiji era, there have been two genres of painting, *Nihon-ga* and *yō-ga*. *Yō-ga* is used to describe the Western style of painting while *Nihon-ga* embraces all Japanese painting in the traditional styles. Those artists who were more progressively minded devoted themselves to European painting, while those who were conservative and proud of the Japanese tradition studied *Nihon-ga*. Even the conservatives, however, were gradually influenced by European culture in their basic ways of thinking. In adopting European civilization, Japan had to learn the natural sciences. This was vital because of the intensive effort being made to master Western technology. Naturally this study of natural sciences led to a new way of looking at things based on the outlook of the modern world since the Renaissance. In the case of painting, Japanese artists adopted European perspective with its single fixed viewpoint, developed in the Renaissance, in order to represent space objectively. Methods of shading were also studied in the belief that they were necessary in order to represent three-dimensional objects on a plane. Japanese soon came to look at and represent things in this manner. Their European-style education with its orientation to natural science led them to think that the so-called inverted perspective of Far Eastern painting was wrong. The painters of traditional *Nihon-ga* of the Meiji era were also influenced by this European realism.

This led to a fundamental problem. In *Nihon-ga*, the traditional means of expression is mainly the line, and traditional style uses delicate, melodious lines and expressive brush strokes freely varied in intensity and thickness, which are capable of suggesting three-dimensionality without shading. Using these expressive lines, Japanese painters of the past represented the inwardly apprehended nature in attractively arranged two-dimensional forms. It was difficult to reconcile such an approach and technique with the visual rationalization resulting from the European-style of education. *Nihon-ga* painters experienced great difficulties in this period. Those who studied *yō-ga* (Western painting) had only to learn the realistic techniques of European painting, although perhaps it was not always easy to overcome the contradiction between the traditional way of looking at things and the European objective approach. Therefore, it is more interesting to observe how *Nihon-ga* painters adapted themselves to European culture and how they created a new *Nihon-ga*.

Briefly, it can be said that a new *Nihon-ga* style was born through a revival of

Eastern traditions at the beginning of the twentieth century. At that time, subjectivistic arts were developing in Europe which served as examples to Japanese. Modern European subjectivism in the fine arts stimulated *Nihon-ga* painters at the beginning of the twentieth century to realize the value of the subjective approach of Chinese and Japanese art. From that time, *Nihon-ga* entered a new era. The writings of Okakura Tenshin also contributed much to this movement.

Let us now look at what happened in Europe. As I mentioned earlier, Japanese influence in Europe can be divided into three periods. The first, beginning in the middle of the seventeenth ceutury, corresponds to the late Baroque and Rococo periods. At that time, Japanese arts and crafts were treated as a part of "Chinoiserie" because the Europeans could not distinguish them from those of China. The one outstanding exception, however, was Japanese lacquerware. Japanese lacquer works with gold decoration were recognized as being of far better quality than Chinese. In the second half of the seventeenth century, the word "japan" was used to mean lacquer work just as "china" was used to describe porcelain.

The main exports from Japan were lacquerware and porcelain. Portuguese and Spanish traders accepted gold in exchange for their merchandise, while Dutch merchants had begun to buy Japanese art objects from the middle of the seventeenth century. Part of the reason for this was that it became difficult to buy porcelain from China at the end of the Ming dynasty due to political instabilities. The Ming dynasty was in the process of giving way to the Ch'ing dynasty at that time. Fortunately, at a slightly earlier date, the Japanese had begun to produce porcelain at Arita. Dutch traders switched from buying china from the continent to Japan, and sold Japanese porcelain in European countries on a vast scale. While some Arita porcelain was used as everyday crockery, it was primarily used as interior decoration. Rather than being appreciated individually for the beauty of each, porcelain pieces were used for interior decoration in groups. Japanese porcelains and lacquer works with gold decoration were incorporated into the interior decoration systems of both Baroque and Rococo architecture.

A typical example of this was the porcelain rooms. These display rooms were built with many brackets fixed on the walls. On these brackets Japanese and Chinese porcelain pieces were displayed for the appreciation of their rich decoration on the white shiny surface of the porcelain. They were used mainly for decorative effects. Exoticism was another reason for the fashion in porcelain rooms. The individual beauty of each piece was not appreciated.

There was, however, one exception. The porcelain work of Kakiemon, seems to have gained special appreciation among Europeans, and they copied his work with great care. Other Arita porcelain wares were imitated, but at least up to the middle of the eighteenth century, very poorly, except at the Meissen factory Kakiemon wares, however, were meticulously imitated at many kilns, including Delft, Meissen, and Chantilly.

It is interesting that in this period Europeans did not buy woodblock prints, although they were exported in great numbers to Europe in the nineteenth century. Actually, some foreigners bought *ukiyo-e* prints in the later part of the

eighteenth century, but generally speaking, there was very little appreciation of *ukiyo-e* prints at that time. Referring to porcelain decorations other than that of Kakiemon, books of that time comment that the painting of Chinese porcelains was not so much beautiful as amusing, and the decorations seemed like caricatures to Europeans. In the same way, even though they were familiar with *ukiyo-e* prints, it seems these were not appreciated as works of fine art, and would not have been purchased as such.

A change may be observed by the end of the eighteenth century, for European appreciation of Japanese fine arts began to develop as the Romantic era began to replace the Rococo. Gradually Japanese art came to be recognized as *l'objects d'art*, as evident in the way Japanese lacquer panels were used. In the Rococo period, lacquer panels were cut into pieces without consideration of the original design for use as furniture panels or for the wainscotting of the so-called "Chinese" rooms. However, in the late eighteenth century, we have examples of the furniture of the Louis XVI style, in which lacquer panels are used with some consideration of the beauty of the panel's original design. In the imitations of Arita porcelain manufactured at both Worcester and Chelsea in England during the second half of the eighteenth century, not only Kakiemon ware designs but also those of the so-called Imari wares were very carefully copied. This seems to indicate that Japanese arts and crafts were gradually becoming recognized as artistic objects.

As we know, the vogue of Chinoiserie disappeared in the early nineteenth century, and interest in Chinese art was revived only at the end of that century. Around the middle of the nineteenth century, as Japan opened itself to the outer world, Europe discovered its rich art and culture. This time their appreciation of Japanese art was entirely different. This was the beginning of the second period.

Just at the time Japan was opening its doors after prolonged isolation, European applied arts were suffering an inspirational stalemate. European painting had reached the peak of realism with Courbet and was groping for a new direction of development. Around the middle of the nineteenth century applied arts were sacrificing beauty of workmanship for the sake of industrial mass-production. Wiliam Morris sought a new direction for the arts and crafts movement by learning from the medieval arts, while Godwin, also of Great Britain, believed the solution lay in the arts and crafts of Japan. Godwin's furniture designs used very simple and straight lines, for he seems to have recognized that the merits of Japanese furniture lay in the beauty of combining simple planes and straight lines as well as in emphasizing the beauty of the wood itself. You can see it, for example, in his design of a cabinet in the Victoria and Albert Museum. Christopher Dressor's works show the same trend as Godwin's.

Near the end of the nineteenth century, European artists and craftsmen were greatly influenced by another type of Japanese line, the graceful, flowing curves found in *ukiyo-e* prints, especially in those by Utamaro and Kiyonaga, and also in the designs of Japanese applied arts. This time, unlike Godwin, they learned the beauty of curves from the Japanese fine arts, and this led to the birth of Art Nouveau. Another characteristic of Art Nouveau acquired from the Japanese arts was naturalism. In sharp contrast to those of Europe, the decorative arts of

Japan had always used very naturalistic designs. Although we may detect a degree of influence from Japanese and Chinese naturalism in the Rococo decoration of the eighteenth century, Art Nouveau was much more intensely influenced. It was Samuel Bing who stressed the representation of natural beauty as one of the characteristics of the Japanese fine arts European artists ought especially to study.

Another area of considerable influence, also related to Art Nouveau, was in the European ceramic arts. I consider the influence of Japanese ceramics on late nineteenth century European ceramic art of much greater importance than that of Arita porcelain in the eighteenth century. The beauty of Japanese earthenware and stoneware was recognized for the first time by Europeans in the late nineteenth century, and their characteristics were absorbed into European methods of production and design. They learned from Japanese plain pottery how to make the most of the natural qualities of the clay, and recognized the beauty of unique Japanese glazes, especially feldspathic glaze and ashy glaze used on tea pottery and the importance of firing methods for producing such attractive glazes. The process of firing holds a vital artistic role in oriental ceramic arts, for by limiting the degree of artificial control, a certain measure of accident can be built in. The skillful combination of human control and accidental effect is an important aspect of the beauty of Japanese earthenware and stoneware.

In the 1870s and eighties, far ahead of the time of Bernard Leach, some European artists realized this and tried it in their earthenware and stoneware. In France, there were excellent ceramic artists including Carriès and Rousseau, whose works are displayed in our exhibition, and many others who learned from Japan. In Great Britain as well, ceramic artists such as the Martin brothers studied the beauty of Japanese stoneware. In Denmark, as well, artists learned from Japan. By the end of the nineteenth century, almost the entire realm of European ceramic art had been fundamentally influenced by Japanese tea pottery, except, of course, in ordinary ceramic wares mass-produced by industry for daily use.

Now we come to Impressionism and Post-Impressionism, works of which are the main theme of this exhibition. As mentioned previously, Japanese prints entered Europe just as realism and naturalism in European painting had reached its peak in the work of Courbet. The influence of *ukiyo-e* prints can be divided into two kinds, namely that of the linear representation and composition found in monochrome (black and white) prints and that of expression by the use of color and composition of *nishiki-e* color prints. Hokusai's *Manga* is an example of linear expression (especially in body movement) by the skillful use of brush strokes and interesting composition. Degas, for instance, was greatly influenced by the representation of interesting body postures by Hokusai, and by the ingenious composition of *nishiki-e* prints. He also learned from Japanese prints effective ways to select a point of view freed from the traditional European perspective. Monet, I believe, learned from *nishiki-e* prints how to represent the beauty of nature as the world of light and color without the use of shading.

Impressionist and Post-Impressionist artists were talented and creative, and apart from deliberate copies, they did not simply imitate. They found hints and suggestions in Japanese prints of methods for expression or expression itself and

they incorporated these into their own methods of expression. That is why it is often difficult to pinpoint clearly how Japanese art influenced the great masters of Impressionism. Of course, there are cases where it is relatively obvious, such as in composition or in selection of a viewpoint. Compositions with a high viewpoint exaggerating a spacious extension of earth or sea, those presenting the main motif enlarged in close-up, or the kind of composition used by Manet in his *Nana* or *Boating*, which extract the most impressive portion of a scene to be represented by simply cutting off unnecessary parts of objects or figures, without being concerned about fitting the whole scene neatly into the frame; these are cases where the influence of *ukiyo-e* prints can be identified with relative ease. More subtle examples are also numerous. Many scholars think Monet interpreted the beauty of nature as the world of light and color under the influence of Japanese color prints, but there is no clear evidence for this, and some would argue against it.

Professor Dorival, for example, is one of these, although he acknowledges Monet's debt to Japanese art in other aspects. Dorival believes that considering the development from Corot and Manet in European painting and the theory of Chevreul on coloration, Monet's Impressionist coloring could have been developed very naturally without any influence from *nishiki-e* color prints. There may be various different opinions on this, but this symposium is specifically intended to take up such problems.

In the present exhibition, there are relatively few works by great masters, but there are some works by great painters like Manet, including Manet's illustration of *Le Corbeau*, which show clearly the influence of Japanese *sumi-e* (India ink painting). In the case of works of minor artists, it is easier to point out the influences because of their relatively weaker creativity, and this exhibition displays many such works. In this symposium, however, we are discussing mainly the influence on the great masters. Since their works contributed to later development in European fine arts, it is here that Japanese influence contributed most substantially to European art. The clarification of the question: how much did Japanese art influence Europe, is of great importance. Pissarro, about whom we will hear more in this symposium, wrote to his son, Lucien, on the occasion of the exposition at the Ecole des Beaux-Arts in 1890, of his great admiration for *ukiyo-e* prints. Although he must have been influenced by *ukiyo-e* prints, until recently this effect on his work has been treated lightly.

I have the impression that Whistler received strong influence not only from Japanese prints but also from *Nihon-ga*, especially from the paintings of the Maruyama-Shijō school. I look forward to hearing more of those influences on Whistler. There will also be a report about the influence on the Glasgow School. Although I believe that there was some Japanese influence on Mackintosh, I have not studied it extensively. Therefore, I am looking forward to hearing the talk about it in this Symposium.

With regard to the third period of influence on Europe, after World War II, let me be brief. From the middle of the nineteenth century, European artists recognized that Japanese fine art was based on a completely different tradition and a different standard of value, and they appreciated it as such, and took

from it useful elements which they incorporated into their own modes of expression. Until the beginning of the twentieth century, they were confident of their own traditions, and their study of Japanese fine art was approached from that viewpoint. In the late eighteenth century and the early nineteenth century Hiroshige and Hokusai, too, had learned European perspective from Dutch prints and occasionally adopted it in modification in their own works, firmly confident in the Japanese tradition.

However, in the twentieth century in Europe, there arose doubts about traditional standards of value, and about the validity of European rationalism. After World War II, many Europeans lost confidence in their Western traditions. The mechanisms of industrialized civilization had shown the dangerous potential of materialism, so oblivious to humanity, which had become a Frankenstein out of the control of its creator. The identity of the individual seemed threatened by the organization, and in peril of being sucked into the gigantic gears of mechanized industry. In modern highly industrialized society, the danger of "depersonalization" became a reality. These fears caused people to search for new standards of value to reinvigorate Western culture, and led them to an interest in Chinese and Japanese ways of thinking. In the fine arts, interest developed in the spiritual background of Japanese art, and *suiboku-ga* (India ink-wash painting) with its very subjectivistic expression, and *Nan-ga*, especially the paintings by Uragami Gyokudō, gained popularity in the West. In the ceramic arts, Shino and Oribe wares of the Momoyama period are now drawing the attention of Westerners.

In contrast to this Western devotion to Japanese traditional art, in Japan after World War II, ironically enough, traditional authorities have been almost neglected, while new standards of value, even among the younger generation, have not yet successfully been established. Traditional ways of thinking, however, are not easily or completely changed. For example, Western scholars and businessmen have recently begun to appreciate the Japanese way of doing business. This indicates that even methods of conducting business which we Japanese consider very Westernized, still contain some typical Japanese characteristics. Nevertheless, contemporary Japanese society is very similar in pattern to the industrialized society of the West. This means that the problems of Japanese artists and of European or American artists are shared, and explains why contemporary Japanese artists are in such close contact with Western artists with a view to creating new arts based on highly industrialized society. Foreigners may consider Japanese contemporary art too derivative—that it imitates European or American art. It is true that there are some imitations, but I believe the increasingly Westernized pattern of Japanese society is greatly responsible for these similarities in artistic expression.

THE WESTERNIZATION OF "UKIYO-E" AT THE END OF THE TOKUGAWA ERA

Sakamoto Mitsuru

The fashion for Japonisme in European fine arts was originally touched off by admiration for *ukiyo-e* prints. However, the success of the considerable influence of *ukiyo-e* on European arts which was expressed in the works of Manet or Bracquemond came about not only because these painters were prepared to use the plane expression of *ukiyo-e*, but also because *ukiyo-e* itself had accumulated characteristics of style that brought it closer to European painting. This facilitated its influence on European fine arts. This essay will discuss the Westernization of *ukiyo-e*, a subject that has thus far not been sufficiently evaluated; and offer some relevant supporting evidence.

The Westernization of *ukiyo-e*, I feel, has not been properly appraised by Japanese specialists. Yet *ukiyo-e* assimilated any, if not all, of the characteristics of the European fine arts to complement its own traditional forms of expression. We must not forget that this Westernization was very much the tendency in all the visual arts during this period.[1]

The influence of Western painting on Japanese fine art is clearly seen in the schools of Western-style painting which were founded in Akita, Edo and Nagasaki beginning in the latter part of the eighteenth century and into the nineteenth century. Actually the first Western-style paintings had already appeared in the second half of the sixteenth century in the works of the Jesuit school that accompanied the spread of Catholicism. However, this development did not continue beyond the letter part of the seventeenth century. Later, in the mid-eighteenth century, a second period of painting production commenced stimulated by the import of secular Dutch culture. At that time, the first aritst to adopt elements of European painting was Maruyama Ōkyo, who was an innovator in traditional Japanese painting in Kyoto. The *ukiyo-e* painters took up where he left off.[2] In those days, however, Japanese painters rarely had a chance to see real oil paintings by Europeans. The only thing they had were *vues d'optique*. And, even then, it is believed that these *vues d'optique* were often copies produced in China imitating European *vues d'optique*. The *vues d'optique* themselves involved a simplification and exaggeration of perspective. They were simply playthings, lacking accuracy in form or coloring and having no delicate details nor correct balance. However, it is clear that the very simplicity and exaggeration of expression made it easier for them to be imitated.

The *vues d'optique* (*uki-e*) of the Maruyama School did not develop far, but the *ukiyo-e* style used linear or geometric perspective as exaggerated in the *vues d'optique*. The masters of *ukiyo-e* showed no interest in the true principles of perspective but only imitated them superficially. They did not think it was a contradiction to use Western perspective in one part of a painting only or even to include several vanishing points in the same painting. However, it should be noted here that, through the *vues d'optique*, *ukiyo-e* painters began to recognize the illusionistic effect of linear perspective and to use it, even if imperfectly. In the early *uki-e*, many landscape paintings of theater were produced by Okumura Masanobu and others, which might may be related to the scenographic prints of theaters which are often found in the European prints of the eighteenth century.[3]

The coloring of skies by literati painters such as Ike no Taiga and others is also considered an influence of the *vues d'optique*, as has been pointed out by Naruse Fujio. (In this case, there can hardly be any argument that the influence came from the *vues d'optique*, since the only models Japanese of that time had to consult were they and copperplate prints. The hand colored *vue d'optique* is considered a more possible source than ordinary copperplate prints since we are discussing coloring.) Traditionally in Japan and China there is a blank space in the upper part of vertically hanging scroll landscape paintings although it is not pure empty space. In the case of modern European landscape paintings, by contrast, the skies are usually painted with colors and provided with clouds. It is considered that Ike no Taiga added colors to the skies with the intention of creating the impression of more realistic skies as in the European sense, although he himself had learned the traditional painting techniques of Southern China. Mr. Naruse's analysis of this technique as an influence from European paintings along with the use of perspective or shading is an important finding.

Imitation of the European method of depicting skies in the *vues d'optique* is seen most clearly and conspicuously in the colored copperplate prints of Shiba Kōkan, a member of the school of Western-style painting. In *ukiyo-e* also the zone of color which shades off the upper part of the composition sometimes represents

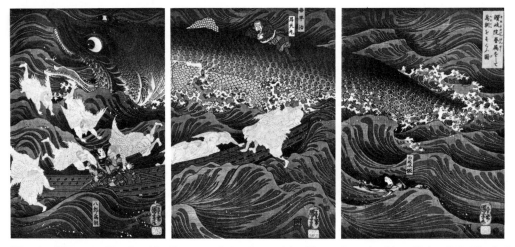

Fig. 1 Utagawa Kuniyoshi, *Tametomo being Rescued by Tengu from the Giant Fish which Wrecked His Ship off the Cost of Sanuki*, c. 1849–50. Triptych of color woodcuts.

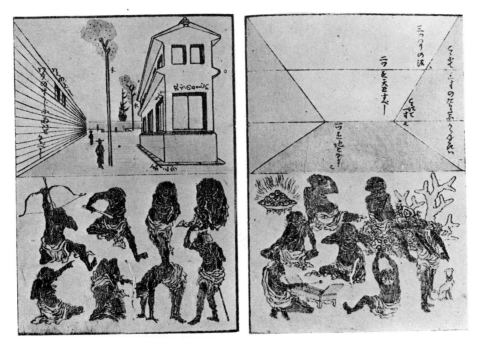

Figs. 2, 3 Katsushika Hokusai, pages from the *Manga*, Vol. 3. Woodcuts.

night or sometimes twilight. In either case, these colored belts became established convention for portraying the colors of the skies and became more and more common in later periods. The same technique can be seen in some of the woodcut landscape prints of Henri Rivière.

This superficial imitation of *vue d'optique* pictures by *ukiyo-e* painters went on, often without any uniformity in expression, but gradually providing a visual unity. We may observe that examples encompassing very broad scenes grew increasingly common. Perspective drawing with a strong expression of width and depth was achieved by Kiyonaga, and later improved upon by Hokusai. Later still even more sophisticated techniques were developed by Hiroshige, Kuniyoshi and various works of the middle of the nineteenth century known as *Yokohama-e* or *kaika-e* which unfortunately have received little attention from an artistic point of view. As another example of the spreading use of the conventions of perspective using a single vanishing point in *ukiyo-e* prints, we can mention some works by Kuniyoshi. In contrast with Kiyonaga's triptych prints, which can be taken as one composition yet each piece with an independent composition, some of Kuniyoshi's triptych or five-piece prints have only one composition and each piece cannot stand independently (cf. Fig. 1). This shows the influence of composition based on single vanishing point perspective.

We can see from the very rough diagrams of perspective in Hokusai's *Manga* (Figs. 2, 3),[4] that the *ukiyo-e* painters, unlike the Western-style painters like Shiba Kōkan, had never studied the geometric principles of linear perspective. It would seem, therefore, that they were trying to match and complement old, original traditions of approved conventions in perspective with some of the traditional Oriental rules of linear perspective which they respected to a certain

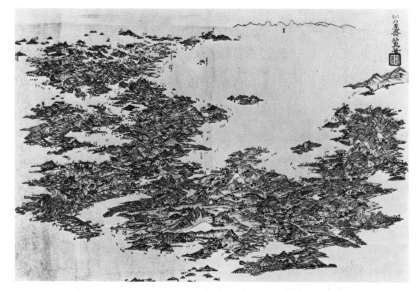

Fig. 4 Kitao Masayoshi, *Map of Japan.* Color woodcut.

extent. For instance, the most popular way of expressing perspective in traditional Oriental painting is to place objects one on top of the other from the bottom of the composition up and reduce them in size as they are placed higher in the picture. Obviously, the result is that the view point seems higher, creating an impression of a bird's-eye view. This results not from their desire to create depth in space, but simply their interest in describing the objects placed in that space. We can see a similar convention of perspective in the medieval arts in Europe. But, there, after the seventeenth century, the view point generally became lower. By contrast, the view point of *ukiyo-e* perspective remained very high even right up to the middle of the nineteenth century, and even after having adopted some European conventions of perspective. It is particularly exaggerated in those prints intended to describe geography (cf. Fig. 4).[5] This may well be the reason that the high, bird's-eye view point is said to be a characteristic of Japonisme. (The reason for this high view point could be, not only the influence of Japanese prints, but also of photography in the middle of the nineteenth century. Shots of scenes such as streets were often taken from high windows or close-up with a wide-angled lens.)

A typical composition, using exaggerated perspective, with extremely unusual, fragmented, large foreground forms that contrast with distant landscape vistas is often employed in *One Hundred Views of Famous Places in Edo*, a work of Hiroshige's later years. A similar form of composition is to be found also in *Jane Avril* and *Divan Japonais* by Toulouse-Lautrec, *The Sower* by van Gogh and *Coin d'un bassin, Honfleur* by Seurat. The dramatic contrast of the large size of foreground objects with the small distant view created a fresh and exciting impression. Naruse Fujio has pointed out in his excellent essay, "From Edo to Paris"[6] that these compositions were anticipated by the Western-style paintings of the Akita School. As described earlier, the characteristics of the Akita School were learned from European prints and other works. Therefore, the source of compositions by Toulouse-

Lautrec or van Gogh can be considered to have originated in the works of their predecessors (i.e. the European artists) of the eighteenth century. One of the most important contributions of Mr. Naruse's essay is to correlate this use of exaggerated perspective of the *ukiyo-e* painters with that of the Akita School. The expression of foreground in the works of the Akita School was developed before the influence of European paintings, and it combined this traditional foreground expression with the European perspective. It is this characteristic which became the forerunner of the composition used in the various works of Hiroshige.

One of the special characteristics of these compositions is that foreground objects are depicted so close that only a part of them can be seen. This technique of including only suggestions of whole objects is characteristic of some Japanese and Chinese paintings. An example is shown here (Fig. 5).[7] The depiction of objects in the foreground in such exaggerated close-up is itself already extraordinary, but by adding a small distant perspective view at the background of the scene under the influence of European works, this traditional expression rationalizes space (Fig. 6). On this point the Akita School is interesting for its unique blend of Japanese and Western art. Beginning with Kiyonaga, *ukiyo-e*

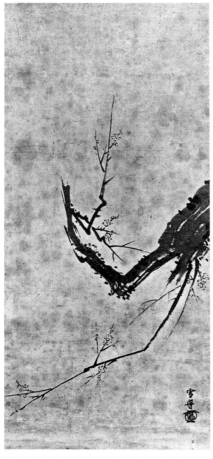

Fig. 5 Sesshū Tōyō, *Plum Tree in Black*. Sumi on paper. Tokyo National Museum.

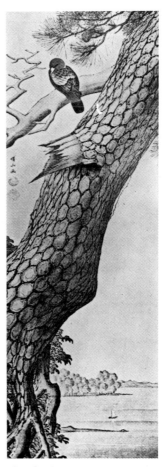

Fig. 6 Satake Shozan, *Foreign Bird on a Pine Tree*. Color on silk.

adopted these techniques, although, as it became more popular around the end of the Tokugawa period, psychological effects were sought after more than a simple expression of distance.[8] In this dramatic expression of the contrast of foreground and background there was less need to take continuity into consideration as a premise of European perspective. It was quite natural for the Akita School, an early school of Western-style painting, to employ an expression of foreground and background which facilitates a feeling of distance. But, in Hiroshige's works, about fifty years later than the Akita School, it is evident that these techniques were used for psychological effect rather than to express simple space.

Finally, I would like to mention the effective use of the black plane in woodcut prints as seen in the graphic arts of Europe at the end of the nineteenth century. What I am referring to particularly here are of course the illustrations of Beardsley, and the works of Félix Vallotton, William Nicholson and others. The application of black in a plane that appears in the works of these European artists is not unfamiliar among some *ukiyo-e* print artists imitating *suiboku-ga*, or Indian-ink painting, although such prints are very scarce on the whole. The strong contrast to the general *ukiyo-e* form has led some people, including Yamada Chisaburō to say that these were influenced by *suiboku-ga*.[9] However, I would suggest rather that the effects of *sumi* brush work as seen in Hokusai's *Manga* were purposely exaggerated under the influence and, parallel with, the new pictorial expression in contour lines and color planes; also the black plane and white plane were expressed more positively in those works than in Japanese prints. I should add, however, that the contrast of black and white as used by Vollotton and Nicholson are very different from the effects of *sumi* brush painting used in *suiboku-ga*, or *ukiyo-e*, in that more importance is attached to the effect of the light contrasts.

NOTES

1. See Sakamoto Mitsuru, *Genshoku gendai Nihon no bijutsu*, Vol. 1, *Kindai no taidō* [The Modernization Movement], Tokyo: Shōgakukan, 1979, chapters 1–3.
2. Suzuki Jūzō, "Uki-e no tenkai to henbō" [The Development and Transformation of *Uki-e*], in *Uki-e*, exhibition catalogue, Riccar Art Museum, Tokyo, September 1975.
3. The subject of the prints depicting scenography may be better understood when seen as a parallel phenomenon rather than a matter of direct influence.
4. The perspective convention of Hokusai is to divide the composition into three equal parts, both horizontally and vertically, and to consider the two upper parts as sky, and the lower one as ground. The vanishing points were then placed at one third from both sides horizontally. Thus there are two vanishing points.
5. *Nippon Zenzu* (Map of Japan) by Kitao Masayoshi. This map shows Mt. Fuji in the lower center part of the map, western Honshū, and Shikoku and Kyūshū Islands in the upper left and north Honshū and a part of Hokkaidō in the upper right. The mountain range shown above the horizon in the upper center of the map is the Korean Peninsula. The horizon is a straight line although the map itself has the form of an orthographic projection scaling down the surrounding areas.
6. Naruse Fujio, "Edo kara Paris e" [From Edo to Paris], *Kikan Geijutsu*, No. 40, Winter 1977.
7. Similar techniques of composition are also to be seen in Europe. Mr. Kagesato Tetsurō pointed out an example in an illustrated book on ornithology. Another example is *Accurate Description of Terrestrial Plants* by Abraham Munting, 1969, reprinted edition.
8. As seen in examples by Degas, it is necessary to consider the influence of photography, since similar techniques appeared in Europe in the end of the nineteenth century.
9. Yamada Chisaburō, *Ukiyo-e to Inshō-ha* [Ukiyo-e and the Impressionists], Tokyo: Shibundō, 1973.

THE DIPLOMATIC BACKGROUND OF JAPONISME: THE CASE OF SIR RUTHERFORD ALCOCK

Haga Tōru

Western Diplomats in the Capital of the Tycoon

It was in 1859 (the 6th year of the Ansei era) on June 26th that the British warship *Sampson* entered Edo's Shinagawa harbor. From Shanghai via Nagasaki, it brought to Japan Sir Rutherford Alcock (1809–97), travelling from his former post in Canton to take up duties as the first British consul general in Japan. Only 10 months had passed since the signing of the Anglo-Japanese Treaty of Commerce and Friendship between the shogunate of Edo and the Earl of Elgin on August 26, 1858, one month later than the Japanese-American treaty.

Alcock was not what is known as a career diplomat. After having spent several years in Portugal and Spain as a surgeon accompanying the British army, he had come to Amoy in China, a port which had only recently been opened following the Nanking Treaty which ended the Opium War. At that time, it was not unusual for doctors, merchants or missionaries to be recruited to work as secretaries for the consulates or legations in countries overseas. Though Alcock had been assigned to open a hospital, he was then appointed first secretary of the newly established British consulate in Amoy. This was to be the first stage of his long career in Asia as a diplomat of the British Empire. The great powers of Western Europe were rapidly extending their influence throughout the world and the situation Alcock found himself in was not uncommon. Yet his former experience as a surgeon was to prove unexpectedly helpful even after he had become a diplomat. After having been chosen in 1844 to become consul of Foochow, he served as consul of Canton and Shanghai for fifteen years, eventually becoming the most eligible person to be appointed to the post in Japan where at that time physical attacks against foreigners by fanatics of the *joi* (expel the barbarian) persuasion occurred frequently.

Alcock was the first diplomat from Europe to be appointed in Edo. American consul general Townsend Harris (1804–78) had been appointed three years earlier, in 1856, but during this period had kept his consulate in Shimoda. A few days after Alcock took up residence in the Tōzenji temple in Takanawa in Edo, which became the general consulate of Great Britain, Harris left Shimoda, having just been elevated to the status of Minister Resident. Harris transferred his legation

to the Zenpukuji temple in the Azabu area of Edo. This happened on July 1859, only five or six days after the ports of Kanagawa, Nagasaki and Hakodate had been opened and free commerce permitted, following a decision of the shogunate.

Two months later, on September 6, 1859, the French consul general in Japan, Duchesne de Bellecourt (?–?) who had come from Marseille via Shanghai, arrived in Edo and settled in his residence in the Saikaiji temple in the Mita area, a location for which Alcock had made all arrangements. Thus, during the summer and autumn of 1859, the diplomatic representatives of America, Great Britain and France settled in Edo. They were followed by Dutch and Russian diplomatic missions and the real diplomatic struggle with the shogunate began, with the "Capital of the Tycoon" (Edo) as the main stage.

I need not explain here in detail how Alcock obtained complete agreement to the treaty with the counsellors (*rōjū*) of the shogunate and bakufu ministers for external affairs (*gaikoku bugyō*) who served as intermediaries. Nor need I elaborate on how quickly he achieved a position of leadership among the diplomatic groups residing in the capital due to his sense of strategy and diplomacy. In those days, the shogunate faced internal turbulence wrought by the *sonnō jōi* (revere the emperor and expel the barbarians) movement, which grew daily more powerful in and around the new center of real power, the court of the emperor in Kyoto. In conciliation, the shogunate attempted to arrange a compromise, in the *kōbu gattai* (court-bakufu coalition) arrangement, at the same time struggling to cope with the new situation of conflict and friction among and with diplomatic and commercial circles, which rapidly increased with the opening of the ports. In the face of the characteristic procrastination of the "yacounin," the officials of the shogunate, Alcock worked ceaselessly for the actualization of the rights and interests which had been agreed on by the treaty. He had to strive constantly to try to discern, from the little information he could obtain on the strengths of both the shogunate and the court, how each would fare in the future. Moreover, both in Edo and in Yokohama, foreign envoys had to defend themselves against the hostile actions of *jōi* raidicals, who posed a very real danger day and night.

On November 6, 1859, four months after arriving to his post, Alcock himself was surrounded at night in the streets of Edo by a group of samurai, including some who were drunk. In order to save his footman although he had no weapon to hand, he exposed himself to great danger. The evening of day before, another incident had occurred in which a Chinese servant in the service of Loureiro, an employee of the French consulate, was killed by two Japanese. Bellecourt reported to the Foreign Minister of his country that the Chinese servant had been wearing European clothes.[1] In the same way, the Japanese servant Denkichi, who had helped Alcock by holding the attackers at bay with a pistol at the time of the street incident, was wearing European clothes and spoke English. He was deeply devoted to his British master, but two months later, at five in the evening on January 29, 1860, he met a tragic death, stabbed in the back with a knife in front of the Tōzenji temple.

Denkichi had been shipwrecked and had found his way to America, and

after spending quite a long time there had returned to Shanghai where he met Alcock and with him returned to Japan. Alcock, who used to call him "Dan Kirche," praised him highly and commented that he was "a most valuable servant."[2] He had been, nevertheless, anxious about Denkichi's future, for, as he wrote, "he was ill-tempered, proud, and violent."[3] When Bellecourt was informed of the attack on Denkichi, he hurried to the Tōzenji temple that same evening to make his condolences. He consulted with Alcock about the dispositions to take after the incident, and helped get information from neighbors. When he returned to the Sakaiji temple late that night, he was aghast to discover that a fire had broken out in the house next to the temple, burning the whole French Consulate to the ground. He returned to the Tōzenji temple to seek assistance and shelter at the British Consulate.[4] On October 30, 1860, an Italian servant (Natal Spinetti) in the service of Bellecourt was attacked by a ruffian in front of the gate of the temple and seriously wounded in the left arm. Two and a half months later (January 15, 1861), the interpreter of the American legation, Henry Heusken, was assassinated by a samurai from the Satsuma domain as he was crossing Azabu-Naka bridge. As a protest against these repeated acts of violence by *jōi* radicals as well as the noncommital response by the shogunate with regard to these acts, the representatives from Great Britain, France, Holland and Prussia decided to leave Edo immediately, from the end of January 1861. Within six weeks, Alcock and Bellecourt had transferred their legations to Yokohama. It is from this period that both the representatives from Great Britain and France started to adopt an independent and firm attitude toward the shogunate, a marked change from Harris's moderate manner.

A SANGUINE BRITON AND A NERVOUS FRENCHMAN

Nevertheless, in spite of their close cooperation, there were obvious differences in both character and attitudes toward Japan between the British and the French diplomats. Bellecourt, no sooner had he entered Japan, a previously isolationist country whose doors had been so recently wrenched open by the West, than he began to complain of the complications and dangers—which were bound to arise—only two weeks after arriving in Edo. In a dispatch to his home country, he wrote somewhat hysterically, "Les difficultés . . . naissent autour de nous à chaque moment comme pour nous dégoûter de cette résidence."[5] This seems a very strong complaint considering that he had only been in Japan for two weeks, and had attended only a few official meetings with the counsellors and bakufu ministers for external affairs, and having been in contact only with the officers of his personal escort. One cannot help thinking that it was too soon to object so strongly. However, Bellecourt apparently felt thrown into a country he saw as savage, where just as he had expected, neither the diplomatic customs of the Occident nor the principles of international law seemed to be in use. Later, during 1860, the French Consul was appointed Chargé d'Affaires and the next year, he gained the same status as Alcock, Minister Plenipotentiary, although this status was "purely honorary." Unfortunately, his first impressions of Japan as "an uncivilized, even dangerous country," were

strengthened day by day, and it seems that Bellecourt labored under this image until the end of his stay.

What was Alcock's attitude by comparison? Of course, he was also well aware of the violence which occurred continuously around him and, for example, when Natal, Bellecourt's servant, was seriously wounded, he sent a letter of sympathy to Bellecourt in these terms: "la vie des agents diplomatiques ici est aussi peu sure qu'à Damas!"[6] (Soon after the attack, Abbé Girard carried Natal to the British legation, and Alcock, as a surgeon, performed emergency surgery.) Alcock complained with almost the same words as Bellecourt, not only of the bloodshed involving foreigners but also of the many difficulties he encountered in complicated diplomatic negotiations with the officials of the shogunate. He wrote that he was "painfully and fully occupied in facing difficulties, which seem to even springing up anew under my feet."[7] This report reflects how much Alcock was concerned with all these problems. Yet Alcock, even after writing these very words, begins his next sentence with "however," " . . . I do not lose sight of what may yet repay all the efforts at present required, and am only too glad to find encouragement myself in the hopes and promises of a better time."[8] He writes with a kind of fearless optimism. His point of view is quite different from the feeling of victimization of his French colleague. In another dispatch addressed to Lord Russell, Alcock wrote:

> It is a small thing for an Agent to incur personal risks, for life is in danger in all places and at all times, even when apparently most secure, and is otherwise nothing worth if it may not be freely risked for adequate ends and in a good cause; but it is all-important that no mistake should be made either as to the means or the end.[9]

These words remind one of the essence of the *bushi* spirit, the Japanese code of the samurai, and are also a good indication of the thinking of British diplomats during the reign of Queen Victoria. This was not simply bravado, as might be made by a young officer of the British diplomatic service when facing a superior. It represented his fundamental belief and resolution, a characteristic that can be clearly seen from his actions and achievements while in office in Japan and by reading his dispatches or his book *The Capital of the Tycoon.*

Certainly, at this time Japan, and particularly Edo and Yokohama, just after the opening of the ports, was a very dangerous place, actually one of the most dangerous diplomatic postings that accompanied the spread of British imperialism throughout the world. Wild animals attacking people was not unheard of, but fanatics wearing swords and deliberately lying in wait for any opportunity to make an attempt on a foreigner's life was much more feared. The men who risked their lives in such a way in order to pursue negotiations met a completely different civilization, whose statesmen dwelled in inertia in a system that could not be easily changed, even by threats and entreaties. That is why it was useless to repeat idle rhetoric or to assume an antagonistic attitude as Bellecourt did. He complained at great length of the attitude of the counsellors and the ministers for foreign affairs of the shogunate for their apparent lack of respect and gratitude toward the French Empire[10] and complained that "during the

meetings, from beginning to end, they are just haughty, and there is not the merest sign that they speak frankly or with trust," and "Do they really not know the principles of international law, or do they pretend not to know these principles; it is impossible to communicate with them. It is a nation that absolutely must be educated from now on."[11] At that time, 6 months after the opening of the ports, considering the poor results of conventional diplomacy, it was necessary, as Alcock reported—Japan being not Europe nor America—to face these difficulties squarely as a challenge most worthy of a diplomat's skills, adopt an unflinching attitude and work patiently toward solution of the problems.

> That little progress should be made in six months under such circumstances is inevitable and will hardly be laid to the account of any want of zeal or diplomatic tact on the part of the several Foreign Representatives. They occupy posts neither very agreeable, nor safe from danger and full of anxious responsibility.[12]

And following that, Alcock says, about this post where bloodshed, fire and earthquakes were concentrated:

> I cannot say the post of diplomatic agent in Yedo is to be recommended for nervous people, and the most sanguine and bold of temperament are likely to find their chief source of congratulation at the end of any given term.... I am not wholly discouraged if I find it impossible to be sanguine.[13]

This sentence is obviously not lacking in humor; it is really quite admirable. His attitude is completely different from that of Duchesne de Bellecourt, who never seemed to understand why misfortune had sent him to the edge of the civilized world, to the Far East. I have read all the dispatches that Bellecourt sent to his country during four and a half years, and until the very last one, dated April 30, 1864, that is the main impression I am left with. Certainly he was one of the "nervous people" of whom Alcock wrote, a man, for whom this country was not suitable. Moreover, he was an "esprit cartésien" in the worst sense of the term. He held fixed ideas about the way diplomatic relations between Western Europe, i.e., France, and the "feudal, backward" Japan should be conducted, and he often became hysterical because of his volatile impatience about the cultural gap that yawned between him and the realities of Japan in the pre-Restoration period. He became very passive toward the reality of Japan and very often mistook the trends of the country. Finally, he was only satisfied when thinking about the differences between the Japanese officials and their European counterparts in terms of psychological analysis. Until the end of his appointment, he had not been able to discern that the power of the court and the Emperor would recover the leadership of Japan. His final and only positive action, sending a mission to France with Ikeda Chikugo in 1864 (Ganji 1) as envoy for negotiations about the closing of the port of Yokohama, brought severe criticism from the French Minister of Foreign Affairs at that time, Drouyn de Lhuys.

Bellecourt's successor, Léon Roches, in the first dispatch he sent to the French Foreign Minister (May 15, 1864) wrote about Bellecourt:

> Ayant à traiter avec ces diplomates habiles et astucieux, l'agent de France n'avait ni précédents à invoquer, ni documents ni traditions à consulter; enlacé dans les fils inextricables de la surveillance japonaise, il ne pouvait lui-même recueillir aucun renseignement sur l'état du pays avec lequel il devait traiter; et n'avait pas à sa disposition un seul homme capable d'exprimer sa pensée ou de le diriger dans ce labyrinthe.

It was an appraisal full of sincere sympathy toward the sufferings of Bellecourt, coming from his successor. On the other hand, Alcock, who was in exactly the same situation, resolutely observed Japanese politics, society and culture with courage, humor and irony, probed the complicated realities of the movement, understood in good time the true situation, and during his short stay of three years, he was able to gather a surprising amount of information and material and even make it public by his own writing.

ALCOCK JAPONISANT

What is the explanation for such a difference in attitudes toward Japan on the part of the British and French envoys? Is it due to personal character, education or ability? Or could it be attributed to the systems of training and appointment of these diplomats or perhaps the difference in their country's experience in diplomacy in Asian countries? Again, perhaps it originated in broader, less definable differences between the rationalism of French culture and the empricism of British culture. Or again was it the difference of national policy and power, between France of the Second Empire as yet buoyed up by the energy of Bonapartisme (although it was to fade within only ten years), and the Great Britain of Queen Victoria where a great inner dynamism propelled its expansion overseas as well as its rapid industrialization. All these reasons, although difficult to analyze, contributed to the differences of behavior between the two diplomats.

In any case, even while busily occupied with his official functions amid the trying conditions explained above, Alcock applied himself diligently and determinedly to the study of Japanese culture, society and landscape. One cannot help admiring the intellectual and physical energy he showed during his tour of duty. It was these qualities that gave him such a profound grasp and insight into the realities of Bakumatsu Japan which were his immediate professional concern and that placed him in a position of leadership among foreign diplomats in Japan at the time. They also made him outstanding among diplomats of his time and the founder of a distinguished line of British "Japanologist-diplomats." We might even say that he was one of the men who initiated the current which came to be known as Japonisme in Europe at the end of nineteenth century.

Alcock first studied Japanese civilization by reading documents relating to Japan that Europeans who had come to Japan before him had written. Admiral Perry, too, on the occasion of his expedition to Japan, had behaved in the same energetic way, having the Congress vote on a special budget for the purpose, and it seems that Alcock did the same thing. He started this study when he was

still in Canton shortly after he had received the order to go to Japan. In March 1862, when he returned to his home country following the first envoy of the shogunate to Europe, he went on with his studies. Then, during a six month furlough, he wrote the book: *The Capital of the Tycoon: A Narrative of a Three Years Residence' in Japan.*[14]

His reading extended from the correspondence of the fathers of the Society of Jesus at the time of the Christian propagation in the sixteenth century to the letters of William Adams to his home country, and, of course, the old observation texts on Japan written by the people connected with the Dutch factory, for example the German Engelbert Kaempfer, the Swedish Carl Peter Thunberg and the Dutch Isaac Titsingh. He also studied the works of his direct predecessors in Japan, for example: Lawrence Oliphant's *Narrative of the Earl of Elgin's Mission to China and Japan* (1859) and Commodore Perry's *Narrative of the Expedition of An American Squadron to the China and Japan Sea* (1856–60).

For Alcock, the first requirement of a diplomat was to study the history and geography, the institutions and customs of a country through existing information, documents or research materials, before going to a new and unknown post. But in such a case, Spain or Russia would be easier to understand than a country of the Far East, and especially Japan. This study was indispensable to a British diplomat at the end of the nineteenth century and Alcock did it faithfully and enthusiastically. Perusing the existing documents of that period he must have seen that though the fundamental structure of Japanese society and culture was accurately recorded, the information was outdated and some parts did not apply to the actual lives of the various classes of Japanese society.

This insufficiency of information was what drove Alcock to take the lead by writing an account in the form of *The Capital of the Tycoon*, an exceptional effort for a diplomat actually in service. He reported of his experiences and observations, being conceited enough not to feel inferior to any one of his predecessors. The French Chargé d'Affaires, Bellecourt, would never have attempted such a thing.

Secondly, Alcock was more than a "Japan expert" in the diplomatic profession; even if he could not be called a "Japanologue," he did qualify as a "Japonisant" for he studied the Japanese language, and at least had a genuine "feel" for it. It has always been an important requirement for a diplomat to learn the language of the country where he is appointed, and if even nowadays this task is easier said than done, much more at that time, when not a single language text or grammar book had been written for foreign learners of the Japanese language by a European and, of course, not by a Japanese. Japanese was naturally a particularly difficult language for both Europeans and Americans to master, yet for this very reason, Alcock, as the first envoy to Japan, felt that if he did not begin to build basic tools with which he overcome this obstacle, it would be to the detriment of future relations between Great Britain and Japan.

On this point only, the French side was one step ahead. Two Catholic fathers, Abbé Girard and Mermet de Cachon of the Missions Etrangères, who had come to the Ryukyu Islands and studied Japanese, had been employed as priests and interpreters at the consulate general. (This caused frequent troubles with the

Japanese authorities who hated Christianity, however.) The British side lacked any such valuable persons. Alcock himself, reflecting upon this in a chapter in *The Capital of the Tycoon* wrote:

> Our want of all knowledge of the Japanese language was the first great barrier to any satisfactory progress in our relations with the country.[15]

Consequently, Alcock not only encouraged and hastened the studies of the two young apprentice interpreters who had been sent to the legation to learn the Japanese language, but himself studied hard and began to prepare an introduction to Japanese grammar. He wrote that this work took eighteen months of diligent daily study, begun shortly after his arrival in June 1859. This introductory book, *Elements of Japanese Grammar for the Use of Beginners* was printed in Shanghai and published in 1861. His teacher was Matabe, an interpreter of the Dutch language appointed to the legation. Needless to say, both men toiled hard against their mutual ignorance. Alcock and the others had to grapple from the Western side with the difficulties that Maeno Ryōtaku (1723–1803) and Sugita Genpaku (1733–1817) had encountered a hundred years earlier when they translated *Kaitai shinsho* (The New Book of Anatomy) from the Dutch. Through the study of kanji, pronunciation, differences in the use of singular and plural, the use of pronouns, and humble and honorific speech, they were able to understand more closely, in a social and linguistic way, the nature of human relations among the Japanese. With the minister himself taking the lead in the study of the Japanese language, and devoting himself so diligently, a tradition of respect for the Japanese language developed within the British legation, and many of the secretaries and interpreters of the legation were to become the leading Japanologists of this early period: Ernest M. Satow, William G. Aston and George B. Sansom.

EXPLORER OF THE JAPANESE LANDSCAPE

Among all the foreign envoys of the period, Alcock excelled both as a "Japonisant" and as a diplomat; he had an adventurous spirit and a strong dynamic personality. He was the first foreign diplomat under the shogunate to make several trips around the country, additional experiences that certainly contributed to deepening his understanding of Japan. This is an important point, for it directly concerns the question of the meaning of "Japonisme." By the spring, 1862, when he temporarily returned to England, Alcock had traveled three times inside Japan.

His first trip, in September 1859 to Hakodate by British warship, was a relatively short one. During his ten day stay, he visited the town and the surroundings of Hakodate, and established a British Consulate there. His second trip in September 1860, however, made for recreation, lasted one month, during which he climbed Mount Fuji and stayed at a hot springs spa in Atami. The third was in 1861; a journey made on his return from an official mission in Hong Kong. Arriving back in Japan at the port of Nagasaki, he returned to Edo by the long overland route which then took more than one month (June 1 to July 4).

Alcock's climb up Mount Fuji, made in the face of the persistent opposition

of shogunal officials, became, in pre-Restoration diplomatic history, an epoch-making event: until that time, the right of diplomats to freedom of travel inside the country, as allowed for in the first article of the treaty with Japan, had not yet really been exercised by any foreign diplomat. Only Harris had made a round trip between Shimoda and Edo, protected by an unnecessarily large escort of shogunal officers. Alcock, moreover, dared to exercise his rights for a private purpose like climbing Mount Fuji, and he did it partly in order to guarantee the rights of all the foreign representatives as well as to jostle the extremely conservative thinking of the bakufu officials. We can easily imagine the shocked and confused expressions of the officials when they heard Alcock mention his planned trip to "Fuji Yama."

Moreover Alcock presented his request saying that he wanted to see for himself, while travelling, the sudden rise in prices due to commerce with foreign countries and the instability inside the country about which the shogunal officials constantly complained. Besides, Alcock wanted to experience for himself this "sacred mountain" that the Japanese people had considered as an object of worship since ancient times. At that time no foreigner was known to have climbed it, but it was well known in Europe from the publication of the book *History of Japan* by Engelbert Kaempfer. Undoubtedly Alcock's adventurous spirit was also at work, inspiring him to want to be the first to climb the holy mountain and by so doing to break down the taboo. More than anything else, however, he probably also sought a brief respite from his position of virtual incarceration in Edo, where he was followed all the year round by security officers, the so-called "body-guard."

Leaving the consulate in Kanagawa with a party of eight on September 4, and somewhat worried because it was late in the season for climbing Mt. Fuji, he found a large procession of nearly 100 people, including officials of the shogunate and their subordinates, and almost 30 horses to carry luggage, ready and waiting for him. As the journey proceeded, the British and the Japanese got to know each other better. They passed Mishima, Ashino Lake, and in Yumoto where a reception was given, Alcock observed that there were mixed public baths; later, in the post town of Yoshiwara, they encountered a storm. Along the route, they were able to study the geography and natural history of the region. From Omiyaguchi, they started climbing the mountain proper, taking with them coffee and biscuits for nourishment. They arrived at the summit on September 11 and stayed two nights on the top of the mountain before starting the climb down. Alcock then stayed two weeks at the seaside resort of Atami for relaxation before returning to Edo.

This was, for all the British participants, a unique expedition full of discoveries from many points of view. For Alcock, it was certainly one of the most delightful experiences of his four year stay in Japan. After returning to Edo, he told Bellecourt the story of his journey and the latter wrote in a dispatch to his minister: "[Alcock] est rentré de son expédition tout enchanté de ce qu'il a vu." But, as always, Alcock had been surrounded during the trip by many officials; he had had to follow only major highways, and put up only at the prescribed inns and do everything as specified, so, said Bellecourt, it could not be said that he

really managed to exercise his right of "free travel" inside the country. "Telles ne sont pas à mon sens les conditions d'une excursion scientifique qui pour être fructueuse a besoin de plus libres allures!"[16] wrote Bellecourt. That is why the French representative was able to understand only the superficial aspects of Japan and could not probe deeply into the nature of the country. He never accepted the fact that he was not a European stationed in Italy or Spain, but in the Japan of 1860. It goes without saying which of the French or British diplomats was the better envoy: the French consul was one who would not move unless all conditions were favorable and preparations had been arranged beforehand. Even then he grumbled constantly. The British minister would start off even amid bad conditions, invariably collect more information than expected and strive to broaden and deepen his understanding.

The same was true for the journey from Nagasaki to Edo at the beginning of the summer of 1861. The Dutch consul General De Witt, and Charles Wirgman, special reporter of the *Illustrated London News* and painter, joined Alcock, forming a party of five. Up until 1858, the successive heads of the Dutch factory in Nagasaki had gone to Edo regularly to pay their respects to the shogunal authorities and men like Kaempfer and C. P. Thunberg had traveled with them. It is almost the same historic route that Alcock followed, though under completely different conditions and circumstances. Along the road, when forced by some local daimyo to do something unpleasant or when they did something purposely to upset him, he took each incident as a way of learning about the reality of Japan. When in Osaka, he went to see a Kabuki performance and, when he had the opportunity to observe the people's lives or the magnificence of the natural landscape, he considered all priceless opportunities to learn. This is clear from Chapter 4 of *The Capital of the Tycoon*, in which the story of his journey is vividly described. On the other hand, although in a letter from Hong Kong Alcock had invited Bellecourt to join him on his Nagasaki-Edo journey, as usual, Bellecourt found an excuse and made no attempt to join him. Even after Alcock's return to Edo, Bellecourt wrote to his home minister refusing to admit defeat:

> Les impressions que M.M. Alcock et de Witt ont rapportées de ce voyage ne sont pas de nature à modifier beaucoup les appréciations que j'ai pu baser sur une étude constante de faits qui se passent chaque jour sous mes yeux . . . [17]

But one may question whether it was good policy to allow such an "uncommunicative and reclusive" type to be a diplomat. Bellecourt was certainly such a man. He cannot have been so old-fashioned as to think that diplomacy was confined to the elegant society of palaces in Vienna. But as one reads his dispatches, he is inclined to pity this man who saw Japan only as a terrible and incomprehensible country. Shortly after he had spent half of his assigned duty in Japan, he complained to his home minister that his health was failing and asked to be recalled to France. When we read this we even feel sorry for such a victim of "culture conflict." We can also say that the government of Napoleon III was quite irresponsible, if not actually cruel, for leaving him for four and

a half years in what was for him miserable exile in Edo. Even now, we know little about Bellecourt, after he returned to his own country. Even his dates of birth and death are unknown. We can imagine that he was completely discouraged after having been assigned to serve under such conditions and then abandoned.

It probably did not make things any less objectionable to be compared with the tough, calm, active and pragmatic Alcock. Meanwhile, although Alcock was subjected, as was usual, to many frustrations and violent situations, such as the attack on the legation by a group of Mito *ronin* the day after he returned from his journey from Nagasaki (July 7, 1861), he went on studying about Japan. By so doing he gradually learned to like Japan and to appreciate its people. As a result, a fundamental shift occurred in his views on diplomacy toward Japan and toward Asian and Western civilization as a whole. He became conscious that Japan was different from Western countries by virtue of its homogenous culture. He dared to grapple with the difficulties arising from these differences as they were the best and quickest way to broaden his outlook and overcome the cultural shock that he experienced. His contribution to Japonisme derived from just such a close personal experience of Japan. At the same time, he was moved toward a greater understanding of Japanese civilization.

ALCOCK'S CONTRIBUTION TO JAPONISME

What can we discover that could have caused this remarkable change of attitude in the British minister's views of the civilizations of East and West? The details of this question have been dealt with in a recent study by Watanabe Akio. In a thoughtful and fascinating essay on civilization and diplomacy,[18] he concludes that the more familiar with Japan Alcock became, the less backward he found it compared with the West in various cultural respects. In fact, this is what Kaempfer and Thunberg had already discovered and mentioned in works which Alcock had read earlier. "But," writes Watanabe, "Alcock's character was such that his understanding of Japanese culture and civilization caused him to seriously question his own cultural background." In other words, while Western man had become convinced that the blessings of material happiness, equality among men, and freedom could be had only through their own advanced civilization, was this in fact true? For Alcock saw in Japan, where religion and the social system were so completely different from Europe, an abundant and rich culture equal in its high level, if not in its essential nature, to that of the West. And he saw that the confident assumptions among Europeans and Americans in trade and diplomacy that the meeting of the "highly advanced civilization" (of the West) and the "inferior civilization" (of Asia) would promote the gradual development of "backward" peoples in exchange for the direct material advantage of "advanced" peoples, and that both sides would eventually merge and coexist in harmony, had to be doubted.[19]

Alcock stood at the very front line of trade and diplomacy of his time, and yet he experienced a real philosophical about-face from the conventional way of thinking of Europeans at that time. Today, it would be considered quite

natural, but in those days, when Western civilization was considered unquestion-ably superior to every other, such an attitude was very rare.

Through what kind of experiences could Alcock finally come to this new interpretation of Japanese civilization? Probably, it was through his intensive study of Japan, as previously mentioned, and through the little things that he saw and experienced while living in Japan. There are many examples reflecting this process in his *The Capital of the Tycoon*. Let us consider here one example. The following passage was written after he had completed his excursion to Mt. Fuji in September 1860 and was on his way to Atami. Alcock and his party crossed the Kano river. They were cautious, as it was about to flood, and later in the evening of September 13th, they arrived at an inn in Mishima where they had a pleasant meal and conversation and slept soundly under mosquito nets.

> The next day, Sept. 14, we mounted early, with beautiful weather, and took our way across the mountainous peninsula which separates Missima from the sea-coast. We first crossed a broad valley, beautifully diversified with clumps of trees, hedgerows, and winding rivulets. Nothing could be richer than the soil, or the teeming variety of its produce. The whole plain was surrounded by an amphitheatre of cultivated hills, and beyond were mountains stretching higher and farther, with a shaggy mantle of scrub and pine. Little snug-looking hamlets and homesteads were nestled among the trees or under the hills, and here and there the park walls, and glimpses of the avenues leading to Daimios' country residences appeared. Much has been heard of the despotic sway of these feudal lords, and the oppression under which all the labouring classes toil and groan; but it is impossible to traverse these well-cultivated valleys, and mark the happy, contented, and well-to-do-looking populations which have their home amidst so much plenty, and believe we see a land entirely tyrant-ridden, and impoverished by exactions. On the contrary, the impression is irresist-ibly borne in upon the mind, that Europe cannot show a happier or better-fed peasantry, or a climate and soil so genial or bounteous in their gifts.[20]

The first half of this quotation is a beautiful, picturesque poem to the land-scape. Alcock obviously had an artistic flair, and he inserted many of his own sketches in *The Capital of the Tycoon* together with works of professional painters like S. J. Gower, who accompanied him on the Mt. Fuji Expedition, or Charles Wirgman who traveled with him from Nagasaki to Edo. Observing the scenic views composed of the beauty of nature and the small villages in Izu with his artistic eye and good sense of perspective, he could not help but begin to doubt whether it were true that the lives of the peasants were oppressed by the infamous "feudalism." In order to accept what he was actually seeing for himself, he had to be skeptical about the notion usually accepted to mask fact. Could he really call those contented and comfortable looking villages "a land entirely tyrant-ridden, and impoverished by exactions."? Alcock was not the type of person to go into raptures about what he saw, but to employ expressions of restraint like, "but it is impossible . . . " or "the impression is irresistively borne . . . " as in the above passage.

What, after all, impressed him most? Could it have been the thought that the isolation and feudalism of Japan had, in fact, been even more successful than modern, cosmopolitan, Western civilization in achieving security of life and happiness to its people? It was not only the day he passed by those mountain villages in Izu that led him to such conclusions. Alcock came to these conclusions as follows:

> This feudalism has left the nation, if not free in our estimate of freedom, yet in enjoyment of many blessings which all the boasted freedom and civilization of Western States have failed to secure for them in an equally long succession of centuries. National prosperity, independence, freedom from war, and material progress in the arts of life—these are all among the possessions of the Japanee as a people, and the inheritance of many generations.[21]

Japan was a country that had created its own distinctive value system, that was why, in the face of Western demands for trade and reform, it showed so much stubborn reluctance to change. It could not survive without changing. Who could know whether the change was to be for the better. "When all is accomplished, whether the civilizing process will make them as a people wiser, better, or happier, is a problem of more doubtful solution."[22] It is extraordinary for a diplomat assigned to Japan, whose mission was to secure and lock the country into the chain of trade for the great British Empire, to speak with such discernment. Such observations must have been only made after turning over many questions in his mind for some time.

One of the reasons for Alcock's enthusiasm about Japan was that, beyond the beauties of the scenery or the abundance he observed in the people's livelihood, he had a great affection for its arts and crafts. During the two weeks at Atami, after Alcock and his party arrived from Mishima, they bought so many things that they almost emptied the village! They also visited a paper-making factory and studied the entire process carefully. On the occasion of his trip from Nagasaki, Alcock bought everything from silks to lanterns and even examples of the different sorts of *hibachi* (braziers) found in Osaka and elsewhere. He must also have bought many things in Edo. We do not know how many things he collected in all, but it was probably on the order of hundreds and even thousands of items. In 1861, he dispatched to London a total of 614 pieces, including lacquerware, porcelain, ironware, woodcraft pieces, picture books, maps and toys, all of which were displayed at the International Exhibition beginning in May 1862.

Alcock discovered things by himself and he grew quite absorbed with his personal discoveries, quite without the guidance of anyone, of the beauty, refinement and skill of workmanship of the handicrafts, arts and folkcrafts, most of which were made by anonymous people. In his *The Capital of the Tycoon*, he devoted half a chapter (Chapter 35) to discussing Japanese civilization, in which he admired the arts and crafts that demonstrated the brilliance of this unique culture and at the same time served as a key to explaining its secrets.

In all the mechanical arts the Japanese have unquestionably achieved

great excellence. In their porcelain, their bronzes, their silk fabrics, their lacker, and their metallurgy generally, including works of exquisit art in design and execution, I have no hesitation in saying they not only rival the best products of Europe, but can produce in each of these departments works we can not imitate, or perhaps equal.[23]

He must have been aware of the International Exposition planned for 1862 when he arrived in Edo in 1859, but it is not clear when he was requested or instructed to invite the Japanese Government to participate in this Exhibition. In any case, we can easily imagine that the officials of the bakufu were not very enthusiastic. They had no no idea what a world exposition was and besides, they were preoccupied with very pressing domestic concerns. The result of this situation was that Alcock became the agent of the Japanese government with regard to the exposition. However, it must have been mostly due to his personal initiative that he was accepted as such. He might well have hoped to show off to his mother country and his European colleagues the beauty he had found in his place of assignment. He writes, "I collected (the fine specimens of old lacker) for the Exhibition, to illustrate the progress of the Japanese in the mechanical and higher industrial arts, and as evidence of their civilization."[24] His admiration for Japanese arts further continues with high compliments such as,

> Perhaps in nothing are the Japanese to be more admired than for the wonderful genius they display in arriving at the greatest possible results with the simplest means, and the smallest possible expenditure of time and labor or material. The tools by which they produce their finest works are the simplest, and often the rudest that can be conceived. Wherever in the fields or the workshops nature supplies a force, the Japanese is sure to lay it under contribution, and make it do his work with the least expense to himself of time, money, and labor. To such a pitch of perfection is this carried, that it strikes every observer as one of the moral characteristics of the race, indicating no mean degree of intellectual capacity and cultivation.[25]

This is quite unabashed praise. The skill of Japanese craftsmen was also remarked upon by Westerners since the time of Kaempfer and Thunberg, and it had become legendary. But, Alcock had observed for himself the work of the craftsmen in Edo, Yokohama and during his travels in Japan, where he never ceased to be amazed at how quietly and diligently the craftsmen worked, how cheerful and exuberant they seemed, and how the end product which they created was inevitably so perfectly refined. He attributed the refinement of their work, in fact to the density of Japanese culture which, passing through such a long period of peace and stability, had allowed all handicraft skills to develop and mature in a unique way.

In the same chapter, he introduces some of the illustrations from the woodcut print picture books which he calls Japanese "Charivari," and we can tell that he sincerely appreciated them as an amateur. For example, he wrote about the *kamiyui* (barber) as follows: "Here we have a Japanese, it may be your servant, taking his ease and enjoying the luxury of being well shampooed—and one

he will by no means forego, though you should want him ever so much. He engages to serve you only on those well-understood conditions."[26] Actually he mistook hair-dressing for shampooing, but his lighthearted comments are delightful. Alcock amused himself by inventing stories, while looking at the pictures of *Shokunin-zukushi* (Album of the Professions) with the fellow who came back from the barber as the principal character. When the man returns home, a family dispute arises, and having got his clothestorn by his wife, he comforts himself by purchasing a new kimono (in fact, this is a scene where he is haggling in a pawnshop). These glimpses provide an image of a man who was knowledgeable and admiring of Japan to the extreme; it is almost impossible to imagine that he is the same person who made the Japanese governors quail several times during their diplomatic negotiations and who once ordered British naval forces to open fire on Shimonoseki as part of a retaliatory move by a combined fleet of the four Western nations, Great Britain, America, France and Holland.

Intending to end his chapter on sketches several times, he keeps adding comments, for he seems to have happened upon the Hokusai *Manga*. He interprets one of the pictures showing a man blowing bubbles sitting in the street as follows:

> Here is a very pleasing specimen, full of life and fun, and worthy of Hogarth for its truth to nature; it needs no explanation. It shows plainly how children of large growth blow soap-bubles to amuse their progeny, and are not above enjoying the sport.[27]

What an interesting point of view to compare Hokusai with Hogarth! After this, he continues his comments, pointing out grotesque, long-nosed goblins, or a humorous lantern mender, and so on, all in a relaxed vein which could be described at great length. However, we too must close this chapter shortly.

Alcock sent to the International Exposition of 1862 a variety of Japanese items which you might call bric-a-brac or bibelot, and this provided a strong stimulus to the fashion for Japonisme which was just beginning in Europe.[28] We might well say that he was pursuing and enjoying a personal devotion to Japonisme. As we have already seen, Alcock's contribution to Japonisme in Europe and his affection for Japan was derived from his versatile activities and his study in Japan as the tough, cool, courageous and active diplomatic representative.

That was the main reason his activities were so forceful and his Japonisme was so strong. The areas of Alcock's Japonisme unexplored in his earlier book, are recounted and clarified in his second book, *Art and Art Industries in Japan*.[29] Alcock's Japonisme became for himself a wellspring for appreciation of Japanese culture as a whole and a critical perspective on British diplomatic policies towards Asian countries at that time. In other words, the Japonisme movement, as conceived by a diplomat who took the initiative in that endeavor, meant a counterattack or a criticism of the Western views of civilization from an Eastern standpoint.

(Translated by Lynne E. Riggs)

NOTES

1. Archives du Ministère des Affaires Etrangères, Dépêches de Duchesne de Belle-court, microfilm, Institute of Historiography, University of Tokyo. Bellecourt au Comte Alexandre de Walewski, le 7 nov. 1859.
2. Ibid., R. Alcock to the Minister of Foreign Affairs (of the bakufu), Jan. 1860.
3. Rutherford Alcock, *The Capital of the Tycoon, A Narrative of a Three Years' Residence in Japan*, 2 vols., London and New York, 1863, Vol. I, Chapter 16, p. 322.
4. Bellecourt à Walewski, le 30 jan. 1860.
5. Ibid., le 30 sept. 1859.
6. Ibid., Alcock à Bellecourt, le 31 oct. 1860.
7. Alcock to Lord John Russell, March 6, 1860.
8. Ibid.
9. Ibid.
10. Bellecourt à Walewski, le 10 dec. 1859. "ai-je entendure depuis mon arrivée ici la moindre parle gracieuse soit pour mon pays, soit pour mon souverain."
11. Ibid., le 30 sept. 1859. The original French of these two quotations is as follows: ". . . des entretiens toujours sollennels, et d'autant plus pénibles qu'il faut se résoudre à n'y recontrer ni abondon ni confinace."
 "Le Japon est . . . un pays dont l'éducation est entièrement à faire et où les principes du droit international semblent à l'état complètement rudimentaire, soit qu'on les ignore, soit qu'on feigne de les ignorer."
12. Alcock to Lord John Russel, Jan. 7, 1860.
13. Ibid.
14. The preface is dated January 21, 1863.
15. Vol. I, Chapter 8, p. 166.
16. Bellecourt à Thouvenel, le 14 oct. 1860.
17. Ibid., le 4 juillet 1861.
18. "Bunmeiron to gaikōron—Rutherford Alcock no baai," (Civilization and Diplomacy: With Particular Reference to Sir Rutherford Alcock's "The Capital of the Tycoon") *Kyōyōgakka kiyō*, 11, University of Tokyo, 1978.
19. Ibid.
20. Vol. I, Chapter 21, p. 431.
21. Ibid., Vol. II, Chapter 35, p. 238.
22. Ibid.
23. Ibid., p. 243.
24. Ibid., p. 245.
25. Ibid.
26. Ibid., p. 253.
27. Ibid., p. 262.
28. Miyauchi Satoshi, "Dai ni-kai London Kokusai Hakurankai to Nihon no shuppin-butsu ni tsuite," *Kyūshū Geijutsu Kōka Dai Kenkyū Ronshū*, 4, 1979. (I have not referred to much of the content of the Exposition in London in this essay as I believe there is already considerable detailed research and comment in Miyauchi's essay.)
29. London, 1878. See also Alcock's *Catalogue of Works of Industry and Art, Sent from Japan*, London, 1862.

LES MILIEUX JAPONISANTS A PARIS, 1860–1880

Geneviève Lacambre

Lorsqu'il y a tout juste quinze ans, je soutenais une thèse à l'Ecole du Louvre sur *Le rôle du Japon dans l'évolution de l'habitation et son décor en France*, la situation était bien différente de ce qu'elle est aujourd'hui. L'influence japonaise en France dans la seconde moitié du dix-neuvième siècle était à ce point assimilée qu'elle était pratiquement oubliée, au moins en ce qui concerne les arts décoratifs—et l'Art Nouveau—, car on ne pouvait négliger quelques cas précis d'influence évidente des estampes japonaises sur les peintres.

Le domaine que Nicolas Pevsner, en 1936, signalait comme inexploré, celui du rôle de la Chine et du Japon dans l'évolution des arts européens depuis 1860 restait alors à étudier. Dans l'article qui s'intitule "Le Japon à Paris," publié en 1878 et que, fort à propos, le catalogue de l'actuelle exposition reproduit, Ernest Chesneau suggérait d'écrire un mémoire: "De l'influence des arts du Japon sur l'art et l'industrie de la France."[1] Et c'est ce sujet que j'ai choisi à ce moment-là. Ce qui pouvait sembler, pour Ernest Chesneau, pédantisme, devenait alors fort éclairant pour la compréhension des transformations esthétiques de la fin du siècle. Et pour comprendre le fonctionnement de ce réseau de découvertes et d'influences, il était alors utile de rechercher dans la pressé du temps, l'image que l'on se faisait au dix-neuvième siècle du Japon, de rechercher aussi une approche des différents milieux touchés par le Japonisme et de leurs motivations, une analyse des différents types d'influence et les raisons qui rendent perméable le pays récepteur de ces influences. Car il faut bien distinguer dès l'abord, connaissance et curiosité, de la notion, plus complexe, plus profonde, d'influence.

Nous verrons qu'apparaissent en France, tour à tour:

—l'introduction de motifs japonais dans le répertoire de l'éclectisme, qui s'ajoutent sans les remplacer aux motifs décoratifs de tous les temps et de tous les pays;

—l'imitation préférentielle des motifs exotiques et naturalistes japonais, ces derniers étant le plus rapidement assimilés;

—l'imitation des techniques raffinées du Japon;

—l'analyse des principes et méthodes que l'on peut déceler dans l'art japonais et leur application.

Tous ces éléments combinés—et combinés seulement par certains—, font que, de l'exotisme à l'assimilation complète, l'exemple japonais apparaît bien comme le modèle, voire la justification du modernisme de ce temps.

Les raisons de cette influence tiennent à l'image que l'on se faisait alors du Japon, —et elle a évolué, bien sûr—, aux milieux japonisants qui se constituent à Paris, enfin à la situation même de l'art et de l'art industriel, comme on disait alors, dans la seconde moitié du dix-neuvième siècle. La France du temps se trouvait—et c'est un des rôles des expositions universelles que cette prise de conscience—dans une situation de malaise dû au rapide développement de l'industrie et à ses conséquences esthétiques: on peut, à l'époque, tout imiter et bon marché! Elle était donc particulièrement vulnérable et réceptive.

Ce qui permet à Roger Marx, un critique d'origine nancéenne comme Gallé, de dire en 1891, au moment de l'apogée de l'influence japonaise encore consciemment perçue: "Ceux qui la voudraient désormais oublier, se condamneraient à mal connaître les origines de l'évolution moderne et à ne point discerner l'élément essentiel de ce qui constitue à notre insu le style d'aujourd'hui. Du même coup ils se trouveraient ignorer, dans l'histoire des variations de l'art, l'exemple d'une prépondérance décisive entre toutes, avec qui peut seule être mise en parallèle, l'action exercée par l'antiquité au temps de la Renaissance."[2] La simple lecture de la presse du temps me confirme donc dans le choix de ce sujet sur l'influence du Japon.

Bien sûr, ces propos de Roger Marx étaient imprimés dans une revue spécialisée, *Le Japon artistique* de Bing. Néanmoins il restait à prouver qu'il voyait juste. Quelle était donc, peu après la réouverture du Japon, l'image que l'on se faisait de ce pays en Occident? Lorsque Baudelaire note en 1860: "Les récits de Marco Polo, dont on s'est à tort moqué méritent notre créance,"[3] il nous rappelle que ses contemporains et lui-même conservaient ainsi cette vision médiévale d'un Japon riche et civilisé, que plus tard Christophe Colomb crut reconnaître en abordant Cuba prise par erreur pour Cipangu. S'y ajoute l'opinion des Encyclopédistes, témoins de la découverte et de la fermeture du Japon, qui admirent "ce peuple étonnant, le seul de l'Asie qui n'ai jamais été vaincu."[4] A l'époque je m'étais attachée à collecter beaucoup de ces temoignages quasiment linguistiques du prestige immense qu'avait alors le Japon.

Ainsi le Japon arrivait, lorsqu'il n'était plus, soudain, ni lointain, ni inaccessible, avec une image de marque remarquable. Il est absent, on l'a redit, des premières expositions universelles, celle de Londres en 1851, celle de Paris en 1855, mais, dès la première participation à Londres en 1862, il est intéressant de remarquer que les produits japonais furent vendus, après l'exposition, par la firme, Farmer and Rogers et qu'un jeune commis de cette firme était le futur organisateur de l'Art Nouveau anglais, Arthur Lasenby Liberty. Déjà s'impose donc l'hypothèse qui maintenant est bien prouvée, selon laquelle tous les tenants de l'Art Nouveau, et non seulement Liberty, sont d'anciens japonisants.

Par ailleurs, l'exposition universelle apparaît comme le mode d'introduction d'objets exotiques non seulement à voir, mais à acquérir. Et cela fonctionne à Paris dès 1867, lorsque le Japon expose pour la première fois. En effet il ne faut pas négliger une vente organisée à Paris en 1868, 41 rue de la Victoire des "pro-

duits et objets d'art japonais composant la collection envoyée du Japon pour l'exposition universelle," vente qui comptait 1308 objets, armes, meubles, porcelaine, terre cuite: le n° 233 est une "théière en terre cuite, décor feuilles émaillées, vert et rouge," les deux vases qui l'accompagnent (n⁰ˢ 234 et 235) sont à "feston, forme feuille" et me semblent déjà annoncer certains exemples de céramiques et d'orfèvrerie au naturalisme végétal de Tiffany ou, plus tôt en France, de Christofle.

Il y avait certes au Trocadéro, une ferme japonaise fort admirée, mais sans influence immédiate et aussi, dans l'exposition, on le sait par des archives, une centaine d'estampes japonaises contemporaines représentant les femmes des différentes classes de la société japonaise, très hiérarchisée, et cinquante vues d'Edo[5] qui semblent ensuite avoir été également vendues à Paris. Mais à l'époque, certains comme Philippe Burty, Théophile Gautier ou les Goncourt ont déjà une vision du Japon, perçue à travers des livres et des estampes japonais qui ont été diffusés depuis quelques années. Trois ans auparavant, les Goncourt voyaient déjà "japonais" lorsqu'ils notaient, le 19 juillet 1864; "ce soir le soleil ressemble à un pain à cacheter cerise, sur un ciel, sur une mer gris perle. Dans leurs impressions en couleurs, les Japonais seuls ont osé ces étranges effets de la nature . . ."[6] Les travaux postérieurs à ma thèse ont permis de voir plus clair dans l'épineux problème de l'introduction en France des livres illustrés et des estampes japonaises. Mais il faut nettement distinguer la transcription pittoresque de modèles japonais dans des livres occidentaux, néerlandais ou français notamment, et l'assimilation par les artistes des nouveautés esthétiques qu'il ne pouvaient déceler qu'à travers des originaux, même de qualité modeste. Et sans doute faut-il situer "cette journée émouvante et féconde où un grand artiste français se rencontra pour la première fois . . . avec une petite estampe japonaise"[7] chez le graveur Delâtre; il imprima en 1859, ce *Recueil de dessins pour l'art et l'industrie* d'Adalbert de Beaumont et Eugène V. Collinot, contenant, entre autres, dix huit planches d'oiseaux, de fleurs, d'insectes, vie japonaise et paysage d'après Hokusai.[8] Mais, noyées au milieu de modèles divers, ces images n'eurent pas d'influence avant plusieurs années . . . Nombreux sont ceux qui, quelques années plus tard, se sentent "inventeurs" du Japonisme. Ernest Chesneau laisse, dans son article de 1878 "Le Japon à Paris," le choix entre plusieurs artistes, Stevens, Whistler, Diaz et, plus étonnant, Fortuny ou Alphonse Legros. Mais il ne cite pas Bracquemond,[9] tandis que les Goncourt, de leur côté, prétendent être les premiers propagateurs de l'art japonais en France.

Sont maintenant bien connues les boutiques qui se multipliaient alors à Paris, et la magique histoire de la *Porte Chinoise*, seul lieu où aurait été disponible la production japonaise dans les années 1860, est maintenant abandonnée. C'était une vieille maison de thé et de curiosités, alors sise 36 rue Vivienne (Fig. 1), qu'il faut bien distinguer de la boutique de curiosités plus célèbre où réellement se réunissaient les artistes, celle de Monsieur Desoye et, après sa mort, de Madame veuve Desoye, 220 rue de Rivoli, qui s'ouvre seulement en 1860. L'une reste toujours un de ces magasins d'alimentation où l'on trouvait aussi quelques curiosités, tandis que la boutique de Madame Desoye était une galerie d'art et d'artisanat du Japon. Je pense qu'une étape future de l'étude de ces milieux japonisants

serait justement de faire la distinction entre ces deux types de magasins. La
Porte Chinoise en 1895 (Fig. 2) continuait à vendre d'abord du thé, tandis que Mon-
sieur et Madame Desoye, ayant eux-mêmes voyagé en Extrême-Orient et s'étant
spécialisés dans la curiosité, offraient près du Louvre, un lieu privilégié dont
Edmond de Goncourt pouvait écrire: "ce magasin a été l'endroit, l'école pour
ainsi dire où s'est élaboré ce grand mouvement japonais qui s'étend aujourd'hui
à la peinture et à la mode" tandis que, pour lui, le 31 mars 1875, Madame Desoye
apparaît comme "une figure presque historique de ce temps."[10] Et citant les
premiers clients de la boutique, il indique: "Ç'a été tout d'abord quelques
originaux comme mon frère et moi, puis Baudelaire, Villot, presque aussi amou-
reux de la marchande que de ses bibelots . . . "[11] Il ne s'agit plus là d'une boutique
d'alimentation.

En 1878, Ernest Chesneau cite une liste beaucoup plus longue de précurseurs
du Japonisme: on y trouve Frédéric Villot, conservateur des peintures, puis
secrétaire général du Louvre et ami de Delacroix, et aussi des artistes, Manet,
Tissot, Fantin-Latour, Alphonse Hirsch, Degas, Carolus-Duran, Monet,—
donc pas uniquement des artistes dont les œuvres sont ensuite japonisantes—,
des graveurs comme Bracquemond et Jules Jacquemart, un céramiste de Sèvres,
Solon, des écrivains et critiques, les Goncourt, Champfleury, Philippe Burty et
bien sûr Zola, leur éditeur Charpentier et, ce qui me semble important, des
représentants des industries d'art, Barbedienne, Christofle, Bouilhet, Falize et
enfin des voyageurs qui s'étaient fait connaître plus récemment, après la fin du
Second Empire, l'industriel Cernuschi qui avait voyagé avec Théodore Duret,
l'industriel lyonnais Guimet et le peintre Régamey.[12]

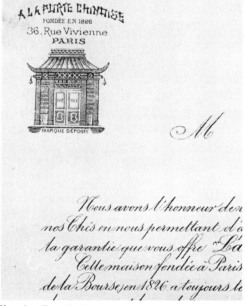

Fig. 1. Détail d'un prospectus pour La Porte
Chinoise (collection de la boutique *La Porte
Chinoise*, 71 boulevard de Courcelles, Paris, en 1963).

Fig. 2. Publicité pour la *Porte Chinoise*,
vers 1895. Collection particulière.

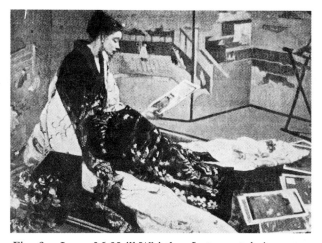

Fig. 3. James McNeill Whistler, *Le paravent doré*,
1864, Huile sur bois. Freer Gallery of Art, Wa-
shington, D.C.

Fig. 4. James McNeill Whistler, *La princesse du
pays de la porcelaine*, 1864, Huile sur bois. Freer
Gallery of Art, Washington, D.C.

D'autres sources permettent de préciser une chronologie, l'état de ce milieu
japonisant à la fin du Second Empire. Les travaux de Mme Yvonne Thirion ont
montré les premières atteintes du goût japonisant chez les peintres. Dès 1863,
Millet et Théodore Rousseau—morts tous deux bien avant 1878—possédaient
des albums et des images du Japon,[13] tandis que Whistler est un des premiers à
représenter dans ses tableaux des objets japonais et à subir une fructueuse in-
fluence esthétique, par exemple dans *Le paravent doré* (Fig. 3), *Le balcon*, *La princesse
du pays de la porcelaine* (Fig. 4), de 1864. Et il portait un kimono dans le tableau,

rapidement détruit, du *Toast à la vérité* de Fantin-Latour, du Salon de 1865. Bracquemond produit en 1866 un service décoré d'après Hokusai, tandis que se constitue la Société du Jing-lar autour de Solon et que Zacharie Astruc se déclare, en 1868, le premier à avoir voulu défendre l'art japonais.[14]

C'est donc non pas dans les milieux académiques, mais dans celui des artistes et écrivains les plus modernes du temps, celui des réalistes et des naturalistes que l'on trouve les japonisants. Dès 1869, Champfleury dans *Les chats* reproduit un "caprice japonais tiré de la collection de M. James Tissot" représentant un groupe de chats, ainsi qu'une "caricature japonaise" de Hokusai et note que cet artiste laissa "une grande quantité d'albums dont la principale série composée de quatorze cahiers, excita lors de son introduction à Paris, une noble émulation."[15] Donc les objets, les images sont là, et déjà ils commencent à influencer les artistes. Pour lui, qu'une querelle devait opposer plus tard à Edmond de Goncourt au moment de la parution de *Chérie* en 1884—ils sont tous les deux les tenants du naturalisme littéraire—, c'est Villot et quelques-uns de ses amis qui sont responsables de la mode du Japonisme, tandis que dans un article de *la Vie parisienne* du 21 novembre 1868 qu'il intitule ironiquement "la mode des japoniaiseries," il rappelle le rôle de découvreur de Baudelaire, la part immense prise par Whistler et la diffusion déjà envahissante des sujets japonais avec Tissot.[16]

Après l'exposition universelle de 1867, le goût pour le Japon descend au bourgeois. L'annuaire de la *Gazette des Beaux-Arts* de 1870 cite encore d'autres catégories d'artistes pris dans la vogue japonisante; ainsi Reiber, directeur des travaux d'art chez Christofle que dirigent alors les héritiers du fondateur, Christofle et Bouilhet, tandis que Barbedienne ou Albert Jacquemart ne sont cités que comme amateurs de chinoiseries (sans insister je voudrais signaler qu'il y a là tout un problème de définition de ce qui est japonais ou chinois qui n'est pas toujours clair pour les contemporains eux-mêmes). Curieusement, les Goncourt ne sont encore que des collectionneurs d'art du dix-huitième siècle, malgré la mention de quelque "monstre japonais, bronze fascinatoire" dans leur *Journal* le 12 septembre 1868.[17]

Sans doute faut-il penser que s'ils possédaient déjà des estampes japonaises, ils ne jugeaient pas digne d'avouer qu'ils les collectionnaient et ce n'est vraisemblablement qu'en 1873—assez tard[18]—qu'Edmond de Goncourt s'est mis à collectionner, au sens propre, des estampes japonaises.

Baudelaire, encore, apparait comme un précurseur, lorsqu'il écrit en 1861 à Arsène Houssaye que son lot de "japonneries" est composé d' "images d'Epinal du Japon, deux sols pièce à Yeddo,"[19] tandis que Zola défend Manet dont les toiles rappellent, pour d'acerbes critiques, les "gravures d'Epinal," en notant que l'utilisation simplifiée des couleurs s'y retrouve comme dans les gravures japonaises. Ainsi, se met déjà en place l'esthétique des artistes de la fin du siècle.

Dans ces premières années, les aspects connus de la production japonaise sont variés. On connait surtout le raffinement extrême des techniques du bronze, du laque, de la porcelaine. On connait aussi la verve osée, l'observation naturaliste des albums et des images, leur coloration éclatante, leur composition assymétrique faisant intervenir le gros plan, les lignes d'horizon hautes et les découpages hardis. Et dans la variété des sujets traités, les collectionneurs entrevoient déjà

certains aspects de la vie japonaise, l'architecture, les éléments essentiels du mobilier dont les Goncourt notent seulement le pittoresque étincelant ou Philippe Burty, l'élégante simplicité. Au delà du pittoresque, de l'étrange, il y a toujours quelque chose d'idéal, de parfait dans ce que l'on connaît du Japon. L'aventure du Japon à Paris commence sous les exclamations admiratives et c'est, en fait, plutôt l'aventure d'un lot de meubles de paravents, de bronzes, de céramiques souvent oubliés maintenant au profit des seules images, plus que celle d'un peuple; le Japon alors va devenir fournisseur privilégié de joies esthétiques.

Bientôt les curieux, les marchands vont faire le voyage et rapporter des caisses d'objets, car la demands s'accroit; mais l'esprit n'est plus tout à fait le même que celui des marchands de thé et d'éventails de la fin du Second Empire. Le Japon n'est plus, croit-on, à découvrir; on veut "du" Japon. Certains ont un souci plus archéologique qu'esthétique. Ainsi du voyage de Cernuschi en 1871. Mais il est accompagné de Théodore Duret, un proche des futurs Impressionnistes, alors réfugié en Grande Bretagne après la Commune. Un détail comme celui-ci montre que les amateurs d'art japonais se situent parmi ceux qui ne défendent pas le Second Empire. Il y a plus de républicains que de fidèles de l'Empire parmi les japonisants. Si Duret cherche au Japon les albums entrevus à Paris et a quelques difficultés à en trouver—il n'en rapporte que de modernes[20]—, Cernuschi amasse des objets de tous les pays d'Asie. Lors du premier congrès des orientalistes organisé en 1873 à Paris par le linguiste Léon de Rosny et consacré au Japon—on parle alors de japonistes—, la collection Cernuschi est exposée au Palais de l'Industrie en septembre et modifie les images façonnées les années précédentes. On assimilait jusque là l'art japonais aux "albums modernes importés à profusion"[21] et aux bronzes hérissés d'une abondance de détails, œuvres de virtuosité comme en avait le duc de Morny sous le Second Empire. On trouve l'art japonais plus classique dans sa variété et sa perfection, on reconnait qu'il est essentiellement *décoratif* et cela devient sa qualité la plus appréciée.

Pour la céramique, les œuvres rapportées par Cernuschi permettent pour la première fois de distinguer deux industries parallèles, "l'une ayant un caractère étranger . . . et c'est la porcelaine, l'autre nationale qui emploie comme matériau la faïence ou plutôt le grès."[22] Il y a en effet des grès mats ou vernissés avec ou sans décor.

Cet aspect de l'art japonais sera déterminant pour les années suivantes et sera associé bientôt à une première connaissance de la calligraphie et l'usage du pinceau. On y voit une heureuse combinaison des effets de la nature et du hasard d'une part et de l'intervention de l'artiste d'autre part; on y trouve un modèle à suivre pour justifier le rejet des techniques traditionnelles issues de la sage Renaissance. Même esprit encyclopédique dans le voyage de Guimet et de Régamey qui s'intéressent, eux, plutôt à l'histoire des religions; Régamey rapporte des vues de sanctuaires d'Asie exposées à l'exposition universelle de 1878. Plus spécialisés sont les voyages de Philippe Sichel en 1873 et de Bing en 1875: ce sont des marchands partis pour mieux s'approvisionner. S'y ajoute bientôt l'arrivée à Paris d'artisans japonais. Burty organise ainsi des démonstrations de calligraphie ou de travail du laque; le peintre Watanobe-Sei éxécute chez lui, un

kakemono, comme le rapporte le *Journal* de Goncourt du 28 novembre 1878. Cela préfigure l'emploi à la fin du siècle par Tiffany, aux Etats-Unis, d'artisans japonais pour fabriquer les objets Art Nouveau. Quant à Bing, il ouvre peu après son retour une boutique où, dès 1877, il est attesté que Philippe Burty et Goncourt font des achats. On y rencontre aussi Sarah Bernhardt.

Avec l'exposition universelle de 1878, la position du Japon s'affermit, tandis que l'image de la Chine dont il se distingue parfois mal, surtout pour les arts décoratifs, se dégrade de plus en plus. Puis le japonisme entre dans une phase plus didactique encore, notamment avec l'exposition rétrospective organisée en 1883 par Louis Gonse. Le moment le plus important pour la diffusions des modèles japonais sera, à partir de 1888, la publication du *Japon Artistique* sous la direction de Bing.

Si l'on perçoit déjà les progrès de l'occidentalisation du Japon—et les esthétes s'en désolent—, l'image d'un Japon insulaire qui a gardé sa civilisation encore traditionnelle—connaissance inexacte, mais omniprésente—est comme une garantie de pureté originelle. Il semble qu'il s'agit d'un art "qui n'emprunte à l'art d'aucun pays et d'aucun temps ses données."[23] Traditionnel, non mécanisé, primitif, sauvage même, voilà l'art japonais. "Le Japonais a encore un peu du sauvage"[24] note Duranty, tandis que Goncourt se complait à admirer une poche à tabac achetée chez Hayashi—tardivement donc, puisqu'il s'installe à Paris à la suite de l'exposition universelle de 1878—car elle est "fabriquée par le sauvage le plus artiste de la terre,"[25] ou dit d'une écritoire de Korin qu'elle est "d'un goût barbare merveilleusement artistique."[26]

Les comparaisons les plus inattendues se développent, vantant les qualités de l'art japonais: les grès de Bizen, ramenés par Cernuschi, sont dignes de l'art égyptien; la comparaison avec la Grèce antique se développe jusqu'à l'étonnant article de Pottier "Grèce et Japon", qui note—nous sommes en 1890 après l'exposition du café Volpini où Gauguin et ses amis montrent leurs créations de Pont-Aven—que l'art japonais est fait de cernes et tons plats comme l'art grec.[27]

Vers 1880, l'art japonais apparait donc comme un exemple privilégié: on y trouve liberté et modernité. Il donne des exemples à suivre, et des exemples tout à fait exempts de cette contamination considérée comme déplorable de l'esthé-tique industrielle du temps.

L'art japonais justifie toutes sortes de nouveautés et notamment la rapidité de la facture et le rôle laissé au hasard: un des premiers exemples en est donné, par le potier Carriès qui commence à utiliser le façonnage à la main plutôt que le tour de potier et laisse le hasard se jouer des émaux des grès dans le four. Il faut cependant noter qu'un des japonisants les plus célèbres comme Gallé qui con-naissait très bien l'art japonais pour de multiples raisons (il était allé en Angleterre, un botaniste japonais se trouvait à Nancy) se cantonne encore en 1878 dans la simple imitation de modèles japonais. Avant de devenir un des personnages princi-paux de l'Art Nouveau—à ce moment-là il a assimilé les différents aspects exo-tiques et naturalistes de l'art japonais—, il fait encore donc partie de ceux qui se servent du Japon comme d'un simple répertoire de l'éclectisme.

Mais Gallé n'est pas le seul. Quels ont été les fruits des conseils d'Ernest Ches-neau recommandant en 1868 de tirer de l'art japonais "les enseignements qu'il

peut contenir,"[28] tandis que Philippe Burty y voyait un moyen de "nous donner une nouvelle avance sur l'Angleterre."[29]

Sans parler des artistes qui feront l'objet des prochaines communications, je voudrai signaler que la réalité ne suit que lentement les intentions et que 1878 nous donne encore l'exemple d'un éclectisme qui s'est contenté d'ajouter à son répertoire l'exemple japonais. A côte d'une buire arabe, la cristallerie de Baccarat présente des vases japonais de sa fabrication (Fig. 5) ou une lampe à six pans (monture bronze) (Fig. 6), M. Collinot, un vase à décor japonais orné de dragons et d'oiseaux (Fig. 7). Guillemin modèle pour Christofle cette torchère qui représente une Japonaise (Fig. 8) et bientôt Reiber (japonisant de la première heure et collaborateur également de Christofle) cette statuette en faïence de Deck (Fig. 9). Avec un vase à fond d'émail cloisonné, au décor de bronze, patiné or, la maison Christofle s'inspire de l'iconographie extrême-orientale, mais veut aussi imiter la technique, cherchant non à la restituer, mais à trouver un procédé qui en imite l'effet (Fig. 10). On le retrouve exposé, avec un meuble d'encoignure de Reiber, dans une présentation touffue des produits de Christofle en 1878 (Fig. 11) et le même entassement totalement opposé à l'esprit japonais s'observe dans le cabinet oriental de M. Jules Jacquemart, en 1878 (Fig. 12). On est loin d'avoir compris tous les aspects de la civilisation japonaise, notamment en ce qui concerne l'habitation: l'exemple de la ferme japonaise du Trocadéro en 1878, fort admirée, n'est pas près d'être suivi (Fig. 13).

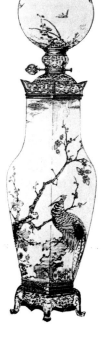

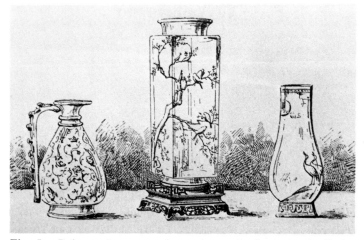

Fig. 5. Buire arabe et vases japonais en cristal gravé, cristalleries de Baccarat, 1878 (d'après la *Gazette des Beaux-Arts*, 1878, t.2, p. 701).

Fig. 6. Lampe à six pans en cristal opalisé—monture en bronze, cristalleries de Baccarat, 1878 (d'après la *Gazette des Beaux-Arts*, 1878, t. 2, p. 697).

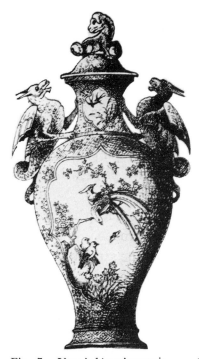

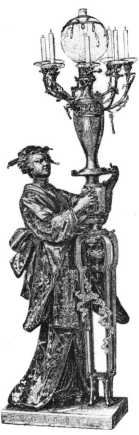

Fig. 7. Vase à décor japonais, par Collinot, 1878 (d'après la *Gazette des Beaux-Arts*, 1878, t. 2, p. 683).

Fig. 8. Torchère modelée par Guillemin pour Christofle, en bronze ciselé, 1878 (d'après la *Gazette des Beaux-Arts*, 1878, t. 2, p. 226).

Fig. 9. La japonaise, statuette en faï- ence de Deck, composition de Reiber (d'après la *Revue des Arts décoratifs*, 1882– 83, t. 3, p. 297)

Fig. 10. Vase à fond d'émail cloisonné, décoré de bronze, patiné d'or, par Chri- stofle et Cie, 1878 (d'après la *Revue des Arts décoratifs*, 1882–1883, t. 3, p. 361).

Fig. 11. Vase et meubles en émaux cloisonnés et en bronzes patinés et niellés de style japonais, maison Christofle et C^ie, 1878 (d'après la *Gazette des Beaux-Arts*, 1878, t. 2, p. 227)

Fig. 12. Cabinet oriental de M. Jules Jacquemart (d'après *L'art et l'industrie de tous les peuples à l'exposition universelle de 1878* . . . Paris, librairie illustrée, p. 225).

Fig. 13. La ferme japonaise du Trocadéro, 1878 (d'après *L'art et l'industrie de tous les peuples à l'exposition universelle de 1878* . . . Paris, librairie illustrée, p. 68).

L'éclectisme en France est si puissant dans l'architecture qu'il ne se passe rien à ce moment-là. Il faut attendre la fin du siècle avec un nouveau bâtiment prestigieux à Chicago pour que Frank Lloyd Wright soit inspiré réellement par l'art japonais et en France il faut attendre 1905 avec la maison de Perret, rue Franklin, si l'on veut, ou plutôt les années 1920. Ainsi ces premières années du japonisme montrent les décalages qui existent entre connaissance et influence.

S'il se passe quelque chose, le stade du répertoire nouveau de l'éclectisme, du pittoresque exotique est rarement dépassé. Et peut-être faudrait-il voir aussi sous cet aspect l'histoire de la peinture. Quelques recherches techniques apparaissent qui laissent présager la phase suivante d'une compréhension profonde, d'une réelle assimilation. Ce rôle ne peut d'ailleurs se faire qu'en fonction des problèmes qui se posent et les problèmes, à l'époque, ne se posent qu'aux novateurs, tant aux peintres qu'à ceux qui souhaitent rénover les arts décoratifs. Il ne faut, de plus, pas s'étonner de voir que les plus intéressants des japonisants ne sont nullement conservateurs, ni en politique, ni en art. Pour répondre aux angoisses du temps, le modèle japonais, parfois médiocre d'ailleurs, jouit du prestige de l'image de ce lointain pays et de l'attrait de la nouveauté. Qu'un monde aussi préservé, semblait-il, des méfaits de l'industrialisation soit enfin révélé, et il apparait comme le sauveur! L'aspect le plus intéressant qui se perçoit alors et qui ne fera que s'amplifier, est l'utilisation des modèles japonais comme nouveau répertoire du naturalisme, à travers Hokusai essentiellement, et comme facteur de progrès.

Notes

1. Dans la *Gazette des Beaux-Arts*, 1er septembre 1878, p. 386.

2. Roger Marx, "Sur le rôle et l'influence des arts de l'Extrême-Orient et du Japon," dans *Le Japon artistique*, mai 1891, p. 148.

3. *Les paradis artificiels*, chapitre II, de "Le Poème du hachisch," dans Baudelaire, *Oeuvres complètes*, t.I, Paris, bibliothèque de la Pléiade, 1975, p. 404.

4. *Encyclopédie* . . . de Diderot et d'Alembert, 3ème édition, Genève, 1779, t.XVIII, p. 88.

5. Cf. *Le Japon et la France, Images d'une découverte*, Publications orientalistes de France, [Paris] 1974, p. 118.

6. *Journal* des Goncourt, t.2, p. 213.

7. Formule utilisée par Octave Mirbeau dans son roman *La 628E8*, p. 210.

8. Cf. *Japonisme: Japanese Influence on French Art, 1854–1910*, exposition à Cleveland, et al., 1975–76, p. 142.

9. Ernest Chesneau, "Le Japon à Paris," dans la *Gazette des Beaux-Arts*, 1878, 1er septembre 1878, pp. 386–387.

10. *Journal* des Goncourt, t.5, p. 153.

11. Ibid.

12. Chesneau, art. cit., p. 387.

13. Cf. William Leonard Schwartz, *The Imaginative Interpretation of the Far East in Modern French Literature 1800–1925*, Paris, 1927, p. 70, note 5.

14. Cf. son article "Le Japon chez nous," dans *L'Etendart* du 26 mai 1868, cité par G. P. Weisberg, dans *Japonisme* . . . , catalogue cit., 1975–76, pp. 10 et 18, note 64.

15. Champfleury, *Les chats*, Paris, 1869, pp. 129 et 193, cité dans Champfleury, *Le réalisme*, textes choisis et présentés par Geneviève et Jean Lacambre, Paris, 1973, p. 140.

16. Ibid., pp. 143–145.

17. Cf. Schwartz, op. cit., p. 77, note 3.

18. C'est déjà le moment du retour de Duret et Cernuschi. Ce dernier reçoit une médaille comme organisateur de l'exposition au moment du Congrès des orientalistes. Cf. *Le Japon et la France*, op. cit., pp. 84–86.

19. Cité par Schwartz, op. cit., p. 36, note 5.

20. Cf. Théodore Duret, *Livres et albums illustrés du Japon*, Paris, 1900.

21. A. Jacquemart, "Les bronzes japonais au Palais de l'Industrie," dans la *Gazette des Beaux-Arts*, 1873, t.2, p. 447.

22. A. Jacquemart, "L'Extrême-Orient au Palais de l'Industrie—la céramique—collection de Cernuschi," dans la *Gazette des Beaux-Arts*, 1874, t.1, p. 54.

23. Josse, "L'art japonais à propos de l'exposition organisée par M. Gonse—lettres de M. Josse à M. Louis Gonse, directeur de la *Gazette des Beaux-Arts*," dans la *Revue des Arts décoratifs*, 1882–83, p. 330.

24. Edmond Duranty, "L'Extrême-Orient à l'exposition universelle" dans la *Gazette des Beaux-Arts*, 1878, t.2, p. 1040.

25. *Journal* de Goncourt, 4 février 1891, t.8, p. 166.

26. Ibid., 10 mars 1884, t.6, p. 209.

27. Dans la *Gazette des Beaux-Arts*, 1890, t.2, pp. 107–108.

28. Ernest Chesneau, *Les nations rivales dans l'art*, Paris, 1868, p. 453.

29. Philippe Burty, "Les industries de luxe à l'exposition de l'Union centrale," dans la *Gazette des Beaux-Arts*, 1869, t.2, p. 531.

WHISTLER AND JAPAN: WORK IN PROGRESS

Robin Spencer

In 1887 Whistler's pupil and follower, the Australian artist, Mortimer Menpes, visited Japan. He had gone without Whistler's permission and on his return was, in his own words, "filled with remorse and shame," and could not resist telling Whistler that he had met in Japan "another master." "What!" screamed Whistler, "How dare you call this Japanese a master on your own responsibility? Give me your reasons. What do you mean by it?" Menpes proceeded to explain the method of painting adopted by the Japanese artist, Kyōsai (or Gyōsai):[1]

> ... every touch Kyōsai placed upon his stretched silk was perfectly balanced and well placed, and that therefore, if the picture were arrested at any moment during its career, it would form a perfect whole, every line balancing the other. "That is my method," interrupted Whistler in a protesting, impatient voice. "No," I answered gently: "that is the method of Kyōsai" ... after having made his drawing, Kyōsai proceeded to paint his picture, and when painting a figure began by mixing his different tones in little blue pots, such as flesh tone, drapery tone, tones for the hair, gold-ornament tones, and that there was no searching for tones as on the average palette. There was no accident: all was sure, a scientific certainty from beginning to end ... Kyōsai displayed enormous facility and great knowledge. A black dress would be one beautiful broad tone of black, the flesh one clear tone of flesh, the shadows growing out of the mass forming a part of the whole. "That is my method," Whistler broke in volubly: "that is exactly my method. I don't paint my shadows in little blues, and greens, and yellows until they cease to be part of the picture. I paint them exactly as they are in nature, as a part of the whole. This Kyōsai must be a wonderful man, for his methods are my methods. Go on, Menpes: tell me more!" I then told him that when a Japanese artist was drawing a bird he began with the point of interest, which, let us say, was the eye. The brilliant black eye of a crow fixed upon a piece of meat attracted his attention; he remembered it, and the first few strokes he portrayed upon his stretched silk would be the eye of the bird. The neck, the legs, the body—everything radiated and sprang from the bright eye, just as it would in the animal

itself. Whistler was quiet after this last description—quite quiet, and very thoughtful. He forgot his anger against me for going to Japan, forgot everything, save his intense interest and desire to hear more of the Japanese painter who was also a master ... we sat up talking until the small hours of the morning; or I talked, for once, and Whistler sat drinking in every word. I described Kyōsai's method in detail, even to the mixing of his pigment and the preparing of his silk panels, for Whistler in some ways was a faddist and he revelled in detail. When he was bidding me goodbye on the doorstep, Whistler's last words were "These Japanese are marvellous people, and this man Kyōsai must be a very great painter; but,—do you know?—his methods and mine are absolutely similar!"[2]

Between 1853–54, when Commodore Perry[3] arrived in Edo, and 1888, the year in which S. Bing published *Le Japon Artistique*,[4] the exposure of occidental art to Japanese artists, and the influence of Japanese art on Western artists, had produced hybrid styles which had little to do with the ancient traditions of any one civilization. By 1888 Japonisme was already a major source for the decorative style in Europe known as Art Nouveau, one of the vital ingredients of the Modern Movement, on which Whistler's painting and decoration was a significant influence.[5]

Just what Whistler knew of Japanese artistic methods, and when he first came into contact with the art of Japan, has long been the subject of speculation in the West.[6] A Western analysis of Whistler's interpretation of the Japanese color woodcut has made a distinction between the decorative assimilation of Japanese *objets d'art*—fans, prints and kimonos—in the first Japanese pictures of the mid-1860s, and the gradual move to a rejection of traditional occidental perspective and space in the Nocturnes of the river Thames painted some five years later.[7] In terms of nineteenth-century pictorial practice in France and England this is generally seen as a radical departure from tradition, on the part of Whistler, Manet and the Impressionists, foreshadowing the synthetism of Gauguin and the Nabis, and an important influence on the formal developments of twentieth-century painting in the West.[8] Whistler's procedure of mixing his colors and keeping them in separate pots, and floating colors and shapes on an essentially two-dimensional surface,[9] is suggestive of Japanese painting techniques, which by the early 1870s Whistler could well have known about from books and articles published in England and France.[10] However, it would be a mistake to believe that Whistler's development as a Japonist was based on his knowledge of these sources. We have no firm evidence that he might have read them. Furthermore, a distinction between Whistler's first period of Japonisme and the Nocturnes, suggests a formal development invented more by an art historian than by an artist. That Whistler arrived by a more complex route at some of the methods used by Japanese artists is suggested by his description of the "secret of drawing" which he referred to as "Japanese"[11] and which he told his followers, Sickert and Menpes, he discovered in Venice in 1879–80:

I began first of all by seizing upon the chief point of interest—perhaps it might have been the extreme distance,—the little palaces and shipping

beneath the bridge. If so, I would begin drawing that distance in elaborately, and then would expand from it until I came to the bridge, which I would draw in one broad sweep. If by chance I did not see the whole bridge, I would not put it in. In this way the picture must necessarily be a perfect thing from start to finish. Even if one were to be arrested in the middle of it, it would still be a fine and complete picture.[12]

Whistler's adoption of Japonisme was a much more empirical absorption of Oriental art, and was tempered by the interest of his friends, artists, critics and collectors, in Paris and London. He was of course friendly from the start with all the early Japonists, artists such as Bracquemond, Fantin, Manet, Stevens, Rossetti and Tissot; and collectors and critics, including Baudelaire, Burty, Chesneau and Villot.[13] As a painter there were technical reasons which made Japanese principles conducive to his art, and as an exhibitor in Paris and London Whistler shared his friends' dissatisfaction with the limitations set by the pictures exhibited year after year at the Salon and the Royal Academy.

The two pictures Whistler exhibited at the Royal Academy in 1864 were *Wapping* (Coll. Mr. and Mrs. John Hay Whitney, New York) and *The Lange Lijzen of the Six Marks* (Coll. John G. Johnson, Philadelphia Museum of Art) (Fig. 1). It was the first occasion Whistler had exhibited one of his oriental pictures in public. Although *Wapping* was begun in 1860,[14] the figure group was finally painted at exactly the same time as *The Lange Lijzen*[15] in the winter of 1863–64.[16] The modelling of the flesh tones in both pictures is very similar, the *contre-jour* effect is quite occidental in technique and shows cast shadows

Fig. 1. James McNeill Whistler, *Purple and Rose: The Lange Lijzen of the Six Marks*, 1863–64. Oil on canvas. Philadelphia Museum of Art, John G. Johnson Collection. The frame, designed by Whistler, bears the Chinese characters for the 'Six Marks' at the corners and the center of the left and right sides.

built up from darks to highlights. But the two pictures are of quite different subjects. *Wapping* was begun out-of-doors in 1860–61, but Whistler was unable to finish it because of the difficulties he experienced in capturing the shifting tonal values of light on the river and boats. The figures were finally painted in the studio in the winter of 1863–64, and, although very much a detailed realist subject like his Thames etchings (in a letter to Fantin, Whistler warned him not to tell Courbet about it),[17] the neutral relationship of the figures silhouetted in contour against the water was not what Whistler had originally planned. X-rays of *Wapping* show that Whistler originally planned a narrative relationship between the three figures, which he explained to Fantin in his letter:

> Je suis arrivé à y mettre une *expression*! ... une vraie expression ... et avec cette fameuse expression dont je te parle—un air de dire à son matelot, "Tout ça est bien mon vieux, j'en ai vu d'autres!"tu sais elle cligne de l'œil et elle se moque de lui![18]

The Chinese pots in *The Lange Lijzen* are from Whistler's own collection. "Lange Lijzen" is Dutch for "long Elizas," and was the Delft name for the blue and white porcelain decorated with figures of "long ladies." The "Six Marks" of the title are the potter's marks, giving the signature and date, at the bottom of the vase. Whistler had the Chinese characters transcribed from the bottom of the pot the girl is holding to decorate the frame. It may have been done by a Chinaman whom Whistler could have met in the East End of London. They read: Great, Ch'ing, K'ang, Hs'i, Year, Made.[19] Whistler made little distinction between Japan and China. There are Chinese pots and Japanese items as well in his picture. Whistler's mother referred to it as a "Japanese study,"[20] and in 1864 Whistler called it his "Chinese picture."[21] Fantin too made little distinction between Japan and China, for when he visited Whistler in London in the summer of 1864 he wrote:

> Ici, je suis presque dans le Paradis. Nous faisons une vie impossible, tous les trois dans l'atelier de Whistler [the third was the French painter, Alphonse Legros, who by then was living in London]. On se croirait à Nangasaki [sic] ou dans le Palais d'Eté, la Chine, le Japon, c'est splendide.[22]

Fantin had little difficulty in transcribing figures from Japanese prints, such as those after Toyokuni,[23] into a Western context, and, like Whistler in the early 1860s, was also working on Japanese "costume" pictures.[24]

On February 10, 1864 Whistler was putting the finishing touches to both *Wapping* and *The Lange Lijzen*. By then, Whistler's studio in London was "ornamented by a very rare collection of Japanese and Chinese items," according to his mother, and Whistler considered "the paintings upon them the finest specimens of art and his companions, artists, who resort here for an evening relaxation occasionally get enthusiastic as they handle and examine the curious subjects portrayed, some of the pieces more than two centuries old." Whistler also had "a Japanese book of painting, unique in their estimation. You will not wonder that Jimmie's inspiration should be under such influence."[25] At the same time Whistler was in correspondence with La Porte Chinoise, in the Rue

de Rivoli in Paris, about "une certaine soupière en vieille laque dont ils m'ont écrit," and asked Fantin on his way home from the Louvre to look at it for him, ". . . si l'affaire est vraiment superbe, et d'un splendide qualité ils me la garderont." Whistler asked him to compare it with a lacquered box decorated with swans which he already had, which he described as "une vraie vieille laque," because he wrote, "laques plus modernes comme les grandes plateaux (demandes à les voir) ne sont pas aussi bien dessinées et manquent les splendides qualités des anciennes."[26] In another letter in 1864 he also asked Fantin to get the shop to put on one side for him "tous les costumes."[27]

The technical aspect which concerned Whistler at this time was the question of "finish." When he was working on *Wapping* and painting seascapes in France in 1862 he wanted to capture the effects of nature out-of-doors, but at the same time achieve a degree of "finish" that would be as acceptable to the Royal Academy in London as it would be to the Salon in Paris. Whistler found that he was unable to achieve this and to satisfy himself and the Academy at the same time.[28] *Wapping* was Whistler's only attempt at painting a figure group out-of-doors, and as such it was a failure. He was never to attempt a painting like it again. *The Times* critic considered the figures in *Wapping* to be "repulsive and unfinished" and the great blue vase in the foreground of the *Lange Lijzen* to be "out of perspective."[29] Fortunately, *The Lange Lijzen* was bought by one of Dante Gabriel Rossetti's patrons, James Leathart (1820–95), probably on Rossetti's advice, because Leathart (who ran a shipping line) was an avid collector, like Rossetti, of blue and white porcelain.[30]

We have no documentary evidence for the "Japanese book of painting" which Whistler's mother tells us her son had in 1864. Whistler's collection of blue and white china and Japanese woodcuts is still in existence, but because he was declared bankrupt in 1879 and lost most of his possessions, the prints may have been acquired after this date.[31] We know they once belonged to Whistler's wife, so they might have been owned either by Whistler himself, or by his friend the architect, E. W. Godwin,[32] who was one of the earliest collectors of Japanese art in England, a close friend of Whistler's in the 1860s and whose widow Whistler married in 1888. Most of the woodcuts date from the late eighteenth to the mid-nineteenth century. They include works by Hiroshige, Hokusai, Kiyonaga, Shunchō and Toyokuni, as well as some pattern books and early tourist items in copper plate engraving, very Western in pictorial terms, which date from the period after the visit of Commodore Perry in 1853–54. Whistler knew very little about earlier Japanese art—his enthusiasm, like that of his many colleagues in France, was probably fired by the more recent examples of the *ukiyo-e* schools.[33]

Whistler's collection of Japanese woodcuts is of interest because of the similarity of many of them to Whistler's Japanese paintings in the 1860s. In *The Golden Screen* of 1864 (Freer Gallery of Art, Washington, D.C.) (Fig. 2), the model is dressed in one of the costumes Whistler may have bought in the rue de Rivoli, a screen of the Tosa School is in the background,[34] and a lacquered box is in the sloping foreground, as "out of perspective" as the pot in *The Lange Lijzen*. By 1864 Whistler owned prints by Hiroshige, because it is generally agreed that

Fig. 2. James McNeill Whistler, *Caprice in Purple and Gold: The Golden Screen*, 1864. Oil on wood panel. Freer Gallery of Art, Washington, D.C. The frame, designed by Whistler, with Japanese *mon* and paulownia leaves.

the prints in the picture are based on ones by him, probably from *Sixty-odd Famous Places of Japan*. Although they no longer exist, a woodcut by Hiroshige of *Cranes and Waves* of 1858, now at Glasgow University, was in Whistler's collection. The painting of the woodcuts in *The Golden Screen* show exactly what it was that attracted Whistler to them. They are a paraphrase of the originals, painted with brilliant colors very freely to produce a flat decorative effect. In *The Golden Screen*, the Japanese woodcuts had already liberated Whistler from the practical and technical restraints which his obsession for painting from nature had placed upon him.

Japanese art had another function for Whistler in the 1860s, quite apart from the purely pictorial. The new fashion for Japonisme was a way of keeping his name before the critics in Paris while he was living in London. He went to Paris in the spring of 1865 to pose with his Japanese costume in Fantin's allegorical picture *Le Toast: La Vérité*,[35] which Fantin destroyed after the Salon except for the portraits of himself, Whistler[36] and Vollon. In February 1865 Fantin described the picture as including the allegorical figure of Truth in a classical pose in the center, and Bracquemond, Manet, Cordier and Whistler at a table in the front, with Whistler's Japanese robe in the foreground, "bien jolie à peindre,"

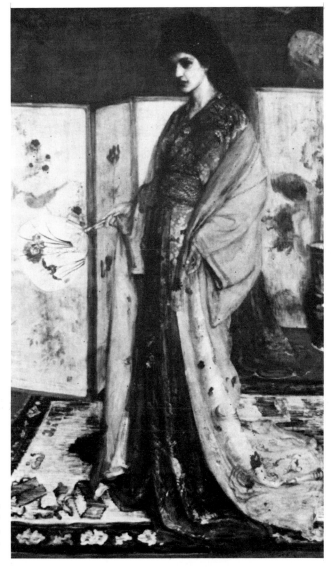

Fig. 3. James McNeill Whistler, *La Princesse du Pays de la Porcelaine*, 1863–64. Oil on canvas. Freer Gallery of Art, Washington, D.C.

vous savez que c'est tout pour moi et je suis bien disposé à tout sacrifié à ceci, ce qui est agréable à peindre, tout sacrifié à cela, sujet, convenances, action, tout, puis encore Whistler est si connu ici! puis sa Japonaise au Salon, tout cela m'a donné ce premier plan. Je lui ai écrit hier, pour lui parler du tableau, le sujet, sa place dedans . . .[37]

The "Japanese Lady" at the Salon was Whistler's *La Princesse du Pays de la Porcelaine*[38] (Freer Gallery of Art, Washington, D. C.) (Fig. 3), and Whistler's double appearance at the Salon as a Japonist attracted the attention of the critics which Fantin and Whistler both desired. Most critics, while admiring the vigorous color of Whistler's picture, considered it to be merely an enlarged tracing of a Japanese print, without the breath of real life. One critic complained because he did not want Japanese art, but a more personalized interpretation of a Japa-

nese figure by someone, he admitted, who was as talented as Whistler, but "non par le talent et l'esprit des artistes japonaise eux-mêmes."[39] The critic, Paul Mantz, who had praised Whistler's *White Girl* (National Gallery of Art, Washington, D. C.) at the Salon des Refusés in 1863, complained that although Fantin had wanted in his picture to "réunir . . . les derniers amis de la nature" the presence of Whistler, "peintre de la fantaisie," and Manet, "prince des chimériques," was proof enough that "il n'y a plus de réalistes."[40] In his turn Whistler planned a studio picture for the Salon of 1866 which was to show portraits of himself, Fantin, and the English artist, Albert Moore, and include his collection of porcelain as well as "La Japonaise." It never became more than an oil sketch, of which two versions are recorded.[41]

Whistler's Japanese paintings were criticized in London for much the same reason they were criticized in Paris. His submission to the Royal Academy in 1865 was as premeditated as his submission had been at the Salon in the previous year. *The Golden Screen* was painted in 1864 and exhibited at the Royal Academy in 1865 in answer to John Everett Millais's *Leisure Hours* of 1864.[42] It is a Japanese translation of Millais's picture. In 1865 *The Little White Girl* (Tate Gallery, London), which Whistler later called *Symphony in White No. II*,[43] was favorably compared to *The Golden Screen*:

> The exquisite Japanese screens are so truly rivalled that Western art is altogether eliminated—the result, we presume which the gifted painter aimed at.[44]
>
> Beautiful as are the studies he has thus designed—*The Gold Screen* above all—and useful as such practice may be in technical points, it is of course when the artist chooses his subject from English life in *The Little White Girl* that he cannot only astonish, but arrest us.[45]

It was this desire to become an original Japonist rather than a mere *pasticheur* of the art of Japan which seems to have occupied Whistler from about 1864 onwards. *Variations in Violet and Green: The Balcony*[46] (Freer Gallery of Art, Washington, D. C.) (Pl. I) was begun in 1864 but not finished until 1870 when it was shown at the Royal Academy. It is still a realist subject, with the Thames and chimneys of Battersea in the background, but the light falling on the water is one of few concessions to Western practice. The flesh tones are not modeled in a Western manner, but are flatter and more decorative. Whistler added the flowers and his butterfly signature later. The picture looked rather different in 1865,[47] and there is also a water-color version in Glasgow University which in technique and inspiration appears much more Japanese.[48] The group of figures is probably based on a print after Kiyonaga once owned by Whistler,[49] and the figures were eventually painted, not from living models, but from Japanese toy dolls which Whistler bought in a London shop.[50] It makes an interesting comparison with paintings by Dante Gabriel Rossetti of the same period, such as *Regina Cordium* of 1866 (Glasgow Art Gallery and Museum) and *Venus Verticordia* of 1864–8 (Russel-Cotes Art Gallery, Bournemouth), which are probably also indebted to Japanese decoration, but are painted much more literally.[51] The subject of the Balcony was one which Manet and Fantin were also painting at

Fig. 4. Henri Fantin-Latour, *Le Poète*, Décembre 5, 1866. Pencil and crayon. Inscribed "Esquisse à Whistler." Cabinet des Dessins, Musée du Louvre, Paris.

the same time as Whistler. Manet's famous picture of 1868 (Paris, Louvre) is indebted to Spanish painting, particularly Goya, as much as it is to Japanese art; but Fantin's version *Le Poète*[52] begun at the same time as Whistler's, and which Whistler certainly knew (the drawing (Fig. 4) is inscribed "Esquisse à Whistler"),[53] is more Western and Romantic in conception, although the pose of the figures and the inclusion of what look like Japanese fans, suggest that he too intended to produce a Japanese effect. Fantin planned many similar allegorical compositions in the 1860s which never came to fruition, such as a picture called *Japonisme*, which included Whistler's Japanese robe hanging in the center and Japanese boxes resting on Japanese prints on the table.[54] Unlike the items in Whistler's *Balcony* they are all rendered with shadows and the spatial implications are quite conventionally Western in their intention and execution.

If Fantin did not paint subjects as individually Japanese as Whistler, his art did at least meet with Whistler's approval for its Japanese qualities of design and color. Whistler's first statement about the aesthetic principles of Japanese art was made in 1868 and was prompted by two still life paintings Fantin had sent Whistler from Paris.[55] Whistler was enthusiastic about their color, which he believed was translated from nature exactly as the Japanese would have painted it:

Eh bien, ils sont arrivés les deux bouquets et je les ai vu—Mon cher ·Fantin ils sont charmant!—C'est d'un éclat de couleur inattendu! inattendu est beau le mot—car bien que je m'attends toujours à voir, lorsqu'il s'agit de me montrer de nouvelles toiles de toi, les fraicheurs et les belles couleurs que tu sont particulier, j'ai été cette fois si plus surpris que jamais par la brillant et le pu006bté de ces bouquets!—L'effet dans mon atelier est étourdissant—et il me semble que tu as trouvé quelque chose de nouveau, dans la hardiesse de tes couleurs qui pour moi est énorme comme progrès— tu comprends ce que je veux dire—ce n'est plus une affaire de bien peint du tout—ni ce que l'on appel ton, mais les couleurs des fleurs sont pris sur nature cranement et posées sur la toile tel que, pures et crues—sans crainte—

comme les Japonais ma foi! Que c'est joli! les petites fleurs grises sur le fond gris clair et dans le bouquet de celui-là il y a des rouges inous, l'assiette blanche sur la nappe aussi—c'est charmant. Mais tu sais je préfère la composition de l'autre toile—pas tu comprends seulement les objets peints ni même l'arrangement de ces objects—mais la composition des couleurs qui fait pour moi la vrai couleur—et voici comment d'abord il me semble que la toile donnée, les couleurs doivent être pour ainsi dire *brodées* la dessus—c'est a dire la même couleur reparaître continuellement ça et là comme le même fil dans un broderie—et ainsi avec les autres—plus ou moins selon leur importance—le tout formant de cette façon un *patron* harmonieux—

Regardes les Japonais comme ils comprennent ça! Ce n'est jamais le contraste qu'ils cherchent, mais au contraire la répétition—Dans la seconde toile le tout est d'abord un patron charmant et pour le reste il n'y a personne qui puisse le prendre comme toi—Mais voir comme c'est parfait—le fond se retrouve dans le bouquet, et la table remonte par les raisons rougâtre et va retrouver des tons pareils parmi les fleurs—les rouges des fruits sont répétés dans plusieurs endroits—et les raisons vert—sont-ils délicats et fins de couleur! vont chercher d'autres verts dans les [?] C'est un patron ravissant!—et d'une couleur délicieuse—Les deux sont je trouve les plus belles que tu aies fait—Maintenant pour ma critique: je pense que dans le premier le ver qui tient le bouquet est un peu noir—pas comme *ver*, ou pour *la réalité*, mais comme *couleur* pour le tableau, et ne se retrouve nul part ailleur.[56]

From 1867 Whistler was clearly thinking of his own work solely in terms of color and arrangement on the canvas; rather than in terms of "reality." In 1867 he had used the title *Symphony in White No. III*[57] to draw attention to these qualities and to suggest their relationship to the sensation of music, a synaesthetic idea which he probably derived from Baudelaire and Wagner.[58] In 1867 too, Whistler had written to Fantin regretting that he had been so much influenced by Courbet's Realism and wished instead he had been a pupil of Ingres.[59] Soon after he began a series of pictures later called *The Six Projects*.[60] They were probably intended to evoke the mood of six pieces for the piano by Franz Schubert.[61] They should be seen in the context of some of the classically-inspired decorative pictures painted by other artists in England at the time,[62] and of Fantin's attempts to paint elaborate allegorical compositions concerning poetry, music and literature. Like Fantin, Whistler was unable to enlarge them into full-scale compositions, and except for one,[63] they remained as oil sketches only (Figs. 5, 7, 9). Their subject matter is close to several woodcuts that were in Whistler's collection, in particular prints by Kiyonaga depicting the flowing, sinuous curves of drapery, and rickety balconies and landing stages which appear in Whistler's pictures (Figs. 6, 8, 10).[64] They are as much indebted to classical drapery, such as that of the Elgin Marbles in the British Museum, as they are to the art of Japan (at this period Whistler was living just opposite the British Museum). The relationship between the Western tradition of classicism and Japanese art, between Occidental and Eastern practice in painting and

Fig. 5. James McNeill Whistler, *Symphony in Blue and Pink*, 1868. Oil on millboard mounted on wood panel. Freer Gallery of Art, Washington, D.C.

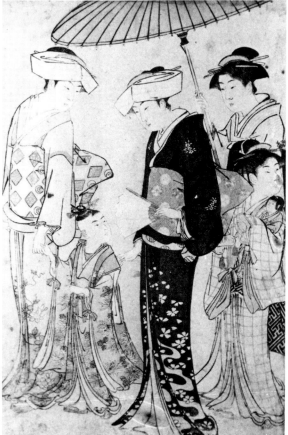

Fig. 6. Torii Kiyonaga, *Ladies*, ca. 1790. Color woodcut. Glasgow University, Birnie Philip Bequest (ex-collection, J.M. Whistler)

Fig. 7. James McNeill Whistler, *Variations in Blue and Green*, 1868. Oil on millboard mounted on wood panel. Freer Gallery of Art, Washington, D.C.

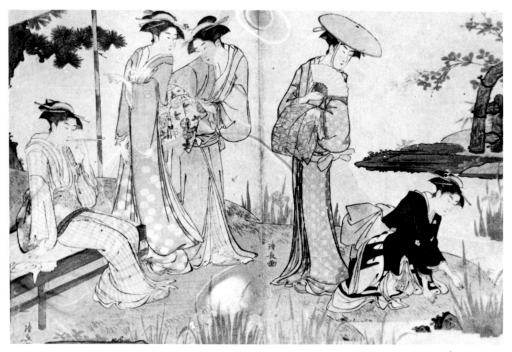

Fig. 8. Torii Kiyonaga, *Two Sheets from a Tryptych of Ladies by an Iris Pond*, 1790. Color wood-cut. Glasgow University, Birnie Philip Bequest (ex-collection, J.M. Whistler).

Fig. 9. James McNeill Whistler, *Symphony in White and Red*, 1868. Oil on millboard mounted on wood panel. Freer Gallery of Art, Washington, D.C.

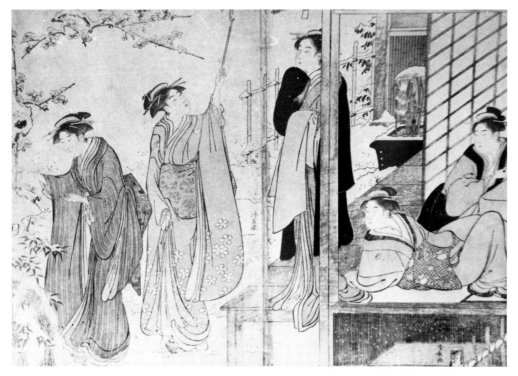

Fig. 10. Torii Kiyonaga, *Two Sheets from a Tryptych, Winter Scene with Ladies on a Balcony and in the Garden*, ca. 1790. Color woodcut. Glasgow University, Birnie Philip Bequest (ex-collection J.M. Whistler).

drawing, was a question which occupied Western theorists of Japonisme in the 1860s, particularly Ernest Chesneau, who believed that the subtle and rarified asymetric principles of Greek art and architecture could be confirmed by the principles of Japanese design. "L'art japonais," he wrote in 1868, "a toutes les aspirations, toutes les élévations, toutes les supériorités du grand art." He analyzed Japanese decorative art under three headings: "1. l'absence de symétrie, 2. le style, and 3. la couleur." Of "style" Chesneau classified:

1. la merveilleuse harmonie que les artistes savent établir entre la forme et la destination de l'objet
2. entre la forme constitutive et le décor superficiel de l'objet
3. entre la forme et la matière de l'objet.

Of the two-color Japanese print in red and green, Chesneau wrote:

C'est qu'en effet, plus que nous, ils possèdent et appliquent les principes infaillibles qui permettent de transformer en œuvre d'art decoratif les elements fournis par la nature.[65]

Whistler was on cordial terms with Chesneau in 1867, as well as Villot, who had worked at the Louvre, had been one of Delacroix's best friends, and an early collector of Japanese art.[66] We can be sure that by the late 1860s Whistler had already formulated the views which he expressed about Japan, and the relationship of its art to other periods and cultures, in the "Ten O'Clock" lecture of 1885.

Implicit in any discussion of Japonisme and Whistler is the distinction made in the West between painting and decoration. One of the most lasting influences of Japonisme in Western art was the effect which it had on the applied arts, on ceramics, metalwork, posters, illustration and interior design. In the early 1870s Whistler's art reflected the fashionable taste for Japanese artifacts and designs which by then were readily available in London shops, such as Farmer and Rogers, or Liberty's where Whistler was a regular customer. By 1872 the sale rooms at Christie's in London were holding auctions of Japanese enamels, and *The Art Journal* reported in the same year that "Japanese articles, in lacquer, in metal, or in silk, fill the windows of our costliest shops."[67] English firms were adopting Japanese materials to English work, and the London firm of Bontor and Collins specialized in folding screens which they manufactured in all sizes "ornamented with the drawings, the coloured prints, or the gorgeous silks and embroideries of Japan."[68] Whistler's screen, *Blue and Silver*[69] (Glasgow University), which he painted for F. R. Leyland in 1872, may have been one of them, for the reverse side, although of Chinese rather than Japanese silk, is dated in Chinese characters, 1867. It is the first of two painted versions of Old Battersea Bridge, showing the view downstream, with the clock tower of Chelsea Church on the left, a pier of Battersea Bridge bisected in the center, and, in the background, Albert Bridge. The subject was first studied in daylight, in a series of pencil drawings of 1871–72 (Albright Knox Art Gallery, Buffalo, and Glasgow University). They are topographically accurate because they show the Albert Bridge in the background in the process of construction, with its scaffolding and timber

piers. A pastel of the same subject takes the composition a stage further, where the compositional elements are tried out in slightly different positions (Freer Gallery of Art, Washington, D. C.). The screen was the basis for the slightly later *Nocturne in Blue and Gold: Old Battersea Bridge*[70] (Tate Gallery, London), which was finished after August 1873 when Albert Bridge was opened to the public, for in Whistler's picture lights can be seen illuminating the bridge by night. As has been observed, by Western contemporaries of Whistler, and by Fenellosa,[71] Noguchi[72] and others,[73] Whistler's paintings of Battersea Bridge with its piers and fireworks in the sky, closely resemble the bridges and fireworks in many of Hiroshige's woodcuts. The dramatic accent of the pier which dominates the composition is much closer to Hiroshige than to Battersea Bridge as Whistler first drew it, or as it appeared in reality in contemporary photographs. The "secret of drawing," or Japanese style of drawing which Whistler referred to and which he claimed he discovered in Venice would also seem appropriate for some of his etchings of Battersea Bridge.[74]

Extant Hiroshiges from Whistler's Japanese collection are not the most appropriate sources for his painting of *Old Battersea Bridge*, but the tonal paintings of the Thames near his home in Chelsea which directly precede the Nocturnes in 1872 may well have been derived from Japanese street scenes almost contemporary in date with Whistler's Thames paintings of the early 1870s.[75] It is another reminder that it was the recent wave of *ukiyo-e* prints, rather than older work, including those produced under Western influence after Commodore Perry's visit, which most influenced Japonist artists in Europe, including Whistler. The shore life activity on the Thames in London, which appears too in some of Whistler's river paintings of the 1860s, may well have found parallels in Whistler's imagination with the tourist views of Edo and environs as depicted by Shuntōsai in copper-plate engraving in 1857 (Glasgow University). Their subjects are reflected in pictures such as *Brown and Silver: Old Battersea Bridge*[76] of about 1862 (Addison Gallery of American Art, Andover, Massachusetts) (Fig. 11). The flat decorative appearance of the Nocturnes was accompanied in 1872 by the introduction of painted decoration on the frames of his pictures. Whistler proudly claimed it to be his own invention;[77] but, like his first Japanese pictures, the painted decoration derives from an Oriental source. He may have come across examples of this type of decoration in the books of early European Japonists, but it seems quite likely that he came across it at first hand in Liverpool, which he visited regularly in the late 1860s and early 1870s. He had received several commissions from the Liverpool shipping owner, F. R. Leyland: for *The Six Projects*; in the 1870s, for the painted screen of Old Battersea Bridge; portraits of all his family;[78] and later in the decade his final work for Leyland, *Harmony in Blue and Gold: The Peacock Room*.[79]

In the autumn of 1872 an exhibition of Oriental art was held in Liverpool which included Japanese ceramics, ivories, metals and lacquer work.[80] By far the largest contribution to the collection was made by James L. Bowes, who owned a large collection of Japanese art.[81] Bowes, together with George Ashdown Audsley, published a lavishly chromolithographed volume which contains a number of plates in black and gold, most suggestive in motif and arrangement

for Whistler's decorative work in the 1870s.[82] Perhaps the closest similarity is
with the wave and cloud motifs which Whistler adapted for the decoration of
the walls and ceiling of the Peacock Room in 1876–77.[83] There is too an uncanny
similarity between the descriptions of Whistler painting the peacocks on the
shutters, surrounded by friends and admirers whom he invited to Leyland's
house, and Utamaro's woodcut, *Utamaro, painting a Hō-ō bird in one of the Green
Houses*, from the *Annals of the Green Houses*, 1804.[84] Either for his own house in
Chelsea, for his patron, W. C. Alexander, or as a preliminary scheme for Leyland,
Whistler also planned a version of Old Battersea Bridge (Glasgow University)
(Fig. 12), which is very close to his other versions of the same subject.[85]

What did Japan and Japanese art mean to Whistler in the nineteenth century,
in comparative cultural terms of other periods and styles? His views on this,
expressed in the "Ten O'Clock" lecture given in 1885,[86] had already been
discussed in a similar way some fifteen years earlier by a fellow American, the
early Japonist, James Jackson Jarves.[87] In the "Ten O'Clock" lecture Whistler
adopts the extreme position of the *l'Art pour l'Art* philosopher. Whistler pours
scorn on the view that art can be inspired or improved by the glories and virtues
of the State. "Art is," he says, "Art we in no way affect." He cites the noble
history of Switzerland which produced only the cuckoo clock. "Instead," Whistler
continues, Art "cares not," but is to be found in the East, "among the opium-
eaters of Nankin, a favourite with whom she lingers fondly—caressing his blue
porcelain, and painting his coy maidens, and marking his plates with her six
marks of choice—indifferent in her companionship with him, to all save the
virtue of his refinement."

The Lange Lijzen is very much Whistler's "manifesto" painting, full, as it is
with items of porcelain from Whistler's own collection. Although not "Japa-
nese" in any sense, it celebrates Whistler's introduction to Oriental art which
encouraged him to look at the art of the Japanese print maker. The flowing
calligraphic brushstrokes on the Chinese porcelain was probably a technical
influence on liberating his own brushwork, to achieve a balanced relationship
between line and color—a problem which we know preoccupied him between
1865 and 1867[88] and which resulted in the confluence of Greek and Japanese
art in the very beautiful *Six Projects*. In 1876 Whistler once again paid homage
to this life-long inspiration, in the thirty-eight pieces of Chinese porcelain which
he drew with pen and brush for the English collector, Sir Henry Thompson.
He did not attempt to reproduce every detail of the designs on the porcelain, some
from the K'ang-hs'i Dynasty—the period of the porcelain in his own collection—
but tried instead to indicate the essential lines of the composition and the style
of brushstrokes and area of pattern.[89] In the "Ten O'Clock" lecture, Whistler
lists Greek, Japanese art and Velasquez—the three main influences on his life's
work. "The story of the beautiful is already complete," Whistler concluded,
"in the marble of the Parthenon and embroidered with birds on the fan of
Hokusai—at the foot of Fusiyama." [sic]

In 1890, Whistler wrote, under the name of one of his pupils Sidney Starr,
a review of an exhibition of Hokusai that was held by the Fine Arts Society
in London. He quoted, with delight, Hokusai's famous autobiographical state-

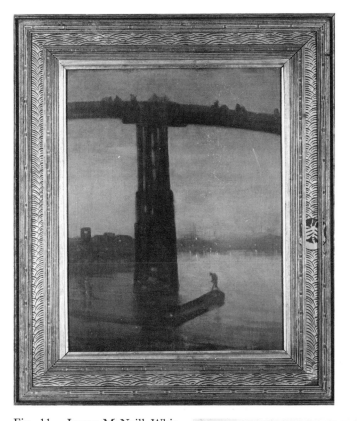

Fig. 11. James McNeill Whistler, *Nocturne: Blue and Gold—Old Battersea Bridge*, 1872/3–6. Oil on canvas. Tate Gallery, London. The frame, painted by Whistler and signed with a butterfly.

Fig. 12. James McNeill Whistler, Design for Wall Decorations for F. R. Leyland's House, 49, Princes Gate, London, with Old Battersea Bridge, ca. 1876. Ink. Glasgow University, Birnie Philip Bequest (ex-collection, J.M. Whistler).

ment about his mania for drawing, and of Hokusai's art Whistler wrote:

> And here are . . . some of the works of Gwa-kio Rojin—the old man mad about drawing—for us to look upon with wonder. This for the simple, who by accident may dispense with remark from critic, which by habit they still have with them, is a restful room, a rare occasion; and, to no one, not even to Ruskin—sublime and ridiculous—should occur the indecency of blaming the faults he fabricates, or of praising the drawing of which he is unaware.[90]

It was Whistler's passion for Oriental art which encouraged the American, Charles L. Freer, in the 1890s to form his collection of Chinese and Japanese art. Freer visited Japan and sent Whistler photographs of the works he brought back.[91] It is no coincidence that America's largest collection of Whistler's works, which includes the Peacock Room itself, can now be seen in Washington alongside one of the West's greatest collections of ancient Chinese bronzes, Japanese painted screens, and drawings by Hokusai.

With regard to Japan itself, Whistler expressed a colonialist's view, common to late nineteenth-century Europeans and particularly Americans, of a civilization that had for so long remained closed to Western eyes and customs. A remarkable handwritten document by Whistler is in Glasgow University Library. It consists of an eight-page translation made by a resident of San Francisco who had spent several years in Japan, from the diary of an astonished Japanese witness at the sight of the arrival of the American fleet of Commodore Perry in 1853–54.[92]

The passage begins:

> While yet cold weather, even colder than previous years, and at the time of New Year, although the plum blossoms had put forth, the nightingale had not begun to sing—why so later, the reason could not tell. Loving to hear its voice, I listened and listened; while thus listening, I heard the footsteps of people going by the Tokaido to and from Yedo, saying, 'This spring, foreigners will come to our country'; and this was wonderful and surprising news.

Then on the eleventh day seven vessels were sighted at Natsushima. The writer and a head priest took a boat and went to Kanagawa:

> At the time of starting, [he continued] it was yet early day and cloudy, and the hills of Awa-no-Kuni could but be indistinctly seen. At sunrise, therefore, there was a beautiful view. The sun arose in all its splendour, and near it was seen a rainbow . . . The great illumination in the front of the view, and darkness hanging over the other point of Kanagawa, gave it the appearance of a fan, and was a beautiful landscape to behold. It was so lovely a sight that I composed a piece of poetry, although so early in the morning. As we reached Homoro with the sails of our boat flapping in the breeze, I saw in the distance that the wonder of the world was before me; the Ocean had put forth woods, and high trees were visible, and they told me that was the foreigners' vessels.

This account of the arrival of the American vessels concludes:

> Foreign vessels' masts could be plainly discerned from the opposite shore, Kazusa. There arrived from Yedo, a red painted vessel, covered on the outside with paintings of all kinds, really beautiful; had purple curtains, and the crest of white also red and green silk curtains—As the breeze wafted them, it was beautiful to behold. The sailors were covered with clothing in embroidery of (?) or plum flowers.

> Night and day were the same—all excitement and the lights were as day. On the American and Japanese vessels were so many lights that it appeared as though summer had returned and that they were once more celebrating at Ryōgokubashi—"taking a nice breeze in Ryōgokubashi."

Unfortunately the original source and date of this document has not yet been traced. It was probably copied by Whistler in the 1870s, to judge by his handwriting. It shows that Whistler may have derived as much inspiration from Japanese literature for the mood and atmosphere of his paintings, particularly the Nocturnes, as he did from Japanese prints. We know he read Japanese poetry in English translation in the 1870s,[93] probably the collection of ancient and modern poems, the *Kokinshū*, first quoted by the Portuguese Père Rodriguez in his treatise on the Japanese language of 1604.[94] Perhaps the Nocturnes of Valparaiso[95] (Tate Gallery, London, and Freer Gallery of Art, Washington, D. C.), the second completed only in 1874 and showing ships at anchor, were associated in Whistler's mind with the American vessels which brought Commodore Perry to Japan in 1853–54.

Unlike many of his Victorian contemporaries Whistler never intended his painting to be illustrative or literary, as he was always at pains to point out.[96] But it was the English poet, A. C. Swinburne, who saw the poetry in Whistler's painting, and challenged Whistler to deny its associative and evocative qualities[97] which, in spite of himself, he described in the "Ten O'Clock" lecture, in passages such as:

> And when the evening mist clothes the riverside with poetry, as with a veil, and the poor buildings lose themselves in the dim sky, and the tall chimneys become campanili, and the warehouses are palaces in the night, and the whole city hangs in the heavens, and fairy-land is before us—then the wayfarer hastens home; the working man and the cultured one, the wise man and the one of pleasure, cease to understand, as they have ceased to see, and Nature, who, for once, has sung in tune, sings her exquisite song to the artist alone, her son and her master—her son in that he loves her, her master in that he knows her.[98]

For many years, Whistler's art has been seen by occidental critics as Japanese. To Japanese eyes he must always seem quite Western. Yet whoever views his work must agree, as one of his friends put it, that Whistler "grafted on to the tired stump of Europe, the vital shoots of Oriental art."[99]

NOTES

1. Kawanabe Kyōsai (or Gyōsai), a pupil of Kuniyoshi, was born in 1831 and died in 1889, two years after Menpes visited him. See William Anderson, "A Japanese Artist, Kawanabé Kyōsai," *The Studio*, XV, 1898, pp. 29–38. Menpes first published an account of his meeting with Kyōsai in "A Personal View of Japanese Art," *Magazine of Art*, 1888, pp. 192–99, 255–61.

2. Mortimer Menpes, *Whistler As I Knew Him*, London, 1904, pp. 40–2. For an account of Menpes's experiences in Japan see also his *Japan, A Record in Colour*, London, 1901, in particular Chapter III, "Painters and Their Methods," pp. 51–73, for an extended account of Kyōsai. Menpes revisited Japan in 1896. See "Mortimer Menpes' Japanese Drawings," *The Studio*, XI, 1897, pp. 165–75 and Mortimer Menpes, "A Letter from Japan," ibid., pp. 32–6, XII, 1898, pp. 21–6.

3. For Perry's visit to Japan see Samuel Eliot Morison, *"Old Bruin," Commodore Matthew Calbraith Perry*, Oxford and London, 1968.

4. S. Bing (ed.), *Le Japon Artistique*, I—VI, May 1888–April 1891. The journal was also published separately in English and German.

5. Whistler strongly objected to *L'Art Nouveau*. For his remark on the style made in 1900, see E. R. and J. Pennell, *The Whistler Journal*, Philadelphia, 1921, p. 73.

6. Léonce Bénédite believed that Whistler was aware of Japanese art when he painted *The Music Room* (Freer Gallery of Art, Washington, D.C.) in 1860–61, a supposition that has since been challenged, notably by Sandberg (see below). Léonce Bénédite, "Artistes Contemporains: Whistler," *Gazette des Beaux-Arts*, XXXIII, 1905, p. 507.

7. John Sandberg, "'Japonisme' and Whistler," *The Burlington Magazine*, CVI, 1964, pp. 500–5, 507.

8. H.R. Rookmaaker, *Synthetist Art Theories, Genesis and Nature of the Ideas on Art of Gauguin and His Circle*, Amsterdam, 1959, pp. 50–1 and passim.

9. E.R. and J. Pennell, *The Life of James McNeil Whistler*, London and Philadelphia, 1908, Vol. I, pp. 164–65.

10. See especially James Jackson Jarves, "Japanese Art," *The Art Journal*, June 1869, pp. 182–83; "A Genuine Artistic Race," *The Art Journal*, March—July 1871 (in five installments), pp. 77–79, 100–101, 136–37, 161–62, 185–86. This material was incorporated in Jarves's *A Glimpse at the Art of Japan*, New York, 1876. Surprisingly, Jarves has received little attention from Western Japonistes.

11. Pennell, *James McNeill Whistler*, I, pp. 285–87.

12. Menpes, *Whistler*, pp. 22–23. The American artist, Otto Bacher, who was with Whistler in Venice, confirms the incident. Otto Bacher, *With Whistler In Venice*, New York, 1906, pp. 207–15.

13. Whistler's familiarity and friendship with all the above may be judged by his references to them in his letters to Henri Fantin-Latour written between 1859 and 1867 (Library of Congress, E. R. and J. Pennell Collection), parts of which are quoted by Bénédite, "Artistes Contemporains: Whistler," XXXIII, pp. 403–10, 496–511, and "Artistes Contemporains: Whistler," *Gazette des Beaux-Arts*, XXXIV, 1905, pp. 142–58, 231–46.

14. *Wapping*, signed and dated "Whistler. 1861." was probably the "chef d'œuvre" which George du Maurier described Whistler working on "in secret" in Rotherhithe in October 1860. Daphne du Maurier (ed.), *The Young George du Maurier. A Selection of His Letters, 1860–67*, London, 1951, p. 16. *Wapping* was described and drawn by Whistler in an undated letter to Fantin-Latour quoted by Bénédite, "Artistes Contemporains: Whistler", XXXIII, pp. 496–7 (Library of Congress, E. R. and J. Pennell Collection). The letter was almost certainly written before July 1861, when Fantin visited Whistler in London and would have seen the incomplete picture. Whistler's drawing of *Wapping* is reproduced in Théodore Duret, *Histoire de J. McN. Whistler et de son œuvre*, Paris, 1904, p. 41.

15. Signed and dated "Whistler" "1864." For documentation and the dating of Whistler's paintings cited here see Andrew McLaren Young, Margaret Mac-Donald, Robin Spencer, with the assistance of Hamish Miles, *The Paintings of James McNeill Whistler*, New Havenand London, 1980.

16. On December 15, 1863, D.G. Rossetti described the figure on the right of *Wapping* as an English sailor "hardly yet commenced" (Rossetti to James Leathart, Dec. 15, 1863, University of British Columbia). On February 10, 1864, Whistler's mother described it as "so improved by his perseverance to perfect it, a group on the inn balcony has yet to have the finishing touches." K. Abbott (ed.), "The Lady of the Portrait, Letters of Whistler's Mother," *Atlantic Monthly*, CXXXVI, 1925, pp. 324–5. On February 25, 1864, the artist William Bell Scott described the figures in the foreground of *Wapping* as "just rubbed in, one of them merely in a tentative way" (Scott to James Leathart, Feb. 25, 1864, University of British Columbia). See Young, MacDonald, Spencer, *Paintings of James McNeill Whistler*, cat. no. 35.

17. Bénédite, "Artistes Contemporains: Whistler," XXXIII, pp. 496–97.

18. Ibid.

19. 'Made in the K'ang Hs'i Dynasty' (1662–1722).

20. Abbott, "Lady of the Portrait," p. 323.

21. Bénédite, "Artistes Contemporains: Whistler," XXXIV, pp. 146, 148.

22. Fantin-Latour to his parents, written from Whistler's house, 7, Lindsey Row, Chelsea, July 12, 1864 (copy, Bibliothèque Municipale, Grenoble).

23. An undated drawing, annotated "Toyo-Kouni" is in the Musée de Grenoble. See Mme Fantin-Latour, *Catalogue de l'Oeuvre Complet (1849–1904) de Fantin-Latour*, Paris, 1911, cat. no. 2290.

24. Fantin-Latour, cat. no. 2274, lists *Les Princesses au Palanquin* by Fantin, then (1911) in the collection of A.M. de Launay, present whereabouts unknown. Fantin described it in a letter of June 12, 1896, quoted by Fantin-Latour, *Catalogue de l'Oeuvre*, "Cette esquisse doit dater de 1860 à 1863. C'est un projet de tableau que j'avais donné à mon ami Duranty. Le sujet en est très vague. Autant que je me rappelle, c'est un souvenir des choses japonaises qui nous hantaient alors. La porte ronde, le palanquin avec lequel on vient chercher les deux princesses, c'est de la fantaisie pure."

25. Abbott, "Lady of the Portrait," p. 323.

26. Whistler to Fantin-Latour, n.d., [June 1864] (Library of Congress, E.R. and J. Pennell Collection).

27. Whistler to Fantin-Latour, n.d., [June 1864] (Library of Congress, E.R. and J. Pennell Collection).

28. See especially *Seascape with Figures* and his remarks on it, a marine Whistler was attempting to complete at Guéthary, Basses Pyrénées in October 1862. Young, MacDonald, Spencer, *Paintings of James McNeill Whistler*, cat. no. 40.

29. *The Times*, May 5, 1864.

30. For James Leathart as a collector see *Paintings and Drawings from the Leathart Collection*, (exh. cat), Laing Art Gallery, Newcastle-upon-Tyne, 1968.

31. The collection of Japanese prints owned by Whistler is split between the British Museum and Glasgow University, and was given by Whistler's sister-in-law and executrix Miss Rosalind Birnie Philip. Those in Glasgow University are accompanied by a note by Miss Philip which states that they were presented "in memory of Mrs. J. McNeill Whistler to whom the little collection owed its origins." This provenance obviously casts doubt on whether the prints were in Whistler's possession as early as the 1860s. Either Mrs. Whistler inherited them from her first husband, E.W. Godwin, or owned them independently of him, or else Whistler owned them and presented them to his wife after they were married in 1888. Because Whistler was declared bankrupt in 1879 and was obliged to sell most of

his possessions it is difficult to establish what exactly was in his collection before that date. The annotated catalogue of Whistler's bankruptcy sale held on May 7, 1879 lists a number of Japanese items (Library of Congress, E.R. and J. Pennell Collection), but does not give sufficiently detailed descriptions to identify them with the Japanese prints in either Glasgow or London. The present physical condition of the prints in Glasgow University may be generally described as "poor" to "fair," those in London being in a better condition; but whether or not some of the prints were as faded in the last century as they are today is impossible to say. I intend to publish a short catalogue of all Japanese items known to Whistler in his lifetime, based on his own paintings, the extant collection of Japanese prints, the annotated catalogs of Whistler's sales in 1879 and 1880 and other sources.

32. For Godwin see Dudley Harbron, *The Conscious Stone: The Life of Edward William Godwin*, London, 1949. For aspects of Godwin's Japonisme see his Notebooks in the Victoria and Albert Museum, London, and Elizabeth Aslin, "The Furniture Designs of E.W. Godwin," *Victoria and Albert Museum Bulletin*, III, Oct. 1967, pp. 145–54.

33. It would seem unlikely that Whistler, or any other European artist, owned prints by the earlier masters, Kiyonaga, Shunchō or Toyokuni, as early as the 1860s, because their work was not generally available in the West as early as this. The English collector Arthur Morrison, who invited Whistler to view his Japanese prints (probably in the 1890s) confirmed in letters of November 7, 1906 and May 7, 1907 to Joseph Pennell that Whistler did not see "the work of the earlier Japanese, as at one time he was going to do, here." (Library of Congress, E.R. and J. Pennell, Collection). It would seem more likely that in the 1860s Whistler owned prints by contemporary Japanese artists after compositions by the earlier masters, but did not acquire his eighteenth century prints until they became available in Paris after about 1890. Whistler may then well have chosen particular prints because their compositions were the sources for the later Japanese prints he owned in the 1860s and consequently linked to his own paintings in that decade, particularly *The Six Projects* (see below). This thesis would be supported by the fact that Whistler returned to similar subject matter in the 1890s (see Young, MacDonald, Spencer, *Paintings of James McNeill Whistler*, cat. nos. 400, 491–98). The recurrence of such themes in the 1890s and their relationship to similar subject matter in Japanese prints of different periods requires closer attention. I am grateful to Sebastian Izzard who drew some of these problems to my attention during conversations in Tokyo in December 1979.

34. According to A. Yonaumara, Curator of the Oriental Collections, Freer Gallery of Art, Washington, D.C., the screen is not specifically identifiable, but the subject appears to be of the literary type, such as the *Tales of Genji*. See Young, MacDonald, Spencer, *Paintings of James McNeill Whistler*, cat. no. 60.

35. For a detailed account of the gestation and final destruction of Fantin's picture see Léonce Bénédite, "Histoire d'un tableau: 'Le Toast,' " *Revue de l'art ancien et moderne*, XVII, 1905, and M. Crouzet *Un Méconnu du Réalisme: Duranty*, Paris, 1964, pp. 196–201. Drawings for *Le Toast* are in the Cabinet des Dessins, Musée du Louvre, Paris. See Fantin-Latour, *Catalogue de l'Oeuvre*, cat. nos. 271, 281–2, Album I, cat. no. 2437.

36. The portrait of Whistler is now in the Freer Gallery of Art, Washington, D.C. Burns A. Stubbs, *Paintings, Pastels, Drawings, Prints and Copper Plates by and attributed to American and European Artists, together with a list of Original Whistleriana in the Freer Gallery of Art*, Washington, D.C., 1948, 1967, p. 95 (06.276).

37. Fantin-Latour to Edwin Edwards, February 15, 1865 (copy, Bibliothèque Municipale, Grenoble).

38. Young, MacDonald, Spencer, *Paintings of James McNeill Whistler*, cat. no. 50.

39. "Les Exentriques," "Salon de 1865, III," in *Le Constitutionnel*, May 16, 1865.

40. Quoted by Crouzet, *Duranty*, p. 203.

41. In the Dublin Municipal Gallery of Modern Art and the Art Institute of Chicago. See Young, MacDonald, Spencer, *Paintings of James McNeill Whistler*, cat. nos. 62 and 63 respectively.

42. In 1864 the critic of the *Daily Telegraph*, May 9, compared Millais's *Leisure Hours* with Whistler's *Lange Lijzen*, both of which were in the Royal Academy exhibition that year. Whistler preserved the press cutting in a book of press cuttings, now in the Birnie Philip Bequest, Glasgow University Library (hereafter referred to as GUL. BP.), P/C, I, p. 13.

43. Young, MacDonald, Spencer, *Paintings of James McNeill Whistler*, cat. no. 52.

44. *Daily Telegraph*, May, 15, 1865, GUL. BP. II, P/C, I, p. 11.

45. *The Saturday Review*, June 3, 1865, GUL. BP. II, P/C, I, p. 32.

46. Young, MacDonald, Spencer, *Paintings of James McNeill Whistler*, cat. no. 56.

47. A photograph of the picture, in the Lucas Collection, Baltimore, signed by Whistler "Whistler. 1865," shows less blossoms and no butterfly signature.

48. *Glasgow University Pictures*, (exh. cat.), P. and D. Colnaghi and Co., London, 1973, cat nos. 72–3 (repr.). A second oil painting, a sketch for the composition, is also in Glasgow University. Its relationship to the Freer picture and the water-color is discussed in Young, MacDonald, Spencer, *Paintings of James McNeill Whistler*, cat. nos. 56–57.

49. *The Fourth Month*, from Kiyonaga's *Twelve Months in the South* of 1784, once in Whistler's collection and now in the British Museum (1949–4–9–006). See Tom Prideaux, *The World of Whistler*, New York, 1970, repr. p. 94.

50. As related in a letter from Clifford Addams to E.R. Pennell, Jan. 26, 1912 (Library of Congress, E.R. and J. Pennell Collection).

51. Virginia Surtees, *The Paintings and Drawings of Dante Gabriel Rossetti (1828–1882)*, *A Catalogue Raisonné*, Oxford, 1971, cat. nos. 190 and 173 respectively.

52. Fantin-Latour, *Catalogue de l'Oeuvre*, cat. no. 2201, then (1911) in the collection of Mme Philippe Burty, having once presumably, (and appropriately) belonged to her husband.

53. Ibid., Album I, cat. no. 2437. The drawing, in the Cabinet des Dessins, Musée du Louvre, is on p. 22 (recto). It is also inscribed "Le Poète," "5 décembre 1866." It is possible that the design may have been based on Whistler's *Balcony* composition which Fantin could have seen on his visit to London in the summer of 1864.

54. Ibid., Album II, cat. no. 2438. The drawing, in the Cabinet des Dessins, Musée du Louvre, is on p. 18. It includes the inscription "Robe de Whistler" (presumably the robe in which Whistler posed for Fantin's *Le Toast* in 1865) and is dated "3 Janvier 1869" "Septembre 70." Fantin's progress with this composition is described in a letter to Whistler of January 4, 1869 (GUL. BP.II L/38).

55. It is possible that the still lifes can be identified with Fantin-Latour, *Catalogue de l'Oeuvre*, cat. nos. 310, 311, or 312, although their present whereabouts are unknown. Whistler may have retained the pictures, because it is tempting to identify them with the two flower pieces "of the finest period—very large" which Whistler's brother Dr. William Whistler offered for sale on Whistler's behalf to D. C. Thomson of the Goupil Gallery in 1890 (Library of Congress, E.R. and J. Pennell Collection).

56. Whistler to Fantin-Latour, September 30, 1868 (Library of Congress, E.R. and J. Pennell Collection). See Bénédite, "Artistes Contemporains: Whistler," XXXIV, p. 238.

57. Young, MacDonald, Spencer, *Paintings of James McNeill Whistler*, cat. no. 61.

58. Pennell, *James McNeill Whistler*, I, p. 144, cites Baudelaire, Gautier and Murger as precedents.

59. Bénédite, "Artistes Contemporains: Whistler," pp. 234–34. Whistler to Fantin-Latour, n.d., written after Aug. 31, 1867 (Library of Congress, E.R. and J. Pennell

Collection).

60. Young, MacDonald, Spencer, *Paintings of James McNeill Whistler*, cat. nos. 82–7.

61. Ibid., see cat. no. 88.

62. See John Sandberg, "Whistler Studies," *The Art Bulletin*, L, 1968, pp. 59–64. Robin Spencer, *The Aesthetic Movement*, London and New York, 1972, pp. 30–37.

63. Young, MacDonald, Spencer, *Paintings of James McNeill Whistler*, see cat. nos. 88–89.

64. *Variations in Blue and Green* and *Symphony in Blue and Pink* (ibid., cat. nos. 84, 86) are worth comparing with Kiyonaga's *Cool of the Evening by the Sumida River* (British Museum, 1909–8–18–31). *Symphony in White and Red* (ibid., cat. no. 85) would seem to relate to Kiyonaga's *Jōruri-Hime Serenaded by Ushiwaka*, owned by Whistler (British Museum, 1949–4–9–065). There are further parallels between *The Six Projects* and Kiyonaga's compositions which were in Whistler's collection and are now in Glasgow University.

65. Ernest Chesneau, "L'Art Japonais, conférence faite a l'Union Centrale des Beaux-Arts appliqués à l'industrie." First published in *Le Constitutionnel*, Jan. 14, 22 and Feb. 11, 1868. Analogies and comparisons between Japanese and Greek art are also made by Jarves, "Genuine Artistic Race," (1871) passim.

66. In a letter to Fantin-Latour of 1867, Whistler wrote: "As tu eu la gentillesse de donner l'eau forte à Chesneau? et Villot?" (Library of Congress, E.R. and J. Pennell Collection).

67. "Japanese Decoration in England," *The Art Journal*, Jan. 1872, p. 29.

68. Ibid.

69. Young, MacDonald, Spencer, *Paintings of James McNeill Whistler*, cat. no. 139.

70. Ibid., cat. no. 140.

71. See Ernest F. Fenellosa's article on Whistler in B. Matsuki (ed.), *Lotus*, I, Boston, 1903 (a special issue devoted to the Japanese elements in Whistler's art) and the same author's "The Collection of Mr. Charles L. Freer" in *Pacific Era*, I, 1907, pp. 57–66.

72. Yone Noguchi, *Catalogue of Memorial Exhibition of Hiroshige's Works on the 60th Anniversary of his Death* (ed., Shozaburo Watanabe), Tokyo, 1918. (Panegyric Read by Yone Noguchi on the Occasion of the Exhibition, translated by himself).

73. Notably, Edward F. Strange, *The Colour-Prints of Hiroshige*, London, New York, Toronto, Melbourne, 1925, Chapter 13, "Hiroshige and Western Art," pp. 124–30.

74. Such as *Under Old Battersea Bridge*. See Edward G. Kennedy, *The Etched Work of Whistler*, New York, 1910, K. 176.

75. *Variations in Pink and Grey: Chelsea* (Freer Gallery of Art, Washington, D.C., dated 1871–72 by Young, MacDonald, Spencer, *Paintings of James McNeill Whistler*, cat. no. 105) closely resembles an anonymous street scene in a mist, a Japanese print of about 1870, once in Whistler's collection and now in Glasgow University.

76. Young, MacDonald, Spencer, *Paintings of James McNeill Whistler*, cat. no. 33.

77. On January 18, 1873, Whistler wrote to George A. Lucas in Paris concerning some of his pictures that were on exhibition at Durand-Ruel: " . . . You will notice . . . that my frames I have designed as carefully as my pictures—and that they form as important a part as any of the rest of the work—carrying on the particular harmony throughout . . . " Quoted by John A. Mahey (ed.), "The Letters of James McNeill Whistler to George A. Lucas," *The Art Bulletin*, XLIX, 1967, pp. 252–53. Young, MacDonald, Spencer, *Paintings of James McNeill Whistler*, cat. no. 138. See also Ira Horowitz, "Whistler's Frames," *Art Journal*, Winter 1979–80, XXXIX/2, pp. 124–31.

78. Young, MacDonald, Spencer, *Paintings of James McNeill Whistler*, cat. nos. 95–97, 106–11.

79. Ibid., cat. no. 178.

80. *The Times*, Dec. 26, 1872.

81. Professor T.C. Archer, "Oriental Art in Liverpool. With Especial Reference to the Collection of Japanese Enamels, etc. of James L. Bowes, Esq., and the Liverpool Art Club's First Exhibition," *The Art Journal*, Jan. 1874, pp. 13–14.

82. George Ashdown Audsley and James L. Bowes, *Keramic Art of Japan*, Liverpool and London, 1975. See also George Ashdown Audsley, *A Descriptive Catalogue of Art Works in Japanese Lacquer, Forming the Third Division of the Japanese Collection in the Possession of James L. Bowes*, London, 1875, and by the same author, *Ornamental Arts of Japan*, London, 1884.

83. Spencer, *Aesthetic Movement*, repr. pp. 69–74.

84. J. Hillier, *Utamaro*, London, 1961, repr. pl. 96.

85. See Young, MacDonald, Spencer, *Paintings of James McNeill Whistler*, cat. no. 175.

86. James McNeill Whistler, *The Ten O'Clock Lecture*, London, 1888, reprinted in Whistler's *The Gentle Art of Making Enemies*, London, 1890, 1892, pp. 135–59, and subsequent editions.

87. See Jarves, "Genuine Artistic Race", p. 161.

88. See Bénédite, "Artistes Contemporains: Whistler," XXXIV, pp. 232–34.

89. Margaret MacDonald, "Whistler's Designs for a Catalogue of Blue and White Nankin Porcelain," *The Connoisseur*, Aug. 1978, pp. 291–95.

90. "Sidney Starr," [James McNeill Whistler], "Hokusai," *The Whirlwind*, II, No. 23, Dec. 6, 1890, p. 150. For Whistler's identity as the true author of the review see Herbert Vivian, "Reminiscences," *John Bull*, Nov. 17, 1906.

91. Freer's letters and the photographs he sent to Whistler are in Glasgow University Library (BP. II), and Whistler's letters to Freer are in the Library of the Freer Gallery of Art, Washington, D.C.

92. GUL. BP. II 36/45, 8 pp. The ms. is headed in Whistler's hand "Commodore Perry's Arrival in Japan," and continues "The following translation made by a resident of San Francisco, who spent several years in Japan, from the diary of a Japanese present gives a ludicrous idea of the astonishment felt by the Natives of those Islande at the sight of the American fleet—."

93. In an undated letter to Charles Augustus Howell, headed "Friday," "2 Lindsey Houses" (and therefore written between February 1867 and June 1878) Whistler enclosed "the Japanese poem which was perhaps well used," and which Whistler had carried "ready to read," in his "pocket book." Whistler hoped that Howell would "have some copies printed. With very many thanks for lending it to me for such an age. Ever yours" (Signature). GUL. BP. II 18/4.

94. Cited in the *Westminster Review* for Oct. 1870 and quoted by Jarves, "Genuine Artistic Race," p. 137. The question of the influence of Japanese literature on Western painting in the nineteenth century, as distinct from literature about Japanese art, deserves closer study by Japonists.

95. Young, MacDonald, Spencer, *Paintings of James McNeill Whistler*, cat. nos. 73 and 76 respectively.

96. See James McNeill Whistler, "The Red Rag," "Mr. Whistler at Cheyne Walk," *The World*, May 22, 1878, reprinted in Whistler, *The Gentle Art*, pp. 126–28.

97. Charles Algernon Swinburne, "Mr. Whistler's Lecture on Art," *Fortnightly Review*, June 1888, reprinted in Whistler, *The Gentle Art*, pp. 250–58, with Whistler's reply, pp. 259–62.

98. Ibid., p. 144.

99. Ralph Curtis, quoted by Pennell, *James McNeill Whistler*, I, p. 274. Curtis, an American, was a close friend of Whistler's for over twenty years.

REMARQUES SUR LE JAPONISME
DE BRACQUEMOND

Jean-Paul Bouillon

Parmi les différentes façons d'aborder la question si complexe du Japonisme sous ses divers aspects, formel, historique, culturel, social, voire politique, on peut dire que l'une surtout a prévalu jusqu'à présent: l'analyse à la fois anecdotique et formaliste, placée sous le signe de la recherche et de la confrontation des "documents" apportant des informations sur les *dates* d'apparition et de développement du phénomène, et "démontrant" l'*influence* d'une catégorie d'objets sur l'autre.[1] J'ai essayé de montrer ailleurs comment on pouvait tenter d'expliquer d'une tout autre manière, et sans doute d'une manière plus satisfaisante, des événements liés directement au Japonisme, mais qui relèvent peut-être d'abord de l'analyse sociologique, comme par exemple la constitution de la Société dite du "Jing-Lar," dans les années 1868–1869.[2] Mais je voudrais ici revenir, en apparence au moins, au point de vue formaliste traditionnel, pour essayer de démontrer cette fois que la seule notion d'*influence* ne suffit pas non plus à rendre compte du phénomène sous ses aspects formels. Et dans la mesure où l'on peut considérer que Bracquemond est, en France, au centre du mouvement depuis ses origines jusqu'à la fin des années 1880 environ, je pense que son cas, une fois de plus, aura valeur exemplaire.

Pour cette démonstration, les trois thèses que je vais essayer de défendre sont les suivantes:

1. Avant le milieu des années 1860, l'estampe japonaise intervient essentiellement pour aider l'artiste à résoudre les problèmes posés *dès le début des années 1850*, et dont Bracquemond avait déjà esquissé les solutions: il y a convergence et coïncidence, notamment dans la façon de représenter sur une surface plane un espace tridimensionnel, plutôt qu'*influence* ou véritable "découverte."

2. Après cette date, l'*image* japonaise, rapidement diffusée dans le milieu artistique puis dans le public, est déjà utilisée comme une "référence" plus ou moins ironique, tant pour ses sujets que pour ses grands principes d'organisation formelle.

3. Enfin, aux yeux mêmes de Bracquemond, et contrairement à ce qu'il peut en être chez d'autres artistes ou des littérateurs comme ses amis Goncourt, l'estampe et l'art japonais en général n'ont jamais été considérés

que comme des éléments secondaires, sinon mineurs, du débat esthétique, dans la mesure où ils relevaient d'une conception, ou d'une "convention" artistique, entièrement différente de la sienne.

Pour démontrer ces trois points, j'envisagerai successivement l'estampe japonaise dans ses rapports avec les premières œuvres de Bracquemond jusqu'au milieu des années 60 environ, puis plus rapidement, les positions théoriques de Bracquemond sur la question de l'art japonais, telles qu'elles ont été exposées dans quelques textes peu connus ou inédits.

Je ne reviendrai donc pas sur la question des dates, si abondamment et, à mon sens, si vainement traitée jusqu'à présent, sinon pour souligner, comme je l'ai fait dans plusieurs publications récentes,[3] d'abord que selon son propre témoignage, Bracquemond, à supposer qu'il ait bien aperçu en 1856 un volume de la *Manga* d'Hokusai, ne l'aurait en fait acquis qu' "un an ou dix-huit mois après" ou même "dix-huit mois ou deux ans après,"[4] ce qui nous amène donc finalement *en 1858* pour la véritable prise de connaissance de cette œuvre et le début de sa diffusion dans le milieu artistique parisien; et que d'autre part ce témoignage tardif (1905), dont il existe ainsi deux versions légèrement différentes, n'est confirmé jusqu'à présent par aucun autre document. Dans l'état actuel de nos connaissance, les premières dates à peu près certaines pour le "Japonisme" de Bracquemond, sont l'emploi du papier Japon de provenance directe, utilisé pour certains tirages faits par Delâtre en 1859,[5] et quelques indications sur la propagande en faveur de l'estampe japonaise faite par le graveur à la fin de 1861 et au début de 1862.[6] Les autres documents inédits que je pourrais présenter ici, comme cette tête copiée dans un carnet de dessin utilisé entre 1854 et 1863, sur le *Kōmō Zatsuwa* publié en 1787 par Nakajima Chūryō, ne permettent pas d'être plus précis.[7]

En revanche, il me paraît beaucoup plus important de montrer, et ce sera mon premier point, que la plupart des recherches formelles que l'on met habituellement au compte de "l'influence" de l'estampe japonaise sur l'art occidental apparaissent avant 1859, et même avant 1856, dans l'œuvre de Bracquemond, pour des raisons spécifiques que j'essaierai de dégager ensuite.

Pour simplifier, ces caractéristiques formelles peuvent être regroupées ici autour de trois rubriques principales:

La remise en cause de la perspective linéaire traditionnelle au profit de la superposition des plans dans le sens de la hauteur, ou de la juxtaposition de perspectives multiples; et la réduction de la profondeur ou au contraire son accentuation, mais par l'opposition d'une vue éloignée à un premier plan très rapproché.

Le renouvellement de la composition, en particulier par l'emploi de cadrages insolites, d'objets en premier plan coupés par le bord du cadre, de groupements très asymétriques.

Enfin la réduction du volume et de la forme "tournante" au profit de l'aplat de couleur ou de valeur, emprunté à la technique de l'estampe sur bois de bout.

Toutes ces innovations, qui se recoupent et se renforcent, vont dans un même sens, ou concourent à une même entreprise: la remise en question ou même la destruction de l'espace illusionniste et rationaliste de la Renaissance (le cube d'Alberti), au profit d'un autre espace, "forme symbolique" d'un nouveau moment de la civilisation occidentale.[8]

Or, bien qu'on ait affirmé à plusieurs reprises et récemment encore[9] que ces innovations "japonisantes" n'apparaissaient pas chez Bracquemond avant les années 1866–1867—date de réalisation du *Service Rousseau*, qui reste en effet son œuvre "japonaise" la moins mal connue et la plus étudiée ces dernières années, il est facile de voir que ces caractéristiques se trouvent dans des estampes largement antérieures. En voici quelques exemples, datés en fonction des informations recueillies dans mon nouveau catalogue des gravures.[10]

Réduction de la profondeur et superposition des plans dans la hauteur de la planche, avec ce très étrange paysage de 1850, publié dans un *Cahier de vues d'Italie* (Fig. 1) gravé d'après les dessins d'un certain Beaunier, qui serait architecte, mais que nous ne connaissons pas par ailleurs.[11] La date et la localisation ne sont données que par Burty dans le catalogue de sa vente de 1878, mais une autre planche de la série confirme qu'il s'agit bien de l'Italie, et ce type d'eau-forte, chez Bracquemond, n'est certainement pas postérieur au tout début des années 50—1851 ou 1852 au plus tard. Le rapprochement pourrait être fait avec de nombreux paysages d'estampes japonaises, pris par exemple dans la série des Cascades d'Hokusai (1833).

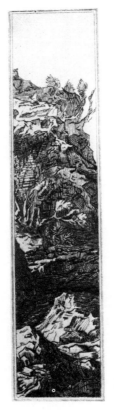

Fig. 1. Félix Bracquemond, *Cahier de vues d'Italie*, 1850. Eau-forte, 2ème état (Ae8).

La réduction de la profondeur et le cadrage en plan très rapproché d'objets coupés par le bord du cadre apparaissent en de nombreux endroits, mais ils sont particulièrement nets dans une planche capitale pour ma démonstration, les *Sarcelles* (Fig. 2), dont la date est absolument certaine: 1853.[12] La ressemblance avec les œuvres japonaises est frappante, et même tout à fait étonnante, quand on rapproche cette gravure des célèbres séries des *Grandes fleurs* et des *Petites fleurs* d'Hokusai, et par exemple de l'*Iris et criquet*, de 1830. De surcroît, on retrouve dans les deux cas des motifs comparables, avec l'association des oiseaux ou insectes, aux plantes d'eau, dont la représentation est très caractéristique.[13]

Enfin, la réduction du modelé et les grandes surfaces en aplat apparaissent dans certaines des œuvres les plus originales et les plus importantes de Bracquemond dès le début des années 50. Et tous ces traits se trouvent déjà réunis dans une planche comme le *Battant de porte* de 1852 (Fig. 3) qui présente une vue strictement frontale, presque sans profondeur,—comme les sujets de fleurs d'Hokusai que l'on vient de voir—, de grandes surfaces presque vides, une composition décentrée, puisqu'il s'agit d'un *coin* du battant, plus asymétrique encore dans les premiers états de la gravure, où ne figure pas encore la planchette qui porte la légende.[14]

Les analogies que l'on a parfois cherché à établir entre certaines œuvres de *la seconde moitié* des années 50 cette fois, et les estampes japonaises me paraissent en revanche assez extérieures et superficielles, et montrent simplement, de la même façon, la coïncidence de recherches *formelles parallèles*, sur des *sujets* eux tout à fait différents d'*inspiration*.

Fig. 2. Félix Bracquemond, *Les Sarcelles*, 1853. Eau-forte, 4ème état (Ac2).

Je n'en prendrai que deux exemples. *Les Canards l'ont bien passée*, gravure dont nous savons seulement de façon certaine qu'elle a été déposée en 1859 alors que les amis de Bracquemond, Burty et Béraldi, la datent de 1856.[15] Cette pièce est célèbre parce que Bracquemond l'a associée lui-même à la découverte de la *Manga*, et que, pour cette raison sans doute on a voulu voir dans la représentation de la pluie un rappel d'un motif typiquement japonais, qu'on trouve dans de nombreuses estampes, et en particulier, en effet, dans la *Manga*.[16] Mais si, comme pour la date de 1856, l'on veut se fier au témoignage de Bracquemond tel qu'il a été rapporté par Bénédite, il convient de remarquer que le graveur a bien indiqué qu'il *allait porter* cette planche, *déjà gravée*, chez son imprimeur Delâtre le jour où il a vu pour la première fois ce fameux album.[17] Quant à l'effet de pluie, il se trouve déjà identique dans de nombreuses œuvres de la Monarchie de Juillet, que Bracquemond avait eu l'occasion d'étudier, chez Paul Huet ou Charles Jacque, et même auparavant chez Raffet ou Decamps.[18]

Pour la forme Bracquemond fait alors un travail exactement parallèle, dans le temps, à celui d'Hiroshige par exemple.[19] Mais pour lui l'essentiel de cette œuvre précise n'est pas la recherche formelle ni même l'observation de l'effet de pluie, comme le montre en particulier le dessin préparatoire (Fig. 4), où cet effet est moins marqué, mais l'illustration d'un thème de chanson, dans la perspective "réaliste" de la réhabilitation de l'art populaire, qu'on trouve aussi au même moment chez ses amis Courbet ou Champfleury; et la représentation de la portée musicale sous l'image, à partir du deuxième état, est certainement plus impor-

Fig. 3. Félix Bracquemond, *Le Haut d'un Battant de Porte*, 1852. Eau-forte, 8ème état (Ac1).

tante à ses yeux, que les traînées de pluie qu'on voit sur la gravure, et qui sont beaucoup plus discrètes au demeurant que dans les estampes japonaises comparables.

L'autre eau-forte, intitulée *O Lune* (Fig. 5), qu'on a datée autrefois de 1854 ou 1855, et qu'on pourrait être tenté de rapprocher elle aussi d'un motif classique de l'estampe japonaise, également représenté dans la *Manga*, est en fait une œuvre *satirique* exécutée vers 1857 et très directement inspirée, comme nous avons pu l'établir, d'un poème des *Odes funambulesques* où Banville, qui est alors l'ami de Bracquemond, attaque très vivement le personnage du critique littéraire.[20] Et comme pour les *Canards*, l'effet de lune lui-même se trouve déjà dans les années 40 chez Daubigny et Damour: en 1856 encore Auguste Delâtre, l'imprimeur de Bracquemond, avait lui-même publié dans *L'Artiste* une gravure sur le même motif.[21]

Dans tous ces cas, représentatifs de bien d'autres, il n'y a donc pas plus "japonisme" que ce qu'on appellerait absurdement "pré-japonisme," mais poursuite d'un travail autonome, et cohérent, dont Bracquemond va simplement *découvrir*, *ensuite*, qu'il *coïncide* avec ce que l'on trouve dans l'estampe japonaise. Et ainsi s'expliquerait en particulier, sa surprise et son enthousiasme quand il a découvert l'album de la *Manga*.

De la prise de conscience, alors, de cette *convergence*, beaucoup plus que d'une *influence* directe et soudaine, je donnerai deux séries de preuves. Les premières montrent comment les motifs anciens vont s'intégrer naturellement aux premières planches qui portent réellement la trace de la découverte des estampes japonaises —pas avant 1861–1862 semble-t-il, c'est-à-dire au moment même, comme je l'ai rappelé, où Bracquemond commence son travail de propagande parmi ses amis. Les secondes montrent, inversement, que même au moment où il paraît le plus "japonisant," Bracquemond prouve, par la citation de ses œuvres anciennes, qu'il a bien conscience de n'utiliser qu'un répertoire de motifs et de formes tout extérieurs, au service d'une recherche *différente*, et amorcée bien avant la découverte de la *Manga*.

Pour la première série, les œuvres les plus caractéristiques sont deux gravures importantes, *L'Inconnu* et *Vanneaux et Sarcelles*, toutes deux datées sûrement de 1862.[22]

Dans *Vanneaux et Sarcelles* on retrouve de façon très caractéristique le *sujet* et les oiseaux mêmes des *Sarcelles* de 1853. La différence principale est qu'il y a cette fois une volonté de composition "à la japonaise," qui frôle le pastiche, et se traduit d'une part, par le choix d'une vue très rapprochée pour les motifs végétaux du premier plan, opposés à un paysage relativement lointain, d'autre part, par la libre et insolite disposition de ces motifs, que vient couper le cadre de l'image. La composition est volontairement asymétrique et déséquilibrée, voire désordonnée.

Le dessin préparatoire (Fig. 6), inédit, montre très bien cette recherche volontaire d'originalité dans la mise en page, qui passe, cette fois, avant le *sujet*, pourtant essentiel pour Bracquemond, de l'observation très attentive "objective" et "réaliste" des oiseaux en liberté.[23]

Mais ce dessin nous montre aussi comment Bracquemond, *ensuite*, a procédé

Fig. 4. Félix Bracquemond, *Les Canards l'ont bien passée*, vers 1856? Dessin préparatoire (Ac16).
Bibliothèque Nationale, Paris.

Fig. 5. Félix Bracquemond, *O lune*, vers
1857–1858. Eau-forte, 2ème état (Af37).

Fig. 6. Félix Bracquemond, *Vanneaux et Sarcelles*, vers 1862. Dessin préparatoire. Collection
particulière, Paris.

par montage, en *introduisant* précisément des oiseaux dessinés *antérieurement* avec
une grande minutie, au début des années 50: c'est le cas surtout pour les vanneaux
eux-mêmes, qui viennent d'une feuille signée et datée de 1851 (Fig. 7)—même
si nous pensons que sa date réelle est peut-être légèrement plus tardive.[24] L'artifice
de ce montage n'a d'ailleurs pas échappé à la critique, puisqu'en 1863 la planche
a été décrite dans la *Chronique des Beaux-Arts* comme "des Vanneaux et Sarcelles
volant et plongeant au milieu d'un marais japonais."[25]

De la même façon, *L'Inconnu* (Fig. 8), planche particulièrement importante et
complexe qui a été choisie pour ouvrir, en 1862, la série des publications de la
Société des Aquafortistes,[26] montre un motif principal: le canard, qu'on trouve
observé de la même façon, avec ses attitudes caractéristiques, dans les eaux-
fortes et croquis des carnets de dessins au début des années 50.[27] Mais Bracque-
mond a intégré ce motif dans une composition elle aussi très japonisante, en
redressant le point de vue, en simplifiant le modelé et en stylisant les formes.
Ce parti pris japonisant est également frappant pour les plantes aquatiques de
l'arrière-plan, très proches de celles que Bracquemond va copier en 1866 pour
le *Service Rousseau* (Fig. 9), avant que Manet ne les utilise à son tour dix ans plus
tard, et sans doute par son intermédiaire, pour son édition illustrée du *Faune*

Fig. 7. Félix Bracquemond,
Les Vanneaux, vers 1851? Dessin
(Ac3). Musée Magnin, Dijon.

Fig. 8. Félix Bracquemond,
L'Inconnu, 1862. Eau-forte, 3ème
état.

Fig. 9. Félix Bracquemond, Assiette du *Service Rousseau*, 1866.

Fig. 10. Félix Bracquemond, Eau-forte pour le *Service Rousseau*, 1866.

Fig. 11. Félix Bracquemond, Assiette du *Service Rousseau*, 1866.

de Mallarmé.[28] Cette façon très explicite et *systématique* de se référer à l'estampe japonaise n'a pas été comprise par Burty, qui a critiqué assez vivement l'œuvre au moment de sa publication, en écrivant que le canard "est taillé au couteau dans un bloc de sapin, et les roseaux de cet étang se rattachent à l'école d'Epinal."[29] Cette dernière indication confirme la volonté de stylisation "japonisante" du graveur, mais elle indique aussi, incidemment, que Burty, qui ne fait pas le bon rapprochement et passe pourtant pour l'un des premiers amateurs de japonaiseries, connaissait encore fort mal le sujet, et que le travail de propagande de Bracquemond était donc lent à porter ses fruits.

La deuxième série de preuves qu'il y a bien eu prise de conscience d'une convergence est peut-être plus curieuse et plus inattendue. Elle concerne justement les planches du *Service Rousseau* de 1866 achevé et exposé en 1867, et assez bien connu depuis plusieurs articles et expositions récentes. Mais contrairement aux analyses que l'on fait habituellement sur ce sujet—à partir des remarques des faites du vivant même de Bracquemond sur l'origine japonaise de la plupart motifs,[30] je voudrais mettre en évidence ici quelques uns des sujets qui précisément *ne sont pas japonais*, et viennent de l'œuvre de Bracquemond *antérieure* à la découverte de la *Manga*.

Il y en a au moins trois exemples: le canard de l'*Inconnu* de 1862 (Fig. 10), que nous venons de voir; une des *Sarcelles* de la gravure de 1853 qui porte ce titre,

comme Martin Eidelberg l'a bien remarqué en présentant récemment une assiette qui porte ce motif[31]; et enfin, le plus intéressant pour nous, un superbe canard prenant son vol qui vient d'une gravure datée sûrement de 1856 (Fig. 11), que nous analyserons tout à l'heure.

Aux deux "sources" d'inspiration du Service, signalées dès l'époque même: les estampes japonaises et la céramique française du dix-huitième siècle, il faut donc en ajouter une autre, qui me semble de loin la plus importante: l'évolution interne, et la continuité, de l'œuvre de Bracquemond lui-même.

Quelle est alors la signification de cette convergence entre le travail du graveur français et celui des artistes japonais? Nous abordons là un problème délicat, et plus difficile sans doute à traiter que la simple recherche des "sources" supposées de "l'inspiration" du graveur. Pour ma part, et sans prétendre avancer ici un type d'explication original, il me semble que le travail de Bracquemond *depuis le debut des années 50*, témoigne avant tout, pour des raisons qui dépassent largement la personnalité de cet artiste précis, de la crise de l'espace figuratif mis en place dans l'art occidental depuis la Renaissance; et qu'à ce titre, il était naturellement appelé à reconnaître dans une tradition non occidentale, une démarche parallèle à la sienne. Beaucoup plus que des motifs ou des procédés particuliers, dont l'emprunt occasionnel n'est que superficiel, c'est la logique et la continuité de ce travail qui me paraissent expliquer la découverte—ou plus exactement la rencontre de l'art japonais à la fin des années 1850, pour des raisons historiques, voire anecdotiques, tout extérieures. Et si la date de la rencontre, ou plutôt *la période* pendant laquelle elle a pu se produire n'est pas indifférente en effet, le hasard des expéditions militaires ou des signatures de traités joue sans doute moins ici que l'évolution interne de la société dont l'art, avant toute chose, porte témoignage.

C'est de cette recherche très empirique, et de la crise qu'elle manifeste, que je

Fig. 12. Félix Bracquemond, *L'Etang*, vers 1855–1860. Première planche, ler état (Ac19).

voudrais maintenant montrer et analyser quelques exemples. Reprenons d'abord les *Sarcelles* de 1853, qui forment une série absolument décisive avec le *Battant* de 1852 déjà vu, et les *Perdrix*, de 1853 également, que nous verrons tout à l'heure.

Le sujet particulier du *Battant* permettait une présentation frontale, en aplat, et pratiquement sans profondeur. A l'opposé, les *Sarcelles* étaient conçues initiale-ment comme un vaste paysage, comparable à celui du dessin des *Vanneaux*, peut-être contemporain. Dans cette dernière composition on ne manquera pas de relever le violent hiatus, le "trou" qui existe entre le premier plan des oiseaux, et la "fuite" très rapide du paysage, vers un horizon lointain placé très bas: du même coup, les vanneaux paraissent très peu intégrés à ce paysage.[32]

Dans les *Sarcelles*, les deux premiers états de la gravure se présentaient de façon comparable, avec un horizon vaste et lointain dans le centre de la planche; mais Bracquemond a jugé, à juste titre, que cet espace était peu satisfaisant, et au troisième état il a introduit le rideau d'herbes du fond que nous voyons main-tenant, *parallèle au plan de la feuille*, et lui aussi déjà si "japonisant."

Dans la même planche on remarquera encore, avec la sarcelle en vol qui sera reprise dans le service Rousseau, la curieuse traduction du vol des oiseaux: alors que celui de droite se dirige du premier plan à droite vers le fond de la planche, les six autres sont disposés dans un ordre de grandeur *croissante* qui suggère un mouvement *inverse*, *contredisant* celui de la sarcelle du premier plan. Ce *double mouvement* contribue d'une façon surprenante à *annuler* l'effet de pro-fondeur, *de la même façon* que le rideau d'herbes du second plan.

Ce problème perspectif apparaîtra avec plus d'évidence encore dans une planche ambitieuse de la seconde moitié des années 50, *L'Etang*, gravure non datée, mais dont l'achèvement doit être à peu près contemporain de la découverte des estampes japonaises.[33] Bracquemond a repris le sujet des *Sarcelles*, mais cette fois-ci, devant le même problème, il a échoué, et n'a fait aboutir son eau-forte, d'ailleurs médiocre, qu'en gravant un second cuivre. Dans la première planche

Fig. 13. Félix Bracquemond, *L'Etang*, vers 1855–1860. Deuxième planche, 3ème état (Ac20).

(Fig. 12) on voit bien l'une des raisons de l'échec: les oiseaux du second plan ont tendance à "monter" dans la planche plus haut que l'horizon, là aussi placé très bas. Dans le second cuivre (Fig. 13), Bracquemond recourt au même artifice que dans les *Sarcelles* et finalement introduit un rideau d'herbes au second plan pour fermer l'horizon. Mais le parti est moins franc, et le résultat final reste très incertain; *l'espace n'est pas cohérent*, et la surface de l'eau paraît même monter sur la droite. Le graveur, *sur ce même motif*, n'arrivera à un résultat satisfaisant qu'avec les *Vanneaux et Sarcelles* de 1862, c'est-à-dire en s'aidant d'un *procédé de montage*, dont l'artifice, emprunté à l'estampe japonaise, est ouvertement déclaré. Et cette solution sera reprise désormais, avec plus de discrétion, dans la plupart des planches postérieures mettant en jeu les mêmes éléments, par exemple dans les *Hirondelles* ou dans les *Roseaux et Sarcelles* du milieu des années 1880.[34]

Ce que je veux montrer par là c'est que l'estampe japonaise a surtout pour fonction ici d'*aider* à résoudre aisément, par le biais d'une référence qui n'échappe à personne, un problème qui a pris naissance *avant* que Bracquemond ne l'ait découverte, et pour lequel il a déjà, de lui-même, esquissé les solutions.

Quel est très concrètement ce problème? Techniquement, il me paraît résulter de la prise de conscience de la *bidimensionalité* du support sur lequel vient se poser l'image, et de la contradiction qu'il y a d'y faire figurer, avec la perspective illusionniste traditionnelle, un espace à trois dimensions.

Ce problème, naturellement, est bien connu. Et l'on sait à quelles révolutions il conduit finalement dans les premières années du vingtième siècle. Mais son apparition dans les arts plastiques occidentaux "modernes" est le plus souvent présentée, par la référence privilégiée aux recherches systématiques de Gauguin et des Nabis en ce domaine par exemple, comme l'une des *conséquences* majeures de la découverte de l'estampe japonaise. Pour ma part, et à l'aide de l'exemple très précis de Bracquemond pendant les années qui *précèdent* son "invention" du

Fig. 14. Félix Bracquemond, *Perdrix*, 1853. Eau-forte, 1er état (Ac3).

Japonisme, j'y verrais bien plutôt l'une des conséquences majeures de la réapparition de l'eau-forte "de peintre," dont Bracquemond est *aussi* l'artisan principal, au *même moment*. (Et c'est là bien sûr qu'il faut voir la raison d'une coïncidence "curieuse" et rarement commentée: pourquoi le *graveur* Bracquemond est-il à l'origine du Japonisme?)

Ce n'est évidemment pas le lieu de revenir sur ce qu'est l'eau-forte des années *50*—pourtant négligée, et sensiblement plus importante pour la suite des évènements, que l'eau-forte déjà en grande partie "vulgarisée," de la Société des Aquafortistes, après 1860. Mais c'est, entre autres choses, et même peut-être, avant toutes choses, un phénomène de civilisation, qui traduit moins le "génie créateur" de quelques individus—en l'occurrence Bracquemond—qu'un processus *de rupture* par rapport à tout ce que *représente* l'espace illusionniste tridimensionnel des Académies. Pour ce qui nous intéresse ici l'eau-forte marque alors, par son opposition au burin rangé de l'Institut aussi bien qu'à la molle lithographie du commerce, une révolte non contre le "modelé," mais contre la forme "qui tourne" régulièrement et insensiblement dans un espace continu. Elle est l'affirmation d'un espace—qui est aussi un espace social—où par opposition s'affirme la *succession* et la *hiérarchisation* des *plans de valeurs*.

L'estampe, et l'eau-forte surtout est évidemment un terrain privilégié pour cette découverte—ou cette révolution—dans la mesure d'une part où elle échappe alors totalement au contrôle de l'Institution, et dans la mesure d'autre part où "l'impression" sur la "feuille" met mieux en évidence la platitude *des surfaces* que les superpositions et les épaisseurs de la peinture. Dans ses écrits théoriques de la Troisième République, Bracquemond énoncera d'une façon saisissante cette idée, révolutionnaire en effet par rapport à toute la tradition du burin académique (et dans une certaine mesure de la *photographie*, qui en prend le relais): "L'élément fondamental de l'estampe c'est le blanc du papier."[35] Mais dès le début des années 50 cette surface, sous la forme des blancs justement, apparaît, d'une façon étonnante dans ses planches les plus importantes. En voici quelques exemples particulièrement frappants.

Et d'abord le très surprenant premier état de la gravure (Fig. 14) à laquelle j'ai fait allusion tout à l'heure et qui forme série avec le *Battant* et les *Sarcelles*, donc en 1853.[36] Entre autres choses on remarquera comment les *taches* de valeurs sombres des oiseaux ont tendance à se répartir sur la planche: en frise au premier plan, et sans vraiment respecter la diminution des grandeurs qu'imposerait la perspective linéaire au second plan.

On sera frappé aussi par la tendance du paysage à se disposer dans la verticalité de la feuille, par la composition asymétrique et fort peu classique du motif, et bien sûr par le découpage et l'emboîtement des surfaces en "aplats."

Sans doute il s'agit d'un premier état, et dans beaucoup de premiers états d'eaux-fortes antérieures on trouverait des réserves blanches d'une importance comparable. Mais dans les états postérieurs, et dès le deuxième, où elle est achevée, l'eau-forte garde le même caractère, notamment par l'uniformité du métier adopté pour *chacune* des grandes surfaces découpées à l'origine: la gravure se présente donc d'abord comme un assemblage de *plans* de valeurs.

On trouve des caractéristiques comparables dans les grandes planches des

années suivantes, par exemple dans le premier état des *Taupes* de 1854.[37] Mais pour les *Sarcelles* qui précèdent immédiatement et qu'on a déjà vues, je voudrais signaler un autre procédé qui va dans le même sens et nous rapproche d'une façon plus surprenante encore de l'estampe japonaise. Certaines épreuves du troisième état—donc au cours des années 1850 et avant les retirages de Cadart —présentent un effet d'encrage qui est exactement celui du Ichimonji-Bokashi, d'Hiroshige—c'est-à-dire le système de la bande dégradée du ciel, à partir d'une teinte plus sombre passée *uniformément* contre le bord supérieur de l'estampe, et dégradée vers le bas[38]: en même temps qu'une anticipation de l'eau-forte mobile de Lepic (puisqu'il en résulte aussi un effet de nuit ou d'orage), j'y vois pour ma part un autre signe de la prise de conscience de la valeur du plan du support, et du refus de faire "fuir" la planche vers le fond, en réaffirmant dans le haut de la feuille une valeur soutenue—en noir, ne l'oublions pas—contraire aux règles de la perspective aérienne, et pratiquement indépendante d'une vision "naturaliste" du motif.

Que ces recherches relèvent avant tout de la remise en question de l'espace tridimensionnel et du souci de remettre en évidence le plan de l'image, *sans la "trouer,"* comme l'estampe japonaise montrera pour sa part qu'il est possible de le faire, j'en vois enfin une preuve supplémentaire dans d'autres œuvres

Fig. 15. Félix Bracquemond, *Le Canard*, 1856. Eau-forte, 4ème état (Ac22).

de la période où le problème de l'espace fait pratiquement le principal sujet de la gravure ou du dessin. Je n'en prendrai que deux exemples.

Voici d'abord une feuille d'un carnet de dessin qu'on peut dater avec certitude des années 1849–1853.[39] Il s'agit très vraisemblablement d'un croquis sur le motif, et non pas d'une recherche de composition faite dans l'atelier, et ce type de paysage se rencontre en effet dans la région précise des environs de Paris où travaille alors Bracquemond.[40] La superposition des plans, l'unification des valeurs à l'intérieur de chaque surface, l'indifférenciation de la composition sur toute la largeur de l'image, se passent de commentaires: c'est le type même des recherches expérimentales que feront les Nabis par exemple une quarantaine d'années plus tard, en s'appuyant sur l'exemple de l'estampe japonaise.

Mais plus complexe et plus intéressant encore pour notre propos est le grand *Canard* de 1856 (Fig. 15), dont le motif principal sera repris, on l'a vu, dans le *Service Rousseau* japonisant de 1866, exactement dix ans plus tard.[41] Là aussi la signification de la planche est compliquée, voire ambiguë et par rapport aux intentions moralisatrices ou satiriques de la gravure la forme semble n'avoir qu'une importance secondaire. Cette fois-ci pourtant les blancs conservent la même importance dans les états postérieurs aux deux premiers, sans les vers, et ces blancs tiennent une place considérable,—à l'inverse d'ailleurs de ce que recommandent les lois de la perspective aérienne (les lointains sont aussi sombres, sinon plus). Mais la mise en page surtout révèle une recherche très consciente et étrangement moderne, sur le problème des "surfaces": la profondeur infinie du ciel blanc sur lequel se détache le canard est brutalement ramenée au mince plan de la feuille, à la fois par les vers que celle-ci supporte à partir du troisième état, et par le titre du "Journal" imprimé en aplat sur la feuille réelle, et que masque en partie la feuille imaginaire placée sur elle. Le débordement des ailes du canard sur les limites du cadre ramène lui aussi l'horizon le plus lointain au papier de l'estampe.[42] La superposition d'espaces *contradictoires* nie aussi l'illusion de la profondeur au profit de la répartition—et ici de l'équilibre très subtil—des valeurs dans le plan.

Le choix de ce canard pour le *Service Rousseau* nous surprend alors moins. Comme la sarcelle de 1853, qui s'envole vers des oiseaux qui vont à sa rencontre, comme le canard de *profil* de *L'Inconnu* en 1862, cet oiseau en vue frontale qui adhère au blanc du papier est un motif de choix pour voisiner avec les dessins en aplat de la *Manga*: lui non plus ne risque pas de "trouer" la céramique—problème fondamental pour le *décor* de l'objet.

Si nous en avions le temps et la place il faudrait alors montrer maintenant comment le choix des motifs et toute l'iconographie des principales œuvres de cette période, marque *parallèlement*, par son caractère "populaire" qui s'oppose au "grand art," une réaction également *semblable* à celle de l'*ukiyo-e* au dix-septième et au dix-huitième siècles. L'exemple le plus explicite serait ici *Les Canards l'ont bien passée* que nous avons vu tout à l'heure et dont le sujet est emprunté à une chanson enfantine qui se chante encore aujourd'hui en France.[43] Par cet aspect de son travail, Bracquemond appartient bien à la même tendance "réaliste" qu'un Champfleury et qu'un Courbet, et tous les trois se trouveront d'ailleurs réunis dans deux œuvres au moins, en 1859 et 1860 (cette dernière année

à propos des *Chants et Chansons populaires de la France*), au moment même de la "découverte" du japonisme—pourtant présenté le plus souvent comme un "formalisme" de nature toute contraire[44] . . . L'estampe japonaise pourrait bien en fait à cette date, et pour des raisons comparables, jouer le même rôle que les œuvres des hollandais, et des espagnols surtout, une dizaine d'années plus tôt, pour les peintres "réalistes": point d'appui, et justification de la pertinence des recherches entreprises face à l'hostilité de l'Institution et à la résistance ou à l'hostilité du public des Salons.

A cette remise en cause du rôle de l'estampe japonaise dans ces premières années, ou en tout cas à cette réfutation de toute notion d' "influence"—dont j'ai peut-être forcé le caractére systématique, pour réagir à l'orientation prise par les études sur ce sujet depuis quelques années—, je voudrais maintenant, dans une seconde partie, confronter ou juxtaposer pour vérification quelques textes peu connus ou inédits de Bracquemond lui-même, qui définissent avec beaucoup de clarté sa position sur ce sujet une trentaine d'années plus tard.

Le plus important et le plus explicite se trouve dans la préface à la vente des estampes modernes de la collection des Goncourt les 30 avril et ler mai 1897.[45] Bracquemond y fait état de ses divergences de vues avec Goncourt (qu'il compte pourtant bien, avec Burty et avec lui-même, parmi les premiers collectionneurs à Paris d'albums japonais[46]):

> Rarement nous étions d'accord sur ce sujet (. . .). Certes, ma sympathie, mon admiration n'ont subi aucun amoindrissement pour cet art qui sait tout dire, tout exprimer par des formes ornementales d'une originalité qui se renouvelle sans cesse. Mais, après la période des surprises, des enchantements provoqués par la nouveauté d'expressions si inattendues, est venu le calme de l'examen critique (. . .). Par sa conception élémentaire, l'art japonais, ou plutôt l'art de l'extrême Orient, est inférieur; inférieur, parce qu'il est incomplet dans la représentation de la nature. Pour lui le dessin est réduit à la convention graphique du *trait*, il rend l'expression des choses seulement par leurs contours (. . .). L'infériorité de l'art japonais vient de la suppression voulue du clair et de l'obscur dans sa conception. C'est à la fois sa faiblesse et son originalité. Elémentaire dans sa technique, il est à la portée de tous et semble naturel à toute main; c'est une écriture. Elle n'en a pas moins permis l'éclosion d'un génie du dessin tel qu'Hokousaï . . . Goncourt parlait d'*expression*, je répondais *moyen*; nous ne pouvions nous entendre.

Bracquemond répètera ce jugement sévère dans l'un de ses carnets de notes inédits, en 1903: "L'art réduit à l'emploi conventionnel du trait est une technique inférieure par la raison qu'il est un art incomplet: l'art japonais."[47]

Quelle est la raison de cette condamnation? Elle tient avant tout aux théories esthétiques de Bracquemond, qu'il serait évidemment trop long d'exposer ici, mais dont on peut dire qu'elles reposent principalement sur la notion de *modelé*, c'est-à-dire, selon la définition de son livre de 1885, "la distribution, dans les œuvres d'art, des valeurs claires et des valeurs obscures, à l'imitation des lumières, des reflets et des ombres dans la nature."[48] Cette définition technique prend en fait chez lui la valeur d'un principe philosophique, sinon métaphysique, qui

correspond à toute une conception de l'art et de ses rapports avec "la nature"—conception déduite, comme je l'ai montré par ailleurs, du positivisme d'Auguste Comte.[49]

Sur le plan *théorique*, l'art de l'estampe japonaise paraît évidemment en complète opposition avec cette notion de modelé: d'où la condamnation de Bracquemond au moment où il rédige son grand traité et se consacre à la réflexion esthétique, c'est-à-dire, à peu près, à partir de 1880.

Cette attitude tout intellectuelle est pourtant contraire à sa *pratique* et aux affinités qui l'ont porté, comme on l'a montré, à reconnaître la convergence de certains des procédés de l'estampe japonaise avec ses propres recherches. A d'autres occasions sa position s'est donc exprimée de façon plus nuancée, voire avec plus d'embarras.

Dans un carnet de 1895 par exemple je trouve cette notation: "Là même où le volume n'étant pas représenté, c'est-à-dire par la représentation limitée au *trait*, et d'où par conséquent le modelé semble absent, ses prémices, ses rudiments suffisent à constituer un art complet, l'art japonais par exemple"; ce qui est expliqué par la phrase suivante: "Les proportions sont les prémices du modelé, la métrique, la mesure, la mensuration, la convention du trait en sont les pratiques rudimentaires."[50]

Le fils de Bracquemond, Pierre, a très clairement et très richement développé ces idées dans un manuscrit inédit important consacré aux idées de son père.[51] Quand, pour condamner l'usage du trait de contour aux dépens du modelé, Bracquemond rapporte le mot d'Ingres "l'école du trait, mauvaise école" et qu'on lui objecte l'exemple des Japonais, le graveur répond qu'il s'agit alors d'un système entièrement conventionnel, complètement étranger à celui de l'art occidental et il insiste par exemple sur la différence fondamentale qu'il y a à ses yeux entre le dessin japonais et le dessin d'un Toulouse-Lautrec[52]:

> Lorsqu'un occidental choisit dans un visage par exemple, un caractère qui le séduit, et qu'il l'exprime par un trait, ce trait représente pour lui la place de l'ombre qui accuse, enveloppe et révèle une forme. Il modèle en un mot. Il modèle d'une manière simplifiée (. . .), il marque la direction et l'importance de l'ombre par un trait suffisant à faire connaître et fixer son mouvement. Votre ami Lautrec (. . .) modèle, il ne dessine pas du tout en se plaçant au même point de vue que les Japonais, bien que son faire puisse, pour les gens non prévenus, porter à de fâcheuses confusions.[53]

Inversement, dans un autre passage important qu'il faudrait pouvoir citer intégralement, Bracquemond analyse avec beaucoup de finesse le rôle des valeurs dans des plans différents, peints ou coloriés en aplats:

> Les valeurs sont aussi importantes pour donner l'impression de fuite, d'éloignement progressif des choses dans un tableau, que les lignes perspectives elles-mêmes (. . .). Dans ce cas, la valeur se marque souvent par une teinte à plat, large, uniforme, sans détail particulier de modelé: on dit alors, en employant des termes différents, ton local, localité (. . .), les Japonais (. . .) constatent et emploient des valeurs ainsi généralisées. Leurs paysages sont classés premier, deuxième, dernier plan par valeur, par localité. Leurs

figures ont toutes un ton local qui les sépare du fond sur lequel elles se profilent. Mais eux ne vont pas plus loin, ils mettent délibérément de côté le modelé particulier de chaque objet pris en lui-même. C'est leur convention.[54]

Finalement, Bracquemond défend la légitimité de trois conventions différentes, mais parallèles: "celle des arts orientaux, pas de modelé, quelques valeurs, le trait; la seconde aussi absolue et arbitraire, l'art des grande dessinateurs comme Holbein, Raphaël, Léonard de Vinci, le Poussin, Ingres," qui proscrivent à la fois le trait seul et le jeu perturbateur du reflet, et enfin "ceux qui prennent la nature telle qu'elle est, acceptent toutes les difficultés, manient et interprètent les reflets avec leur fantaisie quelquefois déconcertante (. . .) Rembrandt, Rubens, Véronèse, Tintoret, Watteau, Fragonard, Delacroix."[55]

Cette distinction importante, qui donne sans doute le dernier état de la pensée de Bracquemond, permet de comprendre les critiques adressées antérieurement à l'art japonais. Bracquemond lui-même se rattache à la seconde tendance, mais admet la légitimité des deux autres—l'important étant ici pour nous que la "convention" extrême orientale soit présentée, au-delà de voisinages ou d'analogies *superficielles*, comme complètement *étrangère* dans la théorie et dans les faits, aux deux conventions occidentales. C'est évidemment rejeter entièrement toute idée ou toute possibilité "d'influence" ou "d'assimilation," et cela nous permet de comprendre aussi le détachement, étonnant au premier abord, avec lequel Bracquemond parle de l'art japonais dans la préface à la vente Goncourt de 1897.

On se souvient de la phrase qui concluait le passage que j'ai cité tout à l'heure: "Goncourt parlait d'*expression*, je répondais *moyen*. . . ." Pour les moyens en effet je pense que Bracquemond et ses amis ont finalement peu "emprunté" à

Fig. 16. Félix Bracquemond, Dessin préparatoire pour l'assieette *le Ruisseau*, vers 1870. Collection particulière, Paris.

Fig. 17. Félix Bracquemond, Projet d'assiette, vers 1870–1880. Gouache. Collection particulière, Paris.

l'estampe japonaise: leurs innovations résultent d'abord, comme j'espère l'avoir montré, de leurs recherches antérieures et des problèmes *spécifiques* qui se posent alors aux artistes de l'avant-garde occidentale. Au-delà de ses *motifs expressifs* repris directement aux dessins d'Hokusai, le *Service Rousseau* de 1866 est finalement un "objet artistique" qui a fort peu à voir avec le Japon; et Martin Eidelberg, avec lequel je suis d'accord sur ce point, a eu raison de souligner la part essentielle qu'y jouait notamment une certaine interprétation de dix-huitième siècle français.

Quant à la présence des *motifs* japonais, c'est un tout autre problème, qui demande à être analysé au niveau de l' "expression," c'est-à-dire dans une perspective iconographique, ou mieux iconologique. Les objets japonais jouent alors *à l'intérieur* d'un *système de signification* exclusivement français, comme j'espère

Fig. 18. Félix Bracquemond, Dessin préparatoire pour une assiette du *Service Parisien*, vers 1876. New York Public Library.

Fig. 20. Félix Bracquemond, Vase, vers 1882. Collection particulière, Paris.

Fig. 19. Félix Bracquemond, Dessins de vase, vers 1882. Collection particulière, Paris.

aussi l'avoir montré à propos de la Société du Jing-Lar, et par exemple à propos de cette étrange gravure de Solon dédicacée à Bracquemond qu'il est impossible d'analyser comme un simple témoignage de la présence du "Japonisme" parmi. un cercle d' "amateurs" autour de 1868–69. La dimension "ironique" de ces images, comme celle du fameux sonnet de Zacharie Astruc est à prendre en considération au premier chef.[56]

Après 1868 et surtout 1870, le problème est sans doute différent. Bracquemond fait alors passer au premier plan une recherche purement "formaliste" si l'on veut, dans laquelle la question de l'ornement et de l'adaptation du décor à un *matériau* précis vient au premier plan: la virtuosité éblouissante avec laquelle il joue des motifs en même temps que des procédés de composition de l'estampe japonaise ne doit pas dissimuler que l'essentiel de sa recherche est à nouveau ailleurs, comme le prouvent à la fois l'usage concomittant de motifs non japonisants et les réflexions théoriques que Bracquemond élabore simultanément sur le problème du "décor" et des arts décoratifs en général.

Voici, parmi bien d'autres, quatre exemples empruntés à des dessins inédits (Figs. 16–19), que je place entre 1870 pour le premier et 1882 pour le dernier.[57]

Sur cette dernière feuille on remarquera en haut à droite, et à côté des motifs typiquement "japonisants" un sujet typiquement parisien, et en bas à droite la première pensée d'un des plus beaux vases de Bracquemond (Fig. 20) pendant cette période.[58] Or ce dernier motif reprend une fois de plus le thème qui est apparu pour la première fois avec les *Sarcelles* de 1853! Et d'autre part il donnera lieu, parallèlement, à une *gravure* dont les caractéristiques techniques et même stylistiques sont fondamentalement différentes, comme je l'ai déjà souligné ailleurs[59]: précision "réaliste" du dessin et représentation "illusionniste" des différentes matières dans l'eau-forte, jeu des grandes surfaces et du grain du matériau dans le vase. Dans les deux cas, l'essentiel de la recherche et la valeur des œuvres repose non pas sur le caractère japonisant du motif et de la composition mais sur le respect de la *spécificité* de la technique et du support utilisés.

Et les déclarations de Bracquemond, publiées postérieurement, confirment cette interprètation, de façon très explicite, pour la céramique tout au moins: " . . . la matière de fond a plus de part à la qualité du décor que l'art même de ce décor," ou encore "la valeur d'art d'une décoration céramique est indifférente en elle-même," etc.[60]

Il me semble ainsi que cet aperçu très rapide sur la production des années 1870–80, qui d'un point de vue tout extérieur peut passer d'abord pour la plus "japonisante" de toute l'œuvre de Bracquemond, conduit au contraire tout naturellement aux déclarations si surprenantes au premier abord, du catalogue de la vente Goncourt en 1897, et amène à conclure à nouveau, malgré le paradoxe apparent, à la relativisation sensible du rôle joué par l'estampe japonaise dans une évolution qui trouve ailleurs ses motivations principales et ses principaux axes de recherche.

En prenant ainsi résolument un parti inverse de celui des analyses tradition-nelles, je n'ai pas voulu, dans cet exposé, nier la présence des objets japonais dans l'œuvre de Bracquemond, ce qui serait absurde à l'évidence, mais simplement souligner le fait que l'étroite positivité d'une bonne partie des études sur le

Japonisme, à la recherche, vaine à mon avis, des "dates," des "sources," et des traces d'une "influence" conçue dans une relation de causalité mécaniste, risque de détourner notre attention du phénomène *principal*, il est vrai plus délicat à étudier. Le cas de Bracquemond, considéré, non sans raison, comme "l'inventeur" ou "l'importateur" du Japonisme dans l'art occidental du dix-neuvième siècle, montre précisément à mon sens qu'il n'y a pas eu "invention" ou "importation" d'une esthétique, mais que les motifs et les procédés de composition de l'image japonaise sont intervenus comme justificatifs notamment, dans le développement et l'évolution interne d'une crise propre à l'art occidental depuis au moins le début des années 50, c'est-à-dire une dizaine d'années avant l'apparition de ces premiers objets japonais sur le marché français. Cette crise se manifeste avant tout par la destruction progressive de l'espace perspectif traditionnel, pour lequel l'estampe japonaise aide simplement, à partir du début des années 60, à la formulation des solutions nouvelles, esquissées déjà dès le début des années 50. Dans les années suivantes, et à partir du moment où l'objet japonais trouve sa place sur le marché, dans le commerce d'art et auprès du public des Salons et des expositions, le Japonisme devient un phénomène de société qu'il n'est plus possible d'analyser seulement en termes formels. Et l'analyse sociologique, que j'ai volontairement laissée à l'écart ici, devrait pour cette recherche, s'appuyer non plus seulement sur les motifs, l'organisation formelle ou même l'enquête iconologique, mais sur des épisodes qui mettent d'emblée en évidence cette dimension sociale, comme celui de la *Société du Jing-Lar*, de l'atelier d'Auteuil de la Maison Haviland, ou déjà même toute l'affaire du *Service Rousseau*—qui est bien un service de table précisément, et non une simple suite d'images. Peut-être reconnaîtrait-on alors l'importance secondaire des déterminations stylistiques ou esthétiques qui, dans le cas particulier de Bracquemond, provoquent l'étonnante collision, en l'espace de quelques années, de notions aussi vagues et contradictoires, selon les classifications de l'histoire de l'art traditionnelle, que romantisme, réalisme, ingrisme et japonisme.

NOTES

1. On n'en finirait pas de relever les titres de livres, d'articles ou de chapitres, dans lesquels le terme "d'influence" signale l'orientation générale de l'étude—sans que cette notion vague dont le fondement théorique est rien moins qu'incertain, fasse jamais l'objet d'une mise au point ou d'une discussion préalable. Voir la bibliographie donnée dans le catalogue de l'exposition intitulée elle-même significativement *Japonisme: Japanese Influence on French Art 1854–1910*, Cleveland, 1975 (cité ensuite *Japonisme*), celle, chronologique, qui figure à la fin du livre d'U. Perucchi-Petri, *Die Nabis und Japan*, Munich, 1976, pp. 230–32, et en dernier lieu l'article de B. Dorival, "L'Influence de l'estampe japonaise sur la peinture française," dans *Le Japon et l'Occident*, éd. par Yamada Chisaburō, tr. fr., Paris, 1977, où l'on trouvera aussi une bibliographie très complète mise à jour par Ikegami Chūji.

2. "A gauche, note sur la Société du Jing-Lar et sa signification," dans *Gazette des Beaux-Arts*, mars 1978, pp. 107–18 (cité ensuite JPB. 1978).

3. Ibid., p. 117, note 18; "Correspondance de Bracquemond et de Poulet-Malassis," dans le *Bulletin du Bibliophile*, 1975, IV, pp. 386–87, et 1976, IV, pp. 398–99, note 39, ainsi que dans ma thèse *Félix Bracquemond: les années d'apprentissage (1849– 1859)*, *La genèse d'un réalisme positiviste*, Paris, 1979 (inédit, cité ensuite JPB. 1979).

4. Témoignages recueillis par Léonce Bénédite dans *deux* articles de 1905, dont le texte précis est rarement cité: "Félix Bracquemond l'animalier," dans *Art et Décoration*, février, p. 39, et "Whistler," dans *Gazette des Beaux-Arts*, ler août, p. 142 (c'est dans ce texte postérieur et qui peut apparaître comme une correction du premier, qu'il est parlé de "deux ans après").

5. Voir JPB. 1979, p. 1033 sq. La question de l'apparition des vrais papiers Japon, de provenance directe, ne paraît pas bien éclaircie. Les catalogues mentionnent des tirages sur ce papier d'eaux-fortes de Daubigny ou de Meryon autour de 1850–1851, mais il peut s'agir soit d'imitations, soit de tirages plus tardifs. L'utile mise au point de Andrew Robison, *Paper in prints*, National Gallery of Art, Washington, 1977 (où Bracquemond n'est pas cité) n'apporte aucune précision à ce sujet. Toutefois j'ai pu établir que pour lui les tirages sur Japon, même d'œuvres antérieures, n'interviennent au plus tôt qu'à partir de 1857 et plus vraisemblablement à partir de 1858.

6. Voir l'article du *Bulletin du Bibliophile* de 1975 cité ci-dessus à la note 3.

7. Carnet 8, n° 52 (selon le catalogue établi dans JPB. 1979), où l'on trouve aussi quatre autres croquis copiés sur la même page du livre japonais (page reproduite dans le livre de Kobayashi Taichirō, *Hokusai et Degas*, p. 415). Dans le manuscrit inédit de Pierre Bracquemond cité plus bas (voir note 51) il est fait une allusion précise à la commode Louis XVI, au fond de l'atelier du graveur; qui au début de vingtième siècle encore, était "pleine d'albums d'estampes japonaises." Quelques-uns de ces albums ont été conservés (coll. part., Paris), mais la *Manga* n'y figure plus, et le seul qui porte une indication de provenance donne l'adresse "A l'Empire Chinois, 53, rue Vivienne, Decelle, Thés et Chinoiseries": il a donc sans doute été acheté après 1875 (*Japonisme*, p. 17, note 35).

8. C'est un des points développés avec force, après bien d'autres, par P. Francastel, notamment dans la seconde partie de *Peinture et Société*, Paris, 1951, où "l'influence" directe du Japon est minimisée (rééd. 1965, p. 128). L'étude du même auteur sur *L'Impressionnisme* (Paris, 1937) contient de la même façon, à côté de nombreuses erreurs ou approximations historiques, plusieurs aperçus intéressants (rééd. 1974, pp. 104–132).

9. Par exemple C. Van Rappard-Boon, "Japonism, the First Years, 1856–1876," dans *Liber amicorum Karel G. Boon*, Amsterdam, 1974, p. 111, ou F. Whitford, *Japanese Prints and Western Painters*, New York, 1977, p. 101, ou encore K. Berger dans l'ouvrage cité ci-dessous à la note 13, p. 15.

10. Première partie (1849–1859), avec catalogue de 192 gravures, dans JPB. 1979;
 je donne la référence à ce nouveau catalogue en la faisant suivre entre parenthèses
 de la numérotation de Béraldi, *Les Graveurs du XIXème siècle*, t. III, Bracquemond,
 Paris, 1885.

11. Ae 8 (B. 234), 2ème état.

12. Ac 2 (B. 111), 4ème état; la planche est déposée par l'imprimeur Delâtre le 15
 février 1853.

13. Sur ce thème voir l'aperçu de S. Wichmann, "Die Schwertlilie und Iris als euro-
 päisches Bildthema im 19. und beginnenden 20. Jahrhundert unter dem Einfluss
 chinesischer und japanischer Malanleitungen," dans *Weltkulturen und Moderne
 Kunst*, Munich, 1972 (cité ensuite *Weltkulturen*), pp. 218–221. Mais Bracquemond
 n'est pas cité et pour l'art occidental les exemples choisis sont largement posté-
 rieurs.

14. Ac 1 (B. 110) (8ème état, ou tirage, en 1865). Il est tout à fait caractéristique de
 voir J. Pennell ecrire en 1919: "a crow nailed to a door proves how much he was
 indebted to Japanese prints which he with Whistler made known to Europe"
 (*Etchers and Etchings*, p. 195).

15. Ac 23 (B. 154), tirage tardif (le cuivre a été conservé).

16. *Japonisme*, n. 30, et n° 5 b, p. 23.

17. Bénédite, 1905, article d'*Art et Décoration*: . . . "en 1856, un beau matin, Bracque-
 mond s'en allait porter chez l'imprimeur Delâtre la planche de sa gravure: *Les
 canards l'ont bien passée* (. . .), tout en causant, Bracquemond découvrit un livre
 bizarrement broché, à couverture rouge (. . .) il avait servi à caler des porcelaines
 expédiées par des Français établis au Japon," etc.

18. Pour Paul Huet voir par exemple *L'Inondation* de 1835; pour Charles Jacque
 plusieurs paysages (Guiffrey n° 28, 1844; Guiffrey n° 82, 1845); pour Decamps
 la scène de chasse sous la pluie de l'album lithographique de 1829, etc. Jean C.
 Harris a bien remarqué ce point dans son compte rendu de *Japonisme*, dans *The
 Art Bulletin*, septembre 1977, pp. 451–452, mais semble douter de la date de la gra-
 vure ("perhaps of the fifties"), attestée au moins par le dépôt légal.

19. *Le pont de Ōhashi sous la pluie*, de la suite des *Cent lieux célèbres d'Edo*, vers 1857, bien
 connu et souvent reproduit en raison de la copie de Van Gogh (cf. *Weltkulturen*,
 n. 653 et 654).

20. Af 37 (B. 153); le poème de Banville s'intitule "Le critique en mal d'enfant":
 dans ce passage le critique supplie la lune de bien vouloir l'inspirer pour qu'il
 puisse créer une œuvre à son tour; la planche de la *Manga* a été reproduite dans
 Japonisme n° 67 c, mais l'on pourrait citer bien des exemples comparables.

21. Pour Daubigny voir Delteil n° 54 (1845) ou n° 60 (1846); pour Damour une
 planche de son album de dix eaux-fortes, imprimé par Delâtre en 1848 (n° 7);
 la planche de Delâtre s'intitule *Lever de lune*.

22. B. 174 et B. 175.

23. Crayon et gouache; feuille, h. 42.7×28.5 cm; tracé du trait carré, h. 25.2×18.5
 cm; coll. part., Paris.

24. Musée Magnin, Dijon; catalogue des dessins, Ac 3, dans JPB. 1979. L'un de ces
 vanneaux apparaît aussi dans une petite eau-forte qui date des années 1857–58
 (B. 146, et cat. JPB. 1979, Aa 19, pour cette gravure très curieuse): de toute façon,
 le motif des vanneaux est nettement antérieur à la gravure de 1862.

25. 15 février 1863, p. 128. Voir encore les commentaires de P.G. Hamerton dans
 "Modern Etching in France," dans *The Fine Arts Quarterly Review*, vol. II, janvier-
 mai 1864, p. 103, puis dans *Etchings and Etchers*, 3ème édition, Londres, 1880, p.
 195, où il critique le "Japonisme" de la gravure.

26. Première planche de la première livraison, le 1er septembre 1862; la gravure avait
 été déposée le 5 juillet précédent.

27. Par exemple dans le "Carnet 16," utilisé entre 1849 et 1857, et qui présente de

nombreux croquis de canards dont certains, marqués d'une croix, seront repris dans des eaux-fortes postérieures.

28. Pour ce motif, Anne Coffin Hanson a bien noté la référence à la *Manga* (volume 1) dans *The Art Bulletin*, puis, dans son livre *Manet and the Modern Tradition*, New Haven, 1977, p. 186 et fig. 116, mais les relations étroites entre les deux artistes rendent vraisemblable le passage par la gravure ou le *Service Rousseau* de Bracquemond.

29. Dans la *Gazette des Beaux-Arts*, ler février 1863, p. 190. Dans son texte de 1864 cité ci-dessus à la note 25 P.G. Hamerton trouve pour sa part que les plantes aquatiques sont "rendered in a firm effective way, but with little of the mystery of real plants."

30. Par exemple par Lostalot dans la *Gazette des Beaux-Arts* du ler août 1884, p. 161. Huysmans, dans son compte-rendu de l'exposition "impressionniste" de 1880 (repris dans *L'Art Moderne*, 1883, p. 111) a parlé, à propos du n° 5, d'une "série d'eaux-fortes sur Chine destinées à orner un service de table, curieuses, il est vrai, mais presque absolument tirées des albums d'Okou-Saï," mais à cette date il s'agit plus vraisemblablement des planches pour les services "parisiens" et "grand feu" de la fin des années 1870. Gabriel P. Weisberg et Ikegami Chūji ont entrepris simultanément, à partir de 1969, d'identifier les motifs japonais utilisés dans le *Service Rousseau* (articles cités dans *Japonisme*).

31. Dans *Japonisme*, pp. 141–143 et n° 194 et 195.

32. Bracquemond, par une marche à rebours dont il est très vraisemblablement inconscient, en revient ainsi à un espace figuratif "pré-classique": celui des compositions en frise ou à "plate forme" de l'Italie de la seconde moitié du quinzième siècle—du *Saint-Sébastien* de Pollaiuolo par exemple (1475), pour ne citer qu'un exemple très connu dans l'histoire de la perspective. D'une façon générale, le retour aux "primitifs," comme on sait, est aussi à interpréter en ce sens.

33. Ac 19 et 20 (B. 141 et 142). Une épreuve retouchée du premier état de la première planche (British Museum) montre que Bracquemond a cherché en vain une solution pour la représentation d'un espace classique ouvert.

34. B. 224 et 225; commencées en 1882, les deux gravures ont été publiées dans un même cahier en 1887.

35. *Etude sur la gravure sur bois et la lithographie*, Paris, 1897, p. 29; une réédition anthologique de ces textes est en préparation.

36. Ac 3 (B. 112).

37. Ac 7 (B. 134). Il faudrait aussi mentionner l'utilisation de l'aquatinte *en aplat* à partir de 1856 environ, notamment dans une copie de "chats du Japon" d'après Hokusai (B. 166), non retrouvée jusqu'à présent. Ce point est traité dans JPB. 1979, p. 1030.

38. The Baltimore Museum of Art, et New York Public Library.

39. Carnet 3, n° 84, dans le catalogue JPB. 1979.

40. La région de Villers-Cotterêts.

41. Ac 22 (B. 116). Déposée quelques jours auparavant, la planche a été publiée dans *L'Artiste* du 7 septembre 1856.

42. Ce débordement du motif sur le cadre qu'on trouve naturellement chez d'autres artistes et à d'autres époques, mériterait assurément une étude comparative. Chez Bracquemond, il apparaît exactement au même moment dans les illustrations pour les *Chansons* de Desforges de Vassens (Af 20 et 21, B. 357 et 358). On en trouvera le rappel dans les *Hirondelles* des années 1880 mentionnées plus haut.

43. A. Ravizé, *Comptines et formulettes*, Paris, 1965, p. 42 (avec les mêmes paroles, mais un autre air que celui noté par Bracquemond).

44. Af 40 (B. 374): titre pour les *Amis de la Nature* de Champfleury, gravé d'après un dessin de Courbet—œuvre curieuse et peu commentée sur laquelle il y a beaucoup à dire; et B. 375, frontispice d'après Morin pour les *Chansons populaires* . . . , recueil auquel Courbet participe, et dont Champfleury rédige les notices.

45. "Les Estampes modernes de la Collection des Goncourt," vente des 30 avril et 1er mai 1897, Paris, Hôtel Drouot, pp. 5–6.

46. Voir ci-dessous note 52.

47. Carnet 9, n° 22, dans le catalogue JPB. 1979.

48. *Du Dessin et de la Couleur*, Paris, 1885, p. 116.

49. Dans JPB. 1979, passim.

50. Carnet 13, n° 19 et 21, dans le catalogue JPB. 1979.

51. "Les Idées de Bracquemond," six chapitres dactylographiés, rédigés sans doute au début des années 1920, et dont le chapitre IV, "Une visite de Félix Bracquemond à Gaston La Touche," a été publié dans la *Gazette des Beaux-Arts*, mars 1970, pp. 161–77.

52. Ce texte, comme les suivants, se trouve dans le chapitre 1, "La leçon de dessin, le Modelé dans l'atelier." On peut encore citer cet extrait du passage qui précède immédiatement celui-ci et où il est question des artistes japonais: "Certes, je les aime, je raffole de leur art, j'ai été l'un des premiers avec Goncourt et Burty à posséder les quelques albums qui ont d'abord été introduits en France, nous nous sommes précipités dessus (. . .). Ils représentent toutes les formes par un trait, le plus souvent égal à lui-même dans toutes ses parties. Ils imposent à toutes les expressions, à tous les caractères, de se réduire à l'abstraction subtile d'un trait, et par ce moyen peu naturel (. . .) ils arrivent à une puissance d'exposition aussi complète et émotionnante que nos artistes les plus vénérés. Mais lorsque je vous ai dit: l'Art emploie des moyens conventionnels pour représenter la nature, nous nous trouvons avec les Chinois et les Japonais devant le procédé conventionnel le plus tyrannique de tous. Eliminer l'ombre, la lumière, les plans, le modelé, en un mot ne se servir que d'un trait pour poursuivre les formes dans leur inflexion, voilà certes une convention. Les Chinois et les Japonais ont fait ainsi des chefs-d'œuvre; le résultat légitime leur moyen."

53. On pourra rapprocher ce commentaire de l'un des plus pertinents de ceux de Francastel, dans l'ouvrage cité ci-dessus à la note 8, à propos du dessin de Degas et de celui des Japonais (éd. 1974, p. 105).

54. Ibid., p. 17. Bracquemond distingue à cet endroit deux significations voisines mais distinctes du mot valeur: "J'ai commencé par appeler valeur une partie de modelé par rapport à une autre partie, élément que l'on pourrait représenter par un chiffre si l'on se servait comme instrument de rapport et de mesure d'une règle dégradée au lavis du noir au blanc, et divisée ainsi qu'un mètre. J'emploie le même mot maintenant dans un sens plus général: je vous parle de la valeur d'un ensemble par rapport à un autre qui l'approche ou lui sert de fond. C'est la même idée certes, mais plus étendue, ainsi l'on dit la valeur d'une maison, d'une figure toute entière par rapport à la masse d'arbres sur laquelle elle se détache, de la valeur de ce fond de verdure lui-même sur le lointain du paysage qui se trouve derrière elle."

55. Ibid., p. 18.

56. Voir analyse et références dans JPB. 1978, et l'étude de Jean Laude citée à la note 2 de ce texte, qui, dans la ligne de Francastel, fait à ce sujet des suggestions décisives (par exemple p. 99: "les signe ou les systèmes de signes qui ont été empruntés —et dès le moment où ils ont été empruntés—réappartiennent plus à leur culture d'origine: ils sont naturalisés, mais comme signes différentiels référant à une image de ce à quoi ils ont été empruntés.")

57. Dessins provenant de la New York Public Library pour le troisième et de deux collections particulières, Paris:
a) feuille h. 30.5 × 47.3 cm, projet pour "Le Ruisseau," assiette de 26 cm de diamètre environ, qui donnera lieu ensuite à une gravure (B. 558), dans une série de six pièces commentée ainsi par Clément-Janin: "Tout y est, y compris cet aspect un peu dansant que prennent les dessins japonais à nos yeux inhabitués

d'occidentaux'' (*L'Estampe et l'Affiche*, 15 avril 1897, p. 49). Mais la série comporte aussi deux motifs typiquement parisiens: une rue sous la pluie, et une vue de Notre Dame (B. 557 et B. 560) . . .

b) feuille h. 32×37 cm, projet d'assiette de 24.5 cm de diamètre, à rapprocher peut-être du suivant (il existe une variante).

c) feuille h. 28.3×27.1 cm, projet pour le "Soleil couchant," assiette du *Service parisien* de 1875, exposé en 1876 (24.2 cm de diamètre), avec un tirage de l'assiette correspondante.

d) feuille h. 44×37.8 cm, avec six motifs de vase.

58. Voir le catalogue de l'exposition *Céramique impressionniste*, Paris, 1974, n° 93 (repr.) et reproduction en couleurs dans *Plaisir de France*, n° 401, juillet-août 1972, p. 47.

59. Ibid., n° 88 (repr.) et introduction de ce catalogue "Bracquemond impressionniste" (non paginée); il existe un dessin préparatoire, avec quelques variantes (coll. part., Paris).

60. Ibid., note 17 de l'introduction, citant des phrases de la brochure *A propos des Manufactures nationales de céramique et de tapisserie*, Paris, 1891.

PHILIPPE BURTY AND A CRITICAL ASSESSMENT
OF EARLY "JAPONISME"

Gabriel P. Weisberg

Though Philippe Burty's name as a student and early connoisseur of Japanese culture and art has been partially obscured by the fame of others such as Edmond de Goncourt, Louis Gonse, S. Bing or Henri Vever, during the nineteenth century Burty (Figs. 1 and 2) did as much as these well-known individuals to bring Japanese art and culture to the attention of the general public.[1] He was among the first to recognize the importance of *ukiyo-e* prints and decorative art; Burty brought these novel discoveries to light through published newspaper articles and small pamphlets such as *Les Emaux cloisonnés anciens et modernes* first published in 1868.[2] In effect, Burty became a popularizer for the movement he called

Fig. 1. Photograph of Philippe Burty, ca. 1860s. Private Collection, France.

Fig. 2. Photograph of Philippe Burty, ca. 1870s. Private Collection, France.

"Japonisme" and in *Les Emaux cloisonnés anciens et modernes* he provided a brief historical survey of the evolution of cloisonné enamel which showed the significance of this art form for French industrial decorators. This text also became important for another reason: it was an early attempt to understand Japanese art from an aesthetic standpoint.[3]

In the latter part of *Les Emaux cloisonnés anciens et modernes*, Burty advanced reasons why there was an increasing appreciation and acquisition of *ukiyo-e* prints and albums. In quoting an ironic phrase from La Bruyère who said Japanese artists saw themselves as having " . . . a pure language . . . highly developed mores, beautiful laws but . . . (were) Barbarians for some people" Burty indicated one way in which Westerners saw Japan in the decade after the country had been opened to foreigners.[4] In contrast to this point of view, Burty found France to be the country that was crude and coarse; Japan remained in his mind an uncorrupted paradise, a utopian haven and a realm of timeless beauty. As the critic compared Western pretensions and commercialism with Japan he created a mystique which was essential for the promulgation of "Japonisme." During the late 1860s, as more of Burty's writings were published, he stepped to the forefront of this new movement championing Japan over the course of the next twenty years.

<h1 style="text-align:center">I</h1>

As a powerful and influential art critic Burty wrote for a number of the leading reviews and journals during the 1860s. These included the *Gazette des Beaux-Arts*, *La Presse*, *La Liberté* and *Le Rappel*.[5] Fascinated by many aspects of modernism Burty advocated a renaissance in printmaking, a revival in the decorative arts and the liberalization of the Salons. He was widely read and respected not only by avant-garde painters such as Edouard Manet, with whom Burty was an exceptionally close friend, but he was also an advocate of realism supporting somewhat more conservative painters as François Bonvin, Jean Charles Cazin and Léon Lhermitte.[6] Aside from a continuous support of friends, and his advocacy of change, Burty disliked seeing the Salons controlled by representatives of the Ecole des Beaux-Arts. He maintained his independence in areas outside painting, becoming an avid collector of contemporary prints; and by the mid-1860s, he had also begun to formulate his large collection of Japanese art.[7] The latter collection he opened to a number of his friends from Félix Bracquemond and Edgar Degas to the de Goncourts. In this way, perhaps more so than in his published articles, Burty inculcated an appreciation for Japanese art among artists and writers. His collection provided new ideas and a sense of direction for advanced French creativity.

Burty's early advocacy of Japanese art led to his playing a prominent role in the organization of the secret society of the Jing-lar which met in the decorative designer M. L. Solon's house at Sèvres in 1867/68. Here Burty, and his companions—Félix Bracquemond and the art critic Zacharie Astruc among others—discussed Japanese art and culture.[8] The setting for the club parodied the elaborate entertainments of the Second Empire. Burty's methods of learning about Japan were both simple and practical. He believed that one could learn about

Japanese life by studying the pages of print albums for it was here he thought that the customs, history, mythology and literature of the country were revealed.[9] By scouring small shops along the Seine, by visiting tea houses such as La Porte Chinoise, or by finding albums in Parisian department stores Burty increased both the scope of his collection and his knowledge of Japan.[10] But this was not the only way in which the critic studied the country. As "Japonisme" matured Burty read all the publications he could find on Japanese literature, culture and history which had been published in the West. Thus, while the *ukiyo-e* prints piqued his curiosity, it was Burty's own scholarly inclinations which drove him to study Japan on a deeper level establishing a library that equaled the art work he collected.[11]

II

With this as background it is essential to return to *Les Emaux cloisonnés anciens et modernes* to examine how Burty formulated an analysis of Japanese art by applying it to Western theories and concepts. If Burty was not alone in attempting to decipher the intricacies and beauty of Japanese art during the 1860s—Zacharie Astruc and Ernest Chesneau also wrote informational articles—he was among the first to undertake systematically the difficult task of trying to understand how Japanese art could be related to established French traditions.[12] Since little was known about the history and evolution of Japanese art in the late 1860s, and Burty had been confronted with objects pulled out of context and which had no written history available in the West, it was a challenge to make these novel images comprehensible. Thus, the explanation of Japanese art (essentially *ukiyo-e* prints) became a serious matter as art critics tried to relate these examples to their own culture and background. Burty's clarity of writing greatly assisted him in making his ideas vividly attractive. According to the critic, the Japanese tried to eliminate a stiffness or artificiality from their art by " . . . breaking the dependence on the straight line and by using many angles and curves."[13] By contrasting Japanese art with the West Burty wrote further on that

> . . . in the creation of compositions (Japanese art) rejects the symmetry of parallel lines; it always uses imperfect quantities such as three, five, seven; this is contrasted with us where we (in the West) proceed by two, four, eight.[14]

In this statement, written before Burty became an active proponent of Impressionism in 1874, he saw Japanese art as a force by which it would be possible to break the dominance of traditional academic balance and compositional arrangement. By showing that the Japanese relied on the use of "irregularity" he underlined that they organized their images, and their decorative details, in an asymmetrical way. Whether this was completely true of Japanese art or not, Burty had seized on one way in which he could make Japanese art understandable and useful for younger artists. In the process, Burty also recognized that it was essential that he find a predecessor in the French tradition who did similar things—his search for a model led him directly to Eugène Delacroix, Burty's idol among European artists, whose reliance on variety and irregularity had been

one of the hallmarks of his romantic aesthetic. Therefore, Burty's appreciation and understanding of Japanese art (as well as Japanese culture) was affected by his inbred French romanticism. Japan cannot only be seen as a model for literal realism but as another example of romanticism in the nineteenth-century's quest for a novel, exotic, mysterious realm. Burty underscored this association as he linked Delacroix with Japanese art in *Les Emaux cloisonnés anciens et modernes*.

Burty's dedication to the memory of Delacroix remained one of the critic's life-long passions: he was the first to publish Delacroix's letters in the late 1870s.[15] It was no wonder then that, in the late 1860s, just a few years after Delacroix's death the painter was still regarded as the leader of a new generation of roman-tics. As noted, Delacroix's theories were especially important to Burty since he had to find a model to which he could pin his understanding of both Japanese art and the continuation of romantic aesthetic theory. Copying sentences from Delacroix's notebooks Burty stressed that the painter had utilized the same sense of creativity as the Japanese, had held the same aesthetic principles when he had written " . . . there are certain lines which are monstrous: the straight line, the regular line and especially parallel lines."[16] In the heated atmosphere of the 1860s, when modernism was emerging in café discussions, Burty had found a parallel in Eastern and Western art which he attempted to clarify for artists and the general public. He recognized that if genius was to be achieved in art—a quality the Japanese had found and something the Romantics advocated—then it was necessary to follow an aesthetic of asymmetry and change.[17] If *Les Emaux cloisonnés anciens et modernes* cannot be seen as a call to change on the part of the perceptive critic it did give Burty an opportunity to present a way of seeing Japanese art in a context that was stimulating and new. To underline this im-portance Burty wrote that " . . . the Japanese, more than any other people, have found the secret of absolute charm in the irregular. . . ."[18]

Burty's reliance on romantic aesthetic theory when investigating Japanese art is important since it gives us clues about the way other art critics, and by asso-ciation painters and decorative designers, looked at and understood an art that was essentially mysterious. It explains how critics who were linked to the avant-garde (as Burty was later to be linked with Impressionism)[19] had the foresight to see the importance of an art expression which they felt should be studied and assimilated by French artists who hoped to transform and renew French crea-tivity.

III

The Far Eastern Exhibition of 1869

If Burty's advocacy of Japanese art had been solely limited to his discussion in *Les Emaux cloisonnés anciens et modernes*—a small volume quickly forgotten—his place in the evolution of "Japonisme" would not have been as significant as it became. Burty clearly recognized that in order to explain his theories about Japanese art and romanticism it was essential for him to obtain as many sup-porting examples as he could find. In this way it was possible for him to test his theories and to instruct his friends in the differing aspects of Japanese creativity. As already mentioned, by the end of the 1860s, Burty (along with others such

as the de Goncourts, Félix Bracquemond and Ernest Chesneau) had become a collector of Japanese art. But, for him, more than for many of the other enthusiasts, collecting Japanese art objects became a veritable mania which consumed much of Burty's time; his house became a storage area of Japanese art which threatened to consume the occupants and undermine Burty's marriage. By 1869, with his collection rapidly growing, Burty's friends encouraged him to send a number of his best Japanese examples to an exhibition at the *Union centrale* in Paris.[20] When this large show, housed in seven rooms and a grand Salon, opened in 1869, the oriental section was dubbed by the critics and officials as "le Musée oriental" since it showed a variety of objects from China, India, Persia, and, importantly, from Japan; next to it was the industrial arts section showing current work done by artists in France. Coming only two years after the 1867 Paris World's Fair—where Japanese art had been introduced officially to Parisians—the Musée oriental was, in effect, a more prestigious collection of objects since many of the works were owned by Parisian collectors.[21] Overlooked by art historians, this exhibition accelerated the appreciation and use of Japanese (and other exotic) motifs in French decorative arts providing a considerable opportunity for French industrialists to see how Oriental motifs could be further adopted in all aspects of French design.[22]

This exhibition also provoked a certain amount of antagonism in the press. In opposition to Burty, and others, was Edmond Duranty a recent advocate of the Realists and a critic who would unite with Burty in support of the Impressionists. If Duranty was impressed by the amount of Japanese art that was now available in Paris, he was also extremely fearful of its affect on French artistic creativity. Duranty correctly saw that an "Ecole japonaise" existed in France but he saw Hindu, Chinese and Japanese art as anachronistic.[23] Duranty found Japanese art too decorative, too ornamental, noting that it was not the direction to be taken by French industrial art or artists. He firmly believed that if artists continued studying Japanese art they would fall into idle erudition and into the "magasin de bric-à-brac" and he denounced Japanese art as something fit only for dilettantes. This was extremely harsh criticism in 1869 as it demonstrated that there were two opposing camps being formed: one, where critics saw Japanese art as a threat because it might lead artists to commercial ends (e.g. the decorative arts) and the other, those who championed Japanese art as providing a new sense of freedom, a chance to break away from stultifying traditions, a means of lightening one's palette and seeing the world from a variety of new viewpoints. To a degree, Burty's articles in 1869 and a small pamphlet written by Burty's friend Chesneau—entitled *L'Art Japonais* (1869)—as well as Burty's collection, were diametrically opposed to Duranty's position and in effect answered Duranty's negative criticism. Indeed, much that Burty wrote at this time, along with his avid acquisition of objects, must be regarded as justification not only for his own love of Japan but also for his acceptance as the leader of "Japonisme" in France.

Burty's first journalistic articles on the importance of Japanese art and its influence on French decorative motifs appeared in *Le Rappel* (late in 1869) under the title "Le Musée oriental à l'Union centrale." Seizing the opportunity, Burty was concerned that a museum for continuous study of Oriental art be established.

He wrote:

> The project for an oriental museum is one of the best which can come
> from private initiative since the influence of (oriental art) is already apparent
> in the general education of artists and public. . . . [24]

Burty and many of his fellow Japanese art enthusiasts sent art works to the
exhibition documenting that collectors such as Frédéric Villot (of the Louvre)
and Ernest Chesneau (one of Burty's fellow art critics) had objects important
enough to be publicly displayed.[25] Like Chesneau, Burty was placed in the
delicate position of commenting on his own works in a review for *Le Rappel* as
he had sent print albums by Hokusai along with lacquers and bronzes to the
exhibition. Unfortunately, no accurate listing exists (outside of a small cursory
catalogue) which can provide information on the quality of the objects shown
or what periods in Japanese art were actually represented. Since photographs
of the 1869 exhibition were apparently not taken, it has proven difficult to
establish specific objects shown or to assess whether or not the objects owned by
Parisian collectors were authentic and representative of a variety of periods of
Japanese art.

If Burty was impressed by the bronzes and enamels in the *Union centrale* he also
used this opportunity to emphasize how important Japanese motifs and design
were becoming for a wide range of French industrial designers. At this moment
in time, Burty emerged as one of the few art critics to champion the use of Jap-
anese motifs in the decorative arts writing that " . . . in sum, this exhibition . . .
is of the highest interest. Parisian ceramists come every day. The Sèvres Manu-
factory has sent two of its best designers to do drawings from the objects. Yes-
terday, one of the principal industrialists from Limoges arrived to study the
series of objects which will never again be brought together. He spoke with
enthusiasm for ideas and projects . . . " to be developed from these models.[26]
Whether this visitor to the *Union centrale* was indeed Charles Haviland—soon to
become Burty's son-in-law through marriage to Madeleine Burty (Figs. 3 and 4)
—remains conjectural.[27] What is important is that both Sèvres and Limoges,
the centers of French porcelain and ceramic manufacturing, had recognized
that the time had come for them to initiate designs based on Japanese motifs
and to meet a growing market sponsored by bourgeois materialism.[28] The success
of the Rousseau-Bracquemond ceramic service of 1867, and Burty's enthusiastic
support of this innovative table service in the press, had convinced manufac-
turers that the taste for things Japanese could be utilized to their advantage.[29]
Thus, the "Ecole japonaise" which Duranty had derisively noted in his writings
and which Burty had specifically examined as existing when he commented on
the decorative art of Bracquemond, Barbedienne, Christofle & Co., or Eugène
Rousseau was to receive added support as numerous decorative designers used
Japanese motifs within a few months. "Japonisme" had fully arrived prior to the
Franco-Prussian War; money could be made by meeting the demands of the
nouveau riche for novelty and romanticism.

In a third article for *Le Rappel*, Burty singled out one Japanese printmaker
for special recognition and attention—Hokusai.[30] Burty's advocacy of Hokusai

as one of the greatest of Japanese artists had occurred almost simultaneously with Félix Bracquemond's use of motifs from his own Hokusai albums in his well-known ceramic table service completed in time for the Paris Fair of 1867.[31] But Burty's examination of Hokusai, stimulated by the fact that he owned or knew several albums from Hokusai's *Manga* and by Hokusai's pupils, led the critic to see Hokusai as having "the same strength as Daumier combined with a genius for observation that was truly subtle and an imagination that was truly poetique."[32] This was exceptionally high praise for any Japanese artist in 1869. When seen in light of Duranty's attack on all Japanese art as being suitable only for dilettantes, it must also be seen as quite courageous.

If Burty's articles in *Le Rappel* were widely read at the time, Ernest Chesneau's articles in *Le Constitutionnel* beginning in 1868 and continuing in 1869 and his pamphlet on *L'Art Japonais* were equally well-known.[33] Chesneau was continually impressed by the inventiveness of Japanese designers and the imaginative effects found in all their works; he also had been deeply struck by the quality of the drawings of Oksai (Hokusai) whom he saw as one of the major Japanese artists for the West to study. Chesneau was drawn to the harmony implicit in Japanese works of art where " . . . the shape of the object was in perfect rela-

Fig. 3. Photograph of Madeleine Burty Haviland. Private Collection, France.

Fig. 4. Photograph of Charles Haviland. Private Collection, France.

tionship to its use.''[34] In his pamphlet *L'Art Japonais*, also published at the time of the *Union centrale* 1869 exhibition, Chesneau went on to point out how the clarity of Japanese design and the use of asymmetry were significant to Western designers.[35] When these were combined with the delicacy of Japanese color and style and the perfection of working in many materials, he hoped—like Burty——that French artists and craftsmen would study Japanese art seriously and continuously.

But in spite of Chesneau's support of Japanese art it was Burty who was seen as the major spokesman for the new art.[36] If this did not endear him to Chesneau, Burty had emerged as the champion of Japonisme through his close association with all types of artists and through his ability to amass a collection which soon became a meeting place for many. By 1870 Burty was fully identified with Japonisme in the minds of many Parisians.

THE "JAPONISME" ARTICLES
Remaining in Paris during the disastrous days of the Franco-Prussian War and the commune, Burty found time to absorb himself in his leading passion. It was not long before he began signing letters and writing inscriptions in books with the word—*Japoniste*—after his name.[37] The distinctive name coined for the entire movement—Japonisme—was used by Burty for the first time in 1872. He wrote in the English periodical *The Academy* in 1875 that

> The study of the art and genius of Japan, what is called here *le Japonisme*, makes marked progress in France. I am very proud of it because if I did not give the first impulse to the study, I at least originated the word for it. The word *Japonisme* was written for the first time in a young journal of literature and poetry. . . . [38]

This journal was *La Renaissance littéraire et artistique* where, in May 1872, Burty wrote his first article on "Japonisme." Burty's original goal had been to attract " . . . public attention to Japan." The critic began examining many different customs of the country, from macabre death customs to the ways in which Japanese art and culture were being appreciated in Paris. In his second article on "Japonisme" Burty stressed the way in which Japanese was being taught at the Collège de France in the class of Léon de Rosny, writing amusingly about himself not managing to keep awake while the course was being conducted.[39]

Criticism of Japanese art continued and in 1875, again in answer to negative comment, Burty wrote " . . . all is singular and delicious in this country and this race: the poetry, the brevity of which contains treasures of delicacy concealed under heaps of allusions; the history . . . ; the painting, which is brilliant; the sculpture, which is full of fine observation and delicacy; the art of working metals and that of manufacturing china, which have been carried to the highest point of perfection. . . . All this is worth considering."[40] This strong support of Japanese art was not lost on Burty's friends in the decorative arts and in the Impressionist camp especially since in 1874 Burty had staunchly supported Impressionism in reviews for *La République française* and the English journal, *The Academy*.[41]

Throughout the 1870s Burty increased the pace of his reporting on the craze for "Japonisme."[42] Articles appeared twice a week on all aspects of the current interest: the taste for new books, translations of Japanese poetry, art works, the formation of the Congress of Orientalists, the burgeoning interest in Japanese decorative art and the importance of the Paris World's Fair of 1878 in bringing a larger variety of Japanese art works to the attention of the Parisian public. Burty not only wrote from a theoretical standpoint as he had done in 1868; now, with the Japanese section of the Paris Fair of 1878 far surpassing what had been shown in 1867, he tried to reveal all aspects of the sociological phenomenon that was sweeping France.[43]

Burty's articles in *La République française* and *L'Art* extolled the Japanese pavilion in 1878. The critic singled out the men who had done the work, naming M. Maeda and Hayashi Tadamasa as being instrumental in raising France's knowledge of all periods of Japanese art.[44] In other articles, Burty discussed the interrelationship between art and industry declaring both to be a triumph. Many of the ceramics on display had been donated by French Japonistes including Burty and his new friend, the art dealer S. Bing. The latter, who was just beginning to establish himself as one of the foremost art dealers in Japanese art objects, had not yet made a trip to Japan—this was to occur only in the 1880s.[45] His shops in Paris had, however, received a wide range of objects from the Far East supplied by many of Bing's relatives. Burty was one of Bing's best clients frequently going to his store to purchase objects for his own collection. Burty appreciated what Bing was doing for the promotion of things Japanese and, in his review on the 1878 Fair, wrote that " . . . M. Bing has exhibited an entire vitrine where one's eye can rejoice in the variety and quality of the enamels"[46] exhibited. Since there was no general catalogue published of the works exhibited by the different Parisian collectors, it is difficult to arrive at a complete picture of the extent and richness of the display. The only way to grasp the high level of quality is to read the reviews of both Burty and Chesneau who once again found themselves competing with each other in their advocacy of Japanese art and culture.

Following the close of the Paris Fair (1878), Burty continued to write other articles on new developments in the movement. One of these was the publication, in 1879, of Thomas Cutler's *A Grammar of Japanese Ornament and Design* which brought together—in sixty plates—numerous motifs for industrial designers. Published as a type of easy-access pattern book, Burty identified the book suggesting that it would help rejuvenate designers working in textiles, ceramic, glass, and wallpaper.[47] Reiterating one of his earlier themes he saw the book as a tool to combat the sterility of official teaching which still relied on decorative motifs from the past instead of reflecting current interests and passions.

By 1883, Burty found himself engaged in still another activity for the promulgation and promotion of Japanese art. Louis Gonse's exhibition of all forms of Japanese art, held in April 1883, was one of the most impressive private shows ever held for the benefit of furthering awareness of Japanese art in France.[48] The exhibition was supported by a number of the leading French collectors and again Burty found himself coupled with S. Bing as he lent bronzes, swordguards, and lacquers from his collection to Gonse's show. Among the collectors who

eagerly lent Japanese print albums was still another influential art critic—
Théodore Duret, whose early support of Impressionism had been appreciated
by the avant-garde painters, but whose Japanese print albums were among
the finest in Paris. Duret's print albums—which he later donated to the Biblio-
thèque Nationale—became as important for French artists as Burty's collection
was, as both men may have vied with each other in considering their albums as
top-quality.[49] Importantly, Duret's collection had been formed after his trip to
Japan in 1875 and Burty's had only been formulated through the art critic's
perspicacity and zeal for finding objects once they had reached France.[50] Burty
avidly promoted the 1883 exhibition in a review for *La République française*; he
also praised Gonse's volume *L'Art Japonais* at a time when other critics chose
to attack the author on the grounds that he had assessed Japanese art and devel-
oped artistic periods on a purely intuitive basis.[51] Objects from Burty's own col-
lection were etched by Félix Buhot for a series on Japonisme ca. 1883. Thus they
became well appreciated and known through another means.[52]

Because of Burty's wholehearted endorsement of Japonisme and his continuous
ardent support of exhibitions, a number of Burty's friends advocated the award
to him of an honor from the Japanese Legation in France. In February 1884,
Burty was presented with the Order of the Empire of the Rising Sun—a singular
honor for the critic since it had gone to him without his ever having been able to
go to Japan to see the country or the art work in its native habitat (Figs. 5 and
6).[53] Everything he had learned about Japanese art Burty had secured in a
practical way: by studying on his own, in discussions with scholars and travelers
to Japan, and by closely scrutinizing the art works themselves. The medal was
accompanied by a diploma in Japanese that was translated by both Burty and
the Japanese legation as it noted that Burty was being given this rare award
because of the high esteem in which he was held by the Japanese. Burty was
also awarded a second medal by the Japanese although its name and the date
of the award have not been located. These decorations and the fact that he had

Fig. 5. Medal awarded by
Japanese to Philippe Burty.
Private Collection, France.

Fig. 6. Diploma given to Philippe Burty at the
time he was awarded medal by Japan. Private
Collection, France.

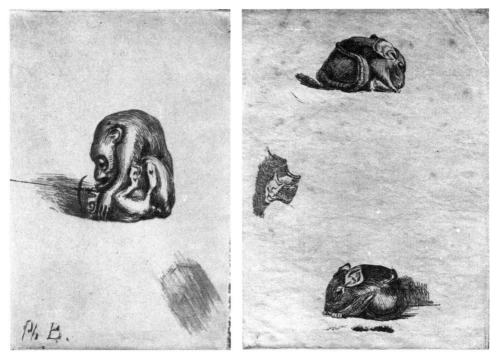

Fig. 7. Philippe Burty, Etching of Japanese netsuke, undated. Private Collection, France.

Fig. 8. Philippe Burty, Etching of mask and Japanese netsuke, August, 1873. Private Collection, France.

been awarded the Légion d'honneur (1879) because of his support of Japanese art—among other reasons—made the critic one of the most honored Frenchmen to promote and promulgate "Japonisme."[54]

THE ART COLLECTION

At the same time as Burty's published reviews were educating the French public about Japonisme, his private collection was growing in size and importance. Since 1869 when Burty had shown pieces at the *Union centrale,* he had contributed to every major exhibition of Japanese art held in France. Examples from his collection had been etched by Félix Buhot and reproduced in Gonse's *L'Art Japonais.* Burty had also been eager to give examples from his collection to fellow Japonistes as a way of expressing gratitude and friendship (Figs. 7–8). However, aside from the summary catalogue published at the time Burty's collection was auctioned by S. Bing in 1891 and the few etchings that Burty did of objects in his collection, there is no accurate record of the actual objects he owned.[55] Few objects were photographed; only a few pieces such as these swordguards, sheaths, or other metalwork examples, have been traced to current collections (Figs. 9–13) or museums making it very difficult to assess the quality of Burty's connoisseurship or to see whether the objects he collected were really from the periods he thought they came from.[56] Judging from the way in which other collections of the time were formulated, Burty's collection may have been filled with secondary objects although in the case of bronzes, lacquers, and some small objects and prints he most likely collected works of aesthetic quality and historical importance.

Fig. 9. Sword sheaths from Philippe Burty's collection. Courtesy, Musée des Arts Décoratifs, Paris.

Fig. 10. Sword guards from Philippe Burty's collection. Courtesy, Musée des Arts Décoratifs, Paris.

Fig. 11. Sword guards from Philippe Burty's collection. Courtesy, Musée des Arts Décoratifs, Paris.

On the other hand, there can be little doubt that Burty's art collection provided considerable delight both to himself and to other collectors such as Edmond de Goncourt. His persistent negotiations with a number of the leading art dealers of the day from Auguste Sichel to S. Bing reflected the seriousness of his passion and eventually led to extensive personal debts. Friendly with writers, such as Emile Zola, and many artists, Burty's art collection was open to all who asked to see it as his gregarious, friendly nature helped make a visit to his collection a memorable experience. In the final analysis Japonisme may have gained more through Burty's advocacy than it is possible to document since his compassionate discussions with artists must have led many of them to see how Japanese art could help them in their own work. Without a diary and a record of whom Burty knew intimately or an accurate reconstruction of his collection and those of many others, it is only possible to note—because of the importance he occupied in the movement—that he and his friend S. Bing were significant figures in the promulgation of Japonisme in France. When Burty died in 1890, the Japonisme movement had lost one of its most avid, gregarious spokesmen, whose accurate position in the movement still awaits further clarification and documentation.

Fig. 12. Japanese bronzes from Philippe Burty's collection. Courtesy, Musée des Arts Décoratifs, Paris.

Fig. 13. Japanese objects owned by Philippe Burty. Courtesy, Musée des Arts Décoratifs, Paris.

NOTES

1. Burty can be seen as a collector, whose objects were available to many for study, and a popularizer whose articles in the press promoted the taste for things Japanese. These articles began appearing in the 1860s and continued into the 1880s and were found in such periodicals as *Le Rappel* and *La République française*. Considerable work needs to be done to establish the scope and quality of the early collections of Japanese art formed in France. Catalogues were originally published on a number of these collections but they were incomplete in their listing of objects and they reproduced only a few examples from the works originally owned by either the de Goncourts, Gonse, Bing or Vever.

2. For further reference see Philippe Burty, *Les Emaux cloisonnés anciens et modernes*, Paris, 1868.

3. Japonisme studies have been hampered by a lack of examination of reasons why Japanese art was appreciated and used in England and France. Considerable work should be done on the theoretical aspects of the movement. For a start in this direction see David John Bromfield, *The Art of Japan in Later Nineteenth Century Europe, Problems of Art Criticism and Theory*, unpublished Ph.D. dissertation, The University of Leeds, Department of Fine Art, February, 1977. The author is indebted to Professor T. J. Clark for calling this work to his attention.

4. Burty, *Les Emaux*, p. 72.

5. Burty's reviews have never been republished. They provide an accurate barometer of a Parisian tastemaker during crucial decades for the development of modern painting and the taste for Japonisme. For an introduction to Burty's career see Gabriel P. Weisberg, *The Early Years of Philippe Burty: Art Critic, Amateur and Japoniste, 1855–1875*, unpublished Ph.D. dissertation, The Johns Hopkins University, 1967.

6. Burty wrote about Cazin and Lhermitte in *La République française* when these painters exhibited work at the Salons. Bonvin was an earlier interest, as Burty wrote about this important early realist in *Le Rappel*.

7. For further information see *Collection Ph. Burty, Catalogue de peintures et d'estampes japonaises, de kakemonos, de miniatures indopersanes et de livres relatifs à l'Orient et au Japon*, Paris, 1891 (introduction by Ernest Leroux); and *Collection Ph. Burty, Catalogue objets d'art japonais et chinois* (introduction by S. Bing), 23 to 28 March, Paris, 1891.

8. For further information on the Jing-lar society see Gabriel P. Weisberg, "Japonisme: Early Sources and the French Printmaker, 1854–1882," in *Japonisme: Japanese Influence on French Art*, Cleveland Museum of Art, 1975, pp. 1–10, and Jean-Paul Bouillon, " 'A Gauche': Note sur la Société du Jing-lar et sa signification (avec lettres de Solon à Bracquemond)," *Gazette des Beaux-Arts*, March, 1978, vol. XCI, pp. 107–118. Debate is being formulated on the importance of this society in the dissemination of Japanese art and the seriousness of their meetings at Sèvres. This can only be answered by continued work on the neglected members of the group: M. L. Solon, Jules Nérat, Alphonse Hirsch and Zacharie Astruc.

9. Burty, *Les Emaux*, p. 63 ff. Burty seems to have been following an ethnographic approach toward understanding Japanese art in the 1860s, combining this with native Western traditions from the classical past, the eighteenth century and the romantic generation. Ethnography was a continuation of an earlier interest in Japanese art originated by the Dutch.

10. For mention of Burty's scouring stalls and tea shops for albums see Philippe Burty, "Japonisme II," *La Renaissance littéraire et artistique*, 1872, p. 59.

11. Burty's library was extensive and contained many books by contemporary authors and volumes on the study of Japan. For a list see *La Bibliothèque de Ph. Burty* (introduction by Maurice Tourneux), Paris, 1891.

12. Burty's response to Japanese art in the 1860s was essentially that of a fashionable enthusiast, who rationalized his taste for Japanese art in terms of other interests.

His use of romanticism as one way to justify Japan mirrors the process through which Japanese art brought changes in Western painting and decorative art. Burty, like Chesneau, avoided any distinction between "fine art" and "design," aspects he detected in the art of Japan and which he urged should be utilized in France. For further reference to Chesneau see *L'Art Japonais*, Paris, 1869. Astruc is extensively discussed in Sharon Flescher, *Zacharie Astruc: Critic, Artist and Japoniste (1833–1907)*, New York: Garland Publishing Co., 1978. David Bromfield examined Burty's writings in his dissertation but failed to fully recognize the importance of Burty's way of examining Japanese art for the future of Japonisme.

13. Burty, *Les Emaux*, p. 71.

14. Ibid.

15. For further reference see Philippe Burty, *Lettres d'Eugène Delacroix*, Paris, 1878 and 1880. The support given Japonisme by staunch romantics is also found in the case of Frédéric Villot, Curator at the Louvre, whose active early interest in Japonisme needs further study.

16. Burty, *Les Emaux*, p. 69.

17. For a discussion of this aspect in art criticism see Anita Brookner, *The Genius of the Future, Studies in French Art Criticism: Diderot, Stendhal, Baudelaire, Zola, The Brothers Goncourt, Huysmans*, London, 1971.

18. Burty, *Les Emaux*, p. 69.

19. Ronald Pickvance in his study "Monet and Renoir in the Mid-1870s," (paper delivered at the Tokyo Symposium on Japonisme, December, 1979) carefully showed how Burty was "the high priest of Japonisme" as well as an advisor to certain Impressionists such as Auguste Renoir.

20. This exhibition needs further study. For further reference to the 1869 show see Yvonne Brunhammer, "L'Art Nouveau et le Japonisme," (paper delivered at the Tokyo Symposium on Japonisme, December, 1979). This exhibition should be partially reconstructed so that an idea of the quality of the art work exhibited can be grasped.

21. For reference to the objects shown see *Exposition des beaux-arts appliqués à l'industrie*, Guide du visiteur au Musée oriental, Paris, 1869 and *Catalogue du Musée oriental*, Union centrale des beaux-arts appliqués à l'industrie, Exposition de 1869, Paris, 1869.

22. The interest in Japanese industrial art objects must be seen in the context of a broad interest in decorative design which was helping change French art education. It must also be seen as part of the broader context of an oriental revival, a much larger phenomenon which saw Persian and Indian art also influencing French design as part of an extended interest in exoticism.

23. For Duranty's specific articles see *Paris Journal* for August and September, 1869. For further information see Marcel Crouzet, *Un Méconnu du réalisme: Duranty (1833–1880), l'homme, le critique, le romancier*, Paris, 1964, p. 294. Little is known, in general, about Duranty's interest in Japonisme.

24. Philippe Burty, "Le Musée à l'Union centrale," *Le Rappel*, 1869, date indecipherable.

25. *Exposition des beaux-arts appliqués à l'industrie*, Guide du visiteur au Musée oriental, Paris, 1869, p. 21.

26. Philippe Burty, "Le Musée oriental à l'Union centrale," *Le Rappel*, October 25, 1869.

27. The full relationship between Charles Haviland, Madeleine Burty and her father remains to be examined. Letters may exist which would shed light on their relationships and their interest in Japanese art.

28. The creation of numerous examples of Japonisme industrial pieces for a French market should not be discounted as one way in which the movement reached the level of a fad and craze. Money could be made in meeting the needs and taste of

bourgeois materialism; clever promoters and businessmen recognized this aspect and further advocated the taste for things Japanese on a popular, mundane level. This tendency may have stimulated the need for an accurate awareness of the higher levels of Japanese art as true connoisseurs tired of the phenomenon of faddish interest in things Japanese.

29. Further reference can be found in Philippe Burty, "Un Service en terre de Monte-reau," *La Chronique des arts et de la curiosité*, June 9, 1867, pp. 181–182.

30. Philippe Burty, "Le Musée oriental à l'Union centrale," *Le Rappel*, November 2, 1869.

31. For further reference to this service see Gabriel P. Weisberg, "Félix Bracquemond and Japanese Influence in Ceramic Decoration," *The Art Bulletin*, 51, 1969, pp. 277–280.

32. Philippe Burty, "Le Musée oriental à l'Union centrale," *Le Rappel*, November 2, 1869. Bromfield correctly noted that Burty could not locate all the volumes of Hokusai's *Manga* since he could not always identify Hokusai's style from the other Japanese printmakers then entering Paris (Bromfield, p. 253). On the other hand, the early Japonistes made no claim to be completely knowledgeàble in their grasp of Japanese prints and to denigrate Burty for his lack of careful documentation of Japanese prints in the 1860s is unfair.

33. Ernest Chesneau's early articles appeared in *Le Constitutionnel* on January 14, 22 and February 11, 1868 entitled "Beaux-Arts, l'Art Japonais." Since Chesneau knew the other collectors of Japanese art quite well and his article "Le Japon à Paris," published at the time of the 1878 exhibition in Paris, served as a basic source for further research for a number of years it would seem imperative that he was worthy of further study in order to understand the varied aspects of the Japonisme movement at its inception.

34. Ernest Chesneau, *L'Art Japonais*, Paris, 1869.

35. Chesneau spent a large part of his time, like Burty, discussing the asymmetry of Japanese design noting that they never make two of anything exactly alike. Like Burty, he believed that "irregularity" was necessary for life. See Ernest Chesneau, *L'Art Japonais*, p. 12.

36. Chesneau was among the first to see the influence of Japanese art on Western painters when, in 1867, he wrote of the impact of Japan on Eugène Boudin. But in spite of these inventive insights it was Burty who, in the 1870s, was recognized as the main spokesman for the movement. The reason for this may lie in the fact that Burty was linked in the mind of the public with the avant-garde while Chesneau was somewhat more conservative in his support of contemporary painters. Further clarification of the relation between Burty and Chesneau should be undertaken to establish exact use of aesthetic terms in the early discussion of Japonisme.

37. A copy of a book by Burty with this inscription is found in the library of the Sèvres Porcelain Manufactory. See Philippe Burty, *La Poterie et la porcelaine au Japon*, Paris, 1885, title page.

38. Philippe Burty, "Japonism," *The Academy*, August 7, 1875, p. 150.

39. Léon de Rosny seems to have given Burty considerable advice and assistance in understanding Japanese culture and art. He is a figure who deserves further study by comparative historians interested in discovering information about individuals who were instrumental in fostering Japonisme in areas outside of the visual arts.

40. Philippe Burty, "Japonism," *The Academy*, August 7, 1875, p. 150.

41. For Burty's earliest signed review on the Impressionists see Philippe Burty, "The Paris Exhibitions, Les Impressionnistes, Chintreuil," *The Academy*, May 30, 1874, pp. 616–617.

42. For another aspect see Philippe Burty, "Revue des sciences historiques, Le Roman japonais," *La République française*, August 13, 1875, pp. 1–2.

43. Philippe Burty, "Exposition universelle de 1878, Le Japon ancien et le Japon

moderne," *L'Art*, 1878, p. 241 ff.

44. Contacts between Burty and Hayashi Tadamasa remain unknown. Further research should be conducted on Hayashi's contacts in France.

45. For further information on Bing's explicit connections with Japan and the use of his relatives as agents to obtain art work for him, see Gabriel P. Weisberg, "L'Art Nouveau Bing," in *Arts in Virginia, The Art Nouveau Symposium*, Fall, 1979, vol. 20, number 1, pp. 2–15.

46. Philippe Burty, "L'Exposition universelle de 1878, Le Japon ancien et le Japon moderne," *L'Art*, 1878, p. 251.

47. See Philippe Burty, "Livres—Grammaire de l'ornement et du dessin japonais, by Thomas W. Cutler," *La République française*, October 8, 1879.

48. For further reference see Louis Gonse, *L'Art Japonais*, Paris, 1883. Also see Philippe Burty, "L'Exposition rétrospective de l'art japonais," *La République française*, April 12, 1883, p. 2.

49. The relationship between Burty and Duret needs further examination. Both men were undoubtedly friends as they were interested in the avant-garde.

50. Why Burty never went to Japan remains difficult to explain. Since his idol Eugène Delacroix had journeyed to the Near East it would have seemed imperative for Burty to travel to his oriental paradise—Japan. However, Burty remained a true romantic, content to fantasize about Japan and to learn about the art and country from his friends: Théodore Duret, Léon de Rosny and art dealers such as Sichel and Bing. Another, more practical reason, may have been one of financial consideration. During the 1870s, Burty had little money to even pay his daughter's dowry. He owed considerable debts to art dealers; he simply wrote as much as he did so that he would have money to live. Many of those who traveled to Japan had their own funds or were doing it simply for business purposes.

51. See Philippe Burty, "L'Exposition rétrospective de l'art japonais," *La République française*, April 12, 1883, p. 2.

52. For this series see *Japonisme: Japanese Influence on French Art, 1854–1910*, Figures 96 a–i.

53. The author is indebted to the Burty descendants who kindly shared this information with him. They are still in possession of this award.

54. Burty was named *Inspecteur des Beaux-Arts* in 1881 to fill the post vacated by the death of his friend Paul de Saint-Victor.

55. See *Collection Ph. Burty, Objets d'art japonais et chinois*, 23–28 March, Paris, 1891, introduction by S. Bing.

56. The full extent of Burty's collection may never be known as the objects were scattered and widely sold after his death. Those objects which can be relocated should be reassembled so that the quality of Burty's perceptions of Japanese art can be reexamined.

TISSOT AND JAPONISME

Michael Justin Wentworth

The influence of Japanese art on the work of James Jacques Joseph Tissot can be divided into three arbitrary but convenient parts.[1] They correspond chronologically to the three decades which begin with 1860, and stylistically to the three virtually separate careers which external circumstance forced upon him. Each is of great interest in itself, reflecting quite different phases of Japanese influence in the West, and taken together they give a remarkably clear picture of the dissemination of understanding which took place among the generation of conservative painters contemporary with the Impressionists as the tenets of Japanese design were gradually assimilated. Tissot himself is not a generative artist of particular significance, and his approach to the art of Japan has little of the searching artistic intelligence which enabled his friends Manet, Whistler, and Degas to incorporate the aesthetic alternatives it offered with an inventiveness which would change the course of Western painting. He was, nonetheless, a gifted and thoughtful painter, and had the ability to cast what he had learned in the vocabulary of his own style. Considering his position at the center of artistic development in the 1860s, it is impossible not to speculate that his early and enthusiastic advocacy of Japanese art did something to begin the dialogue which made possible the more remarkable accomplishments of his peers; in the 1870s, his use of Japanese elements is often individual and audacious; and in the 1880s, a greater assimilation of these elements gives his japonism new strength and flexibility. Tissot's *Japonisme* is at once typical of a general European development and unmistakably personal in its accent. It is always of remarkable interest, if seldom remarkably profound.

There could be no better index of Tissot's character or artistic interests in the sixties than the encyclopedic portrait of him by Degas which can be dated about 1868 (L. 175; The Metropolitan Museum of Art, New York). When Tissot painted a self-portrait about the same time, he portrayed himself as worldly and amused, a gentleman without ostensible artistic interests (California Palace of the Legion of Honor, San Francisco), but Degas goes further in suggesting the neurotic and strangely passive character of his friend, a character which the Goncourts would later describe as "complex, a blend of mysticism and phoni-

ness, intelligent in spite of an unintelligent skull and the eyes of a dead fish, passionate, finding every two or three years a new enthusiasm with which he contracts another short lease on his life."[2] Degas also establishes the precise artistic interests of the young artist. Surrounding him with what might well be, although they probably are not, paintings by Tissot's own hand, he clearly intended a summary of Tissot's artistic development during the first decade of his independent activity: the Northern Renaissance, in a little portrait of Frederick the Wise copied from a picture of the School of Cranach; Venetian painting, a passion shared by both artists; modern life, in a couple of outdoor scenes; and, of greater significance for us today, Japanese art, in what appears to be a Western pastiche of a five-sheet woodcut by a follower of Utamaro or a scroll of the *makimono* type of women in a garden.[3]

Tissot was one of the earliest and most enthusiastic collectors of Japanese art, and he was also one of the first to incorporate Japanese elements in his own work.[4] Yet while he discovered Japanese art as a young man, his style had formed early and he had great difficulty in including any but its most superficial elements in his work. The "Japanese" painting in the Degas portrait of him could only too easily be a picture by Tissot.

In a letter to his mother from Paris dated November 12, 1864, the English painter Rossetti writes of a visit to a shop selling Japanese goods—surely that of Mme Desoye in the rue de Rivoli—only to discover that Tissot had been there before him. He writes:

> I have bought very little—only four Japanese books, . . . but found all the costumes were being snapped up by a French artist, Tissot, who it seems is doing three Japanese pictures which the mistress of the shop described to me as the three wonders of the world, evidently in her opinion quite throwing Whistler into the shade.[5]

It seems certain that the *Japonaise au bain* (Pl. II) which is dated 1864 is one of the paintings Rossetti heard described in such glowing terms. Although Japanese woodcuts of women at the bath undoubtedly suggested the subjects, bringing the prints of Kiyonaga or Shigemasa immediately to mind, they clearly suggested little else, for Tissot's approach remains doggedly Western in its insistence on three-dimensional modeling, spatial recession, and cast shadow. In fact, there is nothing Japanese about the picture except its subject. Everything else, its large scale, opulent surfaces, and heightened realism—to say nothing of its erotic *déshabillé*—clearly demonstrates the impact of Courbet on Tissot's work in the sixties. Aesthetically and spiritually, Tissot's *Japonaise au bain* owes more to Courbet's *Demoiselles des bords de la Seine* (1856–57; Petit Palais, Paris), a work whose influence is strongly felt in many of his pictures at this time, than to the abstract and emotionally distant bathers he would have discovered in the prints of the *ukiyo-e*. As a result, his hybrid *Japonaise* hovers uncomfortably between the unintentionally silly and the unsuccessfully pornographic, a *japonaiserie* in the manner of Offenbach's *Ba-Ta-Clan*, in which the enchanting *mandarine* Fé-An-Nich-Ton proves to be an errant soubrette from the Chaussée d'Antin, but hardly the last Second Empire *parisienne* to augment her charms with an ad-

ventitious kimono and fan.[6]

If the *Japonaise au bain* is a superficial yet attractively eccentric *japonaiserie*, it is hardly careless in its approach to its subject. There is nothing about it of the inventive playfulness with which eighteenth century artists treated the art of China; rather, it gauges the scientific attitude that marked the study of Japanese art in the nineteenth century from the very beginning.[7] Tissot's method in the *Japonaise au bain* is less capricious than it might appear, but it is oblique in its approach to Japanese art and its underlying logic is clear only in reference to his general development as a painter.

He arrived in Paris in 1856 to study painting with Louis Lamothe, a pupil of Ingres, and made a timid but precocious debut at the Salon of 1859 with careful exercises in the manner of his master. Almost immediately, however, he turned away from such predictable and safe models to become a follower of the Belgian archaist painter Henri Leys. Attempting to recreate the glories of Northern painting with ingenuous reconstructions of the early masters, Lyes had combined the Romantic historicism of his idol Delacroix with the incipient attitudes of Pre-Raphaelitism in the hope of founding a national school. Every detail in his pictures was studied with archaeological exactitude and rendered with a "primitive" disregard for iconographical or optical importance. Tissot did the same, and in his enthusiasm often surpassed Leys himself in cramming his canvases with masses of historical bric-a-brac which as often as not overpowers both narrative content and any trace of life itself.

This archaeological approach is everywhere evident in the *Japonaise au bain*, and it fits easily within the pattern of historical reconstruction Tissot had perfected by 1864. It is removed from the artist's experience in space rather than time, but the fundamental approach is the same. When he had painted a medieval *Faust et Marguerite au jardin* (Private Collection, Washington, D. C.) for the Salon of 1861, the architectural elements were based on actual objects in the Musée de Cluny, and we can be equally sure that the kimono and porcelains in the *Japonaise* were prizes culled in the rue de Rivoli. There is a real attempt at accuracy in this assembly of Japanese goods, and if it fails, it fails only from a lack of the information which alone could have guaranteed its success. As Ingres had been called "a Chinese artist lost in Greece," Tissot might be considered a Northern primitive set loose, if not in Japan itself, at least at Mme Desoye's in the rue de Rivoli.

At the time Tissot began his *japonaiseries*, he also became a painter of modern life. His emancipation from historical genre was brilliantly announced at the Salon of 1864 with a *Portrait de Mlle L. L.*.. (Louvre, Paris; now called *Jeune femme en veste rouge*) which was widely admired for the "sincerity" of its modern sentiment, a compliment to the accuracy of its delineation of both psyche and setting. It is hardly surprising that Tissot approached the world around him with the same documentary spirit he brought to his historical reconstructions. The potency of this combination was noticed at the time. Elie Roy would describe the *Jeunes femmes regardant des objects japonais* (Fig. 2) as "ethnographic" in his review of the Salon of 1869 when he remarked, "our industrial and artistic creations might perish, our customs and costumes fall into oblivion: a single

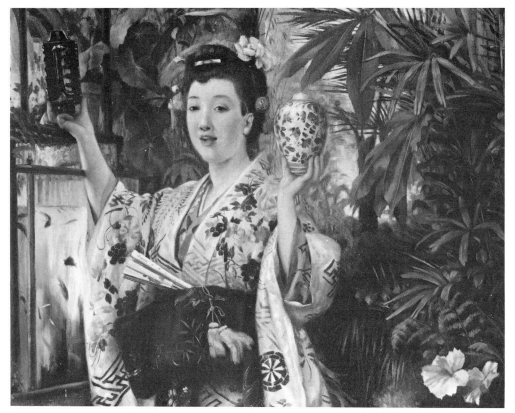

Fig. 1. James Tissot, *Jeune femme tenant des objets japonais*, ca. 1865. Oil. Whereabouts unknown.

picture by Tissot would suffice for the archaeologists of the future to reconstruct our entire era."[8]

Tissot's rapid emergence as a painter of modern life in the sixties is extremely complicated, but without doubt one of the strongest influences on him was Whistler, who also must have suggested the direction he took in a *Jeune femme tenant des objets japonais* (Fig. 1). The picture probably dates from soon after the middle of the decade, or at least after Whistler's *La Princesse du pays de la porcelaine* (1863–64; Freer Gallery of Art, Washington, D.C.) was exhibited at the Salon of 1865, for it is a direct quotation of the formula Whistler had developed for his *japonaiseries* in the early sixties. In both, a young woman models a kimono and admires objects from the artist's collection. Rossetti's mention of rivalry between Whistler and Tissot in the creation of these "wonders of the world" is to the point, for the brand of *japonaiserie*·practiced by both is too close to be coincidental. Whistler was always to be the source of many of Tissot's stylistic "enthusiasms," which he viewed with an understandable lack of charity as simple plagiarism, and even as late as 1880, he would remark to his mother in a letter from Venice in which he describes his new pastels, "Tissot, I daresay, will try his hand at once."[9]

But the differences between their *japonaiseries* are as interesting as the similarities. Whistler's models remain Europeans in kimonos, but Tissot's method

is still superficially anthropological: it seems likely that the model who posed for the *Jeune femme tenant des objects japonais*, wearing another of the kimonos from his collection, has been supplied with a head drawn from a Japanese doll, reversing, but otherwise hardly altering, the approach of the *Japonaise au bain*. Where Whistler attempts to establish a new relationship between the figure and background which is obviously indebted to the Japanese print, Tissot's luxurious winter garden, a setting which was to become one of his most popular technical specialities, points to nothing more than Japanese art as an ingredient of fashionable taste, or perhaps a lingering memory of the Cathay of Boucher's *chinoiseries*. If one senses that Whistler had already discovered a meaning in Japanese art more profound than its immediate exoticism and sensuality, it is a feeling which evaporates in the face of Tissot's exuberent delight in the fashionable sheen on his porcelains and costumes. *La Princesse du pays de la porcelaine* seems to mark the actual point of transition between *japonaiserie* and *japonisme* in Whistler's work as he moves towards a new understanding of Japanese design.[10] It is a point which was lost on Tissot, who read in its superficial aspects alternative enough to the archaeological erudition of the *Japonaise au bain* without troubling to plumb its deeper aesthetic possibilities, but *La Princesse du pays de la porcelaine* probably gave him the hint which would bring him to those modern dress *japonaiseries* which are his most attractive as well as his own special contribution to the genre.

It is hardly surprising that Tissot's first *japonaiseries* were painted at the time he began his subjects from modern life, for *Japonisme* and *modernité* were to become nearly synonymous among painters of high life by the end of the decade. Alfred Stevens made a direct equation between the two when he said "Japanese art is a powerful element of modernity,"[11] undoubtedly making reference as much to fashionable taste as to advanced aesthetics, and by the time of the Exposition Universelle of 1867, the triumph of this *mode des japonaiseries* offered irrefutable proof of his statement.

Stevens himself had popularized a genre in which the charm of the contemporary *parisienne* was emphasized in a manner which avoided narrative as much as it emphasized modernity and *chic*, and in many of his pictures oriental costumes and objects are used to give a sense of fashionable currency to their owners. What is probably his masterpiece, *La Dame en rose*, often called *Le Bibelot exotique* (ca. 1865; Musées Royaux des Beaux-Arts de Belgique, Brussels), makes the connection between the two with irresistible charm. Although the object in this case is Indian and not Japanese—Stevens did not become a painter of *japonaiseries* until the early seventies, and then only in a limited sense—it offers an obvious prototype for the pictures Tissot was to paint at the end of the decade.

Tissot was fully aware of the possibilities of Stevens' genre. It had, in fact, contributed significantly to his aesthetic philosophy as a painter of modern life, and Stevens' influence had been noticed in his work by Thoré as early as 1866.[12] The success of the Japanese section at the Exposition Universelle of 1867 seems to have brought Japan to Tissot's attention once again, and he began a new series of *japonaiseries* which are probably best described as half Whistler, half Stevens.

Jeunes femmes regardant des objets japonais (Fig. 2), exhibited at the Salon of 1869

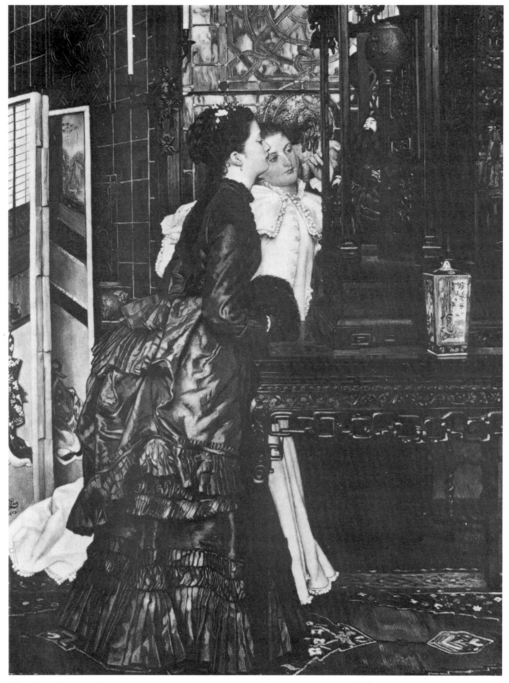

Fig. 2. James Tissot, *Jeunes femmes regardant des objets japonais*, 1869. Oil. Private Collection, London.

and one of at least three versions of the subject,[13] combines its divers elements with an inventiveness which approaches an originality of its own. With the tartness of character which marks Tissot's most characteristic works, its "ethnological" approach gives it an uncanny sense of time and place. As Elie Roy

predicted, it has become the veritable index of an age. A document for the social and architectural historian as much as the japonist and art historian, its jumble of objects mirrors the proliferation of periods and continents which was the hallmark of Second Empire taste, although even then Tissot's lavish hand with his treasures made the critic Borgella wonder whether the picture should be called "*Young Women Looking at Japanese Objects* or *Japanese Objects Looking at Young Women*" before deciding that it all came to the same thing in the end, a "*chinoiserie*," or Chinese puzzle.[14]

Much the same sentiment was voiced with rather less good humor by Champfleury, himself a devoted japonist, who was already tired of a vogue which was making Japanese art into a fashionable cliché. In a sarcastic article published in *La Vie parisienne* in 1868, he made fun of the narratives Tissot had made popular —amorous little dramas in which smart soubrettes flirt with Japanese bronzes or conceal love letters in Japanese bouquets—which had been appropriated by at least fifty other painters. He had seen more than enough, he wrote, of "so-called painters of high life who bore us with their Japanese cabinets, their Japanese flowers, their Japanese lacquers, and their Japanese bronzes which take the principal place in their pictures and play a part more important than that of the figures themselves."[15]

In truth, Tissot's *japonaiseries* must often have been contrived essentially to display the exotic wonders of his collection, and by 1870, his fame as a painter was nearly equaled by his reputation as a collector of Japanese art and guide to such fashionable novelties. Indeed, what might be said to be his most characteristic gesture as a japonist in the 1860s was made as an interior decorator rather than a painter. By the middle of the decade, his financial success had been so great that he was able to build a house with a large studio in the new avenue de l'Impératrice and he was in residence by 1867. The house is no longer standing, but its rooms are recorded in pictures like the *Jeunes femmes regardant des objets japonais*. The studio, which appears to have vanished without a trace,[16] was in the Japanese style and Champfleury began his article in *La Vie parisienne* by calling it "the latest originality."[17] It seems likely that its creation can be linked to the sale of Japanese objects and architectural elements exhibited at the Exposition Universelle which took place after the close of the exhibition in 1868,[18] although Ikegami Chūji has offered the more attractive alternative that the materials were a gift from Prince Akitake, head of the Imperial Commission to the Exposition and the younger brother of the last Tokugawa shōgun, having demonstrated that Tissot was retained by the Prince as his drawing master while he was in Paris.[19] In any case, Tissot's "Japanese" studio became a minor attraction in its own right. Champfleury tells us that society flocked to see it.

The second phase of Tissot's japonism corresponds to the career in London which was forced upon him when an involvement with the Commune that followed the Franco-Prussian War made him leave France. It also corresponds to the general assimilation of the principles of Japanese design which had taken place by 1870. For the first time in Tissot's work, *japonaiserie* gives way to elements which suggest a new interest in the aesthetic and structural complexities of

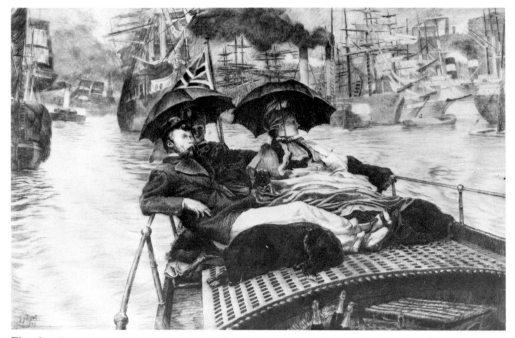

Fig. 3. James Tissot, *The Thames*, 1876. Etching, W. 20. Private Collection, Boston.

japonisme. We do not know exactly what prompted Tissot's new approach, although given his position and friendships it is easy enough to speculate, or even if he was actually a collector of the Japanese prints which would have such a pervasive influence on his style in the seventies. It seems inconceivable that he was not, but none appear in his *japonaiseries* as they do in similar works by Whistler, or among the lots of kimonos, porcelains, and furnishings in the posthumous sale of his collections in 1903.[20] Without examples of documented provenance for reference, it does not seem useful to make numerous comparisons, but, in any case, the aspects Tissot found attractive in Japanese prints were commonplace and it would be possible to cite a dozen examples as the prototype for each of the devices he used. Tissot's japonism is obvious enough without such comparisons, for he was still unable to achieve a total assimilation of what he had borrowed from Japanese art and it remains an easily separable veneer on his otherwise Western paintings.

A new interest in Japanese design is evident in one of the pictures Tissot sent to the last Salon before the war, a *Jeune femme en bateau* (1870; Private Collection, London) in which the bold cutting of the boat by the lower edge of the canvas, the sharply diagonal composition, and the parallel arrangement of elements in relation to the picture plane announces a *japonisme* of new intensity and intelligence. Its design would be repeated in England in the seventies in pictures like *The Thames* (1871; Wakefield City Art Gallery), exhibited at the International Exhibition in London in 1872 and seen here in the etching after it (Fig. 3), and *Portsmouth Dockyard* (1877; Tate Gallery, London) which was engraved as *Entre les deux mon cœur balance* (W. 30).

On the Thames, a Heron (Fig. 4)[21] is one of the first pictures he painted in London

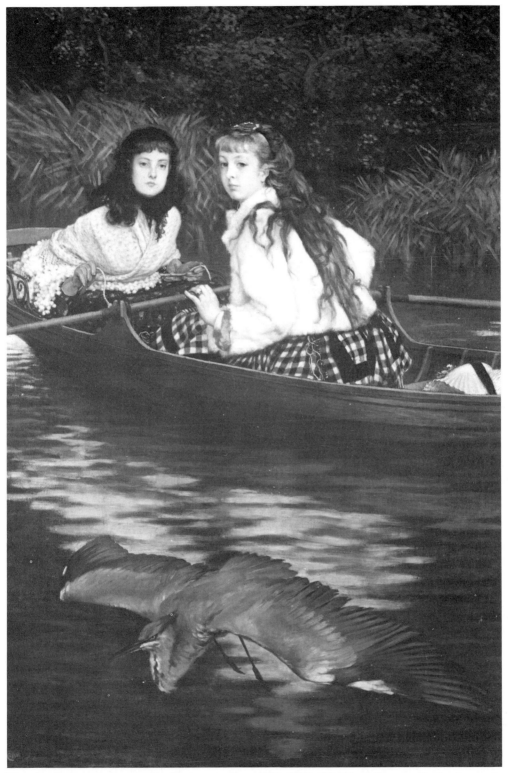

Fig. 4. James Tissot, *On the Thames, a Heron*, 1871–1872. Oil. The Minneapolis Institute of Arts, Gift of Mrs. Patrick Butler, by exchange.

and it offers the clearest evidence of this new attitude. But, once again, it is difficult to assess the route by which understanding was reached. By 1870, Tissot was obviously aware of the compositional possibilities offered by the Japanese print, but given his usual method of approach, it seems as likely that understanding came through familiarity with the work of his Western contemporaries as much as a study of Japanese originals. Here, Whistler once again seems the most obvious possible source. The two men met frequently in London and until they parted company at the time of the Whistler-Ruskin trial in 1878, Tissot had access not only to Whistler's opinions about Japanese art, but also to his collection of Japanese prints. Unfortunately, the only record we have which suggests discussion between the two about such things concerns, not surprisingly, lacquer and blue and white china.[22]

If *On the Thames, a Heron* suggests a page like the *Samurai in the Rain* from the first volume of Hokusai's *Manga* in its high vantage point and radical juxtaposition of separate elements on a shallow ground, or a color woodcut like his *Cuckoo and Azalea* from the series known as the "Small Flowers" in its attempt to capture swift avian movement, it also suggests that these ostensibly "Japanese" elements may well have been discovered in Whistler, whose etching *Speke Hall, No. 1* (1870; K. 96) recalls Hokusai in precisely the same manner, or Bracquemond, whose etching *Vanneaux et sarcelles* (1862; B. 154) is also deeply concerned with the movement of birds. And although we do not know what Japanese prints Tissot may have studied, it is likely that he knew both these etchings.

The extreme composition of *On the Thames, a Heron* is something of an anomaly in Tissot's work, but he quickly came to favor Japanese compositional devices of a less radical nature which were repeated throughout the decade. *Matinée de printemps* (1875; W. 13), one of his earliest prints, incorporates two "Japanese" elements that appear again and again: a clump of plants in the immediate foreground which are reminiscent of the studies of plants and flowers in the *Manga*, and a figure silhouetted against a dark ground in the manner of Japanese actor prints.[23]

The same elements are evident in *Croquet* (Pl. III), which is also of great interest in its clear implication that by the end of the decade Tissot had begun to approximate something of the flat, unmodulated color of the Japanese print in his work. The fresh color of *Croquet* may now seem but the palest imitation of a truth Manet had discovered years earlier, but when such pictures were exhibited at the Grosvenor Gallery in the seventies, English critics found their color even more arrogantly capricious than that of Whistler (if, to their credit, also inferior), and warned Tissot to curb his growing eccentricities.[24] No one, however, appears to have considered them even remotely "Japanese," but to the best of my knowledge, no English critic ever discussed his work in terms of Japanese influence at all.

The "processional" composition so often favored by masters of the *ukiyo-e* like Kiyonaga or Shunchō also became one of Tissot's favorite devices. With its graceful frieze of figures set against a view, *Ramsgate* (Fig. 5), perhaps the most beautiful of his prints, is clearly indebted to such Japanese prototypes. But there are spiritual affinities even more striking. By the middle seventies Tissot's

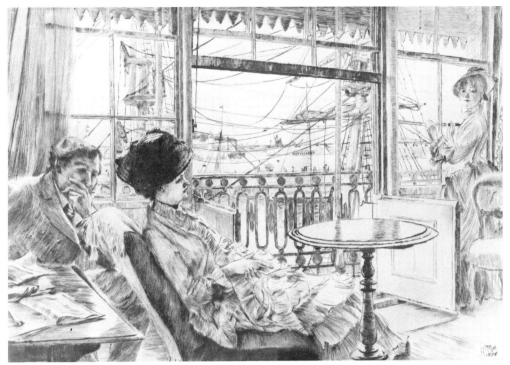

Fig. 5. James Tissot, *Ramsgate*, 1876. Etching, W. 22. Private Collection, Boston.

narrative, disguised with titles of bland descriptiveness, had taken on a tantaiizing opacity. Compare *Ramsgate* with a print like Shunchō's *Atagoyama Hill*
from the series *The Five Hills of Edo*, in which topographical reference is
belied by the image itself: three young women in a tea house from which no
more than a glimpse of Shinagawa Bay, the principal attraction of the hill,
conflicts with the "real" subject, an enchanting display of feminine charms
and fashionable kimonos.[25] In exactly the same manner, Ramsgate and the
sea shore exists for Tissot solely to give the flavor of association to his display of
summer muslins.

 A similar composition and spirit can be found in other works from this time.
In *H.M.S. 'Calcutta' (Portsmouth), Souvenir of a Ball on Shipboard* (1877; Tate Gallery, London), for example, the deliberate thrust and imbalance of the composition, skillfully equated with the psychological state of the protagonists in an
entirely personal way, is one of Tissot's most succcessful essays in *japonisme*, and
its narrative is set well away from the dance it purports to record. Or again, in
a picture of an outing to admire the autumn color of chestnut leaves which is
called by the calendar, *Holyday* (1877; Tate Gallery, London), an image as
indebted to the *ukiyo-e* in its spirit as its design. But, once again, a note of caution.
If *Ramsgate* has affinities with Kiyonaga and Shunchō, it has affinities as close
with Whistler's *Wapping* (1860–64; The Hon. and Mrs. John Hay Whitney,
New York); if the design of the *Calcutta* suggests the *ukiyo-e*, it also suggests, and
quite as strongly, the design of a work like Giuseppe de Nittis' *Che freddo!* (1874;
Giacomo Jucker, Milan). And again, while we do not know what Japanese prints

Tissot may have studied, it is quite certain that he was familiar with both these pictures.

I would like to suggest still another alternative, what might be called the *ukiyo-e* of the English illustrated magazines. Comparison of Tissot's compositional and narrative approach with illustrations in magazines like the *Graphic* or the *Illustrated London News* often points up truly remarkable similarities. In the early seventies, Tissot, like Degas, based his idea of English taste on the evidence of these magazines when he sought to exploit the English market. But, unlike Degas, he was successful in his attempt. Three of his pictures were engraved for the *Graphic* during the decade, and it seems certain that he remained completely aware of the possibilities offered by the magazines for his own work. Their wide and often unexpected range of subject matter, unvarnished modern sentiment, and often truly radical design offered models of the most attractive kind as Tissot sought to adjust the French bias of his painting to the exigencies of British taste. That they proved to be inaccurate as guides to national taste is not important in this context; the illustrated magazines offer another alternative in their suggestion that *Japonisme* was but one of several threads in the development of Tissot's mature style.[26]

Like many of his contemporaries, Tissot sometimes altered the shape of his prints and paintings to conform to traditional Japanese usage. He often experimented with the narrow vertical of the *hashira-e*, or "pillar print," in the seventies, although never with complete success. It is seen at its best in a print like *Printemps* (1878; W. 34) or an oil sketch like *Les Deux amis* (1882; Museum of Art, Rhode Island School of Design, Providence), but even in these works the use of a Japanese format goes little beyond an obvious and superficial exoticism.

In 1876, Tissot met Kathleen Newton, a young woman who became his mistress and lived with him until her death in 1882. Mrs. Newton became the subject of a series of paintings and prints which look to the Japanese "Large Head" print for their inspiration. These *bijin-e*, or "pictures of beautiful women," become a staple of Tissot's art. The etching *L'Eté* (Fig. 6), based on the large oil sketch from Gray which is in the exhibition at Sunshine City, is probably the most obviously "Japanese" of them, but if it makes an attempt to convince us with the *japonisme* of its clipped forms and crisp silhouette, it also insists on Western means to achieve its end, and its uncomfortable mixture of flat pattern and three-dimensional modeling can hardly be called successful in the spatial confusion it creates. Under the most superficial of disguises, it remains a *japonaiserie*.

At the end of the seventies, Tissot's japonism was tempered by growing reliance on photographic sources. The careful, abstract design of his work at mid-decade begins to give way to an almost random approach which can be linked directly to the impact of photography on his work as technical developments made it possible to capture instantaneous movement on film. Photography and the Japanese print had tended to validate one another in the creation of a new way of seeing in the seventies when the striking effects of perspective and design which Western artists discovered in Japanese prints were corroborated by similar effects in the photograph and the one attested to the "truthfulness" of the other.[27]

Fig. 6. James Tissot, *L'Eté*, 1878. Etching, W. 43. Private
Collection, Boston.

In some of Tissot's works in the late seventies, both elements are kept in balance
with great effectiveness, as in the painting *In the Sun* (1881; Private Collection,
London) which was the subject of an etching the same year (W. 54). A photo-
graph of Mrs. Newton exists which was made expressly to serve for the painting,
and what has been preserved by accident must represent a large body of lost
material. Tissot probably came to rely almost exclusively on photographic
material at this time, and his last English works are often regretfully little more
than what Ruskin had once called them, "mere coloured photographs of vulgar
society."[28]

Fig. 7. James Tissot, *The Prodigal Son: In Foreign Climes*, 1882. Etching, W. 59, after the painting in the Musée de Nantes. Private Collection, Boston.

Sometime at the end of the seventies, Tissot took up decorative sculpture, and more than twenty pieces in bronze and cloisonné enamel were included in a large one-man exhibition he held at the Dudley Gallery in 1882.[29] Although most of his sculpture is now unlocated, the most important, *Fortune*, a fountain figure astride a large turtle and surrounded by serpents, is in the Musée des Arts Décoratifs in Paris. *Fortune*, which has an extremely complicated iconographical program, is a hybrid of Near and Far Eastern influences, and doubtless it owes much to the Japanese bronzes to which it bears a vague family resemblance. But until more of his sculpture can be located and studied properly, it seems best simply to mention its existence and its possible *japouisme* in passing.

The Dudley Gallery exhibition also saw one last remarkable japonist statement before Tissot left England: *The Prodigal Son in Modern Life*, a series of four paintings which cast the Biblical parable in modern dress. In the second picture of the series, *In Foreign Climes* (Fig. 7). Tissot's Prodigal comes straight to Japan to squander his inheritance in a *japonaiserie* which has new accuracy if not increased understanding. But like his Japanese studio in Paris, there could be no better "sign of the times" than this tourist's dream of Edo which lights the emotional path to the riches Puccini and Loti would mine at the end of the century. Even considering Tissot's conservative japonism in the seventies, this determined *japonaiserie* comes as something of a shock. It looks like an early photograph, and

doubtless it was based on one. There is certainly nothing Japanese about it except its subject, and despite the real charm of its literary conceit, it is only too reminiscent of Tissot's first "Japanese" pictures in the sixties, a catalogue of kimonos and fans. That the effect is superficially different, or at least more accurate, is due entirely to the photographers and publishers who had made Japan familiar by the time he painted it.

The third phase of Tissot's japonism corresponds to his brief career as a secular artist in the early eighties before he devoted himself to illustrating the Bible in 1885. He had returned to Paris following the death of his mistress in 1882 and was quickly absorbed in spiritualist activity and the mystical faith of the Catholic Revival as he sought to forget his grief and rebuild his life. A series of fifteen pictures with subjects taken from the daily life of Parisian women were his major undertaking at this time, and they are at once the apotheosis and the epilogue of his japonism. If it is a japonism more powerful than ever before, it is also a japonism which has become an unconscious element of his style. It is easy enough to point out Japanese elements in a picture from *La Femme à Paris*[30] like *Ces dames des chars* (Fig. 8), but it is difficult to separate them from the total artistic context. The lesson of Japan is everywhere implicit, but it is no longer anywhere explicit and cannot be isolated as a separate element as it often could in the seventies. This is due in great part to the highly sophisticated approach to Japanese art which twenty years of familiarity and study had made possible, and Tissot's development accurately mirrors that of many of his contemporaries. Even so, Japanese art now appears in his work less as a direct source than as one element among many. Setting *Japonisme* aside, Tissot's new concern with scale corresponds to the search for monumentality which prompted Renoir to abandon Impressionism and Seurat to begin his first great projects at this time; his interest in the series parallels that of Monet, as does his palette, dense brushwork, and decorative approach; and his subjects clearly reflect those which occupied Manet and Degas—as well as the authors of the texts for the series—shopgirls, society *horizontales*, and circus performers, caught up in the ceaseless life and agitation of the city, whose perpetual friction gives the actresses in these little dramas an hysterical brilliancy which is perhaps the "real" subject of the series.[31]

Japanese compositional formulae now long familiar in Western painting are used with great freedom to heighten the visual and psychological effects of these strange pictures, often giving them an impact which looks forward to Symbolism in their compilation of formal elements and erotic sphinxes, pallid virgins, and working class amazons. For the first time, Tissot's strict adherence to the conventions of Western painting gives way to abstract formal considerations which carry him far from the realism of his earlier work. Figures are elongated beyond all anatomical possibility and given expressions as fixed and symbolic as those of masks. Spatial relationships are distorted to give them the hierarchical importance of the dream. Entire surfaces are treated with a crude decorative patterning which frees color from its descriptive function. The actresses in the dramas are brought close to the surface and spill out of the painted world to accost the viewer psychologically and even sometimes physically. It is all very

Fig. 8. James Tissot, *La Femme à Paris: Ces dames des chars*, 1883–1885.
Etching, W. 78, after the painting in the Museum of the Rhode Island
School of Design. Private Collection, Boston.

interesting, but one can only wonder how often Tissot actually thought of Japanese art as he painted the series.

Much the same can be said of the scores of illustrations to the Bible that from an unexpected and perhaps unfortunate and to Tissot's artistic career. If unfamiliar subject matter obscures narrative antecedents in his secular work, their formal debt to Japan is made immediately clear by the sharp perspectives and detached silhouettes which determine composition.[32] For all its overheated piety and Turkish airs, Tissot's approach is familiar. No longer willing—or probably able—to modify his approach or sources, Tissot yet wrought these

strange little pictures with a flexibility and purpose which can only be admired. For the last time, patterns and enthusiasms reaching back to his artistic beginnings were skillfully bent to serve new personal needs and changing times.

As it happened, then, Tissot's most immediate and vital interaction with the art of Japan came early in his career. With an honorable position as one of the early japonists in the sixties, his first *japonaiseries* served as a bridge to his *japonisme* in the seventies. But while *japonaiserie* brings him to the edge of a deeply understood *japonisme*, the actual transition was made only in fitful and usually superficial terms. Although it resulted in works as subtle as *Ramsgate* and the *Calcutta*, it remains indehiscent and never really fulfills the rich promises those pictures make. But if the design of the Japanese print had a limited effect, its spirit was more pervasive. Always alive to the compelling uses of closely observed gesture and to the nuances of weather, setting, and season as the promoters of narrative intent, Tissot must have discovered a vivid reality in the *ukiyo-e* which was of critical importance in the formulation of his style. Reticent and ambiguous, concerned with modern sentiment and the most fugitive states and emotions, the *ukiyo-e* offered models of inspiring usefulness. In the strength and spirit of his best works, Tissot could well, and proudly, have called himself "Japanese."

NOTES

1. In this paper, I have used the French terms *japonisme* and *japonaiserie* as they were generally employed at the symposium: *japonisme*, the incorporation of the principals of Japanese design to Western works which parallel, without duplicating, their prototypes, or, capitalized, as the name of the movement itself; and *japonaiserie*, the equivalent, for Japan, of *chinoiserie*, Western interest in the exotic, decorative, or fantastic qualities of Japanese art for their associative value or fashionable novelty. When speaking of Tissot's interest in the art and culture of Japan in a broad general sense, I have preferred the words "japonism" and "japonist."

2. Edmond and Jules de Goncourt, *Journal des Goncourt: mémories de la vie littéraire*, 4 vols., Paris: Flammarion, 1956, III: 1112. The French text reads: "Tissot, cet être complexe, mâtiné de mysticisme et de roublardise, cet intelligent laborieux en dépit de son crane inintelligent et de ses yeux de merlin cuit, appassionné, trouvant tous les deux ou trois ans un nouveau bail de sa vie."

3. The pictures are identified and discussed in Theodore Reff,' 'The Pictures within Degas' Pictures," *The Metropolitan Museum Journal*, I, 1968, pp. 133–140.

4. The earliest reference to Tissot as both a collector of Japanese art and a painter of *japonaiseries* is contained in Rossetti's letter of November 12, 1864, which is quoted in the present paper and cited below in note 5. In the later 1860s, Tissot is also cited as an early japonist in Zacharie Astruc, "Le Japon chez nous," *L'Etendard*, May 26, 1868, p. 2, where he is called "le gothique Tissot" in reference to his fame as a painter of medieval subjects in a list of early japonists, and in Jules Champfleury, "La Mode des Japoniaiseries," *La Vie parisienne*, November 21, 1868, pp. 862–863, rpt. in Champfleury, *Le Réalisme*, ed. by Geneviève and Jean Lacambre, Paris: Hermann, 1973, pp. 143—145, where he is thinly disguised as "un jeune peintre assez richement doté par la fortune pour s'offrir un petit hôtel dans les Champs-Elysées" and a sarcastic account of his "Japanese" studio and the narratives of his *japonaiseries*, both of which are cited in the present paper, are given. Champfleury also makes indirect reference to Tissot as a collector of Japanese art in *Les Chats*, Paris: J. Rothschild, 1869, when he reproduces, opposite p. 154, a "Groupe de chats, caprice japonais" which is identified, p. 329, as "tiré de la collection de M. James Tissot." Tissot's position as an early japonist is also pointed out in Ernest Chesneau, "Le Japon à Paris," *Gazette des Beaux-Arts*, XVIII, 1878, pp. 385–397. Chesneau, p. 387, includes him in his extensive list of early japonists, and, p. 396, makes reference to the influence of Japanese art on his English works. In a list of the qualities assimilated by various artists, he ascribes to Tissot "des hardiesses et même des étrangetés de composition comme en ses belles *Promenades sur la Tamise*. "The most extensive treatment of Tissot's japonism to date is to be found in the introduction and relevent catalogue entries in Michael Wentworth, *James Tissot: A Catalogue Raisonné of His Prints*, Minneapolis: Institute of Arts, 1978.

5. Dante Gabriel Rossetti, *Letters*, 4 vols., ed. by Oswald Doughty and John Robert Wahl, Oxford: Clarendon Press, 1965, II: 524.

6. *Ba-Ta-Clan*, a "musical *chinoiserie*" by Jacques Offenbach with a libretto by Ludovic Halévy, first given at the Bouffes-Parisiens, December 29, 1855.

7. See Hugh Honour, *Chinoiserie: The Vision of Cathay*, London: John Murray, 1961, pp. 207–208.

8. Elie Roy, "Salon de 1869," *L'Artiste*, IX, July 1, 1869, p. 82. The French text reads: "Nos créations industrielles et artistiques peuvent périr, nos moeurs et nos costumes peuvent tomber dans l'oubli, un tableau de M. Tissot suffira aux archéologues de l'avenir pour reconstituer notre époque."

9. Letter in the Whistler Collection, University of Glasgow.

10. See Mark Roskill, *Van Gogh, Gauguin and the Impressionist Circle*, Greenwich: New

York Graphic Society, 1970, p. 58.

11. Alfred Stevens, *Impressions sur la peinture*, Paris, 1886, no. CI, rpt. in Camille Lemonnier, *Alfred Stevens et son Oeuvre*, Brussels: G. van Oest, 1906, p. 44. The French text reads: "L'art japonais est un puissant élément de modernité."

12. In reference to *Le Confessional* (Salon of 1866, no. 1844; Southampton Art Gallery) in his "Salon de 1866," rpt. in Theophile Thoré (W. Bürger), *Salons de W. Bürger, 1861 à 1868*, Paris: Renouard, 1870, p. 312.

13. Salon of 1869, no. 2270. There are two other known pictures with the same subject and presumably the same title (Private Collection, Cincinnati, and whereabouts unknown). The assumption that the picture here illustrated is the version exhibited at the Salon is based on the evidence of a Goupil photograph in a series which generally, but not always, recorded exhibited pictures.

14. Louis Auvray, "Salon de 1869: promenade à travers l'exposition," *Revue Artistique et Littéraire*, XVII, 1869, pp. 11–12, quoting Frédéric Borgella in *Le Globe*, June 4, 1869. The French text reads: "*Jeunes Femmes regardant des objets japonais*, ou des objets japonais regardant des jeunes femmes, c'est tout un: matiére de chinoiserie!" Borgella's reference to a picture with a specifically "Japanese" title as "*chinoiserie*" is interesting in its suggestion, despite its obvious play on words, that the two modes were considered essentially the same as late as the end of the decade, at least by the uninitiated or the unconcerned. For painters of high life like Tissot or Stevens, Japanese art must have assumed the same comfortable function *chinoiserie* had long played for their fashionable patrons, becoming an up-dated exoticism which had both a traditional role and the freshness of novelty. This is made clear by the *Jeunes femmes regardant des objets japonais* itself, for the identification of the objects in the picture necessitates the positive Chinese origin for a great many of Tissot's "objets japonais." In fact, the two young women have turned their back on what may be the single indubitably Japanese object in the picture, the gold-ground screen. But Chinese or Japanese, in association with Tissot's Napoleon III version of a Louis XV interior—a combination perhaps more clear in other pictures of his house—the essential *chinoiserie* of his *japonaiserie* is made clear.

15. Champfleury, rpt. in Lacambre, op. cit., p. 145. The French text reads: "Déjà même de prétendus peintres de la vie élégante nous fatiguent de leurs cabinets japonais, de leurs fleurs japonais, de leurs laques et de leurs bronzes japonais qui prennent la place principale sur la toile et jouent un rôle bien autrement considérable que les personnages." Borgella, quoted in Auvray, op. cit., p. 11, also refers to Tissot's subject as "familiar."

16. According to a description of the studio in George Bastard, "James Tissot," *Revue de Bretagne*, 2nd ser. XXXVI, November, 1906, pp. 275–276, after Tissot's return to Paris the studio became one of those *ateliers-musées* dear to the *pompiers* and artistic ladies of the *fin-de-siècle*, its Japanese elements—which Bastard does not mention—by then overlaid or discarded.

17. Champfleury, rpt. in Lacambre, op. cit., p. 143.

18. See the *Catalogue des Produits et Objets d'art japonais composant la collection envoyée du Japon pour l'Exposition Universelle de 1867 et groupée aujourd'hui rue de la Victoire, no. 41*, Paris: Renou, 1868.

19. See the paper by Ikegami Chūji, "James Tissot: 'Drawing Instructor' of Tokugawa Akitake," in the present collection. I am indebted to Professor Ikegami for his great kindness at the time of the Symposium: our discussions of Tissot's *Japonisme*, for which Miss Igarashi Yumiko very graciously acted as interpreter, were wide-ranging and clarified many points for me. I am also grateful to Mr. Ōmori Tatsuji and Mr. Abe Nobuo, both of the Bridgestone Museum of Art, and to Miss Inoue Tsuneko and Mr. Mark Seralnick for their invaluable help with various aspects of this paper while I was in Tokyo.

20. See *L'Atelier de J. James Tissot*, Hôtel Drouot, Paris, July 9–10, 1903. Unfortunately, the descriptions given are extremely general: lot 2, meubles de l'extrême orient; lot 3. porcelaines de la Chine et du Japon et de l'Allemagne; lot 6. robes chinoises et japonaises en soie brodées. It has been suggested to the owner of *Jeunes femmes regardant des objets japonais* (Fig. 2) that the screen at the left of the picture is now in the collection of the Musée Guimet, Paris.

21. For *On the Thames, a Heron*, see also Michael Wentworth, "Tissot's On the Thames, a Heron," *The Minneapolis Institute of Arts Bulletin*, LXII, 1975, pp. 35–49.

22. The diary of Alan S. Cole, quoted in E. R. and Joseph Pennell, *The Life of James McNeill Whistler*, 2 vols., London: Heinemann, 1902, I: 189.

23. The same compositional formula is found, for example, in *The Widower* (1877; Art Gallery of New South Wales) and *Orphan* (1878; Private Collection, London), as well as numerous prints.

24. See "The Grosvenor Gallery Exhibition," *Athenaeum*, May 10, 1879, p. 607.

25. See J. Hillier, *A New Approach to the Japanese Print*, Rutland, Vermont, and Tokyo: Tuttle, 1975, pp. 85–86.

26. This question is treated in Michael Wentworth, *James Tissot*, Oxford: Oxford University Press, forthcoming.

27. For a discussion of the relationship between *japonisme* and photography, see Gerald Needham, "Japanese Influence on French Painting, 1854–1910," in *Japonisme: Japanese Influence on French Art*, Cleveland: Cleveland Museum of Art, et al., 1975), p. 116.

28. John Ruskin, "Fors Clavigera," in *Complete Works*, 39 vol., ed. by E. T. Cook and Alexander Wedderburn, London: Allen, 1907, VII: 161.

29. *J. J. Tissot: An Exhibition of Modern Art; The Prodigal Son in Modern Life, Paintings, Etchings, and Emaux Cloisonnés*, London, Dudley Gallery, 1882. nos. 71–91 were works in bronze and cloisonné enamel. Besides *Fortune* (no. 71), forms included vases, jardinières, tea pots, trays, a slab for a chimney piece, a monogram, and trial pieces.

30. *Exposition J. J. Tissot: quinze tableaux sur la femme à Paris*, Paris, Galerie Sedelmeyer, 1885. Tissot planned to issue etchings after the paintings which were to be accompanied by texts by authors including Daudet, Zola, and de Maupassant, but the religious crisis and conversion he experienced in 1885 caused him to abandon the project in favor of illustrating the Bible and only the first five etchings were completed.

31. The relationship of *La Femme à Paris* to contemporary developments in the visual arts is suggested by Henri Zerner in *James Jacques Joseph Tissot: A Retrospective Exhibition*, Providence, Rhode Island School of Design, and Toronto, Art Gallery of Ontario, 1968, introduction, n. p.

32. The Goncourts, like most of their contemporaries, traced the origin of Tissot's illustrations to the Biblical subjects of Horace Vernet and to the *peintres orientalistes* of Romanticism (*Journal*, IV: 559); Fernand Bourgeat may have been alone in suggesting that "ces perspectives presque japonaises, ces silhouettes se détachant, nettement découpées, sur les fonds," could be traced to Japanese prototype (*Salon de 1894*, Paris: Baschet, 1894, p. 59).

JAMES TISSOT, "DRAWING INSTRUCTOR" OF TOKUGAWA AKITAKE

Ikegami Chūji

Jacques-Joseph Tissot (born in Nantes in 1836 and died in 1902 at Buillon) is a modern French painter and etcher. He was often referred to as James. His name appears in the biographies of Manet, Whistler, Degas, with whom he was well acquainted, and as one of the early Japonisants (Japanophiles or connoisseurs of Japanese fine arts) his name is often mentioned along with those of Baudelaire, Manet, the Goncourt Brothers, Whistler, Burty and Degas.[1]

I have been studying the subject of Western interest in Japan for ten years or so, and have published a few articles about it.[2] Quite some time ago, in reading *Shibusawa Eiichi taifutsu nikki* (A Diary of a Sojourn in France by Shibusawa Eiichi)(Tokyo: Nippon Shiseki Kyōkai, 1928), I came across the words, "Drawing Instructor, *Chisō* (in Japanese)." While I was not sure, if the individual referred to as *Chisō* or *Chisou* were in fact Jacques-Joseph Tissot, the prominent Japonisant, it had to be the man well known to Japanese as the art teacher to Prince Tokugawa Akitake (Fig. 1), deputy of the fifteenth shogun Tokugawa Yoshinobu at the International Exposition of 1867 in Paris. I did not pursue this discovery, however, for over ten years, for there was no well organized body of literature available on Tissot at that time, and my interests were absorbed elsewhere.

Over these ten-odd years, however, the study of Tissot has improved considerably both in Europe and the United States. Beginning in the 1950s, several Tissot exhibitions were held in London where Tissot spent his most fruitful decade. In 1968, a big exhibition was held for the first time in the United States of over eighty of Tissot's works, including oil paintings, prints, and drawings.[3] A modest print exhibition in the spring of 1978 was held in London,[4] followed that summer by a complete print exhibition in the United States.[5]

It was quite recently that I have been able to obtain the catalogues of these exhibitions. The total number of Tissot's oil works is still not yet known, but thanks to *James Tissot: Catalogue Raisonné of His Prints* (see footnote 5), our understanding of his prints is now more detailed even that than of Béraldi. His biography, including detailed facts about his famous liaison with Mrs. Newton, is now much clearer. Among his oil paintings that show his interest in Japan are *Japonaise au bain* and *Jeune femme tenant des objets japonais*, two works of the 1860s about which more detailed knowledge has given scholars valuable insights into his relations with Japan.[6]

Intrigued by this connection with Japan, I read over *Shibusawa Eiichi taifutsu*

Fig. 1. Tokugawa Akitake, ca. 1867.
Photograph, probably taken in Paris.
Courtesy Mr. Takahashi Zenshichi,
Fukuoka.

nikki, and studied *Tokugawa Akitake taiō kiroku* (A Record of Tokugawa Akitake's Sojourn in Europe), an extensive three volume collection of official papers.[7] This reprinted edition, unlike the earlier edition I referred to issued by the Nippon Shiseki Kyōkai, contains detailed bibliographical notes. In these bibliographical notes (supplied by Professor Konishi Shirō of Tokyo University), I discovered that there was an unpublished diary by Tokugawa Akitake. A number of people accompanied Tokugawa Akitake on his visit Europe, but only the diary of Shibusawa Eiichi was reported to Japanese historians, according to Prof. Konishi. The diary by Akitake himself is valuable as a historical document in itself, but all the more meaningful to me as a source for investigating the connection with Tissot.[8]

Prince Tokugawa Akitake (1853–1910) was the eighteenth son of Tokugawa Nariaki of Mito, brother of Tokugawa Yoshinobu, and he became the last lord of the Mito clan.[9] He succeeded as head of the Shimizu family in 1866. The following year, as shogunal deputy, he participated in the International Exposition held in Paris representing the Tokugawa government (Fig. 2). He was assisted by several officials including Mukōyama Hayatonoshō (Minister to France), Tanabe Taichi, Shibusawa Atsudayū (Eiichi), and two interpreters (namely the French missionary Mermet de Cachon and Alexandre, the son of Siebold). Tanabe Taichi and Minister Mukōyama, however, were released and sent home after certain diplomatic failures;[10] in their place Kurimoto Joun was dispatched as a special envoy to France in the summer of 1867.[11]

Neither the Tokugawa Akitake party nor the government that sent it to France imagined that the Meiji Restoration was about to take place. Akitake was scheduled to stay in Paris after the Exposition as a student and to acquire a a broad Western education in preparation for his future career. He was a young aristocrat who might well have become the sixteenth shogun succeeding his elder brother, Yoshinobu. Consequently, for about ten months after the closing of the Exposition in the autumn of 1867 until the summer of 1868, he studied a variety of subjects including fencing, gunnery, swimming, horsemanship, languages, drawing, and gymnastics. Most of his curriculum, it seems, was decided upon before his departure from Japan, which indicates that the leading figures of the shogunal government had particularly high hopes for him.[12]

The Meiji Restoration which overthrew the Tokugawa government completely changed Akitake's future. He returned home at the end of 1868, to succeed as head of the Tokugawa family of Mito; and he later became Prefect of Mito. Following the wishes of his father, Nariaki, he devoted himself to the settlement of Hokkaido. Later, from 1878 until 1882, he went to France for further study. The year 1878 coincided with the opening of the third Exposition in Paris, but we know almost nothing of his stay there at that time.

Akitake was known as Ranzan. Kurimoto Joun, in his *Gyōsō tsuiroku* (Memories), reported Akitake as was saying: "Whenever I see Napoleon, his appearance is disheveled and he speaks awkwardly, like an incompetent. Even at a ball, his left hand twists his moustache, while with his right hand he strokes a rib as he strolls silently. Only sometimes does he take up a cup by himself and serve others."[13] The Napoleon referred to here is, of course, Napoleon III. It seems that Akitake was not much impressed with the French Emperor, then around 60 years of age. The Japanese Prince was rather more friendly with Prince Eugène-Louis Napoleon, mentioned in Akitake's diary as the "Prince Impérial."

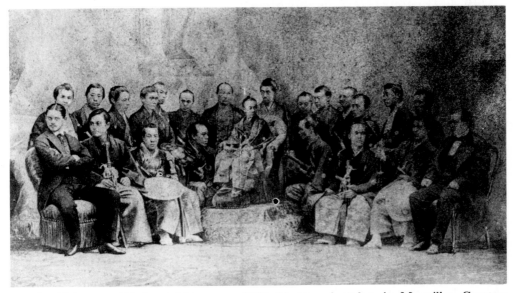

Fig. 2. Tokugawa Akitake and his party, 1867. Photograph, taken in Marseilles. Courtesy Mr. Takahashi Zenshichi, Fukuoka.

This is probably because they were of the same generation, the Prince being just three years younger than Akitake. When Akitake returned to Paris ten years later, however, France was already in The Third Republic; most probably he never met Eugène-Louis during that visit.

Let us now read and compare the diaries of Shibusawa Eiichi and Tokugawa Akitake. The dates of Shibusawa's diary are written by both the solar and lunar calendars while the latter uses only the lunar calendar. I will use the lunar calendar date with the solar date in parentheses. The following entries are those for 1868, the first year of the Meiji era.

Shibusawa's February 14 (March 7) entry reads, "To begin lessons of drawing, the Colonel brought a drawing instructor with him. Agreed to commence from tomorrow the 15th, 12 times a month, from 12:30 to about 2:00, 30 francs per lesson."[14] (The Colonel was a French officer named Wilette who was responsible for attending to the needs of Akitake and his party.) As later entries suggest, the number of lessons recorded does not seem to have been strictly adhered to. Thirty francs per lesson would have been considered quite good renumeration by comparison with that which young painters like Monet or Cezanne were to receive.[15]

Akitake's diary states for Feb. 15 (Mar. 8): "From today a painter comes to give lessons two or three times a week. Companions Bunjirō and Heihachirō." It is not clear what kind of art lessons they were receiving, whether oil, print, watercolor, or sketching; only that study companions were provided for the Prince, as befitting a nephew of the shogun. One was Yamanouchi Bunjirō, and the other Kikuchi Heihachirō. (Heihachirō can also be read Kunihachirō, but there was no person in the party accompanying Akitake with such a name.) Shibusawa's diary states on the same day, "Drawing instructor appeared. Given one hour lesson."

On Feb. 18 (Mar. 11), Shibusawa's diary reads, "Drawing instructor appeared in the evening,"[16] although Akitake's diary does not mention it. On Feb. 22 (Mar. 15), Shibusawa mentions, "Drawing instructor appeared in the morning,"[17] and Akitake, "Painter came at 9:00, and we had a lesson." On Feb. 29 (Mar. 22), Shibusawa writes, "Painter appeared in the morning. Had drawing lesson," while Akitake writes nothing about that morning but only records that he had some instruction in horseback riding in the afternoon.

Later entries in Shibusawa's diary relate that the drawing instructor presented himself on the evening of Mar. 4 (Mar. 27) and in the morning of Mar. 6 (Mar. 29),[18] although Akitake does not make any mention of the fact. In general, Shibusawa writes in great detail while Akitake tends to be rather simple, a difference probably due to their ages and their different positions.

On Apr. 24 (May 16), also according to Shibusawa's diary, "The Colonel, Flury-Hérard, Cachon, Boissière, *Chisō* (Tissot) and others, 26 people altogether, had a big party."[19] It appears that a dinner was arranged by the Japanese delegation for their French hosts. Whether Akitake was present or not is unclear —his diary does not record this event. For the first time, however, the name *Chisō* and appears. In the Apr. 29 (June 19) entry,[20] Shibusawa writes: "In the evening after dinner, we went for a walk accompanied by the Colonel, the draw-

ing instructor, Atsudayū, Tanzō, Yunosuke and others."[21] It notes that the drawing instructor, *Chisō* (Tissot), not only gave lessons in painting drawing, but also joined in the promenade.

Two days later, on May 2 (June 21), Shibusawa's diary reads, "After lunch called at residence of the drawing instructor,"[22] and in Akitake's on the same day we find, "After lunch visited *Chisō*'s." Here both descriptions coincide. The assumption that *Chisō* or *Chisou*'s dwelling was located on the Champs-Elysées will be further discussed later.

After these entries, Akitake's diary makes no reference to *Chisō* nor to a painter, although Shibusawa's states on June 3 (July 22) that, "From today the drawing instructor leaves for a journey; thus his absence."[23] A little while later, Akitake and his delegation also left for an inspection trip to Normandy, Brittany and Touraine, discontinuing their lessons in Paris. The party returned to Paris on June 23 (Aug. 11) and began preparations for their voyage home. On July 21 (Sept. 7), it states, "In the afternoon, told the Colonel that lessons by the language instructor and drawing instructor would be terminated shortly."[24]

Likewise Shibusawa's diary on Aug. 5 (Sep. 20) states, "In the afternoon the painter appeared. Had photographs."[25] The meaning of this is not clear. Had they perhaps taken some souvenir pictures together with the painter? On Aug. 15 (Sep. 30), the diary notes the official dismissal of the Prince's teachers: "Gave notice of dismissal to language instructor Boissière, drawing instructor Chisō, riflemanship instructor Spirmond, and so forth." Then, on the next day (and this is the last notation of interest to me), Aug. 16 (Oct. 1), Shibusawa states, "In the afternoon called at Chisō's accompanied by Tanzō and the Colonel."[26] The honorific verb, "okoshi" is always used for Akitake; he might have been invited to Chisou's house with his companions or visited to present a parting gift.

These collective references in the diaries of Shibusawa Eiichi and Akitake clearly indicate that Akitake took lessons from a "drawing instructor" named either *Chisō* or *Chisou* in 1868 in Paris. Even after careful scrutiny, however, it is not completely clear whether the names written in Japanese phonetic letters refer to the first name or surname of the painter, and it is difficult to judge the spelling of the original French name. We can assume that it was the painter's surname, since the other persons mentioned, including Flury-Hérard, Cachon, and Siebold, were noted by surname. We have no clear indication of the first name of the art instructor, and no other clues seem to be available in the literature available in Japan.

A perusal of biographical dictionaries of Western artists, such as Thieme-Becker and Bénézit, both of which are quite comprehensive, reveals that James Tissot is the only possible person with a name resembling the Japanese "Chisō" or "Chisou."

The references to James Tissot in these dictionaries indicate no details about the year 1868, and there is no better information in the biographical notes and essays in the catalogs of the Tissot Exhibitions in Europe or the United States mentioned earlier.[27] About the year 1868 the only information we have is a list of his works passed for showing at the Salon. Nothing is included regarding

his relationship with Akitake, although we cannot assume there was thus no relationship.

Incidentally, Akitake writes on May 11, 1867 in his diary that he moved to a "new residence" which had just been refurbished from a hotel. Checking this point with Shibusawa Eiichi's diary, it becomes clear that it was still the Grand Hôtel on the boulevard des Capucines when they arrived in Paris in the spring of that year. The new address of Akitake's party beginning May 11 (June 13) was No. 53, rue Pergolèse, quartier Passy.[28] The Grand Hôtel and the rue Pergolèse still exist today; the drawing instructor must have gone to the latter to teach.

As it happens, James Tissot had lived at a good address at No. 64, avenue de l'Impératrice since 1867.[29] Today this is the avenue Foche situated very close to the rue Pergolèse. It would have been a convenient distance to go to teach and would not have necessitated too much of a detour to accompany Akitake's walks around the Champs-Elysées or in the Bois de Boulogne. Akitake often went walking or horseback riding in the Bois de Boulogne. His diary frequently mentions a "flower garden" where it seems he often went to the "woods."

Finally, I would like to mention here certain other evidence supporting the hypothesis that Tissot was indeed the "drawing instructor." This is an entertaining, satirical essay called "La mode des japoniaiseries" written by Champfleury in *La Vie parisienne* on November 28, 1868. It describes how a young painter opened "l'atelier japonais" in his home on the Champs-Elysées, and that the distinguished ladies and gentlemen who frequent the house amuse themselves by dressing up in Japanese costumes and in strange attire. It is easy to guess that "un poète" in the article was actually Baudelaire and that "un jeune peintre américain" refers to Whistler. No actual name for "un jeune peintre" was given either, but as Mr. and Mrs. Lacambre note, it could be no other than James Tissot.[30] The avenue de l'Impératrice, where he lived, could very well be included in the Champs-Elysées. Moreover the existence of works by him, as mentioned previously, like *Japonaise au bain* and *Jeune femme tenant des objets japonais* do match those described in Champfleury's article.

The word "japoniaiseries" in the title of the article, was probably a newly-coined word combining *japon* and *niaiserie* (nonsense). The essay is in general quite cynical, containing other expressions such as "L'imitation est un fauteuil commode," and "L'atelier japonais est 'un signe du temps' dirait Prudhomme." However, in 1869, Champfleury published an odd book, *Les Chats*, which dealt with the subject of cats as they appeared in the literature and art of various periods and countries. One chapter in this book comments on Hokusai's use of various figures of cats with prints from Hokusai's *Manga* as illustrations at the end of the chapter. He must have been writing *Les Chats* when he published his article on Japoniaiserie.[31]

For my purposes, however, the most important factor is the date Nov. 28, 1868 when the Japoniaiserie article was published. As described earlier, Akitake's "drawing instructor" was discharged on September 30 and Akitake visited the instructors' house on October 1. Akitake and his party were supposed to have left Paris during October on their way home.[32] In other words, the opening of

Tissot's "Atelier Japonais" occurred soon after. This cannot but convince us that the "drawing instructor" and James Tissot were one and the same person.

In this essay, I have limited my subject to the question of the identity of the "drawing instructor" and therefore have not touched on Japanese influence in Tissot's works. We do not know what kind of painting Akitake and his companions learned from their instructor in Paris. None of their works are preserved either in France or Japan. If there were photographs of Akitake and others with the painter, my point could be very easily confirmed, but again we must await further investigation and study. As we have seen, however, it is clear that Akitake's "drawing instructor" was, in fact, James Tissot himself, Japonisant and collector of Japoniaiserie.

<p style="text-align:center">* * * * * *</p>

In May 1980 I located a portrait in watercolor of Prince Akitake, with the signature of J. J. Tissot and the date: 27 septembre, 1868 (Pl. IV and Fig. 3). This work verifies the point I have made (May 26, 1980).

Fig. 3. Detail of James Tissot, *Portrait of Tokugawa Akitake*, 1868. Watercolor on paper. Historical Museum of the Tokugawa Family (Shōkōkan), Mito. Inscription: *Paris/27 septembre/1868/au prince Mimboutaiou/souvenir/affectueux/ J. J. Tissot.*

NOTES

1. As an example, see the opening part of "Ōbeijin no ukiyo-e kenkyū" by Nagai Kafū, *Mita Bungaku*, vol. 5, no. 2 (Feb., 1949), summary of the outline of *A History of Japanese Color-Prints* by W. von Seidlitz. The same is published in *Edo geijutsu ron* (*Kafū zenshū*, vol. 14), Tokyo: Iwanami Shoten, 1963.

2. See my articles, "Paul Gauguin and Japanese Painting—in connection with the introduction of several japonaiseries owned by Gauguin," *Bijutsushi*, no. 65 (June 1967), pp. 1–17, and "Le Japonisme de Felix Bracquemond en 1866," *Kenkyū*, Kobe University Bungakukai, no. 43 (Mar. 1969), pp. 30–62.

3. H. Zerner, D.S. Brooke, M. Wentworth, *James Jacques Joseph Tissot*, Museum of Art, Rhode Island School of Design, Providence, Feb. 28–Mar. 29, 1968; The Gallery of Ontario, Toronto, Apr. 6–May 5, 1968. Please refer to the following articles as well. Henri Zerner, "The Return of 'James' Tissot," *Art News*, vol. 67, no. 1 (Mar. 1968), pp. 32–35 and 68–70.

4. Jane Abdy, *J.J. Tissot—Etchings, drypoints and mezzotints*, London: Lumley Cazalet Ltd., Mar. 15–Apr. 21, 1978.

5. M.J. Wentworth, *James Tissot: A Catalogue Raisonné of His Prints*, Minneapolis Institute of Arts, May 25–July 16, 1978; Sterling and Francine Clark Art Institute, Aug. 5–Sept. 17, 1978.

6. Text illustrations nos. 2 and 3 in my articles, "James Tissot's Interest in Japan," *Ukiyo-e shūka*, no. 5 insertion, Tokyo: Shōgakkan, 1979.

7. *Shibusawa Eiichi taifutsu nikki* [Shibusawa Eiichi's Diary of a Sojourn in France] (Nippon Shiseki Kyōkai Sōsho, no. 126), first edition in 1928, reissued in 1967 by Tokyo Daigaku Shuppankai. *Tokugawa Akitake taiō kiroku I–III* (the aforementioned Sōsho nos. 146–148), published in 1932, reissued in 1973 by Tokyo Daigaku Shuppankai.

8. Attempting to read the diary written in brush calligraphy on Japanese paper was more difficult than reading the autographs of Degas or Cézanne. I would like to thank my colleague, Assistant Professor, Fujii Jōji of Kōbe University for his assistance in deciphering the important passages.

9. *Nihon jinmei daijiten*, Tokyo: Heibonsha, first edition published in 1937, first republication in 1979. *Bakumatsu Meiji jinmei jiten*, Tokyo: Gakugei Shorin, 1978.

10. Tanabe Taichi, *Bakumatsu gaikōdan* (Tōyō Bunko), translated, revised and annotated by Sakata Seiichi, Tokyo: Heibonsha, 1966, vol. 2, chapter 16 "Paris hakurankai."

11. Kurimoto Joun, *Gyōsō tsuiroku*, in *The Collection of Narushima Ryūhoku, Hattori Bushō and Kurimoto Joun* (Meiji Bungaku zenshū, vol. 4), Tokyo: Chikuma Shobō, 1969.

12. For details on Akitake and his party's stay in Paris, see Takahashi Kunitarō, "Around the Young Envoy Akitake—the First Expo Participated in by Japan," *Kokusai bunka*, nos. 143–136, 148–150 (May–Aug., Oct.–Dec. 1966). No reference, however, was made of Akitake's diary or to the "Drawing Instructor."

13. *The Collection of Narushima Ryūkoku, Hattori Bushō and Kurimoto Joun*, op. cit., p. 310.

14. *Shibusawa Eiichi taifutsu nikki*, op. cit., pp. 249–250.

15. My translation, *Cézanne no tegami* (Letters of Cézanne), Tokyo: Chikuma Shobō, 1967, pp. 60–61, a letter of March 3, 1861 from Zola to Cézanne. A fledgling painter like Cézanne could subsist on 125 frames per month in 1860 on 1861.

16. *Shibusawa Eiichi . . .* , op. cit., p. 251.

17. Ibid., p. 253.

18. Ibid., pp. 260—261.

19. Ibid., p. 283.

20. The reason why the dates of the solar and the lunar calendars differ so much from here is simply becuase an additional "leap April" of 29 days was inserted.
21. *Shibusawa Eiichi . . .* , op. cit., p. 298.
22. Ibid.,
23. Ibid., p. 312.
24. Ibid., p. 341.
25. Ibid., p. 347.
26. Ibid., p. 352–353.
27. See notes 3, 4 and 5.
28. *Shibusawa Eiichi . . .* , pp. 43 and 79.
29. See chronological record of the catalogue mentioned in note 4. However, according to the following document edited and annotated by Mr. and Mrs. Lacambre, Tissot was living on the rue Bonaparte in 1867. In 1868, according to the catalogue of the Salon of that year, he was living on the avenue de l'Impératrice. Champfleury, *Le Réalisme*, textes choisis et présentes par Geneviève et Jean Lacambre, Paris: Hermann, 1973, p. 143, note 1.
30. Champfleury, ibid., p. 143, note 2.
31. The ad-poster of *Les Chats* was *Rendez-vous des Chats*, a lithograph by Edouard Manet.
32. Akitake's diary was discontinued on June 14 (Aug. 2), 1868, while *Paris gozaikan nikki* which was continued in the *Shibusawa Eiichi taifutsu nikki* terminated August 26 (October 11) of the same year. 'November 11' mentioned on page 360 of the republished edition referred to in note 7 must be an error in writing of Shibusawa or a printer's typographical error.

MONET AND RENOIR IN THE MID-1870s

Ronald Pickvance

This paper will be modest in scope, question-asking rather than profoundly questioning, exploratory, hesitant and ultimately inconclusive. I was asked to speak on Monet and Renoir for the purposes of this symposium. Certainly the linking of these artists can be made easily and naturally, like Gorgione and Titian, say, or Picasso and Braque, but the linking may seem odd in an inquiry into the nature and extent of Japanese influence on their art. In the literature on Impressionism references are constantly made to Monet and Japan, from his early landscapes to the creation of his Japanese garden at Giverny. But scarcely anything has appeared on Renoir and Japan, mainly because most writers have concluded that there is little to say. Following this established pattern, I could well have made a brief mention of Renoir and then concentrated on Monet. I have chosen to do otherwise. Indeed, I have deliberately selected a short period of some five years—years which coincide with the so-called "heroic period" at Argenteuil, when Monet and Renoir achieved their first mature statement of the Impressionist style in their landscapes. But rather quixotically, I have excluded these landscapes from my discussion and limited myself to a consideration of some of their figure paintings executed between 1871 and 1876.

I begin, however, with a painting that was exhibited at the Paris Salon of 1873. It is entitled *La Toilette Japonaise* and it is by a now virtually forgotten artist Firmin-Girard, who was born in 1838 and died in 1921 (Fig. 1). This painting was singled out for special mention by the art critic Castagnary, who wrote, "M. Firmin-Girard has wished to make an excursion to Japan, a fantasy of a Naturalist who likes to propose problems with his brush. The result of this is *La Toilette Japonaise*, which is one of the most successful works in the Salon. There is notably an open window through which one sees the sky, the beach, and a bit of sea. It's delicious in finesse and truth. I stop in front of this little picture because it is the caprice of a man of talent whom, I'm sure, will not delay long in coming back from these exotic subjects to France, where it will be better for him to operate."

"This small canvas is one of the most successful pictures in the Salon," Castagnary noted. Yet he ignores the point of the picture—the three Japanese women surrounded by their accessories and furnishings and involved in their

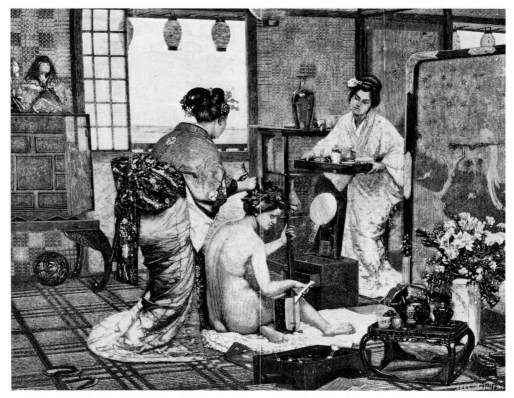

Fig. 1. *La Toilette Japonaise*, after the painting of Firmin-Girard.

toilette, and he prefers to look through the open window at the view of beach, sea, and sky. He sees the fantasy and caprice of Firmin-Girard as but a temporary infatuation with the exotic East and hopes the artist will soon return to French subjects.

Certainly, few artists who adopted Japonisme could have shown such an agglomeration of Japanese props in so small a canvas, nor could they have tried to give such a complete impression of a Japanese interior. Here is everything that one would expect: vases, screens, fans, lanterns, furniture, and so on. It is as if Firmin-Girard had collected them himself in the fever of the Japanese explosion following the International Exhibition in Paris in 1867. On the other hand, there seems to be no evidence that he had in fact himself been to Japan. The style of the painting remains European, the modelling owes something to Ingres and Gleyre and, interestingly, Firmin-Girard, like Whistler, Monet and Renoir, had been a pupil of Gleyre. The space is wholly Western; there is no flattening, no strong contours, and, presumably no simplified colors—at least as far as one can tell from a wood-engraving of the painting.

My second illustration is familiar to those who saw the exhibition *Japonisme* at Cleveland in 1975, or who have looked at the catalogue. This is a painted porcelain panel dated 1886, by an obscure artist called Henri Catelin, who submitted porcelain and faience copies based largely on other artists' designs to the Salon from 1869 onwards (Pl. V). Coincidentally, the design is derived from

Firmin-Girard, whose japonisant tendencies are still couched in European terms. Interestingly, the pseudo-lacquer wooden frame contained a sequence of droll and humorous elements, which have been lifted from various volumes of Hokusai's *Manga*, a practice that had become vieux jeu by 1886. I am not suggesting that Firmin-Girard was an ardent Japonist. Indeed, these two images are the only ones that I have been able to discover from him in the period from 1873 to 1886, but they do show something of the prevalence and all-pervasiveness of Japonisme during these years. Chesneau's famous list of 1878 can be extended beyond Manet, Tissot, Fantin-Latour, Hirsch, Degas, Carolus-Duran, Stevens. Firmin-Girard, in other words can join other juste milieu artists, Tissot and Stevens among them, as a purveyor of Japonisme. Japonisme represented the notion of the exotic, the romantic, a new vision of the recently opened cultural contacts with a distant country in the Orient. The cult of Japonisme could replace the cult of the Near Eastern, the harem, and the odalisque, with its specific props and accessories.

In 1872, Renoir completed a painting which he called *Parisiennes habillées Algériennes* and which is now usually called *The Harem*. It marked the continuation of a tradition that went back to Delacroix and, indeed, to other French artists— the romantic exoticism of North Africa. Renoir is reported to have said that you could smell the incense in Delacroix's *Femmes d'Algers* of 1834, and in this large painting (it measures 157×130 centimeters) as in other less ambitious pictures, including a *Femme d'Alger* dated 1870 and exhibited in the Salon of that year, Renoir constantly sought to reinterpret Delacroix's color and incense. Renoir himself had not been to North Africa, but his close friend Claude Monet had spent almost two years in Algeria as part of his military service in 1860-62. He presumably borrowed the props and accessories that he used both in the *Femme d'Alger* of 1870 and in *The Harem* of 1872. And in both pictures, he is quite honest. These are Parisian models dressed up as Algerian women. Just as Firmin-Girard assembled his Japanese accessories, so Renoir did the same. However, *The Harem* was refused at the Salon of 1872. Not inappropriately, given the context of this symposium, it now belongs to the National Museum of Western Art, here in Tokyo. Paris and North Africa, or Paris and the Near East (the geographical distinction was not always clearly observed) have ended up in the Far East.

But could Renoir abandon this latter-day Romantic imagery and submit himself to the new wave of Japonisme? The year 1872, after all, saw Burty's baptism of the cult of Japan as "Japonisme." Two pieces of evidence from close friends of Renoir suggest a rather negative response. The first, ironically enough, involves the high priest of Japonisme, Burty himself. According to Vollard, Renoir's dealer and biographer, whose reported conversations with the artist are not always to be trusted, Renoir recalled: "During the exhibition of 1889 (and by that presumably he means the International Exhibition in Paris of that year), my friend Burty took me to look at Japanese prints. There were good things among them, I wouldn't deny that, but on leaving the room, I saw a Louis XIV armchair, covered in a little tapestry, and there couldn't have been anything more simple, I would have embraced that armchair." And Georges Rivière, close to Renoir in the 1870s (certainly at least from 1875 onwards) wrote in 1921,

"Renoir escaped from this influence of Japanese art. Never at any moment was he influenced by it. The people in Japanese prints didn't respond in any manner to the conception which he always had of feminine grace. He never had the slightest taste for Japanese printmakers, very inferior, according to him, to French eighteenth-century engravings."

Renoir's dismissal of Japonisme would seem to be confirmed when one looks at his figure paintings executed between 1864 and 1890. There is no figure painting in which he dresses up a Parisian model in Japanese clothes, none where he tries to summon up a Japanese interior or setting as Firmin-Girard had done in his Salon offering of 1873, none in which a Japanese print or print album rests on a table, or is being leafed through by a sitter. (I am, of course, excluding *Mme Charpentier and Her Children* from this discussion). The only concession he makes to Japanese fashion is the occasional introduction of a Japanese fan into his single portraits or studies of women, and between the years 1871 and 1886, this occurs in only six instances. Perhaps the most interesting and obvious of these is the *Femme à l'éventail*, painted around 1879–80, now in the Clark Art Institute, Williamstown, Mass. Here, the young model, seated, bust-length, holds—indeed displays—a fan whose decoration is more clearly seen than in any other of Renoir's pictures. In other instances, the fan held by the sitter or model is either not shown frontally or is too indistinct for its decoration to be identified.

However, there is one other picture, which, conveniently enough, is also in the Clark Art Institute, where fans play a much more significant role. Instead of one fan being held by the sitter, three fans are hung or suspended on the background wall, but although seen frontally, each of these fans is cut by the frame (Pl. VI). Their individual designs, therefore, are again difficult to identify. Renoir has included them in his picture because they belonged to the sitter and her husband. The sitter is Mme Camille Monet, and the portrait was painted in Monet's house at Argenteuil. Looking at this portrait by Renoir, a relaxed, informal image of a fashionably dressed parisienne reading in her own home, we notice the overall decorative design, jumping from the rectangular sequences of the sumptuous dress to the sinuous, organic, rising design of the footstool and sofa, and culminating in the colorful accents of the three fans. Few other paintings by Renoir have such an all-over insistence on decorative pattern and surface texture. But is it necessarily two-dimensional? Does it respond, even in Western terms, to Japanese pictorial organization? It seems to me that Renoir has simply indulged himself in the given play of colorful decorative pattern and rich surface textures. The lighting and modelling remain European. Indeed, one might say that this could belong much more to the eighteenth-century French tradition. Yet it is the only painting of the period from 1872 to 1890 where he indulges so fully in this exploitation of decorative surface patterns.

Compare another portrait of Camille by Renoir, now in the Gulbenkian Museum in Lisbon. Apart from the dress, which is identical to that in the first picture, this painting is an affair of smoothly brushed areas dominated by plain, undecorated surfaces, whether of sofa or cushions and it does not include any Japanese prints. But here Camille reclines. We are reminded of Manet's portrait

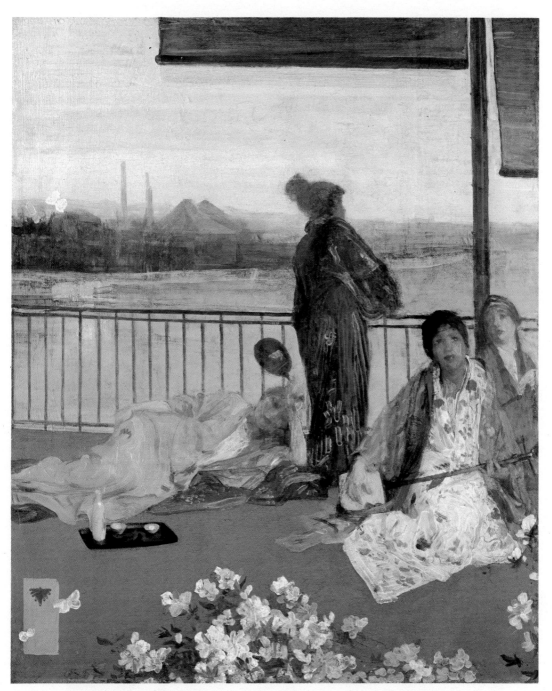

Pl. I. James McNeill Whisler, *Variations in Flesh Color and Green: The Balcony*,
1864–70. Oil on wood panel. Freer Gallery of Art, Washington, D. C.

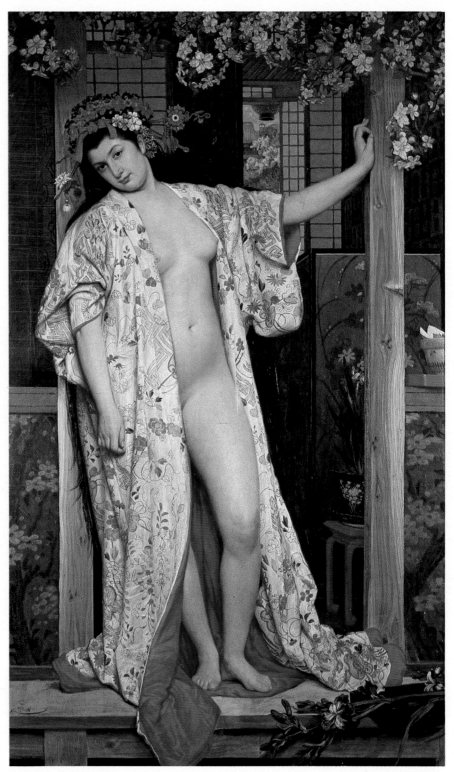

Pl. II. James Tissot, *Japonaise au bain*, 1864. Oil on canvas. Musée des Beaux-Arts, Dijon, Joliet Bequest.

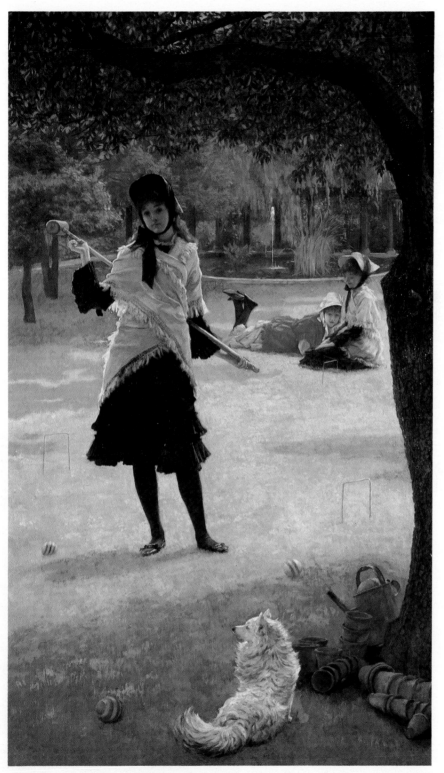

Pl. III. James Tissot, *Croquet*, 1878. Oil on canvas. The Art Gallery of Hamilton, Ontario, Gift of Dr. and Mrs. Basil Bowman in memory of their daughter, Suzanne.

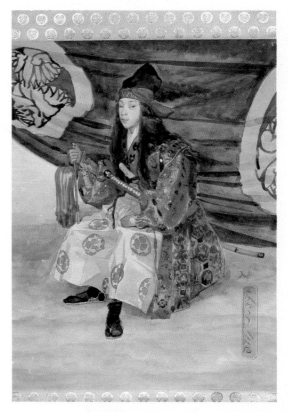

Pl. IV. James Tissot, *Portrait of Tokugawa Akitake*, 1868. Watercolor on paper. Historical Museum of the Tokugawa Family (Shōkōkan), Mito.

Pl. V. Henri Catelin, framed plaque, 1886. Painted pseudo-lacquer wooden frame and painted porcelain panel after a design by Firmin-Girard. Private Collection, Paris.

Pl. VI. Auguste Renoir, *Madame Claude Monet lisant*, 1872. Oil on canvas. The Sterling and Francine Clark Art Institute, Williamstown.

Pl. VII. Claude Monet, *La Japonaise*, 1876. Oil on canvas. Museum of Fine Arts, Boston.

Pl. VIII. Pierre Bonnard, *Le Peignoir*,
1892. Oil on cloth. Musée National d'Art
Moderne, Paris.

Pl. IX. Alexandre Charpentier, *Mother and Child*, from the series *En Zèlande*, ca. 1894. Color embossed lithograph. Rutgers University Fine Arts Collection, New Brunswick.

Fig. 2. Edouard Manet, *La Dame aux éventails*, 1873. Oil on canvas. Musée du Louvre, Paris.

of Nina de Callias, which conflates the two Renoir portraits, in the reclining pose and in the Japanese fans on the background wall (Fig. 2). And we presume that this was Nina de Callias' own salon rather than Manet's studio. Clearly, by 1873 at least, a Bohemian salon in Paris was using Japanese accessories. But did Manet and Nina de Callias give Monet and Camille a lead in displaying their collection of fans in a similar way? It is possible. What evidence is there among Parisian households in the 1870s of displaying Japanese fans in this way? Was it confined to an artistic or Bohemian milieu rather than a bourgeois or upper bourgeois one?

When did Monet and his wife begin collecting Japanese fans, or, indeed, Japanese prints? The published sources do not provide a straightforward answer. Some suggest that Monet first discovered Japanese prints as grocery wrappings in the port of Le Havre in the late 1850s. Others, that he discovered Japonaiserie on a cigar box lid in Holland in 1871, or that he was given a free lot of Japonerie when he bought a Delft vase on that same trip to Holland in 1871. But London also looms as a possibility if we accept that Monet's own portrait of Camille, generally known as *Repose* or *Meditation*, was painted there in 1870–71 (Fig. 3). It shows Camille reclining on a sofa with a mantel shelf behind on which there is a fan and a vase, reminiscent of some of Whistler's paintings (cf. *The Little White Girl*).

Renoir's painting of Mme Monet, however, provides more plentiful evidence. We cannot be sure when it was painted. It is usually said to be 1872. Yet Camille wears the same dress in another portrait of her, this time by her husband, Monet, which is dated 1875 and which is now in the Barnes Foundation, Philadelphia. Would Camille, whom we are led to believe was extremely fashion-conscious,

Fig. 3. Claude Monet, *Méditation* (*Madame Monet au canapé*), 1871. Oil on canvas. Musée du Louvre, Paris.

have worn the same dress in 1875 that she was wearing in 1872? The other solution is to propose either that the Renoir canvas can also be dated to 1875 (which is stylistically unlikely), or that the signature and date on the Monet painting were added after the event. That picture was included in the Impressionist sale in Paris in March, 1875, so the latter possibility is not too unlikely. However, for the moment, Monet's portrait shows what would appear to be the same sofa with the same cushions and the same matting on the floor. Thus, the setting is the same as in Renoir's portrait. Monet, however, has created an all-over design using the leaves of the various plants to give a Japanese-like unity, almost, one could say, à la Whistler. However that may be, Renoir would of course have known Manet's *Repos*, that life-size portrait of Berthe Morisot, painted before the Franco-Prussian War, but not exhibited until the Salon of 1873. Interestingly, Manet has introduced a Japanese triptych on the background wall, and Berthe Morisot holds a Japanese fan in her right hand. Manet's *Repos* helps to emphasize again the essentially decorative, patterned effect of the much smaller Renoir canvas.

Neither Renoir nor Monet, however, has done much more than acknowledge the presence of Japanese fans and prints as exotic and intriguing accessories. Monet himself had discreetly introduced a Japanese fan in his earlier painting of Camille, *Repose*, and in his 1875 portrait. Otherwise there is nothing in Monet's surviving figure paintings before 1876 to suggest that he was either an avid collector of Japanese objects or was greatly influenced by them.

But taking hints from both Manet and Renoir, he proceeded to produce the most startling image of, and, indeed, homage to the cult of Japonisme. This was

La Japonaise, now in the Boston Museum of Fine Arts, which he showed at the Second Impressionist Exhibition in 1876 (Pl. VII). In fact it was catalogued under the title *Japonerie*, and Monet himself referred to it as such in his carnet of the period. But why did he choose to paint it? He gave one reason when asked about it by René Gimpel in 1918, "I had exhibited at the Salon *The Woman in Green*, which had obtained a very large success, and I was advised to paint a sort of pendant. So, *Japonerie* was conceived of as a pendant to Camille or *La Robe Verte*." The success of the Salon of 1866, painted in four days according to the critic Thoré-Bürger, *The Woman in Green* (also known as Camille) measures 231 by 151 centimeters; *Japonerie* measures 231 by 142 centimeters. Looking at the earlier painting of 1866, it is clear that Monet is not yet responding to the Japanese print, but to the current vogue of the fashion plate, and that certain mannerisms in the conventions of the fashion plate have been taken over by Monet in that picture. In that sense, he was a little behind the times. He could have looked at Whistler's *La Princesse du Pays de Porcelaine*, exhibited at the Salon of 1865. (*La Princesse* is in danger of becoming the heroine of this symposium.) But Monet also told René Gimpel: "They tempted me in showing me a marvellous robe in which the embroideries had several centimeters of thickness." Who tempted him? Could it have been the art critic Armand Silvestre, who, in a brief sentence in his review of the Second Impressionist Exhibition, said: "M. Monet has sent a Japonerie of large dimensions, where one will find again all the qualities of the painter of *The Woman in Green*." Three years earlier in his introduction to Durand-Ruel's collection of etched illustrations of works in his gallery, Silvestre noted for the first time in print, I believe, the influence of Japanese prints on Monet's landscapes. Silvestre then could have encouraged Monet to paint *La Japonaise*.

There is, however, a stronger candidate. On October 10, 1875, Monet wrote a letter to Philippe Burty (and if Whistler's *Princesse* is the heroine, I'm sure that Philippe Burty will be the hero of this symposium). Unfortunately, the full text of the letter has not been published, but a precis of it in a Paris autograph dealer's catalogue reads: "Il est en train de peindre une des fameuses robes d'acteur. C'est superbe à faire." It seems that Burty, the high priest of Japonisme, has struck again.

It was in 1875 that Burty had first persuaded Félix Buhot to begin his set of etchings after Japanese objects in Burty's own collection. In the Salon of that year, Buhot exhibited a watercolor with the title of *Japonisme*. The inference from the precis of Monet's letter is that Burty had encouraged him to use the richly embroidered actor's robe; and Burty may also have provided the artist with it. On the other hand, there is some evidence to support the assumption that Monet himself owned such a robe. In another carnet entry of July 1877, he itemizes a sale for 2,000 francs of two frames, two Japanese dresses and three plates. Monet was clearly working on this canvas from the context of that letter, in October 1875, but we don't know how long he continued to work on it, whether in fact it was a repeat four-day miracle like the earlier *Woman in Green*. No other contemporary letter survives, and although the painting is dated 1876, this could have been added just before he chose to exhibit it at the Second Impressionist Exhibition. And *Japonerie* sold for 2,000 francs, so it was a commercial success.

The critical reception was mixed. *La Japonaise* was seen as a Parisienne dressed up, "essayant une robe du théâtre *Japonais*," and the spectacular effect of the dress was commented upon. One nationalist critic interpreted the open fan held by Camille as a reference to the tricolore. But, rather surprisingly, only three critics made reference to the fans on the background wall. One referred to Camille being framed in some thirty Japanese fans; another to those fans being suspended in the void by an incomprehensible miracle of equilibrium; only the third referred briefly to their design: "Other fans, full of bizarre drawings, evolve on a blue background all surrounding the principal motif." At the height of the Japanese craze, then, few critics took any interest in the fans themselves. No one showed the slightest concern for what these fans represented, for their "dessin bizarre."

There are three questions about this picture. First, can those fans be identified? Having identified them, do they make any sense, like the cumulative relevance of pictures within pictures, or are they—as I suggest—just haphazardly arranged as a series of contrasting color accents? Secondly, the hanging—or suspension —of these fans on the wall is a European travesty of Japanese usage. They hang almost as trophies, as emblems, just as examples of primitive sculpture hung in Parisien studios around 1905. But, as I asked earlier, was Manet, in his *Portrait of Nina de Callias* the first to show Japanese fans in such a Parisian interior in the 1870s? Thirdly, does the pose of Camille bear any resemblance to a particular Japanese print? It seems to me a much more European pose, which, perhaps fortuitously, may have reference to several poses or attitudes that can be found in Japanese prints.

I am sorry that this paper has very much appeared as a census of fans in the background of paintings of the 1870s. So let us go outdoors and consider two paintings, both called *La Promenade*, the one by Renoir, the other by Monet. Renoir's *La Promenade*, now in the Frick Collection, New York, is the only Renoir in that collection and, in a sense, it fits well into the ambience of Boucher and Fragonard. I once heard a French lady in the Frick gallery refer to Renoir's painting of the mid-1870s as "sa période Fragonard." But it does seem to me that we are dealing with many influences—the concept of *La Parisienne*, the concept of the fashion plate, the influence of photography. We are also concerned with composition, which is seldom considered when looking at Renoir. In several works of 1875 and 1876, he played with high viewpoints, with the cropping of figures at the edges, with silhouette. In Monet's *La Promenade* of 1875 (now in the Paul Mellon Collection, Washington), the silhouetted figure of Camille is seen very much from below. Can one, abandoning superficial notions of the presence of fans or other accessories, consider this plein-air image as inconceivable without the example of Japanese prints? I think I am asking you the kinds of questions which Professor Reff was posing about Degas and Toulouse-Lautrec.

Similar questions can be asked of another juste milieu artist, De Nittis, who actually exhibited with the Impressionists in 1874. But at the Salon of the same year, De Nittis showed an outdoor subject, *Fait-il froid?* Is the composition and the use of silhouette indebted to the fashion plate more than the photograph, or more so to the Japanese print? In looking at the effects and influence of the

Japanese print on French artists, we have tended to confine ourselves to the Impressionists. In particular, Manet, Degas and Monet have been scrutinized for Japanese elements in their work; and Pissarro, Sisley and Renoir are beginning to attract attention. It is true that some juste milieu artists such as Tissot and Stevens have been considered. But we haven't begun to look at Carolus-Duran who was cited by Chesneau in that famous article of 1878.

Nor have we begun to look at the more immediately obvious responses to Japonisme among artists of all kinds exhibiting at the Salon. I began this paper with a Salon painting of 1873 by Firmin-Girard. I have been able to identify that painting from a contemporary wood-engraving. But at the Salon of 1876, running concurrently with the Second Impressionist Exhibition, was exhibited "une Japonaise" by a certain Pierre-Marie Beyle. I wonder what that picture looked like and how it would compare with Monet's *La Japonaise*? There must be many others buried in Salon catalogues which the historian of Japonisme should be looking for. And he might also keep his eyes open for the survival of North African subjects. The same Pierre-Marie Beyle, for example, exhibited two Algerian subjects at the Salon of 1877. Japonisme in the 1870s could be an occasional indulgence as it was with Firmin-Girard, and with Monet and Renoir. But we need to chart more fully just how occasional it was.

HAYASHI TADAMASA: BRIDGE BETWEEN THE FINE ARTS OF EAST AND WEST

Segi Shinichi

In the exchange of art between East and West, Hayashi Tadamasa (Fig. 1) is a person of great importance. An art dealer, he was engaged mainly in exporting *ukiyo-e* prints to Europe. A detailed biographical study of Hayashi has been made by Jōzuka Toshitake entitled *Gashō Hayashi Tadamasa* [Hayashi Tadamasa: Art Dealer] (Kita-Nippon Publishing Company, Toyama). More recent research on Hayashi is limited to my own rather small scale study. I believe, however, that interest in this figure, so important a personality in art history, will grow. This discussion will focus on Hayashi's activities in Europe.

Hayashi Takamasa was born in 1851 in Takaoka, a city in Toyama prefecture. He entered Tokyo Imperial University, which was founded in 1876, but grew dissatisfied after only one year. He was advised to stay at the university, and eventually, it appears, he became very fluent in French. This coincided with the time the international exposition in Paris was being planned, and, interpreters of French being in great need, Hayashi applied. He was immediately hired and left for Paris shortly thereafter. A company known as the Kiritsu Industrial and Commercial Corporation had been given the responsibility for making all arrangements for the Japanese government concerning participation in world expositions being held in various parts of the world, including the Paris Exposition held in 1878. Thus Hayashi went to Paris as an employee of this corporation. After his role as interpreter had ended, Hayashi did not return to Japan. He had gained the trust and confidence of Wakai Kenzaburō, vice-president of the corporation and thus remained in Paris with him, devoting himself to the reconstruction and expansion of company business through the Paris branch. Ultimately, however, he was unable to obtain the understanding of the head office and therefore left the company. There were several instances during this period when he joined with Wakai Kenzaburō to form a new firm. In 1884 he set himself up in Paris and began vigorous activities as an art dealer. *Ukiyo-e* prints had been first introduced to Paris between the end of the 1850s and the early 1860s. I briefly mention the situation in Paris around 1884 because it was a time when an enormous number of prints were introduced. The persons who contributed most to this influx were Wakai Kenzaburō and Hayashi Tadamasa. Actually, quite a few prints had been brought to Paris and Europe before these

Fig. 1. Hayashi Tadamasa, 1896.
Photograph.

two commenced their activities, but the great increase in the quantity of imports
from Japan was directly the result of their efforts. Their joint business continued
for a few years, an experience through which Hayashi Tadamasa learned much
and gained confidence. In 1889 he ended his partnership with Wakai and began
independent activities.

There were three stages in Hayashi's career, beginning with his work as inter-
preter for the Kiritsu Industrial and Commercial Corporation. During this time
he had not yet developed an interest in art. The second stage was his experience
in Paris, where he learned about art and became familiar with it, training himself
as an art dealer under the guidance of the experienced Wakai Kenzaburō. In the
third stage, from 1889, he gained confidence and began to work independently.

You will note that 1889 is the year before Vincent van Gogh's death. Van
Gogh's letters recount how he would often go to the second floor of Samuel
Bing's store to examine *ukiyo-e* prints, for he himself was a collector and had
encouraged his brother, Theo, to deal more widely in Japanese *ukiyo-e* prints, an
item that was much cheaper and easier to sell than impressionist paintings. It
was a time of intense fascination with *ukiyo-e* prints in Paris, and they sold rapidly.
According to sources in France, the main collections of *ukiyo-e* prints were com-
plete by 1890, and I believe the person who contributed most to forming these
large collections in France was Hayashi. There was a detailed list of art goods
Hayashi exported to Europe. It verified the amount of goods he brought over.
I say *was* because it existed up until about ten years ago. A kind of account
book with invoices, it was lost in the course of a family dispute involving the
owner, and its whereabouts are now unknown. Fortunately, former professor at
Keiō University Shibui Kiyoshi, who had this list in his possession for some time
prior to that, made a detailed record and published it in the journal *Mita*

Bungaku in 1939. We are therefore able to get some idea of its contents. The original recording begins from August 31, 1890, just after Hayashi began his independent activities in Paris, and it continues until 1901, terminated for reasons I will explain later. According to this account book, he made 218 shipments to Paris during this period, including 860 cartons of goods. The contents were largely *ukiyo-e* prints, a total of 156,487. Actually, there were approximately 166,000 prints. In addition, there were 10 picture scrolls, 97 separate drawings and one scroll of drawings. And, there were 9,708 illustrated books. Also, there 846 original paintings, including both *byōbu* (screens) and *kakemono* (hanging scrolls). All in all, the total is a surprising figure. Today, even within a period of ten years, no such large quantity of art works would appear on the entire world market. At that time, however, such goods flooded the markets in Japan and Hayashi bought large quantities and sent them to Paris. They were extremely cheap, for the Japanese people themselves did not recognize the real value of these art works. But in Europe, they were then sold at very high prices. The names of outstanding artists whose works sold so abundantly included Harunobu, of whose prints 2,000 were sold. This is just an example of the thriving export trade in *ukiyo-e* prints and other Japanese art objects Hayashi Tadamasa carried on.

When Japanese later recognized the artistic value of *ukiyo-e* prints, Hayashi was severely criticized and even called a traitor to his own country because of the large quantities of art objects he shipped to Europe. However, I feel that Hayashi should not be too harshly judged, for he never destroyed anything, but simply moved art from one country to another where it was better understood. The same can be said of the French impressionist paintings. The real value of their works was not understood by their countrymen; it was the Americans who first appreciated it. We may well assert that art is best valued from an international point of view. In this sense Hayashi Tadamasa may have even saved *ukiyo-e* prints, for in Japan they faced oblivion. One may also say that he gave the orphaned Japanese art objects the chance for recognition and legitimization as art by bringing them to the French people. He was not just an ordinary merchant, but a genuine researcher, fluent in French and a man of integrity. He was greatly admired by French writers and artists, with whom he had close personal acquaintance and who at that time were enthusiastic collectors of *ukiyo-e* prints. In his shipping records are many important names, including Monet, Gillot, Haviland, Koechlin, Vever, Madame Rouart, Bartholomé, Manzi and others. You will notice that these names include some of the prominent impressionist artists, writers, and collectors of *ukiyo-e* prints in France. Henri Vever, for example, was known for his close connections with Japan. Although his name is not mentioned in the above list, Renoir states, in the biography published by Ambroise Vollard, that he knew Hayashi Tadamasa very well. This gave Hayashi deep-rooted respect within the French artistic world. One of the most famous among his prominent customers was Edmond de Goncourt. In de Goncourt brothers' journal, Hayashi Tadamasa is frequently mentioned. The close relationship between Edmond de Goncourt and Hayashi Tadamasa is reflected in the two books published by Goncourt on Japanese *ukiyo-e* artists, *Outamaro* and *Hokousaï*, where Hayashi Tadamasa is referred to and his cooperation is appre-

ciatively described. Goncourt, of course, purchased art works through other channels (e.g. Bing), but I believe the majority were obtained through Hayashi. Hayashi provided Goncourt, who could not read Japanese, with a variety of information concerning Japanese art which made it possible for the French collector to write two excellent and outstanding books on Japanese artists. I would like here to discuss these works in some detail. During the time Goncourt was writing his book on Hokusai in 1894, records show that Hayashi made for him a list of books illustrated by Hokusai. I had been curious about the content of this list for a long time and was fortunate enough last year to discover something that could be it. It is a scrupulously compiled list handwritten by Hayashi himself and reveals that he did quite a bit of investigation (Figs. 2 and 3). By studying this, one can clearly see what Hayashi saw and how he studied these works and what Goncourt's *Hokousaï* was based upon. It cannot have been easy to complete such a respectable list of Hokusai's illustrated books at that time, and I was deeply impressed by it.

Hayashi also had connections with other artists, such as Degas, and a few letters from Degas to Hayashi still remain (see Fig. 4). Hayashi thus played a most important role of introducing *ukiyo-e* prints to the Western world. By "introducing" I mean commercially and academically. As mentioned before, his export of *ukiyo-e* prints from Japan broke off in 1901, for his outstanding abilities were recognized by the Japanese government, and he was appointed Commissaire Général for the Exposition to be held in 1900. In order to fulfill this official post, he had to close his shop in Paris. As it happened, after his official duties for the exposition were complete, his younger brother, Hagiwara Seirin, who had been his assistant in Paris, died. His grave still stands in Paris. The loss of this greatest collaborator was also another factor that brought Hayashi's art dealing to an end. By this time it had became rather difficult to find quality *ukiyo-e* prints in Japan, and at the same time, the collections in France had almost been completed. Prices rose to a level very few could afford. Even an enthusiastic Japo-

Fig. 2. Cover for a list made by Hayashi Tadamasa of Hokusai's illustrated books.

Fig. 3. Page from the list to the left (Fig. 2).

Fig. 4. Postcard from Degas to Hayashi Tadamasa dated December 13, 1900.

nisant like Goncourt writes ruefully in his journal, "How foolish I was to have spent such large sums of money on *ukiyo-e* prints." And he confesses "what a great collector and how wealthy I would have been if I had spent it on European paintings." Business in Paris no longer looked promising and Hayashi therefore decided to close his shop. In 1902 he left the unsold items in his shop under the care of Samuel Bing to be auctioned.

The relationship between these two competitors, incidentally, must have been extremely complex. A regular meeting of admirers of Japanese art known as *le dîner japonais* had been held for a long period of time, centered around Hayashi Tadamasa and Henri Vever, and certainly Bing must have joined them. As I mentioned before, when Edmond de Goncourt wrote his book on Hokusai, Hayashi showed him various materials, but in fact these materials had first been collected by Hayashi at Bing's request. Because Hayashi showed them to Goncourt first, a great quarrel broke out between the two. The argument between them, quite a violent dispute, is seen in the newspapers of that time with Goncourt defending himself. From this, some researchers consider the relationship between Hayashi and Bing to have been a bad one. However, I think that this was only one incident, since they saw each other often at *le dîner japonais* and as fellow promoters of Japanese art, they were colleagues. That is why in 1902, I feel, Hayashi decided to leave his collection to be sold under Bing's care.

In February 1905 Hayashi left Paris, and with many sad farewells from Japanese art lovers in Paris, he returned to Japan. No sooner had he returned to Japan, however, than his health took a turn for the worse and he died abruptly the following year at the age of 54. His activities did not span a very long period of time, but they were exceedingly lively. His chequered career gave rise to a variety of legends as well as considerable criticism.

In recent years I have made some efforts to study Hayashi more closely, and coupled with Mr. Jōzuka's research work on Hayashi's personality, and I think that we finally have a clear understanding of the nature of this figure and his personal character. A point which I wish to stress here is that Hayashi Tadamasa not only brought vast quantities of *ukiyo-e* prints from Japan to Europe but put much effort into the counterbalancing role of introducing modern European paintings, especially those from France, into Japan. He was a man engaged in what is called cultural exchange in a very literal sense. The customers to whom Hayashi sold *ukiyo-e* prints included, as I mentioned before, a number of outstanding French artists. The artists were quite poor at that time and could not afford to buy the *ukiyo-e* prints. Hayashi's collection began through a kind of barter in art. I think he also made an effort to collect paintings which he himself admired. A large portion of what he collected was exhibited in 1890, when he returned to Japan, in the second exhibition of the Meiji Bijutsu-kai, a group of Japanese oil painting artists established around that time. I do not know clearly what was exhibited there, although the number of painters seems to have been quite limited. It appears to have been focused on paintings of the Barbizon school or those prior to it. When next he returned to Japan in 1893, he displayed a large quantity of works of art he had collected during the three-year period at the fourth exhibition of the Meiji Bijutsu-kai. This is where the artists of the Impres-

sionist school were first introduced in Japan. However, there was not much reaction, and apparently he sold only about two or three works. Later he loaned his collection for display in one of the rooms of the National Museum, but few came to look at them. Hayashi's collection unfortunately had to be disposed of, leaving only a small portion, but this of course was not done in Japan. The collection was auctioned at the American Art Association in New York in 1913 after he died, and those works have been dispersed throughout the world. Ironically a part of the collection has returned to Japan years later —a Delacroix, a Corot and a Manet now hang at the Bridgestone Museum of Art in Tokyo—works which Hayashi once brought to Japan himself.

During his lifetime, Hayashi was thought to be extremely rich since he was engaged in such an active business. However, he seems to have had very high expenses as well, and eventually went bankrupt. All that was left was an enormous collection of paintings which were later sold off. I believe there were five or six auctions besides the one previously mentioned. *A Catalogue of European Paintings and Art Objects from Hayashi Tadamasa's Collection* (Fig. 5) for the auction held in Tokyo in October 1930, the last auction held I believe, shows that at that time quite a number of goods still remained, including a very fine Corot (Fig. 6).

Fig. 5. *A Catalogue of European Paintings and Art Objects from Hayashi Tadamasa's Collection,* for the auction held in Tokyo in October 1930.

Fig. 6. Camille Corot, *Ville d'Avray,* 1835–40. Oil on canvas. Bridgestone Museum of Art, Tokyo.

CAMILLE PISSARRO AND JAPONISME

Christopher Lloyd

"Si tu en trouves l'occasion, regarde les Persans, les Chinois, les Japonais. Forme-toi le goût aux hommes vraiment forts. C'est toujours à la source qu'il faut aller . . ." (Camille Pissarro in a letter dated July 25, 1883).

Camille Pissarro is not an artist one readily associates with Japonisme. Nowhere in his extensive œuvre will one find the equivalent of such paintings as Manet's *Portrait of Zola* or Monet's *La Japonaise* serving as testimony to a consuming passion or even a passing interest in Japanese art. Only one painting by Pissarro, *La Petite Bonne de Campagne*, of 1882 (London, Tate Gallery) advertises the artist's curiosity in this subject.[1] For, on the wall behind the figure hangs a framed Japanese painting on silk. Its subject is a bird sitting on the branch of a tree and it is one of three such paintings included in the sale of the artist's collection after the death of his widow in 1926.[2] Admittedly, some other Japanese items were retained in the family and not offered for sale in 1928, but these, some of which will be mentioned later, number barely more than fifteen. Clearly Pissarro's advocacy of Japonisme cannot be said to have been expressed in collector's terms, as it was, for example, in the cases of Théodore Duret, Edgar Degas, or Claude Monet. Yet, to argue on this basis that Japonisme held no interest for Pissarro would be erroneous for three reasons. First, there is the evidence of his letters where, although the references are not numerous, they do, however, reveal a genuine enthusiasm and knowledge of Japanese art. Secondly, and almost contrary to expectation, there is considerable evidence in the works of art themselves. Thirdly, and fundamentally, because Pissarro maintained a special position in French art during the second half of the nineteenth century, any awareness of Japonisme on his part, however tentative, assumes the greatest significance. Since the last point is a general one, it should be examined at the outset before proceeding to the more detailed arguments raised by the first and second points.

As in so many aspects of French art during the second half of the nineteenth century, Pissarro serves as a test case. He appears, superficially at least, almost to have stood aloof from Japonisme and yet, in reality, he also seems to have been more alive to the full extent of its potentialities than any of his contemporaries. Indeed, it is possible to detect in Pissarro's work a careful and searching analysis of Japanese art as imported into Europe during every decade of his mature working life, that is after 1870, following upon those Promethean paintings undertaken at L'Hermitage at the close of the 1860s. This personal allegiance to Japonisme may not in itself be regarded as of great consequence until it is

remembered that Pissarro assumed what is best described as a professorial role during the final decades of the nineteenth century. The didactic function that he performed can easily be taken for granted and, surprisingly, it has never really been properly demonstrated, but in the present context alone it means no less than that Pissarro forges a link between artists as varied as Manet, Monet, Degas, Gauguin, van Gogh, the Neo-Impressionists, the Nabis, and even Matisse. The importance of Pissarro, therefore, is that he is a constant during a half-century noted for the fecundity of its artistic activities. The artist and critic Félix Buhot, once suggested that "Impressionnisme" as an appellation should be replaced by "Pissarrisme," but, where Buhot intended this to be interpreted in the narrowest sense, it is perhaps also applicable in a far broader context.[3] Pissarro, partly because of his powers of self-discipline and self-criticism, as well as his capacity for prodigious labor, encapsulates several different approaches to Japonisme. The result is that where the application of those principles stemming from Japonisme is normally, and quite correctly, associated with artists belonging to successive generations in France during the last half of the nineteenth century they can, in fact, also be found in microcosm in the work of a single individual, namely Camille Pissarro.[4]

The chief documentary evidence for Pissarro's preoccupation with Japanese art lies in his correspondence. The references to Japanese art are scattered and hardly plentiful. Yet, they are of some significance and, although they have been widely quoted, they are worth repeating if only for their pertinency. The publication of the official edition of Pissarro's letters in the very near future may reveal many more such statements, but it is unlikely that the general tone of the artist's response will be changed. The comments in his letters reveal a genuine enthusiasm for Japanese art, an interest in technical procedures, a desire to attempt new formats (Fig. 1), and an indication of some of the stylistic advantages and disadvantages presented by those works imported into France from Japan.[5] As for many of his contemporaries, the exhibitions of Japanese art visited by Pissarro were revelatory experiences. Thus, in April 1883 after viewing the large exhibition mounted by Louis Gonse and Hayashi Tadamasa at the Galerie Georges Petit, Pissarro wrote to his eldest son Lucien, "Voilà ce que j'ai remarqué dans l'ensemble de l'art de ce peuple éttonant, rien qui saute à l'œil, un calme, une grandeur, une unité extraordinaire, un éclat plutôt sourd et cependant c'est brillant; c'est étonnant de sobriété, et quel goût."[6] It has of course to be realized that Pissarro is here relating the qualities of "unité," "grandeur," and "brillant" to his own predicament at that time when he felt that his works lacked a sense of harmony—a predicament that led him for a time to adopt a Neo-Impressionist style. Again, after the exhibition of the prints of Hiroshige and Utamaro organized by Samuel Bing at Durand-Ruel in 1893 Pissarro wrote in February of that year on successive days to Lucien in England enthusing over what he had seen. "C'est un événement artistique.... J'ai vu Monet à l'exposition japonaise. Sapristi, c'est cela qui nous donne raison. Il y a des soleils couchants gris qui sont d'un impressionnisme épatant."[7] On the following day he wrote again, "Admirable, l'exposition japonaise. Hiroshigué est un impressionniste merveilleux. Moi, Monet et Rodin en sommes enthousiasmés. Je suis content d'avoir fait mes

Fig. 1. Camille Pissarro, *Rameuses de pois*, 1890. Gouache, P & V 1652. Ashmolean Museum, Oxford.

effets de neige et d'inondations; ces artistes japonais me confirment dans notre parti-pris visuel."[8] Now these reactions, too, can be related to current developments in Pissarro's works. As he himself hints in his reference to "effets de neige et d'inondations" there was in Pissarro's paintings in particular a return to the basic tenets of Impressionism at the beginning of the 1890s. Canvases dating from this period possess a luminosity and effulgence of color that almost amounts to a celebration of his escape from Neo-Impressionism. Similarly, a less well known passage in a letter to Duret written twenty years earlier in 1873 (February 2) bears a direct relationship to the emergence of the Impressionist movement. Pissarro writes, "Lorsque vous viendrez j'éspère vous montrer des études hardies qui pourront vous plaire peut-être car il faut penser que vous revenez du Japon, pays hardi et très révolutionnaire en art."[9] It has often been argued that the Impressionists regarded many of the Japanese printmakers they most admired as their artistic forerunners, because they, too, in their own time had been criticized for unorthodoxy in both style and treatment of subject-matter.[10] To what extent French artists would have been aware of this historical nicety at the comparatively early date of 1873 is difficult to ascertain, but clearly Pissarro felt an affinity with their approach to art, which did, in fact, find expression for the first time in his own work of the early 1870s. Pissarro's compositional methods are closely akin to Monet's at the beginning of the 1870s, but it is reasonable to conclude that Duret, who played such an important part in the evolution of Pissarro's style during this critical decade, acted as the main catalyst and, furthermore, was able to provide him with easy access to Japanese art.[11]

Before looking at specific works of art it is necessary to remind ourselves how Pissarro used visual sources in general. Like Degas, and perhaps contrary to the

belief stemming from a statement made by Cézanne that the artist had wanted to burn down museums,[12] Pissarro had a wide-ranging knowledge of art that was firmly based on historicist principles. Pissarro looked at the art of the past not to flaunt it in the face of the present, but in order to redeploy it to different, sometimes diametrically opposed, ends. He is essentially a reflective artist borrowing more in the tradition of the medieval craftsman than in any strictly intellectual sense as Manet did. There is nothing systematic about Pissarro's allegiances to Holbein the Elder, Poussin, Claude, Chardin, Hobbema, Gainsborough, Fragonard, Ingres, or Delacroix, all of whom were subjected to close examination leading to rejection on some occasions and to acceptance on others. Yet, while Pissarro was not averse to quoting almost verbatim from contemporary artists such as Gustave Courbet[13] and Léon Lhermitte,[14] it is often much harder to detect a more established source. There is no need to rehearse these borrowings in full now, but one instance is perhaps desirable in order to illustrate the way in which Pissarro's visual memory operated. A composition entitled *La Traite des Vaches, Eragny*, of 1884,[15] brings to mind Lucas van Leyden's etching known as *The Milk Maid*, of 1510.[16] There is, as yet, no proof that Pissarro knew the print by Lucas van Leyden, but the visual evidence suggests that he had seen it. What Pissarro has aspired to in his gouache is the same sense of balance and the same interplay between vertical and horizontal that Lucas van Leyden has attained in his composition. The French artist, however, has not allowed himself a literal quotation. The process is more subtle than plagiarism in that Pissarro has recognized the elements that make Lucas van Leyden's composition successful and reapplied them in the context of Eragny-sur-Epte: a case, perhaps, of elective affinities. Now, this was exactly how Pissarro reacted to Japanese prints and, indeed, the whole process of the artist's visual sources is possibly more readily understood in this particular context because of the change from one artistic idiom to another. It is, therefore, not enough to be able to point to a drawing of pear blossom in the Ashmolean Museum, Oxford,[17] or to the facture of this painting *Effet de Neige à Eragny avec un Pommier* in The Fitzwilliam Museum, Cambridge,[18] in recognition of the Oriental flavor. The influence of Japanese prints on Pissarro was more deep-seated than a display of decorative qualities, although that aspect does appear to creep into the treatment of the iron scroll in front of which Madame Pissarro sits sewing in a portrait of her now in Oxford.[19] The portrait is dated c. 1877 in the *catalogue raisonné* and it bears a certain resemblance to a drawing by Seurat,[20] now in the Louvre, which was once owned by Pissarro. Both works are in some respects comparable with the *Moon Pine at Ueno* by Hiroshige from *One Hundred Views of Famous Places in Edo*.[21]

After these preliminary remarks we can proceed to examine specific works representative of Pissarro's interest in Japonisme. The canvases painted by Monet and Pissarro at Louveciennes in 1870–71 often share not only the same motif, but also one striking compositional feature.[22] This is the placing of a road, which, whether it is at right angles to the picture plane or at a diagonal, leads the eye straight into the composition, thereby increasing the sense of immediacy and of movement. It was pointed out some time ago that this perspectival system, although it had been adopted by European artists in earlier centuries, was also

inspired by the use made of it specifically in Japanese color prints where its effect was enhanced by the even texture of color.[23] Monet only experimented with this technique for a short period, whereas Pissarro continued to use it until the middle of the decade. In fact, by adjusting the position of the horizon lines he was ultimately, like Sisley, able to invest this compositional procedure with an even greater daring so that it determined the spatial divisions of the whole canvas. An apposite example of this principle, which has the added advantage of also demonstrating Pissarro's interest in seasonal representations, is *Les Quatres Saisons* commissioned as overdoors by Achille Arosa, a relation of Gauguin's mentor Gustave Arosa, and painted in 1872.[24] Here in this group of paintings we have flat horizons bisecting the canvas and in the scene of winter a high view point overlooking the snow-covered roofs' of houses. During the second half of the 1870s and during the 1880s Pissarro rarely deployed this device on its own accord, but with his later series of *boulevards* and *avenues* paintings in Paris dating from the 1890s he reinvoked the idea of a road receding rapidly into the depths of the picture space, and in one example the Boulevard Montmartre is seen at night-time, an isolated case that again recalls Hiroshige.[25] This time, however, the device is even more marked in Pissarro's paintings, because, in the first place, he could not offset the road so easily with long horizontals, and, secondly, because he was looking down on to the street from a height (usually a hotel bedroom), thereby telescoping the distances even more and forcing the spectator to "read" the composition from the bottom to the top. It is perhaps only when one compares a late lithograph by Pissarro of the *Rue Saint-Lazare à Paris* with the *Quelques Aspects de la Vie de Paris* by Bonnard of 1895[26] or related works, that a connection between these two artists becomes apparent, one that was perhaps ultimately dependent upon a mutual admiration for Japanese art.

The crisis that Pissarro's style underwent towards the end of the 1870s was shared by other Impressionist painters. In Pissarro's case, however, one might be justified in asserting that this crisis was partially induced by the change in style wrought while working with Cézanne. The facture of many of the pictures dating from the mid-1870s shows Pissarro seeking to depict spatial depth by overlaying surfaces in canvases for which a deliberately unified palette was selected. Pissarro's crisis, therefore, was one of texture. Even when he broadened his palette the surfaces of his paintings sometimes became overworked with a resulting loss of unity. As so often with Pissarro, he can often be found searching for the answer to a particular problem experienced in his paintings elsewhere in his œuvre. During the late 1870s with the aid of Degas Pissarro revealed himself as an experimental printmaker of some consequence. No doubt with the opaque colors of Japanese prints in mind, Pissarro, often in compositions that are closely allied to his paintings, sought to capture delicately modulated areas of shifting tones with granular aquatint grounds. At least one of the plates printed under the direction of Degas was originally intended for Degas' abortive project, *Le Jour et la Nuit*, in which Félix Bracquemond was also involved.[27]

Pissarro's friendship with Degas during the late 1870s was to have an even more far reaching effect in the first years of the following decade. For, at that time Pissarro suddenly became absorbed by the human figure. Where before

the figures tended to be a single unit inserted into a composition with little degree of individuality, now those same figures, or their counterparts, are placed boldly in the foreground in a variety of complicated poses. There can be little doubt that the influence of Japanese prints is partly responsible for this change, possibly as a result of the advocacy of Degas. There are innumerable paintings where Pissarro's new-found interest in the human figure, often at the expense of the landscape background, can be discerned. An apposite example is *La Moisson* (Tokyo, Bridgestone Museum of Art), a tempera of superlative quality painted in 1882 and exhibited at the seventh Impressionist exhibition.[28] We see a field with harvesters. The horizon line is placed very close to the upper edge of the composition. The main activity is concentrated in the immediate foreground, the figures growing in scale as they approach nearer to the picture plane. As a result, they are depicted against the background of field and distant hill, flattened like flowers in a press. Two drawings in Oxford for this painting reveal something of Pissarro's working processes at this time. He begins with a freely brushed study of the whole composition in which at least one of the important figures in the foreground is already allotted its position.[29] Pissarro then involves himself with individual poses using models arranged in positions previously observed by the artist in life. One such drawing examines the female harvesters in the foreground.[30] It is a large-scale study with bold outlines in black chalk and with the minimum of modeling. The intention seems to have been to realize the shape and mass of the figures before laying them against the background, as though seeking to isolate the harvesters before enmeshing them within their surroundings. In *La Moisson* it can be seen that the artist has still relied upon outlines to create a distinction between the figures and the setting. Yet, in *La Paysanne en Repos* (Bremen),[31] and in many other comparable works dating from the beginning of the 1880s, Pissarro has painted both the figure and the background with similar brush strokes, so that the young female peasant girl is almost camouflaged against the grass on which she lies, although the figure as such is not totally negated as an integral part of the composition. This concentration on the human figure was one of the ways in which Pissarro rediscovered the compositional unity that he felt had been lost during the late 1870s.

Another solution to this problem of unity was to simplify the composition itself and again this might have been done with the aid of Japanese influence. Significantly, it is in the Neo-Impressionist paintings undertaken by Pissarro that we find the principles expounded for the first time in *La Moisson* carried to their furthest extreme. One finds in *La Cueillette des Pommes* (Dallas, Museum of Fine Arts),[32] for instance, figures like cutouts almost silhouetted against the orchard, which is terminated by a curving horizon line placed well above their heads. The facture and the palette allow the artist to blend his figures with the enclosed background. The action takes place in the foreground, but on such a raking stage that the actors are almost in danger of slipping off it. Pissarro has heightened interest in the protagonists by reducing the background to a formula comprising a curving horizon line stretched right across the canvas and a single item in the middle distance that relates to everything else in the composition. The salient motif of the tree, which provides the focal point of the composition,

is again first explored in a drawing in Oxford.[33] The branches of the tree unify the composition: they rise above the horizon repeating its curvature and they shroud the figures beneath, who are also contained within the splash of its shadow. Such devices are to be found in Japanese prints; for example, in the work of Hiroshige.[34] The compositional unity derived from this device is thrown into greater emphasis if *La Cueillette des Pommes* is compared with Pissarro's rendering of those orchards executed at the beginning of the 1870s. In the earlier paintings the trees are set in rows and they are, therefore, used to create a feeling of recession. The trees are self-contained, each separately crowned with blossom or about to be so. Of course, the blossom itself is also reminiscent of Japanese art and comparison between *La Cueillette des Pommes* and *Pommiers en Fleurs, Louveciennes* of 1875,[35] for example, does serve to emphasize the different uses to which Pissarro could put his knowledge of Japonisme. In fact, the origins of the unifying device invested in the tree in *La Cueillette des Pommes* can be found earlier in Pissarro's œuvre. The artist, for instance, often builds up a sense of distance by situating the principal motifs of a landscape behind a tree, whose trunk, or spreading branches, stand between the spectator and the rest of the composition. Obviously, this leads to the overlaying of surfaces, which, until the mid-1870s, remained fairly uncomplicated, being expressed, as in Japanese prints, in purely linear terms, as in *La Haie, Paysage d'automne*, of 1872 (Mellon Collection).[36] Yet, in such a painting as *Jardin Publique à Pontoise* (New York, Metropolitan Museum) this motif reaches a turning point, both stylistically and compositionally, and the debt to Japanese art for this aspect of Pissarro's art of landscape is underlined by a comparison with a print by Hokusai (*Mt. Fuji Seen from Mishima Pass*) where the bare tree trunk performs a similar function.[37]

So far reference has been made to the compositional similarities between Pissarro's œuvre and *ukiyo-e* prints. There are also parallels in the treatment of subject-matter. One of the most important visits undertaken by Pissarro was his trip to Rouen in 1883. Rouen appealed to Pissarro in much the same way as Pontoise did. There was the same sense of history, medieval architecture, and aspects of urban life to explore, such as markets and busy streets, as well as the activities of an inland port to observe. Pissarro relished these motifs and he returned to the city for two longer visits during the 1890s. Indeed, many of Pissarro's recorded reactions to the city of Rouen are comparable with traditional definitions of *ukiyo-e* prints.[38] The visit of 1883 aroused Pissarro's interest in topography and caricature. The evidence for this seems to lie mainly in his drawings and prints. The two main bridges across the Seine at Rouen, near which the *quais* were situated, were the Pont Boieldieu and the Pont Corneille. Both these bridges, like the Pont-Neuf and Pont Royal in Paris, are motifs that recur frequently in Pissarro's later œuvre.[39] It is the visual impact of the structure stretched across the composition that he explores and in this respect it has the same potency as the low horizons of the paintings dating from the 1870s. For Japanese artists the geographical environment demanded the inclusion of such bridges in their prints, but for Western artists it became a compositional device. Perhaps Pissarro's prints of the more modern public places in Rouen, as opposed to those of the medieval streets, may also have been inspired by Japanese

prints. In the etching *Place de la République, à Rouen*,[40] for instance, the quickly moving figures wrapped up for protection against the elements and the almost blurred cinematic effect of glimpsing them as they pass across the spectator's line of vision were techniques inspired as much by Japanese artists as the development of photography.[41] Again this is also apparent in the even more evolved paintings of the *avenues* in Paris.[42] Furthermore, when one examines the crowded pages of *Turpitudes Sociales* of 1890 (Fig. 2), an album of anarchist drawings by Pissarro, and espies the caricatural treatment of individual figures it is tempting to see another possible connection with Japanese prints (Fig. 3). For an artist who declared "Se rapprocher plutôt de la caricature que de faire joli"[43] the humor of Japanese art would surely have appealed enormously.

There is another important link between the subject-matter of Japanese prints and Camille Pissarro. This is the treatment of female figures, and, when it is realized that Pissarro owned ten prints by Utamaro, probably obtained from Hayashi Tadamasa, the significance of this can be fully appreciated.[44] For, perhaps no other artist during the second half of the nineteenth century in France explored the theme of the female peasant so persistently as Pissarro, and, similarly, it is Utamaro's prints that mark the apogee of the representation of

Fig. 2. Camille Pissarro, *Turpitudes Sociales*, Album of drawings in pen and brown ink, 1890. Folio 13. Reproduced from the facsimile edition published by Skira, Geneva, 1972.

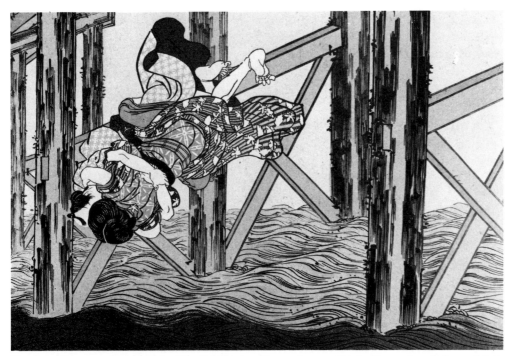

Fig. 3. Utagawa Kuniyoshi, *The Suicide*, An illustration to *Shinjū*. Reproduced from *Artistic Japan*, No. 33, pl. CB1. Bodleian Library, Oxford.

women in Japanese art. Since Utamaro's importance in this respect was recognized by French collectors and writers, including Gustave Geffroy,[45] who, like Duret, was a close friend and a keen admirer of Pissarro, the equation that it suggests between the two artists is worth examining. At the beginning of the 1880s Pissarro, as already mentioned, became fascinated by the human figure, concentrating upon poses, attitudes and gestures, as opposed to landscape. It is, in short, the figures that serve as variables in a composition and no longer the landscape background. This shift in emphasis is also apparent in the drawings and it reaches a climax in 1881–82 when Pissarro painted several canvases of female peasants.[46] Like Utamaro, the French painter shows his women laboring at their work or relaxing from a life of perpetual toil; he depicts them in their domestic environment and, later, towards 1890, he becomes interested in more intimate themes exemplified by the pictures and prints of bathers, which possess a restraint and diffidence that characterize Utamaro's scenes of the *Awabi Fishers*, or the series of *Six Tama Rivers* by Shunman.[47] What is also significant is that during these two decades Pissarro's whole style of depicting the female peasant changes. Both the paintings and the drawings reveal a greater interest in rounded forms and complicated poses that allow the artist to show the human figure from different, often obscure, angles. Again a stylistic consideration links Pissarro and Utamaro, for in the prints by the Japanese artist, as in the paintings and drawings by the French painter, one discovers sinuous, curvilinear outlines elegantly prescribing female forms. Both artists depict a private world into which the spectator is allowed a glimpse, sometimes literally over the shoulder

of the figure concerned. The connection between Utamaro and Mary Cassatt is well known. Cassatt, whom Pissarro knew and admired, seems to have responded literally to Utamaro, whereas Pissarro, having seen the prints by the Japanese master, begins a complicated process of translating them into his own rural idiom. The relationship between Utamaro and Pissarro has not been examined before, or even noticed, but quite apart from the prints owned by the French artist, there is indirect confirmation of the connection in the way in which writers have unconsciously approached and described the work of both artists.[48]

In conclusion, there is the question of Camille Pissarro's *Manga,* the title used by Camille and Lucien Pissarro for a joint project entitled *Travaux des Champs.*[49] It is apparent that Lucien Pissarro had attended the exhibition of Hokusai's work held at The Fine Art Society in London in 1890 and later Camille Pissarro came to own a copy of Hokusai's publication. References to the *Manga* begin in their correspondence after this date when *Travaux des Camps* is often referred to as "notre Mangwa." *Travaux des Champs* is a portfolio of wood-engravings, twenty-five copies of which were issued in 1895 by The Vale Press. The designs were drawn by Camille Pissarro and engraved on wood by Lucien. The joint project was probably begun as early as 1886. It was a protracted affair, partly because of a certain indecision over the exact format that the work should take. The title of the portfolio and two separate schema for its continuation imply a connection with medieval cycles of the months of the year, as well as with Jean-François Millet's undertaking of the same title, but what Camille and

Fig. 4. Camille Pissarro, *Two Women Conversing in an Orchard,* ca. 1895. Ink over charcoal highlighted with gouache on blue paper. Ashmolean Museum, Oxford.

Lucien Pissarro could not decide upon was whether there should be an accompanying text. Would the images be suitable for illustrating a text, and, if so, should it be a text especially written by a contemporary, or else one by Virgil? These issues need not detain us now. What matters about *Travaux des Champs* is the style of the wood-engravings.[50] Only one, the name-piece, evokes direct comparison with Hokusai's *Manga* in the scattered profusion of images over the page. Two earlier wood-engravings in the portfolio, *Le Labour* and *Gardeuses de Vaches*, reflect Pissarro's change of style between the 1870s and 1880s that has already been discussed. *La Femme aux Poules* was an experiment involving woodblocks and zinc plates. The type of composition, as well as the introduction of color, relate it to the last two prints in the portfolio, *Les Sarcleuses* and *Femmes faisant de l'Herbe*, which may be regarded as its climax. In *Femmes faisant de l'Herbe* the luminosity, the tonality, the firm outlines, the compositional procedure of high horizon line and the silhouetting of the figures against the landscape, are in the Synthetist style. Although it is common now to refer to the thick outlines as exhibiting a "cloisonniste" technique, Camille Pissarro himself likened the prints to stained glass windows emphasizing that they should be seen from a distance.[51] If one is seeking a resolution of Japanese stylistic principles in Pissarro's work it is to be found in these two last prints of *Travaux des Champs*. Regrettably, however, the project foundered. A second portfolio of prints was planned as early as 1891. One of the designs for this second portfolio showing four women in an orchard was actually cut on wood. The preparatory drawing for this by Camille Pissarro exists and it reveals a composition that may be regarded as a continuation of those found in the first portfolio.[52] The design that was cut by Lucien Pissarro was done so in outline only. It shows the women at work in an orchard. One woman crouches in the middle distance and three others stand or stoop beneath a tree. They are all contained by the spreading branches of the tree. Some idea of how the print might have looked if it had been printed in color may be gained from an earlier drawing for the composition made by Camille Pissarro (Fig. 4).[53] In this only two figures are shown in relation to a row of trees, but they are dominated by the blossom that is so prominently laid in with a thick chinese white. It is a rare moment of self-indulgence by Camille Pissarro, perhaps reflecting a passing interest in Art Nouveau, and it is hardly surprising that his son seems to have protested that this passage was too difficult to translate into wood-engraving. If further testimony of Pissarro's admiration for Japanese art is needed, it surely lies in the abandon with which he applied the gouache representing that row of trees in blossom. For, it possesses the characteristics most admired in Japanese art by the West. It has strength and forthrightness. It has a decorative quality. It is fleeting and yet it is permanent. All these characteristics when understood in Western terms were the basic theoretical issues that beset Impressionism and the various movements emanating from it.

Yet, finally, a word of caution. Given Pissarro's encyclopaedic knowledge of the art of the past, can we really be sure that in *La Femme au Fichu verte* (Paris, Musée du Louvre), of 1893,[54] the enigmatic turn of the head was inspired by Vermeer's *Head of a Girl with Pearl Ear Rings* (The Hague, Mauritshuis),[55] or

by one of Utamaro's prints that Pissarro must by that date have had to hand in his studio? Certainly without the evidence of Camille Pissarro's letters, or of the specific prints that he owned there might be grounds for asserting that he was not affected by Japanese art at all. Yet, this is wholly in keeping with what we know of Pissarro's use of visual sources. In Japanese prints, as in so many of the other schools and periods of art in which he displayed an interest, Pissarro found support for and confirmation of the principles that he sought to uphold in his own work. Pissarro, therefore, is not a Japoniste in the narrow sense of the term by the quotation of isolated motifs. Rather, he is to be associated with Japonisme in the broadest possible way as a result of his careful examination and total absorption of those compositional devices and methods of depiction transmitted to the West by the importation of Japanese prints. Above all, he would have responded to the apparent spontaneity and directness of execution demonstrated in the prints, since these were the aspects that formed the basis of his own art. As with other sources, the language of Japanese prints was soon introduced into Pissarro's artistic vocabulary. In this process all sources tended to lose their own identity in aiding the artist to establish a lucid and powerful means of personal expression.

ABBREVIATIONS

D.	L. Delteil, *Le peintre-graveur illustré* (*XIX^e et XX^e siècles*), *Vol. 27. Camille Pissarro. Alfred Sisley. Auguste Renoir*, Paris, 1923.
P & V	L. R. Pissarro and L. Venturi, *Camille Pissarro son art—son œuvre*, 2 vols. Paris, 1939. A *catalogue raisonné* of the paintings, temperas, gouaches, pastels, fans, and ceramics by Camille Pissarro with nearly every work reproduced.
Lettres	*Camille Pissarro, Lettres à son fils. Présentées, avec l'assistance de Lucien Pissarro, par John Rewald*, Paris, 1950.
Brettell and Lloyd	R. Brettell and C. Lloyd, *A Catalogue of the Drawings by Camille Pissarro in the Ashmolean Museum, Oxford*, Oxford, 1980.

NOTES

* The author would like to acknowledge the help of Mr. John Bensusan-Butt, who so
 kindly drew attention to the Japanese prints owned by Camille Pissarro.

1. P & V 575. Reproduced in color by J. Rewald, *Camille Pissarro*, London, p. 132.
 For full details see R. Alley, *Tate Gallery Catalogues. The Foreign Paintings, Drawings
 and Sculpture*, London, 1959, pp. 192–193.

2. Paris, Hôtel Drouot, *Collection Camille Pissarro (Deuxième Vente)*, 7–8 December
 1928, lots 284–6. Some other Japanese items were sold at the third sale, Paris,
 Hôtel Drouot, April 12–13, 1929, lot 269, which also included (lot 272) a copy
 of *Histoire de l'art du Japon, ouvrage publié par la Commission impériale du Japon à
 l'Exposition Universelle de Paris*, 1900.

3. F. Buhot [alias Point Sèche], "Le Whistlérisme at le pissarrisme à l'Exposition
 des XXXIII," *Le Journal des Arts*, January 13, 1888, quoted in *La revue de l'art ancien
 et moderne*, 1928, p. 412.

4. It is partly because of an interest in the development of his children as artists that
 Pissarro maintained his enthusiasm for new developments in art. See, for example,
 the reference in J. Bailly-Herzberg, "Essai de reconstitution grâce à une corres-
 pondence inédite du peintre Pissarro du magasin que le fameux marchand Samuel
 Bing ouvrit en 1895 à Paris pour lancer l'Art Nouveau," *Connaissance des Arts*, No.
 283 (1975), pp. 72–81. Thanks are due to Mme. Bailly-Herzberg for drawing
 my attention to this article.

5. As in a letter written by Camille Pissarro to Lucien Pissarro dated May 17, 1891
 (omitted in *Lettres*) discussing a project proposed by the artist's second son
 Georges, "Le fond de son idée est très bonne, combiner les formes modernes et
 figures avec les fonds, il faut pour cela dessiner des terrains, des arbres, des coteaux
 etc. tout cela c'est la marche, mais il faut suivre cela sur la nature sans cela on
 retombe toujours dans les lignes japonaises comme si dessous." (Fig. 5)

Fig. 5. Reproduced from a letter written by Camille Pis-
sarro to Lucien Pissarro dated May 17, 1891. Ashmolean
Museum, Oxford.

6. *Lettres*, p. 40, April 24, 1883.
7. *Lettres*, p. 297, February 2, 1893.
8. *Lettres*, pp. 297–298, February 3, 1893.
9. Quoted by E. Scheyer, "Far Eastern Art and French Impressionism," *The Art
 Quarterly*, VI (1943), pp. 127–128. The original letter is in the Musée du Louvre,
 Cabinet des Dessins.

10. C. Ives, *The Great Wave: The Influence of Japanese Woodcuts on French Prints*, The Metropolitan Museum of Art, 1974, pp. 14–15.

11. The importance of Theodore Duret for Camille Pissarro is stressed by Richard Brettell, *Pissarro and Pontoise. The Painter in a Landscape*, A dissertation presented to the Faculty of the Graduate School of Yale University in candidacy for the Degree of Doctor of Philosophy, 1977, pp. 227–234. The date when Duret acquired his collection of Japanese prints has yet to be established.

12. *Paul Cézanne Letters*, 4th edn. ed. J. Rewald, Oxford, 1976, pp. 331–332, letter dated September 26, 1906 to the painter's son.

13. P & V 45 is dependent upon Courbet's, *Les demoiselles de Village*, of 1851 (R. Fernier, *La vie et l'œuvre de Gustave Courbet. Catalogue raisonné I. 1819–1865*, Lausanne-Paris, No. 127 pp. 78–79).

14. There is a quotation from Lhermitte in Pissarro's etching (D.112) *Marché à Gisors* (*rue Cappeville*), for which see further Brettell and Lloyd, No. 256.

15. P & V 1395, for which there is a watercolor in the Ashmolean Museum, Oxford (Brettell and Lloyd, No. 166 repr.).

16. F.W.H. Hollstein, *Dutch and Flemish Engravings and Woodcuts c. 1450–1700*, X, Amsterdam (1954) p. 177 repr.

17. Brettell and Lloyd, No. 139 repr.

18. P & V 909, of 1895.

19. P & V 423.

20. C. M. de Hauke, *Seurat et son œuvre*, II. Paris, 1961, No. 587 p. 164 repr.

21. Reproduced R. Lane, *Images from the Floating World*, Oxford-London-Melbourne, 1978, fig. 297 p. 249.

22. Two relevant canvases are those now in the Sterling and Francine Clark Art Institute, Williamstown (P & V 76 and 77).

23. See G. Needham, in *Japonisme: Japanese Influence on French Art 1854–1910*, p. 117.

24. P & V 183–186.

25. *Boulevard Montmartre, effet de nuit* (P & V 994), of 1897 (London, National Gallery), for full details see M. Davies (and C. Gould), *National Gallery Catalogues. French School. Early 19th Century, Impressionists, Post-Impressionists etc.*, London, 1970, pp. 112–113. Comparison may be made with *Yoshiwara Gateway with Cherry Trees and Tayū Outside: View Down Street at Night* by Hiroshige from the *Tōto Meisho* series (Ashmolean Museum, Oxford, inv. x 4707 Jennings/Spalding Bequest).

26. *Rue Saint-Lazare à Paris* (D. 184, of 1897) makes an interesting comparison with *Coin de rue vue d'en haut* from Bonnard's *Quelques Aspects de la Vie de Paris* (published in 1899).

27. D. 16, 17, 18, 19 and particularly 20 are good examples of Pissarro's use of aquatint. Only D. 16 was certainly executed in connection with *Le Jour et la Nuit*.

28. P & V 1358. For full details see *Bridgestone Museum of Art*, Tokyo, 1977, Notes on the Plates.

29. Brettell and Lloyd, No. 122 repr.

30. Brettell and Lloyd, No. 123 repr.

31. P & V 565.

32. P & V 726.

33. Brettell and Lloyd, No. 182 repr.

34. As, for example, in *Hamamatsu* from the series *Tōkaidō* repr. Lane, op. cit., fig. 126 p. 237.

35. P & V 152 (sold Christie's July 2, 1979 lot 14 repr. as part of the Mettler Collection).

36. P & V 135 where the spreading branches of the tree may be compared with Hiroshige's *Seba* from *The Sixty-Nine Stations of the Kiso Highway* repr. Lane, op. cit., pl. 186 p. 182.

37. *Jardin Publique à Pontoise* is P & V 257. For full details see C. Sterling and M. M. Salinger, *French Paintings. A Catalogue of the Collection of The Metropolitan Museum of Art*, New York, 1967, pp. 16–18. *Mt. Fuji Seen from Mishima Pass* is from *Thirty-Six Views of Mt. Fuji* by Hokusai (reproduced Lane, op. cit., pl. 170 p. 166).

38. For instance, Pissarro wrote to Lucien on February 26, 1896, "J'ai des effets de brouillard et de brume, de pluie, soleil couchant, temps gris, les motifs des ponts coupés de différentes manières, des quais avec bateaux; mais ce qui m'intéresse particulièrement est un motif du pont de fer par un temps mouillé, avec tout un grand trafic de voitures, piétons, travailleurs sur les quais, bateaux, fumée, brume dans les lointains, très vivant et très mouvementé." (*Lettres*, pp. 399–400).

39. For example, p & V 956 *Le grand pont, Rouen*, of 1896 (Pittsburgh, Carnegie Institute). The bridge is, in fact, the Pont Boieldieu.

40. D. 65 of 1887.

41. Compare *Place de la République à Rouen* with *Ōtsu No. 54: Village Street in Early Spring with Printseller's Shop* from the series *Fifty-Three Stages of the Tōkaidō* by Hiroshige (repr. Ives, op. cit., p. 61 fig. 63).

42. For example, P & V 1030 *La Place du Théâtre Français, effet de pluie* (Minneapolis, Institute of Fine Art).

43. Quoted from a letter from Camille Pissarro to Lucien written on July 5, 1883 (*Lettres*, p. 52).

44. For a list of the prints by Utamaro owned by Camille Pissarro see Appendix.. Hayashi owned at least two paintings by Pissarro, for which see *Lettres*, pp. 231–233, April 13, 1891 and p. 385, October 20, 1895. The painting mentioned in the earlier reference is unidentifiable, although it is described as dating from 1873, but the later one is P & V 904 (*La baigneuse dans le bois*) now in the Metropolitan Museum of Art, New York (Sterling and Salinger, op. cit., pp. 19–20). A reference to another painting (*Les faneuses*, possibly P & V 729) by Pissarro in which Hayashi had expressed an interest occurs in an unpublished letter from Camille to Lucien Pissarro dated May 9, 1891. In the letter of October 20, 1895 Camille Pissarro declares, "Je dois 700 francs à Hayashi, donc il me revient bien peu." It is possible that this sum represents Pissarro's purchase of Japanese prints from Hayashi.

45. G. Geffroy, *La Vie artistique*, I. Paris, 1892, pp. 119–122, first published May 18, 1890 as a review of an exhibition of Japanese woodcuts held at the Ecole des Beaux-Arts in April-May 1890. The essay and catalogue by Edmond de Goncourt, *Outamaro, Le peintre des Maisons vertes* was published in Paris in 1891.

46. For example P & V 567, *Paysannes gardant des Vaches, Pontoise*, of 1882 (Upperville, Virginia, Collection of Mr. and Mrs. Paul Mellon).

47. For the *Awabi Fishers* see Lane, op. cit., fig. 686 p. 341. For the *Six Tama Rivers* see Lane, op. cit., fig. 616 p. 327. Pissarro's attitude to the female nude, as is apparent from his letters, is complicated and is in need of study. The present writer believes that the eighteenth century was a source of inspiration (*The Burlington Magazine*, CXVII 1975, pp. 722–726) in this matter and to a certain extent the stylistic connection that is often made in contemporary literature of the relationship between Utamaro and eighteenth century art lends support to this idea (see T. Duret, *Livres et albums illustrés du Japon reunis et catalogués par T. Duret*, Bibliothèque Nationale. Départment des Estampes, Paris, 1900 p. 110).

48. One thinks immediately of the role of women in the work of both artists. Pissarro was in all probability not at all concerned with the subject-matter of Utamaro and was therefore able to translate the female forms of the Japanese artist into a French rural context.

49. For a detailed account of this whole project with references see Brettell and Lloyd, pp. 66–85 and Nos. 322–378 repr.

50. Reproduced by J. Leymarie and M. Melot, *The Graphic Works of the Impressionists*, English edn. London, 1972, P 199–204.

51. Unpublished letter of September 23, 1893 from Camille to Lucien Pissarro dis-
 cussing *Travaux des Champs*. "Ce matin j'ai beaucoup regardé ta gravure de Tra-
 vaux des champs; je l'ai mis dans du blanc convenablement, vu à la distance
 convenable, cela fait beaucoup mieux que la première inspection m'avait pro-
 duite . . . Elle ressemble à un vitrail et a un certain charme."
52. Brettell and Lloyd, No. 332 repr.
53. Brettell and Lloyd, No. 330 repr.
54. P & V 854.
55. Reproduced L. Goldscheider, *Johannes Vermeer*, London, 1955, pl. 54, Cat. No. 23.

APPENDIX

Prints by Utamaro owned by Camille Pissarro.
 1. *Tsuya Yosooi of the Ōgiya.*
 2. *Okita of the Naniwaya.* No signature, publisher's seal, or date.
 3. *Hitomoto of the Ōmonjiya.* Signed.
 4. *Yamauba and Kintoki.* Publisher: Tsuruya Kinsuke.
 5. *Mother and Child.* No title or publisher's seal.
 6. *The Tama River at Noji* from *The Six Tama Rivers*. Signed. Publisher: Matsumura
 Yahei.
 7. *Bust-length Portrait of Courtesan Drying a Plate.* Signed. No series title.
 8. *Morokoshi of the Echizenya* from *A Collection of Today's Most Beautiful Women*. Pub-
 lisher: Wakasaya Yoichi.
 9. *Hitomoto of the Ōmonjiya.* Signed.
10. *Somenosuke of the Matsubaya.* Signed.
 These ten prints passed from Camille Pissarro into the collection of Lucien
Pissarro, who seems to have owned at least two other Japanese prints, one of which
was acquired in London, as it has the following mark on the verso: *T. Murakami
(Kamura & Co.), Importer of Japanese Goods, 39, High Street, Notting Hill Gate, London,
W.11.*
 Thanks are due to Mr. Sebastian Izzard for his help in identifying these prints.

DEGAS, LAUTREC, AND JAPANESE ART

Theodore Reff

Most of the literature on the influence of Japanese on European art tends to be either very broad or very narrow in scope, either a sweeping survey of several decades, even of several centuries, or a detailed study of one artist, even one phase of his career. Rarely has something between those extremes been attempted: a comparative approach focusing on two important artists and examining in depth their responses to Japanese art. Such a comparison could of course be drawn between any of the modern European artists who were involved with Japonisme, but those who are most interesting to study in this regard, and not least because the one's response also affected the other's, are Degas and Toulouse-Lautrec. They were very different personalities and belonged to different generations; and thus, inevitably, their interests in Japanese art also diverged considerably, though in some respects they also coincided.[1]

Born in 1834, Degas was one of a small group of realist artists and writers who "discovered" Japanese art about 1860; when it was exhibited at the École des Beaux-Arts thirty years later, he was already prepared to call it "old hat" and to regret that it had become so popular.[2] Yet this was the moment when Lautrec, who was born in 1864 and first exposed to Japanese art in the early 1880s, along with Bernard, van Gogh, and other post-Impressionists, began seriously to study and imitate it; and Lautrec continued to admire and collect it to the end of his career. As late as 1900 he was still delighted by the pagodas and geishas at the World's Fair and still dreamed of sailing to Japan in a yacht;[3] whereas Degas wanted to travel no further than Montauban, and then only to catalogue the Ingres drawings in the museum there.[4] What each of them saw and responded to in Japanese art, how it suited his artistic personality, and what use he made of it in his work, is what we shall try to understand in some depth. At the same time, we shall have to distinguish more critically than is often done in the literature between convincing and less convincing examples of its actual influence on their work.

Let us begin with two of their images of themselves which tell us much about the kinds of art they admired. In a well-known photograph taken about 1892, Lautrec sits cross-legged on a mat, wearing a ceremonial kimono and courtier's hat and holding a Japanese doll as well as a fan.[5] In this typical theatrical gesture,

he reveals an eagerness to identify himself with a civilization he found intriguing and admirable. As his friend Gauzi informs us, "Lautrec considered the Japanese like his brothers, the same size he was. Alongside them, he appeared normal. All his life he wanted to visit the land of the *mousmés* and dwarf trees, of which he had formed a marvelous picture based on Hokusai's prints."[6] In deliberately crossing his eyes in the photograph, Lautrec may have been imitating a familiar type of Kabuki actor print by Sharaku (e.g., Fig. 15), where the subject is shown with noticeably crossed eyes to express his intensity of feeling.[7] Given his great interest in physiognomic expression, Lautrec would have been struck by so unusual a feature and, in his usual droll manner, would naturally have adopted it. Emotional intensity was something he valued in art as well as in life. Yet he could also find it in European art, and the list of his enthusiams in that area, from Botticelli and Cranach to Goya and Daumier, is impressively varied and long.[8]

When Degas chose to assume an historical guise, it was of a very different sort. An equally amusing photograph, taken during a summer holiday in 1885, shows him feigning a weary solemnity amid adoring young relatives and friends.[9] Clearly he was parodying Ingres's *Apotheosis of Homer*, a picture he had copied repeatedly as a student. His choice of it as a model suggests not only his continued veneration of that master, despite the criticism implicit in the parody, but also his identification with the blind Homer, an anguished comment about his own failing eyesight.[10] The contrast with Lautrec's imitation of a Japanese actor's crossed eyes could not be more poignant or more complete. But so is the larger contrast between the cultural traditions with which the two artists identify themselves in their photographs.

Yet there is evidence that Degas, too, greatly admired Japanese art. When, for example, the German collector Jäger wanted to gain entrance to Degas's apartment and studio around 1890, an almost unheard-of feat, especially for a foreigner, he "took with him two portfolios. In one there was a pair of drawings by Ingres, which he was risking carrying about uninsured. In the other, there were a dozen of his best Japanese prints. With the Ingres drawings, he got into the apartment, with the Japanese prints into the studio."[11] The anecdote tells much about Degas's continuing interest in Japanese art, even if he thought it was becoming "old hat." Like Lautrec, he knew most of the major collectors of his day—Burty, Duret, Hayashi, Manzi, Portier, above all Alexis and Henri Rouart—and could study the outstanding prints, drawings, and illustrated books in their possession. And like Lautrec he himself had an impressive collection of *ukiyo-e* prints, comprising Kiyonaga's famous *Bath House* diptych, two of Utamaro's triptychs, over forty woodcuts by Hokusai, Shunchō, and others, and fourteen albums, although Ingres's drawings, of which he owned ninety, remained his favorites.[12]

There was, we know, already a vogue of Japanese prints, porcelain, and decorative objects in Paris in the late 1850s and early 1860s. In Degas's œuvre the earliest examples occur in paintings of about 1866. In the *Collector of Prints*, the largest objects in the frame at the upper right appear to be fragments of eighteenth or nineteenth-century Japanese embroidered book covers, widely admired in France at the time for their unusual color harmonies and striking

patterns.[13] Moreover, their scattered arrangement may be based on that of the cards represented on a familiar type of book cover inspired by a popular Japanese game. But it may also be based on European *trompe-l'œil* still-life paintings, which typically depict fragments of imagery and printed matter casually disposed on a bulletin board like the one Degas describes.[14] As is often the case in discussing such sources, the two alternatives coexist, unreconciled.

In the ambitious *Portrait of James Tissot*, among the many pictures in the background of different subjects and styles, the long, horizontal one at the top shows figures in Japanese or possibly Korean costume in an outdoor garden with a pavillion and stone lantern.[15] If it does not reproduce an authentic Japanese work—and the realistic modelling, cast shadows, and atmospheric space argue against that—it evidently was based on such a work, probably a print in triptych form like Eishi's *Evening under the Murmuring Pines*. Its presence here reflects a taste shared by Degas and Tissot, who were at this time equally interested in Japanese art and indeed were cited by Chesneau and others as being among its earliest collectors.[16]

Japanese objects also appear in two of Degas's portraits in 1870. In that of Hortense Valpinçon, a distinctive type of Japanese embroidery covers the chest on which she leans.[17] In that of Mme Camus, the wife of the well-known collector of Oriental ceramics, she holds a white Japanese fan.[18] But these examples merely testify to the vogue of such objects in Degas's circle at that time. Indeed Whistler's *Lange Lijzen of the Six Marks*, of 1865, the apparent model for the portrait of Mme Camus, goes much further in documenting a taste for Far Eastern art, Chinese as well as Japanese,[19] whereas Degas, characteristically more eclectic, also introduces a Baroque gilded mirror and blackamoor statue.

When Toulouse-Lautrec paints a figure in Japanese costume, the effect is of a stark, down-to-earth realism. He portrays Lilly Grenier, the wife of a fellow artist, wearing a kimono merely as a colorful dressing gown;[20] and neither her dyed red hair or sullen expression nor the bare room in which she is shown indicates any interest in the subtlety and mystery, the evocative poetry, of the Far East, such as we find in Degas and Whistler. And when, three years later, Lautrec depicts a Japanese *kakemono*—a floral scroll of the Rimpa School, perhaps by Sōsetsu—in the background of his portraits of Dr. Bourges and Paul Sescau, it seems merely an exotic curiosity, isolated in a realistically described studio.[21] Since the same *kakemono* appears in both portraits, it presumably belonged to Lautrec, who is known to have owned such works, as well as large numbers of Japanese prints, some of great rarity and quality.[22] From his letters and other sources, we learn that he was already exposed to them by a fellow student in 1882, that Georges Petit's exhibition of Japanese art the following year was a great revelation, and that he began collecting *ukiyo-e* prints along with his friends Bernard and Anquetin at about that time.[23] Later he would spend whole days in the Goupil Gallery and evenings in the homes of Camondo and Duret, studying their choice collections of *ukiyo-e* masters.[24] So great was his enthusiam that he had an authentic writing set sent from Japan, so that he could draw with *sumi* ink himself; whereas for Degas European charcoals and pastels still sufficed.

Given the ample evidence of Degas's and Lautrec's interest in Japanese art from early on in their careers, the question naturally arises: what did each one learn from it and make use of in his own art? Many examples of its purported influence have been cited, some more convincing than others,[25] and we must try to distinguish among them.

Lautrec's lithograph *The Jockey at Longchamp* can be compared, as Degas's *Jockeys before the Reviewing Stands* has been, with one of the pages in Hokusai's *Manga* showing a horse in roughly the same position, seen from the same angle.[26] The resultant pattern of the legs is indeed similar, but this proves nothing. The history of art abounds in images of horses rearing back in exactly the same way. As an habitué of the race-track Lautrec would in any event not have needed to look at a detail of Hokusai's *Manga* in order to represent a horse rearing; and even if he did, there is an altogether different feeling in the Hokusai, which would have made it irrelevant.

Another page from the *Manga* (Fig. 1), showing a public bath house with women bathers in vividly realistic attitudes, can also be compared, as some of Degas's bathers have been, with Lautrec's *Woman at Her Toilet* (Fig. 2).[27] There are indeed in the Hokusai figures seen from behind in ungainly poses roughly similar to that in the Lautrec. That this realistic conception of the body is the same in both and that Lautrec would have delighted in finding it in the Japanese

Fig. 1. Katsushika Hokusai, *A Public Bath*, *The Manga*, vol. I, 1814. Color woodcut. The Metropolitan Museum of Art, New York, Gift of Howard Mansfield, 1936.

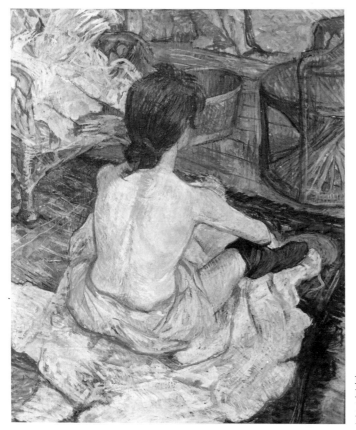

Fig. 2. Henri de Toulouse-Lautrec, *Woman at Her Toilet*, 1896. Oil on cardboard. Musée du Louvre, Paris.

print is surely correct. But that he definitely saw Hokusai's bathers or needed to see them in order to paint his own is surely not. If he looked at anyone, it seems instead to have been Degas, particularly at one version of the *Woman Combing Her Hair*, which shares more important features with the Lautrec than does any of Hokusai's bathers.[28] The figure's unstable, three-quarter turn, the emphasis on her weightiness and fleshiness, the suggestion of her personality, though we see nothing of her face, the detailed description of her boudoir setting— these are features of a sharp, critical, specifically European form of realism that the two artists shared. Lautrec, who venerated Degas, would have responded to just those features in looking at the *Woman Combing Her Hair* at the last Impressionist exhibition in 1886.

For Degas's own work, the *Manga* is among the most obvious and frequently cited sources. *The Baker's Wife*, another of the nudes he exhibited in 1886, has been compared with one of Hokusai's drawings of a sumō wrestler.[29] Although they do stand roughly in the same way, their hands on their hips, the weightiness of Degas's plump nude, whose feet seem firmly planted on the ground, and the explicitness with which her domestic setting is described distinguish her from the seemingly weightless wrestler floating on a blank page in Hokusai, just as the expression of her distinctly bourgeois personality and the sensual implication of her gesture distinguish her from the more impersonal wrestler.[30]

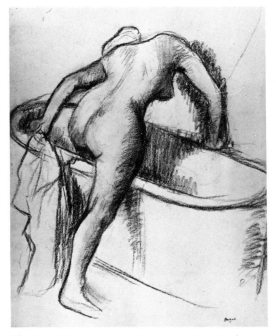

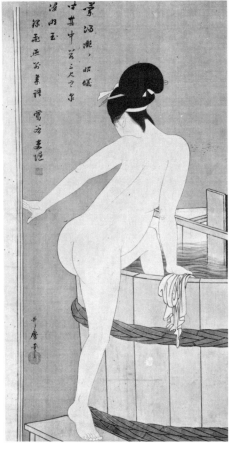

Fig. 3. Edgar Degas, *Woman at Her Bath*, ca. 1888. Charcoal drawing. Present whereabouts unknown.

Fig. 4. Kitagawa Utamaro, *Woman Bathing*, ca. 1790. Ink and color on silk. Kyūsei Atami Art Museum, Atami.

Prints by other Japanese artists have also been suggested as sources for some of Degas's bathers. For the one shown from behind, stepping into a tub, as in the charcoal drawing illustrated here (Fig. 3), Utamaro's well-known painting of a woman bathing (Fig. 4) has been cited; and indeed his bather does assume nearly the same pose as she leans forward to enter the tub.[31] Here, too, however, it is evident that the European artist represents the human body as a ponderous, highly articulated mechanism, in which the transfer of weight from one leg to another affects the entire stance, producing a more dynamic, visually assertive silhouette than the graceful, passive one in Utamaro, where she appears weightless and her action effortless.[32] Moreover, there exist equally good, if not better, sources for Degas's figure within Western art. In Marcantonio's engraving after part of Michelangelo's *Battle of Cascina*, a familiar anatomical model in European art studios, the soldier climbing out of the water corresponds more closely than Utamaro's bather as an image of the physical effort involved and the relative distribution of weight within the body. Degas would not only have seen Marcantonio's print as an art student in the mid-1850s, he had actually copied the soldier in question (Fig. 5).[33] In this case, one among many, we must weigh the purported Japanese influence against a European one and decide what each would have contributed.[34]

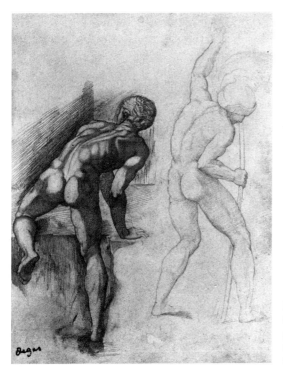

Fig. 5. Edgar Degas, Copy after Marcantonio Raimondi's engraving of Michelangelo's *Battle of Cascina*, ca. 1856. Pencil drawing. The Detroit Institute of Arts, Bequest of John S. Newberry.

In addition to expressive figure types, Japanese art is often said to have provided Lautrec and Degas with striking compositional schemas previously unknown in the West. The influence of Utamaro's *Dream of a Young Woman* on Lautrec's *The Ballet of "Papa Chrysanthème,"* an appropriately exotic subject, has been suggested.[35] But if in both works the steeply tilted ground plane contains large, boldly silhouetted figures in the foreground, intercepted by the frame, and one or two disproportionately small figures above and behind them, this is hardly a sufficient reason for assuming a direct influence of one on the other, since the same features occur in paintings by Gauguin, Bernard, and others in the Pont-Aven School, with which Lautrec was undoubtedly familiar.[36] Similarly, the influence of Hiroshige's woodcut *The Crossing of the Tenryū River* on Degas's painting *The Carriage at the Races* was already suggested nearly forty years ago.[37] In both compositions a very large complex of forms in the lower right foreground is contrasted to a group of small, delicately silhouetted ones in the upper left background. But the same features can also be found in pre-Impressionist works of the 1860s and early 1870s by Manet, Fattori, and others.[38] Similarly, the cutting of the carriage and horses at the lower right of Degas's composition, supposedly an innovation that must be attributed to Japanese influence—and already was, by Huysmans, in 1880[39]—can be found in earlier paintings by Manet, as well as in photographs of the 1860s.[40] In fact, such abnormally large and radically cut forms can be seen in the foreground in much older compositions, such as those of Vermeer.[41] Once again it is difficult to be persuaded of a Japanese source when an equally good and more accessible European one is at hand.

Are there, then, no convincing examples of the influence of Japanese prints on Degas and Lautrec? There are indeed, some of them already published, others not; and in both groups, some more significant, others less so. It is, for instance, at once obvious and unimportant that the tall, narrow format of Degas's etching *At the Louvre* imitates those of Japanese pillar prints and that the circular monogram on Lautrec's posters and prints imitates the seals used by Japanese artists and censors. It is also obvious that, within the wide range of urban genre subjects treated in *ukiyo-e* prints, Degas and Lautrec could both find models or precedents —Degas in the numerous images of women bathing, combing their hair, or shopping for clothes, Lautrec in those of ceremonial dancers, popular actors, and prostitutes. Only when the significant examples have been discovered, do we learn much about the nature of the inspiration these artists found in Japanese art.

Degas's oil sketch *The Cotton Merchants* (Fig. 6), painted in New Orleans in 1873, is perhaps his earliest picture composed in a distinctively Japanese manner, unprecedented even in his "Japonizing" works of the previous decade.[42] The scene is viewed from a high vantage point, and as result the surface is boldly divided by the vertical wall at the right and the sharply diagonal counter at the left; within this geometric matrix the figures are marginal and incomplete, cut by a wall or thrust into the background. Such a composition clearly reflects the

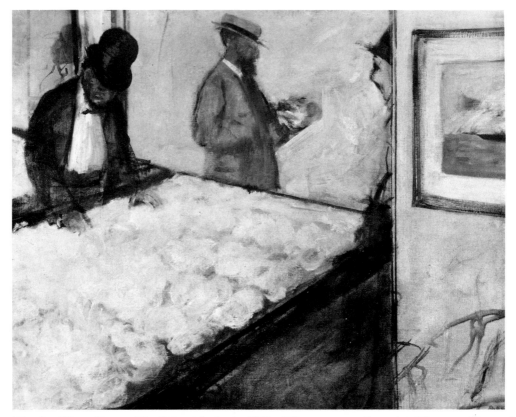

Fig. 6. Edgar Degas, *The Cotton Merchants*, 1873. Oil on canvas. Fogg Art Museum, Harvard University, Gift of Herbert N. Straus.

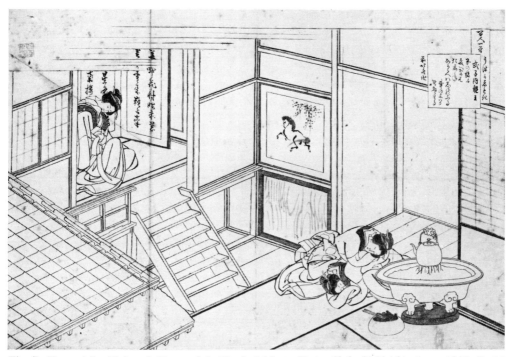

Fig. 7. Katsushika Hokusai, *Poems of the Hundred Master Poets: Shokushi Naishinnō*, ca. 1848. Smithsonian Institution, Freer Gallery of Art, Washington.

influence of *ukiyo-e* prints and drawings such as those in Hokusai's *Poems of the Hundred Master Poets* (Fig. 7); he was, of course, one of the first Japanese artists whose work became familiar in France.[43] It could be argued that this type of composition was in turn based on the European system of perspective, which entered Japan in the eighteenth century through Dutch paintings and prints and the illustrations in manuals on painting techniques.[44] But the typical form of this system, with a single vanishing point and lines converging toward it, has less to do with Hokusai's composition than does the traditional Japanese system of diagonal construction, long used in painting scrolls and screens. The only equivalent in European art is isometric perspective, a type that was evidently not known in the Far East.[45]

Degas's well-known picture *L'Absinthe* is no less clearly based on a familiar type of Japanese design such as Harunobu's *Suzumegai: Nursing Child under a Net*.[46] Here, too, the subject is seen from a steep vertical angle, and the surface is divided by a series of diagonal and vertical lines. The social criticism implicit in *L'Absinthe* is of course absent from Harunobu's image, yet Degas's conception of realism, his way of envisaging such a subject, is close to that of the Japanese artist.[47] Degas stresses the unexpected, the visually confusing and disturbing in our everyday perceptions, the things we must make an effort to interpret. In pictures such as *L'Absinthe* and *The Cotton Merchants* we come upon figures not centered in the field, but thrust to one side, and complicated, zigzagging constructions we must penetrate in order to understand.[48] Through such devices, he captures the unstable quality of our actual experience of the modern city, rather than

the order and clarity implicit in traditional perspective. This is why he could find useful models in prints like Harunobu's.

Among Degas's scenes of ballet rehearsal, too, we find such effects, ultimately derived from Japanese prints. In *Dancers in the Rehearsal Room* there is the same delight in visual paradox.[49] Our entry into the illusory space is blocked by the bass viola lying on the floor; then we encounter a dancer whose large bow we see first before we discover her back and finally her head.[50] It is an anticlassical conception of the human figure, undignified and awkward, and the other dancers appear equally confusing as they overlap and trail into the background. Paradoxical, too, is the contrast between the large, rather dreary wall at the upper left and the many colorful figures crowded together at the upper right. In some of Hiroshige's prints, such as *Changing Horses and Porters at Fujieda*, there are the same kinds of visual paradox, even the same compositional pattern.[51] Entering the scene at the lower left, we come first upon a man in an ungainly stooping posture, then upon others in equally awkward poses, straining and bending as they work. They recede into depth along a curved diagonal from lower left to upper right, on a steeply rising ground with no horizon, so that the design

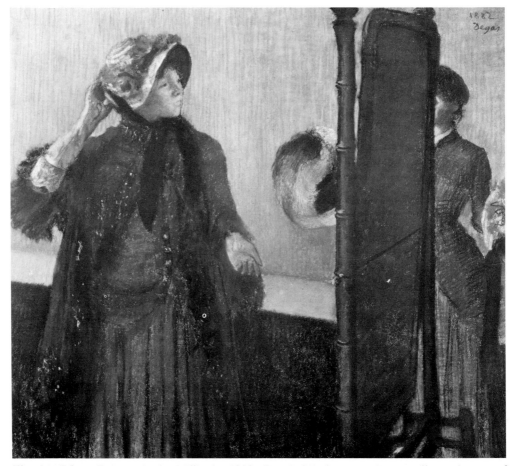

Fig. 8. Edgar Degas, *At the Milliner's*, 1882. Pastel drawing. The Metropolitan Museum of Art, New York, Bequest of Mrs. H. O. Havemeyer, 1929.

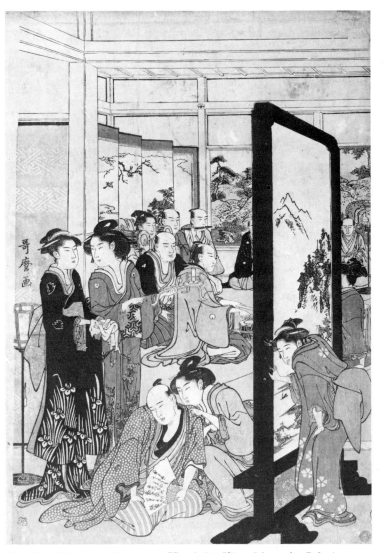

Fig. 9. Kitagawa Utamaro, *The Artist Kitao Masanobu Relaxing at a Party*, ca. 1788. Color woodcut. The Metropolitan Museum of Art, New York, Frederick C. Hewitt Fund, 1912.

seems to end abruptly at the top. As a result, we look down on them from a certain distance; as in the Degas, we are spectators, not participants; but in no other sense are we superior socially to these porters, whereas we clearly are to the dancers.

A particularly telling example of this type of Japanese influence is Degas's pastel *At the Milliner's* (Fig. 8), which is often cited as an illustration of his daringly divided and incomplete compositions.[52] The milliner's mirror extends the entire height of the surface, violating traditional principles of compositional unity in European art. There is a precedent, however, in Japanese art: in Utamaro's print *The Artist Kitao Masanobu Relaxing at a Party* (Fig. 9) a very similar form— a screen rather than a mirror—runs from the bottom almost to the top, inter-

cepting several of the figures.[53] Like the shop girl in Degas's picture, divided by the mirror so that we glimpse her eye and little else of her face, Utamaro's party guests are wittily intercepted by the screen. It could be argued that the screen, indeed the whole interior, is drawn in correct if extreme perspective under the influence of European art; but what counts is the unusual way in which Utamaro uses such a form to create amusing difficulties for the eye, such as the figures one has to read on both sides of the vertical in order to interpret correctly. It is this sophisticated side of Japanese design that Degas responds to and assimilates. For him, however, for the Parisian realist, the interrupted form is not only visually amusing; it is also a subtle means of contrasting the shop-girl, who appears impersonal, literally faceless, a mere holder of hats, and her bourgeois client, who contemplates herself in the mirror, poised, proud, and complete.[54]

Another work in which Degas uses a Japanese compositional device to comment shrewdly on a familiar figure in contemporary society is the *Café on the Boulevard Montmartre*.[55] Very cruelly, he shows four apathetic streetwalkers waiting

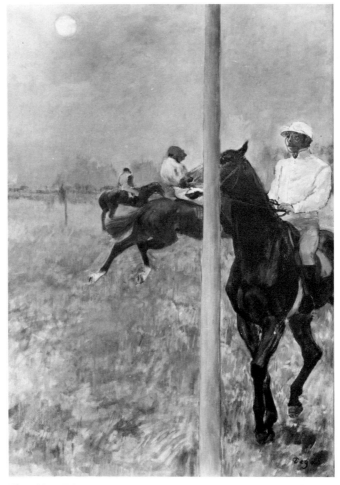

Fig. 10. Edgar Degas, *Jockeys before the Race*, ca. 1879. Oil and gouache on cardboard. The Barber Institute of Fine Arts, University of Birmingham.

for clients on a café terrace, and to emphasize the emptiness of their existence, he shows all of them brutally cut by the picture's edges or the café's columns, which run uninterrupted from bottom to top and are placed so as to intercept or frame all of the women. The only precedents for such a design are in Japanese prints such as one of Kunisada's illustrations of *The Tale of Genji*, where a series of columns disposed across the surface either cuts or frames the figures very much as they are in the Degas, though without its sharp social comment.[56]

Probably the most extreme example of such a design in Degas's œuvre is *Jockeys before the Race* (Fig. 10).[57] Unlike his other pictures of horses manoeuvering at the starting line, this one shows the white pole extending the height of the canvas, dividing it into two unequal rectangles; typically, the larger one is almost empty, while the smaller one contains most of the mounted jockeys. Yet even for this unusual design there are precedents in Japanese art, for example, in Shunchō's *Women on New Year's Day* (Fig. 11), where vertical elements are likewise used as a means of boldly dividing and separating groups of figures.[58]

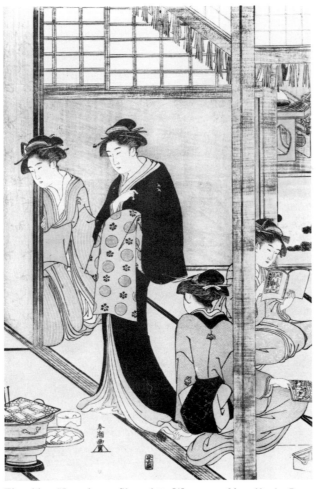

Fig. 11. Katsukawa Shunchō, *Women on New Year's Day*, part of polyptych, ca. 1790. Color woodcut. Formerly Coll. of R. Wagner, Berlin.

Again, however, Degas cleverly transforms and exaggerates his Japanese model. The mounted jockey at the right seems to rush headlong into the starting pole and the horse's head to disappear, as if telescoped into it. Only on closer examination do we discover the horse's muzzle and open mouth on the other side of the pole, deliberately confused with the saddle and breeches of the rider further back in space.[59] In this way, Degas makes visible some of the paradoxes in vision itself, the things we must sort out before we can make sense of them. And in that enterprise the Japanese print seems to have played a crucial role, providing a glimpse into the unexpected look of things.[60]

The same can be said about the influence of Japanese compositional types on Toulouse-Lautrec, and a number of specific examples have been suggested in the literature. His portrait of the actor Samary in the role of Raoul de Vaubert has been compared with Bunchō's portrait of Arashi Hinaji as Yuga-gozen, which likewise shows a steep, plunging perspective and a strong diagonal division of the surface in relation to the figure.[61] But as in some of the cases discussed earlier, there are more likely sources in European art, and in this case, particularly in the work of Degas. His *Friends on Stage*, a portrait of two acquaintances, Ludovic Halévy and Boulanger-Cavé, backstage at the Opera, is the type of composition most relevant to Lautrec, although it in turn may well be based on prints such as Bunchō's.[62] Like the portrait of Samary, it reflects the European artist's delight in the theater as a world of novelty and surprise, full of cleverly incomplete forms, steep angles of vision, and figures silhouetted against the blank stage flats. And as such it would have meant more to Lautrec than the relatively impersonal portrait of Arashi Hinaji.

To take another example, Lautrec's poster *Jane Avril at the Jardin de Paris* has been said to reveal Japanese influence in the contrast between a large, fluidly outlined form in the foreground and a much smaller one in the distance that seem nevertheless to coexist on the picture surface, the one framing the other.[63] Utamaro's *Dream of a Young Woman*, discussed earlier as a possible source for another of Lautrec's works, is precisely that kind of composition; and some of the *art nouveau* aspects of the Jane Avril poster, the way in which the frame grows out of the bass fiddle scroll and forms a twisting linear pattern, for example, undoubtedly do derive from prints such as Utamaro's. But it is just as likely that the design as a whole has sources in European art, and once again in that of Degas. In the *Ballet Seen from the Opera Box* he juxtaposes on the picture surface the greatly enlarged spectator in the loge, her fan and extended hand joined with her silhouette, and the much smaller *première danseuse* on the stage, their forms fused together despite the actual distance between them.[64] Behind the *première danseuse*, still higher up and further back, appear the legs and skirts of the *corps de ballet*, cleverly intercepted by the frame. Both compositionally and in its theatrical subject, Degas's picture is thus very close to Lautrec's, closer than Utamaro's or any other *ukiyo-e* print.

What, then, were the aspects of Japanese art that did influence Lautrec, and why was he attracted to them? He was, of course, a complex artistic personality who responded to many different aspects, the coarse as well as the refined, the

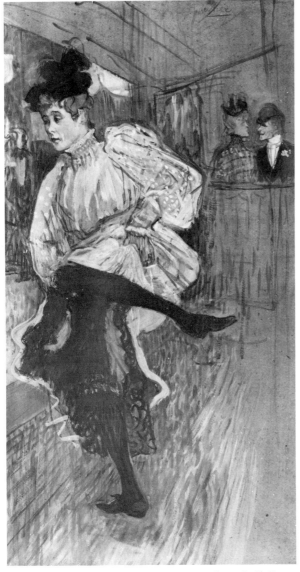

Fig. 12. Henri de Toulouse-Lautrec, *Jane Avril Dancing*, 1893. Oil on cardboard. Musée du Louvre, Paris.

Fig. 13. Torii Kiyotada, *An Actor of the Ichikawa Clan in a Violent Dance Movement*, ca. 1715. Color woodcut. The Metropolitan Museum of Art, New York, Harris Brisbane Dick Fund, 1949.

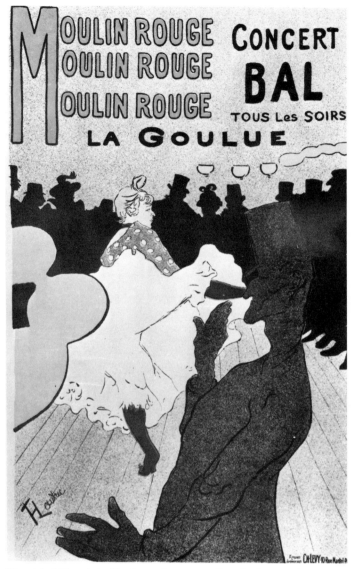

Fig. 14. Henri de Toulouse-Lautrec, *La Goulue at the Moulin Rouge*, 1891. Color lithograph. Musée Toulouse-Lautrec, Albi.

dramatic as will as the lyrical. But above all, it was to elements of expressive intensity—the exaggerated contrasts in scale and physiognomic distortions, the emphatic, sweeping lines in certain drawings, the rare harmonies and glittering colors in certain prints—rather than the purely formal or decorative elements or the obvious thematic similarities usually cited.[65] Living on his nerves, in a frequently high-keyed state, in a milieu of bohemian excess and decadence, he cannot be satisfied by Degas's more aloof and sohphisticated vision. Rather he needs an emotionally gratifying art more responsive to the conditions of his unconventional, frenetic existence; and this need is what forms the most important features of his taste in Japanese art.

Fig. 15. Tōshūsai Sharaku. *The Actor Ōtani Oniji III as Edohei*, ca. 1795.
Color woodcut. The Metropolitan Museum of Art, New York, Bequest of
Henry L. Phillips, 1940.

The subjects Lautrec seems to prefer are those of a racy urban realism that
he often chooses to treat himself, such as the prostitute, the woman at her toilet,
and the lower-class performer.[66] His lively oil sketch of *Jane Avril Dancing* (Fig.
12), whose tall vertical format is Japanese, shares with some of the Kabuki actor
prints both the deliberate awkwardness of the dancer's stance as she balances
herself with her body twisted and one leg thrust out abruptly, and the reinforce-
ment of her irregular, almost jagged silhouette by contrasting colors, causing
it to stand out as a dynamic form expressive of the dance movement.[67] In Kiyo-
tada's *Actor of the Ichikawa Clan in a Violent Dance Movement* (Fig. 13), these features
are still more evident; the subordination of the figure's form to the complex

pattern of his costume is so extreme that it becomes difficult to read, and we discover with surprise a head emerging from his strongly outlined silhouette, more abruptly than any part of Jane Avril's anatomy.[68]

The boldness of the Japanese printmakers' designs must have inspired Lautrec in other respects as well. His color lithographs, especially those made as posters, exploit fully the expressive potential not only of the condensed, clearly outlined forms and bright, unmodelled colors of *ukiyo-e* prints, as has often been noted, but also their striking contrasts in proportion, pattern, and other visual elements. One of his posters for the popular singer and cabaret owner Aristide Bruant, for example, shows the influence of prints such as Shunshō's *Actor Ichikawa Danjūrō V in a Shibaraku Role* in two such features.[69] One is the juxtaposition of the large costumed body and the small piquant face, dwarfed by the body's mass, an amusing contrast that enchances the visual appeal of the theatrical image. The other is the distinctive combination of lettering and representation, the words functioning both as a verbal complement of the actor's figure and, in a more subtle way, as a visual equivalent, an intricate pattern whose "physiognomy" curiously resembles his own. In both features Lautrec's picture of a performer seems directly dependent on Shunshō's. An equally clear example of Lautrec's integration of the two media, though in this case the lettering appears above the image, is his poster *La Goulue at the Moulin Rouge* (Fig. 14);[70] but here another kind of Japanese influence is also felt.

The way in which Lautrec characterizes the Moulin Rouge performers, particularly Valentin "le désossé," or "spineless," a talented amateur who danced in a spontaneous, remarkably uninhibited manner, assuming contorted postures as he does here, owes a great deal to the example of Japanese actor prints. In Sharaku's, the most famous ones, which we have already compared with the photograph of Lautrec himself in Japanese costume, such means of expressive distortion are typically employed.[71] In the portrait of Ōtoni Oniji III as Edohei (Fig. 15), for example, the hands with fingers thrust out, the scowling expression, and the crossed eyes convey an emotional intensity equal to that in Lautrec's image of Valentin "le désossé."[72] Sharaku's expressive devices may ultimately be of European origin, since the realistic interest in portraying personality through subtle facial expressions is virtually unknown in Japanese art before its contact with European art in the seventeenth century.[73] But what counts for Lautrec is the way in which Sharaku develops such devices, exaggerating their expressive force to the extent that they could becomes a point of departure for caricatures such as that of Valentin "le désossé."

Among the Japanese graphic styles, Lautrec seems especially to have admired a type of swift, spontaneous ink drawing in which a single stroke defines an important form without hesitation or revision. The boldness of execution appealed to him through its sense of immediacy and conviction. A self-portrait by the eighteenth-century artist Hakuin, for example, has rightly been considered a model for drawings and prints like *The Conversation*, in which Lautrec defines forms with equally conspicuous, calligraphic strokes.[74] Another example, no less convincing, is his lithograph of Jane Avril dancing, which has been compared with an eighteenth-century Japanese print very likely influenced by Zen Buddhist

ink paintings.[75] On several occasions Lautrec imitated precisely the style of such ink paintings or their reproduction in woodblock prints, using the ink stone, *sumi* stick, and brushes he had obtained from Japan. A landscape drawing of about 1894 (Fig. 16) is clearly based, both in its imagery and its execution in sweeping brushstrokes and clots of ink, on Hokusai's landscape sketches, which Lautrec would probably have known through somewhat stiffer woodcuts but has restored, as it were, to their original vivacity.[76]

If intensity of expression was the first thing Lautrec sought in Japanese art, it was not the only one. Like Bonnard, Vuillard, and other French artists of the time, he also discovered in the woodblock prints a feeling for rare, subtle color harmonies akin to his own. This was especially true of the sophisticated prints of Kiyonaga and Utamaro, which became increasingly available in France in the later 1880s and 1890s, whereas earlier those of the more popular Hiroshige and Hokusai had been.[77] Lautrec's cover for the album *l'Estampe Originale*, for example, is composed entirely of muted orange, olive green, yellow ochre, black and white—not at all a combination he would have learned in Cormon's studio, but one he could easily find in prints such as Kiyonaga's *Minamoto Shigeyuki Executing Calligraphy*.[78] Its daring juxtaposition of calligraphy and figurative imagery would also have appealed to him, since it occurs in many of his own prints and posters. He also employs a characteristically Japanese color harmony in *The Divan Japonais*, whose very subject attests to the vogue of such harmonies in interior decoration, too. Here the familiar combination of orange, green, yellow, black, and white is enriched by the addition of a soft gray and pale yellow, exactly as in a print such as Kiyonaga's *Visitors to Enoshima*; and as in that work it sounds a note of preciousness, almost of decadence, which Lautrec would

Fig. 16. Henri de Toulouse-Lautrec, *Landscape in the Manner of Hokusai*, 1894. Ink drawing. Private collection.

surely have admired and delighted in recreating.[79]

At times Lautrec achieved a still more artificial, decadent effect by imitating an unusual coloristic technique of the Japanese printmakers, the introduction of powdered metallic colors—mica, silver, and especially gold. Utamaro employs it brilliantly in his well-known series, *The Hours of the Green House*, which describes the daily lives of elegant Japanese courtesans and would certainly have interested Lautrec for that reason, too; it may indeed have inspired *Elles*, his suite of lithographs on the routine activities of Parisian prostitutes.[80] It is not in *Elles*, however, but in the technically more advanced print of Loie Fuller performing her celebrated dance at the Folies-Bergère that Lautrec comes closest to Utamaro.[81] Not only in the introduction of the confetti-like *crachis* and sparkling silver or gold, but also in their unusual combination with blue, gray, and mauve, he achieves an effect remarkably similar to that of *The Hour of the Serpent*, one of the most beautiful prints in the *Green House* series.[82]

As in his assimilation of other aspects of Japanese art, Lautrec was anticipated here by Degas, who in his representation of ballet subjects on painted fans—themselves inspired by Japanese fans and screens—employed powdered gold, as well as gold and silver pigments, to suggest the glittering artificiality of the theaters which such fans represent and in which they were used.[83] Thus both artists took up a distinctive feature of Japanese art, either from prints like Utamaro's or from the popular *surimono* prints, though in Lautrec's case Degas's earlier use of it may have been an additional stimulus. Yet each made something quite personal and original of the borrowed technique, and the differences between Lautrec's *Mlle Loie Fuller* and one of Degas's painted fans, *The Dancers*, reveal once again fundamental differences in their artistic personalities.[84] For Lautrec the dancer wrapped in her billowing costume and brilliantly illuminated by electric footlights is like a wraith that looms above him, a huge luminous cloud out of which emerge a head and tiny feet. Performing her spectacular "fire dance," she seems literally suspended in air, rather like the performers in Japanese prints depicting the equally dramatic "lion dance."[85] For Degas, on the other hand, the dancer is an amusing little creature in a white *tutu* whose flirtations with the elderly men-about-town courting her backstage he looks down on from a high vantage point with detached, ironic amusement. The contrast between the two images of the dance sums up concisely the difference in the two artists' conception of realism and expression. It is all the more telling in that each of them found the kind of inspiration he needed in the Japanese art that each in his own way so deeply admired.[86]

NOTES

1. Frank Whitford, *Japanese Prints and Western Paintings*, London, 1977, pp. 207–208, notes briefly some of the differences.

2. Edgas Degas, *Lettres*, ed. Marcel Guérin, Paris, 1945, p. 152, dated April 29, 1890; also George Moore, *Impressions and Opinions*, New York, 1891, p. 306.

3. Gustave Coquiot, *Lautrec, ou Quinze ans de mœurs parisiennes*, Paris, 1921, pp. 45, 84–85.

4. Degas, *Lettres*, pp. 211–212, 217–218, dated July 28, 1896 and August 25, 1897, respectively; also Henri Lapauze, "Ingres chez Degas," *La Renaissance de l'Art Français*, I, no. 1, March 1918, p. 9.

5. Illustrated in Georges Beaute, *Il y a cent ans Henri de Toulouse-Lautrec*, Geneva, 1964, p. 10.

6. François Gauzi, *Lautrec et son temps*, Paris, 1954, p. 53.

7. This point was suggested by Kirsten Keen, Columbia University.

8. See Coquiot, *Lautrec*, pp. 24–25; and Maurice Joyant, *Henri de Toulouse-Lautrec, 1864–1901*, I, pp. 9–10, among others.

9. Illustrated in Luce Hoctin, "Degas photographe," *L'Oeil*, no. 65, May 1960, pp. 36–38. The photographer was a young Englishman named Barnes.

10. Theodore Reff, *Degas: The Artist's Mind*, New York, 1976, pp. 53–55.

11. Julius Meier-Graefe, *Degas*, New York, 1923, p. 65. Colta Feller Ives, *The Great Wave: The Influence of Japanese Woodcuts on French Prints*, New York, 1974, p. 42, suggests that "Utamaro must have provided fresh and singular confirmation of the lessons of Ingres, whom Degas revered. Utamaro combined a delicacy of drawing with monumental dignity in his portrayals of women of all ranks."

12. *Catalogue des estampes anciennes et modernes composant la Collection Edgar Degas*, Hôtel Drouot, Paris, November 6–7, 1918, nos. 324–330. See P.-A. Lemoisne, *Degas et son œuvre*, Paris, 1946–49, I, pp. 176–180.

13. Lemoisne, *Degas*, II, no. 138, dated 1866. See Reff, *Degas: The Artist's Mind*, pp. 99–100, for this and what follows.

14. See, for example, the "letter rack" pictures illustrated in Marie-Louise d'Otrange Mastai, *Illusion in Art*, New York, 1975, pp. 242–243.

15. Lemoisne, *Degas*, II, no. 175; painted in 1866–68. See Reff, *Degas: The Artist's Mind*, pp. 104–106, for this and what follows.

16. Ernest Chesneau, "Le Japon à Paris," *Gazette des Beaux-Arts*, 18, 1878, p. 387; also Léonce Bénédite, "Whistler," *Gazette des Beaux Arts*, 34, 1905, pp. 143–144.

17. Lemoisne, *Degas*, II, no. 206; painted in 1869.

18. Lemoisne, *Degas*, II, no. 271; painted in 1870. Reviewing the Salon in which it appeared in *Le Rappel*, 1870, Philippe Burty observed in it other signs of Japanese influence; see Gabriel Weisberg, in *Japonisme: Japanese Influence on French Art 1854–1910*, Cleveland, 1975, p. 47.

19. *From Realism to Symbolism: Whistler and His World*, Wildenstein, New York, 1971, pp. 19, 41–42.

20. M. G. Dortu, *Toulouse-Lautrec et son œuvre*, New York, 1971, no. P. 302; painted in 1888. As early as 1884 he included a Japanese mask in the background of his portrait *Fat Maria*, ibid., no. P. 229.

21. Dortu, *Lautrec*, nos. P.376, P.383; both dated 1891. For the type of *kakemono*, see Harold P. Stern, *Rimpa: Masterworks of the Japanese Decorative School*, New York, 1971, pl. 15.

22. Coquiot, *Lautrec*, p. 24; Joyant, *Lautrec*, I, p. 77; Henri de Toulouse-Lautrec, *Unpublished Correspondence*, ed. Lucien Goldschmidt and Herbert Schimmel, London, 1969, illus. 33, 34.

23. Lautrec, *Unpublished Correspondence*, illus. 35–37; Coquiot, *Lautrec*, pp. 24, 26; Gerstle Mack, *Toulouse-Lautrec*, New York, 1952, p. 59.

24. Joyant, *Lautrec*, I, pp. 121–122; Thadée Natanson, *Un Henri de Toulouse-Lautrec*, Geneva, 1951, p. 99.

25. See especially Shinoda Yūjirō, *Degas: Der Einzug des Japanischen in die französische Malerei*, Tokyo, 1957; and the critical reviews of it by Eduard Trier in *Kunstchronik*, 12, 1959, pp. 20–22, and by Gerhard Fries in *Art de France*, 4, 1964, p. 356.

26. Jean Adhémar, *Toulouse-Lautrec: Lithographies, pointes sèches*, Paris, 1965, no. 365; printed in 1899–1900. On the *Manga* as a source for Degas's *Jockeys*, see Whitford, *Japanese Prints and Western Paintings*, p. 156.

27. Dortu, *Lautrec*, no. P. 610; painted in 1896. On the *Manga* as a source for Degas's bathers, see Shinoda, *Degas*, pp. 69, 73–75, figs. 45, 46, 57–62.

28. Lemoisne, *Degas*, III, no. 765; painted in 1884.

29. Lemoisne, *Degas*, III, no. 877; painted in 1886. See Shinoda, *Degas*, pp. 72–73.

30. The same is true of the comparisons between Degas and Hokusai made by Bernard Dorival, in *Dialogue in Art: Japan and the West*, ed. Yamada Chisaburō, New York, 1976, p. 45, and by Kobayashi Taichirō, "Hokusai et Degas: Sur la peinture franco-japonaise en France et au Japon," in Japanese National Commission for UNESCO, *International Symposium on the History of Eastern and Western Cultural Contacts*, Tokyo, 1959, p. 74.

31. Shinoda, *Degas*, p. 77, figs. 65, 66; the Degas bather illustrated there (Lemoisne, *Degas*, III, no. 1031 *bis;* painted about 1890) is in fact a poorer comparison than the drawing illustrated here (Sale, *Atelier Edgar Degas*, Galerie Georges Petit, Paris, April 7–9, 1919, no. 348).

32. The same is true of the comparisons between Degas's nudes and Utamaro's and Harunobu's made by Siegfried Wichmann, in *World Cultures and Modern Art*, ed. Wichmann, Munich, 1972, pp. 102–103.

33. Theodore Reff, "Works by Degas in the Detroit Institute of Arts," *Bulletin of the Detroit Institute of Arts*, 53, no. 1, 1974, pp. 27–28.

34. A more convincing example of Japanese influence is that of Hokusai's woodcut *The Strong Woman of Ōmi Province* on Degas's pastel *Mary Cassatt at the Louvre* (Lemoisne, *Degas*, II, no. 581; painted ca. 1880); see Shinoda, *Degas*, pp. 81–82, figs. 73–74.

35. Not in Dortu; see Douglas Cooper, *Henri de Toulouse-Lautrec*, New York, 1956, p. 103; painted in 1892. The comparison is by Wichmann, in *World Cultures and Modern Art*, p. 118.

36. See, for example, Gauguin's *Vision after the Sermon* and Bernard's *Breton Women on a Wall*, illustrated in Wladyslawa Jaworska, *Gauguin and the Pont-Aven School*, Greenwich, 1972, pp. 23, 39.

37. Ernest Scheyer, "Far Eastern Art and French Impressionism," *The Art Quarterly*, 6, 1943, p. 131. Shinoda, *Degas*, pp. 57–58, figs. 93, 94, suggests instead Hokusai's drawing *The Inn*; while Terrence Mullaly, "French Painting and the Japanese Print," *Apollo*, 62, 1965, pp. 194–196, suggests Hokusai's print of *The Bay of Naniwa*.

38. See especially Manet's *Racetrack at the Bois de Boulogne* and *Mme Manet on the Balcony* (Denis Rouart and Daniel Wildenstein, *Edouard Manet*, Lausanne, 1975, I, nos. 184, 202) and Fattori's *Cart with Oxen* and *The White Wall* (Luciano Bianciardi and Bruno della Chiesa, *L'Opera completa di Giovanni Fattori*, Milan, 1970, nos. 165, 167).

39. J.-K. Huysmans, "L'Exposition des Indépendants en 1880," *L'Art moderne*, Paris, 1883, p. 114. See also the review by Burty cited in note 18, above.

40. See Manet's *Departure of the Folkestone Boat* and *Ships at Sea at Sunset* (Rouart and Wildenstein, *Manet*, nos. 146, 150) and Degas's own statement that the *Carriage at the Races* derived from a photograph (Van Deren Coke, *The Painter and the Photograph*, Albuquerque, 1972, pp. 81, 309).

41. See especially Vitale Bloch, *All the Paintings of Jan Vermeer*, New York, 1963, pls. 14, 27, 71, 74. Vermeer's relevance in this regard was already noted in the nineteenth century; see Aaron Scharf, *Art and Photography*, Harmondsworth, 1974,

pp. 193–194.

42. Lemoisne, *Degas*, II, no. 321. Some authors, for example, Whitford, *Japanese Prints and Western Paintings*, p. 150, see signs of Japanese influence as early as 1865 in *The Woman with Chrysanthemums* (Lemoisne, *Degas*, II, no. 125), but this seems unconvincing visually.

43. Gerald Needham, "Japanese Influence on French Painting 1854–1910," *Japonisme*, p. 121, suggests instead the use of diagonals in Harunobu's prints.

44. Michael Sullivan, *The Meeting of Eastern and Western Art*, London, 1973, pp. 20–21, 41–44.

45. On the other hand, photography was known, and its influence may be evident in some of the extreme foreshortenings and contrasts in scale in Hiroshige's prints; see Scharf, *Art and Photography*, p. 357.

46. Lemoisne, *Degas*, II, no. 393; painted ca. 1876. Harold P. Stern, *Master Prints of Japan: Ukiyo-e Hanga*, New York, n.d. [1969], p. 135.

47. Kobayashi, "Hokusai et Degas," p. 74, suggests instead the influence of Hokusai's prints on *L'Absinthe*, but the example he illustrates is not as close visually.

48. See also the *Beach Scene* (Lemoisne, *Degas*, II, no. 406; painted ca. 1876), where in addition the bright, flat colors and sharp outlines also reveal Japanese influence, as Sullivan, *The Meeting of Eastern and Western Art*, p. 203, points out.

49. Lemoisne, *Degas*, III, no. 905; probably painted ca. 1879, not 1887 as stated by Lemoisne; see Theodore Reff, *The Notebooks of Edgar Degas*, Oxford, 1976, I, p. 151. 50. Wichmann, in *World Cultures and Modern Art*, pp. 102, 130–131, suggests a source for this figure in one of Hokusai's *Manga* drawings.

51. See Theodore Reff, "Degas: A Master among Masters," *The Metropolitan Museum of Art Bulletin*, 34, no. 4, Spring 1977, figs. 71, 73.

52. Lemoisne, *Degas*, II, no. 682; dated 1882. Its composition is analyzed in Meyer Schapiro, "Mondrian," *Modern Art, 19th and 20th Centuries*, New York, 1978, pp. 239–241.

53. See Reff, "Degas: A Master among Masters," figs. 70, 72. In *The Red Shawl* (Lemoisne, *Degas*, III, no. 867; painted in 1886), a composition that is similarly divided, Leopold Reidemeister also sees Japanese influence: *Der Japonismus in der Malerei und Graphik des 19. Jahrhunderts*, Berlin, 1965, pp. 22–23.

54. Reff, *Degas: The Artist's Mind*, pp. 168–170.

55. Lemoisne, *Degas*, II, no. 419; painted in 1877.

56. Illustrated in Shinoda, *Degas*, fig. 33, but compared with a different Degas, pp. 45–46; whereas this one, fig. 22, is compared with a print by Shunchō, pp. 41–42. Still another comparison, with a print by Utamaro, is made by Dorival, in *Dialogue in Art*, p. 46.

57. Lemoisne, *Degas*, II, no. 649; painted ca. 1879, not ca. 1881 as stated by Lemoisne; see *Degas 1879*, ed. Ronald Pickvance, National Gallery of Scotland, Edinburgh, 1979, no. 11.

58. Shinoda, *Degas*, pp. 42–44, figs. 34, 35, compares this Degas with a print by Naganawa. Whitford, *Japanese Prints and Western Paintings*, p. 151, suggests the influence of *ukiyo-e* prints on a similarly divided composition by Degas, *At the Café-Concert* (Lemoisne, *Degas*, III, no. 814; dated 1885).

59. This becomes more evident in a color illustration, e.g., in Ian Dunlop, *Degas*, New York, 1979, p. 149.

60. Ives, *The Great Wave*, p. 36, suggests still another type of comparison: "In innumerable woodcuts by Harunobu, silvery gray and gray green backgrounds function as the aquatint does in Degas's prints, to harmoniously blend figures and setting in one continuous texture."

61. Dortu, *Lautrec*, no. P. 330; dated 1889. Charles Stuckey, in *Toulouse-Lautrec: Paintings*, The Art Institute of Chicago, 1979, pp. 140–141, makes this comparison.

62. Lemoisne, *Degas*, II, no. 526; painted ca. 1879. On its derivation from Japanese

prints, see Jean Sutherland Boggs, *Portraits by Degas*, Berkeley, 1962, pp. 54–55.

63. Adhémar, *Lautrec*, pl. 12; printed in 1893. Wichmann, in *World Cultures and Modern Art*, p. 119, compares it with one print by Hiroshige; Phillip Dennis Cate, "Japanese Influence on French Prints 1883–1910," *Japonisme*, p. 109, compares it with another.

64. Lemoisne, *Degas*, III, no. 828; painted ca. 1885. However, Needham, "Japanese Influence on French Painting," p. 121, suggests that Degas's composition is in turn derived from *ukiyo-e* prints.

65. See, among others, Cooper, *Lautrec*, p. 33; and René Huyghe, "Aspects de Toulouse-Lautrec," *L'Amour de l'Art*, 12, 1931, p. 159.

66. See also the interesting comparison between Lautrec's drawing for his *Reine de Joie* poster (Dortu, *Lautrec*, no. D.3224; drawn in 1892) and Koryūsai's print of *Two Lovers*, illustrated in Götz Adriani, *Toulouse-Lautrec: Das gesamte graphische Werk*, Cologne, 1976, p. 46.

67. Dortu, *Lautrec*, no. P.416; painted in 1892. Whitford, *Japanese Prints and Western Paintings*, p. 219, also sees a Japanese influence, but cites no examples.

68. Ives, *The Great Wave*, p. 89, compares the same Kiyotada print with three other images of dancers by Lautrec.

69. Adhémar, *Lautrec*, no. 15; printed in 1893. Ives, *The Great Wave*, pp. 80–81, also makes this comparison. Mullaly, "French Painting and the Japanese Print," p. 194, compares Lautrec's poster with one of Utamaro's prints, but less convincingly.

70. Adhémar, *Lautrec*, no. 1; printed in 1891.

71. For other aspects of Sharaku's influence on him, see Daniel Catton Rich, "A Note on Sharaku's Influence in Modern Painting," *Bulletin of the Art Institute of Chicago*, 29, January 1935, p. 6; Ives, *The Great Wave*, pp. 89–90; and Whitford, *Japanese Prints and Western Paintings*, p. 219.

72. This comparison is also made by Cate, "Japanese Influence on French Prints," p. 64.

73. Exaggerated grimaces were, of course, familiar in traditional art, but the more subtle ones seen in *ukiyo-e* prints may reflect the influence of such European models as those illustrated in Gerard de Lairesse's *Het Groot Schilderboek*, which Japanese artists are known to have studied; see Sullivan, *The Meeting of Eastern and Western Art*, p. 21.

74. Dortu, *Lautrec*, no. M. 6; printed in 1899. The comparison is made by Yamada Chisaburō, in *World Cultures and Modern Art*, pp. 143–148.

75. Adhémar, *Lautrec*, no. 28; printed in 1893. See Yamada, in *World Cultures and Modern Art*, p. 148.

76. Dortu, *Lautrec*, no. D.3525; drawn ca. 1894. See Yamada, in *World Cultures and Modern Art*, p. 146; and Whitford, *Japanese Prints and Western Paintings*, p. 208, for further examples.

77. Joyant, *Lautrec*, II, pp. 100–101, makes this distinction.

78. Adhémar, *Lautrec*, no. 10; printed in 1893. Stern, *Master Prints of Japan*, p. 193, color illustration. Cate, "Japanese Influence on French Prints," p. 63, compares this poster with another print by Kiyonaga.

79. Adhémar, *Lautrec*, no. 11; printed in 1893. Harold P. Stern, *Master Prints of Japan*, p. 191, color illustration. Cate, "Japanese Influence on French Prints," p. 65, compares this poster with another print by Kiyonaga.

80. Adhémar, *Lautrec*, nos. 200–210; printed in 1896. The connection with Utamaro's series is often drawn; for example, in Ives, *The Great Wave*, pp. 93–94, and Whitford, *Japanese Prints and Western Paintings*, p. 242. In addition, Stuckey, in *Toulouse-Lautrec: Paintings*, p. 242, compares *Au Salon, Rue des Moulins* (Dortu, *Lautrec*, no. P.559; painted in 1894) with Chōki's *View in a Green House*, and Adriani, *Lautrec*, p. 117, compares *Mlle Marcelle Lender* (Adhémar, *Lautrec*, no. 131; printed in 1895) whit Utamaro's *The Courtesan Hitomoto*.

81. Adhémar, *Lautrec*, no. 8; printed in 1893. Cate, "Japanese Influence on French Prints," p. 65, relates the use of *crachis* to the Japanese technique of *fuki-botan* and that of gold metallic pigment to the Japanese *surimono* prints.

82. Illustrated in color in *Utamaro, estampes, livres illustrés*, Galerie Huguette Berès, Paris, December 1976, opposite p. 21. Sullivan, *The Meeting of East and West in Art*, p. 238, relates *Mlle Loie Fuller's* color harmony to that of Japanese ink-wash paintings.

83. See Reff, *Degas: The Artist's Mind*, p. 284; Wichmann, in *World Cultures and Modern Art*, pp. 120–122; and Needham, "Japanese Influence on French Painting," pp. 121–122.

84. Lemoisne, *Degas*, II, no. 564; painted ca. 1879.

85. Ives, *The Great Wave*, p. 87, mentions this Japanese dance form.

86. I am indebted to Cheryl Cibulka and Kirsten Keen, Columbia University, for help in gathering material for this paper.

VINCENT VAN GOGH AND JAPAN

Johannes van der Wolk

In preparing this paper on the relationship between Vincent* and Japan,[1] one of the titles that I came across was one written in 1955 by Dr. Shikiba, entitled "Van Gogh and Japan." In fact, it turned out to be not so much about the influence of Japanese culture on Vincent, but rather the other way around: the appreciation for and study of the works and life of Vincent by Japanese scholars. I mention this because I think it is important to be aware of the fact that there is, please permit me the anachronism, a strong mutual influence between Vincent and Japanese people.

It is not so easy, however, to analyze the essential elements of this mutual interest. Just to demonstrate how different both parties can think about one aspect I want to juxtapose two quotations. Both are evidence of a sort of cultural pessimism and at the same time of positive expectations about the healthy influence of Japanese prints on the development of European art. First I want to quote Professor Yamada from his text for the catalogue of the 1968 exhibition on *Mutual Influences between Japanese and Western Arts* held at the National Museum of Modern Art, Tokyo. He wrote (p. 40): "The prints opened up a new path for the rapidly stagnating painting of the West." By contrast, Vincent wrote in one of his many letters (B 2)[2]: "If the Japanese are not making any progress in their own country, still it cannot be doubted that their art is being continued in France." Opposed to the rapidly stagnating European art in the first quotation, Vincent observes that the Japanese are not making any progress in their own country. Both remarks do have a Darwinian belief in the gradual development and improvement of art in general. I prefer to merely accepting it as an historical fact that in the second half of the nineteenth century Japanese works of art were exported on a rather large scale to Europe and that especially the *ukiyo-e* prints have had a deep influence on a group of artists that later turned out to be what we use to call highly representative of its time.

In the case of Vincent I think it to be of interest to begin with some biographical facts. The most important years in the biography of Vincent are the last ten years of his life, from 1880 to 1890. In these ten years he has created all of his pictorial œuvre. In 1880 he was twenty-seven years old when he realized his vocation to become an artist. As a sixteen year old boy, thus eleven years before

his vocation as an artist, he entered the commercial world of art dealing at the Goupil gallery in The Hague. In 1873 he went to the London branch of the same gallery, and in 1874 he was transferred to its Paris headquarters. In 1876, after seven years of work for this gallery he was fired, but by then he had gained a good insight into the art trade in Holland, London and Paris. At the same time he had developed his taste for art in general by visiting the important art museums of his day. These years of work in commercial galleries are in my opinion very important, not only because they acquainted Vincent with the world of art and artists including those interested in Japanese art, but also because he thus became accustomed to travelling abroad and surviving in alien environments. During the four years between his dismissal by Goupil and his vocation as an artist he lived once again in England, in Holland, and in Belgium.

I hope and expect that a more detailed study of Vincent's life before his vocation as an artist will tell us a lot about his early exposure to Japanese prints. For the time being our observations about his knowledge and understanding of Japanese prints until his departure in 1885 to Antwerp have to be rather limited and more or less speculative.

The first observation is that though Vincent's early paintings do strongly fit into the context of the Dutch art of his days, they more than once show sort of Japanese characteristics. For example, when he paints the sea (F 4)[3] he does so from the dunes, not from the beach level. The viewpoint is high, thus providing a well organized survey of the situation. When he paints or draws trees in a landscape (F 44), these trees are treated as if they were human portraits. In them one feels a positive appreciation for the beauty of plants and trees. As a matter of fact, in one of his letters (242) Vincent wrote: "in all nature, for instance in trees, I see expression and soul." This quotation proves that Vincent had at least the ability to be sensitive to the Japanese approach of nature. But no documentary proof has yet been found that Vincent owned in these early years Japanese prints himself.

This brings me to my second observation regarding the practical possibilities that Vincent saw and owned Japanese prints in these years. During the years that Vincent spent his time in The Hague, London and Paris, he had numerous opportunities to get acquainted with Japanese prints. The vogue for these prints was by no means limited to Paris, as even scholarly publications sometimes make believe. It was an European affair that touched for instance The Hague as much us as it did Paris. Furthermore we must remind ourselves that Vincent had a number of internationally oriented relatives, for instance, his uncle's Graeuwen, who was a high naval-officer. In a letter of January 1884 (351a) Vincent wrote: "I have seen excellent things from China and Japan." Vincent did alas not specify the nature of these "excellent things."

You will have noticed that I have quoted several times from letters written by Vincent. Most of his letters were written to his brother Theo and to a number of his colleagues like Gauguin and Bernard. These letters provide us first hand information about his personal observations about his environment. In about sixty out of a total of approximately 700 letters that have been preserved Vincent writes about his appreciation for Japan and its culture. Understandably, but for us un-

fortunately, he did not write many letters during his stay with Theo in Paris. This is the more regrettable because it was during these years that Vincent developed his real knowledge about Japanese prints.

You will pardon, may be even bless me for not paraphrasing each and every one of the letters in which Vincent mentions his interest in Japanese prints. They are, however, so informative that I cannot refrain from summarizing some of its essential information.

The letters give for instance information about what Vincent thought to be typically Japanese. In his very first letter from which we learn that Vincent possessed Japanese prints (437), it is dated December 1885, he writes of his experience of Antwerp as a Japonaiserie. He says: "I mean that the figures are always in action, one sees them in the queerest surroundings, everything fantastic, and at all moments interesting contrasts present themselves." For instance: "a white horse in the mud . . . Quite simple, but an effect of Black and White," and "Through the window of a very elegant English bar, one will look out on the dirtiest mud."

No works of this period are known that exactly fit to the description of what Vincent wrote to like of Antwerp as of a Japonaiserie. With a positive attitude, however, one could discover in a painting done there (F 260) the contrasts between the rather well-organized flat roof and walls in the foreground and the houses in the background that each differ in color and size. In a drawing also made in Antwerp (F 1351) I believe the walking figures in the foreground suggest gaiety and informality.

The still-lifes Vincent painted in Paris during the summer of 1886 (for instance F234 and F286) also are of interest in the context of this paper. In one of his letters (460a) Vincent described a similar but now lost still-life of a branch of white lilies against black as something "like black Japanese lacquer inlaid with mother of pearl." Also in this case Vincent directs our attention towards the contrast between foreground and background. He does the same, by the way, when he writes about Japanese food. "You know," he writes, (W 7) "that the Japanese instinctively seek contrasts—sweetened spices, salted candy, fried ices and iced fried things." And in the same letter to his sister he writes: "You will see that by making a habit of looking at Japanese pictures you will love to make up bouquets and to do things with flowers all the more."

Most of the about four hundred *ukiyo-e* prints that were collected by the Van Gogh brothers Theo and Vincent are now in the collection of the Rijksmuseum Vincent van Gogh in Amsterdam. Last year a catalogue[4] was published giving complete descriptions, many illustrations and introductory texts by Dr. Van Gulik from Leiden and Mr. Orton from Leeds. A small group of fifteen prints from Vincent's collection are now permanently in the collections of the Courtauld Institute in London and in the Musée Guimet in Paris. During this Symposium, the album from the Musée Guimet was on show at the exhibition in Sunshine City. In a future new and revised edition of the catalogue I hope to be enabled to publish the Amsterdam prints together with those from London and Paris. On that occasion I also intend to illustrate all prints in color on microfiche as an appendix to a traditional paper-publication with the textual information.

We do not know of any inventory Vincent or Theo might have made themselves of their collection of prints. This, of course, would have been a dream for art historians. Therefore we cannot be sure that we have traced all the prints Vincent collected and neither do we know how much he knew about the prints. But we know, for instance, that he knew the name of Hokusai very well. He once urged Theo (letter 510) to acquire at Bing's printshop the 300 Hokusai views of the holy mountain. Unfortunately, I must report here that I have found no trace that Theo followed his brother's advice.

Letters 516 and 533 have been related to the two paintings *The Stevedores* (F 437 and F 438). Before exclaiming: "It was pure Hokusai" Vincent described that he saw in Arles one evening a magnificent and strange effect: "A very big boat loaded with coal on the Rhône, moored to the quay. Seen from above it was all shining and wet with a shower; the water was yellowish-white and clouded pearl-gray; the sky, lilac, with an orange streak in the west; the town, violet. On the boat some poor workmen in dirty blue and white came and went carrying the cargo on shore. It was pure Hokusai." In general one erroneously thinks in this context of Hokusai's well-known print of the *Great Wave off Kanagawa*, probably because in letter 553 he wrote: "the waves are claws and the ship is caught in them." The same error by the way is being made continuously when comparing the boats Vincent painted at Saintes-Maries de la Mer with the *Great Wave*.[5] I propose to compare them rather with other prints by Hokusai, also from his series of *Thirty-six Views of Mount Fuji*, as for instance *The Island of Tsukuda* and *At Sea off Kazusa*.[6] These depict boats carrying different types of cargo, not in a struggle with the elements but under more quiet circumstances, as in Vincent's paintings. It is my guess that Vincent would have been attracted by the workmen on the boats, by the very type of their work, and by the cargo itself.

But as a relief to us today Vincent admits in one of his letters from Arles (511) that he and Theo did not know enough about Japanese prints. And he continues: "Fortunately we know more about the Japanese of France, the impressionists." One must read this quotation in the context of one of Vincent's vague ideas about becoming an art dealer like and in companionship with Theo. And he writes (letter 510): "Japanese art, decadent in its own country, takes root again among the French impressionist artists. It is its practical value for artists that naturally interests me more than the trade in Japanese things. All the same the trade is interesting, all the more so because of the direction French art tends to take." For us at this Symposium Vincent's artistic aspirations and ideas are of more interest than his commercial fancies. But his labelling French impressionist artists as the Japanese of France is quite important to remember.

It is significant because when Vincent left Paris to go to Arles he did not go to the South of France, but went, in his imagination, so we can read in his letters, instead to Japan. He was absolutely convinced that he would find a Japanese atmosphere in the South of France. He writes for instance (letters 469 and 500): "I feel as though I were in Japan" and "then why not go to Japan, that is to say to the equivalent of Japan, the South (of France)?" And when he is unhappy about the mistral he writes: "If there were less mistral, this place

would really be as lovely as Japan, and would lend itself as well to art." And there is one more quotation (letter W 7): "For my part I don't need Japanese pictures here, for I am always telling myself that here I am in Japan. Which means that I have only to open my eyes and paint what is right in front of me, it I think it effective."

It is tempting to confront you with many more quotations from Vincent's letters, but I shall present just one more (letter 542), a very important one: "If we study Japanese art, we see a man who is undoubtedly wise, philosophic and intelligent, who spends his time doing what? In studying the distance between the earth and the moon? No. In studying Bismarck's policy? No. He studies a single blade of grass. But this blade of grass leads him to draw every plant and then the seasons, the wide aspects of the countryside, then animals, then the human figure. So he passes his life, and life is too short to do the whole. Isn't it almost a true religion which these simple Japanese teach us, who live in nature as though they themselves were flowers? And you cannot study Japanese art, it seems to me, without becoming much gayer and happier, and we must return to nature in spite of our education and our work in a world of convention."

Two of the Japanese illustrations from Vincent's library represent grass and bamboo. Vincent made two drawings (F 1523 and F 1612) in the same spirit and very close to the Japanese examples. The painting of roses (F 580) from the collection in the National Museum of Western Art, Tokyo is also very appropriate in this context. In addition there are two small paintings both with butterflies (F 748 and F 610) and another couple of paintings that in intention come very close to Hokusai's minute observations of nature (F 402 and F 767). Vincent's renderings of rocks (F 635 and F 1447) with grass growing on them here and there and with the little trees remind us of Japanese drawings of similar subjects.

The drawing F 1424 can be easily identified in one of Vincent's letters. He describes it (in letter B 10) as "an immense stretch of flat country, a bird's-eye view of it seen from the top of a hill—vineyards and fields of newly reaped wheat. All this multiplied in endless repetitions, stretching away towards the horizon like the surface of a sea, bordered by the little hills of the Crau. It does not have a Japanese look, and yet it is really the most Japanese thing I have done: a microscopic figure of a laborer, a little train running across the wheat field— this is all the animation there is in it."

It is interesting to study what Vincent from a practical or technical point of view thought to be Japanese aspects of his works. In his letters 484 and 491 respectively he writes about the Japanese aspects of his paintings and drawings of those days. The drawing (F 1474) and the painting (F 576), *Landscape near Arles*, both measure about 25 by 34 cms, a size very close to the horizontal Ōban-format of Japanese prints. These measurements are so identical, I believe, not by chance but on purpose. The drawing was done in the Arles-countryside. Vincent made the painting afterwards, in his house. To Theo he writes about a very similar case (letter 484): "this will show you that, if you like, I can make little pictures like Japanese prints of all these drawings." As you know Vincent's work includes marvelous watercolors, for instance of his yellow house in Arles

(F 1413) and of the harvest near Montmajour (F 1483). When asking Theo to send him some watercolor-ingredients, Vincent explained he did so because he wanted "to make some pen drawings, to be washed afterwards in flat tints like the Japanese prints" (letter 491). Especially the harvest watercolor is relevant in this context.

Thus far I have mainly been discussing the paintings and drawings by Vincent in relation to statements from his letters. For myself these statements have been very useful in achieving an understanding of why Vincent was attracted by Japanese prints, and there is a great deal more to say on this topic. However, let me devote the remainder of my discussion to a number of paintings from 1887 when Vincent was in Paris.

In the background of the portrait of Père Tanguy (F 364) we see a number of "Japanese prints." As a matter of fact, I do not believe them to be painted after the prints themselves but rather after copies that Vincent had already painted after the prints. None of these supposed copies, however, are known to exist today. So I am presenting this theory for what it is worth. I started thinking them to be paintings after prints rather than prints themselves, mainly because of the image in the lower left corner which to me seems to be standing on the ground rather than pinned against the wall. A second argument I believe to be the frame-like borderlines as of the image in the upper right corner.[7]

At this point I want to do an exercise in print recognition.[8] Let us begin with the image at the middle right and compare it with Hiroshige's Hara print. Vincent was only concerned with representing the inhabited part of the landscape, the houses and the figures. The image at the top behind the head of Père Tanguy must be a view of Mount Fuji. But the matching print has not yet been found. The same must alas be said for the flower print from the lower left corner. Though it resembles the flower prints by Hokusai and Hiroshige, the very example has not yet been traced. The ladies in the lower right corner and in the middle left are adopted from prints by Toyokuni III that have been located in the Amsterdam collection. The print used for the image in the upper right has been identified as a print by Yoshitora. Like those by Toyokuni, it is in the Amsterdam collection. The image in the upper lefthand corner is not a Japanese print but the corner of a painting with a yellow frame painted by Vincent himself (possibly F 383). As far as I know F 383 is the only painting by Vincent with an original frame. It is tempting now to start talking about frames. I will not do so but will reserve the subject for a future occasion.

In a second portrait of Père Tanguy (F 363), in front of a wall full of prints we see in both lower corners color strips that might be references to color theories by Charles Blanc. In the left row we see again the flowers reminiscent of Hokusai and Hiroshige. Hiroshige's print from the Tōkaidō series has been used for the top right image. The lady in the middle left is copied again from a Toyokuni print and the snow landscape in the top left is probably done after a Hiroshige print that remains to be traced. The lady in the lower righthand corner is probably done after the cover illustration of the May 1886 issue of the journal *Paris Illustré*. It shows a courtesan wearing a coat of cloud and dragon design.

The *Paris Illustré* "cover girl" leads me to the three well-known oil copies

Vincent made from Japanese prints. The largest of the three is called *Oiran* (F 373) after the above mentioned Oiran print by Keisai Eisen. Vincent's copy looks as if it were a mirrored version. He did not paint it from the original print, however, but from the *Paris Illustré* cover. It is interesting to note that Vincent enlarged the cover illustration several times so that the size of the Oiran-image is almost the same size as the original print. There is no evidence, however, that Vincent knew the original print or its size. One could develop a theory that Vincent also had the original print in his collection and that this print somehow disappeared, with the result that we now think that he never had a copy of the original print. This seems rather unlikely, however, because Vincent's tracing of the *Paris Illustré* cover has been preserved. Another possibility is that Vincent worked from the then available full size but mirrored printed reproduction of the Eisen print. But also of this reproduction I have found no direct trace in Vincent's estate. The Eisen print was in the 1968 Tokyo exhibition of *Mutual Influences between Japanese and Western Arts* (pp. 48 and 89 of the catalogue) and I regret that the Oiran painting was not shown together with the print. Both the plumtree now at Sunshine City and the Oiran painting were listed in the 1968 catalogue but apparently could for some reason not be brought to Tokyo. In 1976, however, the Oiran painting was included in an exhibition of the Japan Ukiyo-e Society together with prints from Leiden and Amsterdam. The exhibition toured Osaka, Tokyo and five other cities in Japan. The frogs at the bottom of the painting were copied from Yoshimaru's print depicting insects and reptiles. And the cranes at the middle left were copied from a print by Torakiyo.

One of the other copies Vincent made after Japanese prints is the well-known *Bridge in the Rain* (F 372) after the print *Ōhashi, Sudden Shower at Atake* by Hiroshige. This painting accompanied an exhibition of drawings by Vincent that toured Japan in 1976–77 (Tokyo, Kyoto and Nagoya).

The third and last known copy is of the *Plumgarden at Kameido* (F 371) from another print by Hiroshige also from the series of *One Hundred Famous Views of Edo*. This painting was on exhibition at Sunshine City.

I have tried to single out for this paper some of the most essential elements of Vincent's interest in Japanese prints and I do hope very much that the other aspects can be dealt with on other occasions.

NOTES

* Vincent van Gogh's name is being pronounced in many ways, so I propose that we follow in the case of this paper the artist's own advice and call him by his first name Vincent.

1. The relationship between Vincent and Japan has never been the subject of an in-depth exhibition. Of course there have been several exhibitions (with catalogues) in which Vincent was represented. I want to mention the 1951 exhibition at the Stedelijk Museum of Amsterdam devoted to *Rembrandt, Hokusai and Van Gogh*; fourteen years later the 1965 exhibition in Berlin *Der Japonismus in der Malerei und Graphik des 19. Jahrhunderts;* in 1968 the Tokyo exhibition on *Mutual Imfluences between Japanese and Western Arts*; in 1972 during the Olympic Games at Munich the exhibition *Weltkulturen und moderne Kunst;* in 1975 the exhibition first shown in Cleveland on *Japonisme*. The Rijksmuseum Vincent van Gogh at Amsterdam finally installed in 1978 an exhibition focused upon the *Japanese Prints Collected by Vincent van Gogh*.

 The first author who had the courage to write about Vincent and Japan was M. E. Tralbaut who in 1953 presented his first lecture on the subject during a symposium in The Hague (published as ''Van Gogh's Japanisme'' in *Mededelingen van de Dienst voor Schone Kunsten der gemeente's Gravenhage*, vol. 9 (1954), nos. 1–2, pp. 6–40). In 1957 Douglas Cooper published two Japanese prints from Vincent's collection when they were acquired for the Courtauld Institute in *The Burlington Magazine*, June 1957, pp. 203–204. In 1959 Ellen Joosten published her article ''Het rijke begrip invloed'' in *Museumjournaal*, vol. 5 (1959), no. 4 (October), pp. 73–76 in which she defended against a for me unknown opponent Vincent's good rights to be susceptible for outside influences as from Japanese prints and from the French artist Monticelli. Apparently in those days such influences were not generally accepted let be appreciated. Within the context of larger publications contributions to the subject were made by John Rewald in 1956 (*Post-Impressionism*), Mark Roskill in 1970 (*Van Gogh, Gauguin and the Impressionist Circle*), Bogomilla Welsh-Ovcharov in 1976 (*Vincent van Gogh, his Paris Period 1886–1888*) and finally Frank Whitford in 1977 (*Japanese Prints and Western Painters*). Tanaka Hidemichi wrote on Hokusai, Hiroshige and Van Gogh in the *Bulletin Annuel du Musée National d'Art Occidental*, vol. 5 (1971), pp. 14–24 and in 1973 a lecture by René Jullian was published in the *Bulletin de la Société des Amis du Musée de Dijon*, (Années 1970–1972), pp. 81–86. At least two M.A. theses were written on the subject, the first by J.M. Kloner in 1963 at Columbia University (*Van Gogh and Oriental Art*), the second by Fred Orton in 1969 at the Courtauld Institute (*Vincent van Gogh's Japonisme*). Parts of Orton's thesis have been published in *Vincent* (Bulletin of the Rijksmuseum Vincent van Gogh), vol. 1 (1971), no. 3 (Autumn), pp. 2–12 and in the 1978 catalogue of the Amsterdam collection of Vincent's Japanese prints. The Japanese influences on Vincent have also been integrated into a general text on the artist by Griselda Pollock and Fred Orton in their 1978 book *Vincent van Gogh, Artist of his Time*.

2. See *The Complete Letters of Vincent van Gogh*, Greenwich, Conn., New York Graphic Society, 1959, 3 vols.

3. The F numbers refer to J.B. de la Faille, *The Works of Vincent van Gogh*, Amsterdam and London, 1970 in which all works are illustrated.

4. Rijksmuseum Vincent van Gogh, *Japanese Prints Collected by Vincent van Gogh*, Amsterdam, 1978.

5. Also in the exhibition *Ukiyo-e Prints and the Impressionist Painters, Meeting of the East and the West*, Tokyo, Osaka and Fukuoka 1979–1980, catalogue revised and enlarged edition, p. 76.

6. Reproduced in Muneshige Narasaki, *Hokusai, 'The Thirty-six Views of Mount Fuji'*, Tokyo, New York and San Francisco, 1976 (5th pr.), pp. 38 and 90.

7. John House (exhibition catalogue, London, Royal Academy of Arts, *Post-Impres-sionism* . . . , 1979–80, p. 81) has suggested that the Japanese prints have been executed separately from the figure because they are too large in comparison with it.

8. In the footsteps of Fred Orton. See his contribution "Vincent van Gogh and Japanese Prints: An Introductory Essay" to the catalogue *Japanese Prints Collected by Vincent van Gogh*, Amsterdam, Rijksmuseum Vincent van Gogh, 1978, pp. 14–23.

LES NÉO-IMPRESSIONNISTES ET LE
JAPONISME, 1885–1893

Françoise Cachin

La fin des années 1880 et le début des années 1890 sont une des périodes clés du japonisme en France, du côté de Pont-Aven (bientôt poursuivi par les Nabis) comme du côté de Seurat et de ses amis. On assiste à une assimilation artistique, plus grande que le japonisme plus superficiel ou folklorique de la génération précédente. Le seul artiste qui fasse le lien entre les impressionnistes et ceux que l'Histoire rassemble sous le terme de "Post-Impressionnistes," est Pissarro, comme Monet grand amateur d'art japonais depuis longtemps, et qui précisément, de 1886 à 1888, refuse l'impressionnisme traditionel "romantique," pour se plier à la discipline de Seurat et Signac. Il n'est sans doute pas étranger à cet intérêt neuf porté par ses jeunes amis aux estampes japonaises. Je voudrais essayer ici, en commentant surtout quelques œuvres de Seurat, Signac et Cross, entre 1885 et 1893 environ, de définir leur attitude particulière envers l'art des estampes, et quelle a été la singularité de leur japonisme, très différent de celui de Gauguin ou de van Gogh, à la même époque.

Curieusement, les traces de l'influence japonaise chez Seurat ont été remarquées relativement tard, d'abord semble-t-il par Kenneth Clark,[1] puis plus longuement analysées pour la première fois par Henri Dorra,[2] il y a une dizaine d'années.

Les intuitions de H. Dorra sur le japonisme sont très riches et justes sur le plan stylistique, mais il est amusant de voir qu'elles s'appuient sur une interprétation erronnée du texte que Signac a consacré aux sources de Seurat dans *D'Eugène Delacroix au néo-impressionnisme*: "La tradition orientale, les écrits de Chevreul, de Ch. Blanc, (etc.) le renseignèrent."[3] Or, le mot oriental n'a pas tout-à-fait le même sens en anglais et en français: Signac faisait très certainement allusion au "texte turc" sur la peinture qui circulait dans l'avant-garde vers 1886, et s'il avait voulu citer l'art japonais, il l'aurait précisé, ou parlé d'Extrême-Orient, et nommé les artistes de l'*ukiyo-e* qu'il cite plusieurs fois par ailleurs dans son livre.

Seurat est le premier néo-impressionniste à avoir utilisé efficacement l'art japonais. En avril 1883, l'exposition rétrospective de l'art japonais, organisée par Louis Gonse, Directeur de la *Gazette des Beaux-Arts*, comportait surtout des objets, mais permettait pour la première fois d'admirer les collections de Théodore Duret et celles d'Ephrussi, c'est-à-dire l'œuvre presque complète

d'Hokusai. Rien ne permet de l'affirmer, mais il est fort probable que Seurat l'ait vue. On sait que si les "japonaiseries" étaient tout-à-fait répandues, dans le grand public, sous leur forme la plus folklorique, d'objets de curiosité, le milieu naturaliste et impressionniste s'intéressait à des titres divers aux estampes, depuis vingt ans: Degas et Manet y avaient, entre autres choses, déjà puisé des audaces de mises en page, le goût de l'à plat. Et bien que les impressionnistes ne se soient jamais exprimés clairement eux-mêmes à ce sujet, on a très vite attribué leur goût de la couleur pure et claire à l'influence des estampes japonaises; Théodore Duret, par exemple, que sa passion particulière pour l'*ukiyo-e* fait exagérer l'importance de cette source.[4] Quant à E. de Goncourt qui n'avait pas peu contribué récemment à raviver la mode japonisante, avec *La Maison d'un artiste*,[5] il affirme dès 1884 que "tout l'impressionisme est né de la contemplation et de l'imitation des impressions claires du Japon."[6]

On ne possède aucun témoignage de Seurat sur l'art japonais et, à ma connaissance, on ne sait rien sur les estampes ou les albums qu'il aurait pu posséder, ni au moment de l'inventaire de son atelier, ni par aucun témoignage, alors que l'on connait bien celles de ses contemporains, van Gogh ou Gauguin.

Dans *Le Bec du Hoc* (Tate Gallery) (Fig. 1), le rapprochement déjà fait par H. Dorra avec l'une des *Vagues* d'Hokusai (Fig. 2) et concluant, plus encore dans les formes et les valeurs que dans la couleur, ce qui fait penser à une plus grande familiarité des albums en noir et blanc du Mont Fuji que des estampes. Il n'est pas jusqu'aux mouettes que l'on retrouve placées de la même façon dans la composition. On pense aussi, dans l'affirmation du volume, au rocher de *Hakone* par Hiroshige. Ses paysages de 1886, comme *Honfleur le soir* (M.O.M.A. New York), ou *La Grève du Bas-Butin*, (Musée de Tournai), prennent un grandeur,

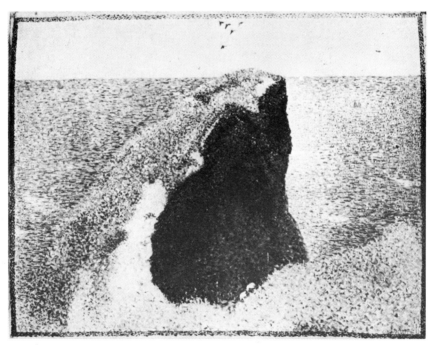

Fig. 1. Georges Seurat, *Le Bec du Hoc*, 1885. Huile sur toile. Tate Gallery, Londres.

une simplicité géométrique dans des proportions qui, sans autoriser un rapprochement terme à terme avec une estampe particulière, en traduisent plus l'esprit que la lettre, dans les ciels, dans le rapport entre les lignes d'horizon et les diagonales du premier plan, dans la vue simultanée de deux points de vue différents, et dans l'absence de profondeur. On pense évidemment aux splendides simplifications d'Hokusai, dans ses grands Mont Fuji. Mais c'est plutôt à Hiroshige qu'il emprunte le procédé qui consiste à évoquer la profondeur de l'espace par un gros plan démesuré, sombre et découpé d'une façon arbitraire, très neuf dans le paysage occidental. Là aussi, les documents en noir et blanc sont plus éloquents, si l'on confronte *Coin de bassin, Honfleur*, (Rijksmuseum Kröller-Müller) à *La Foire aux bœufs à Takanawa*. Peu après, vers 1888-1889, la ligne de Seurat se crispe, dès les payasages de *Port-en-Bessin* (coll. Harriman) où le ciel amorce des volutes extrême-orientales, ou dans les drapeaux agités de *Port le Dimanche* (Rijksmuseum Kröller-Müller) qui fait penser au parti-pris analogue chez Hiroshigedans *Le Temple de Komagata-Dō*.

Il est permis d'être plus réservé sur l'hypothèse émise par H. Dorra que le pointillisme de Seurat aurait sa source dans le marquage discontinu de l'espace, caractéristique des dessins d'artistes japonais, en particulier de Hokusai.[7] L'évolution de la touche de Seurat, d'une touche impressionniste à un système régulier et serré est liée aux problèmes que lui posait la couleur, et qui ne sont pas un simple piquetage de l'espace. Dans son dessin, même, cette technique ne l'a que très exceptionnellement intéressée, dans une étude pour *les Poseuses* en 1887. En revanche, cette influence est à approfondir pour les dessins néo-impressionnistes à la plume faits dès 1886 par les autres artistes du groupe, en particulier Pissarro, Signac et Dubois Pillet. Dans *Les Gazomètres de Clichy* (1886) de Signac,

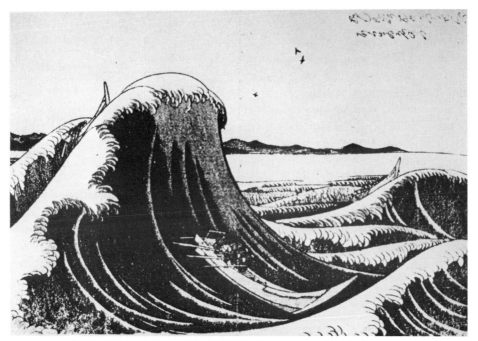

Fig. 2. Katsushika Hokusai, *Barque luttant avec une vague*. Gravure sur bois.

où la technique du pointillé pour délimiter des zones plus ou moins foncées, posées dans des formes qui suivent l'à plat du papier sans simuler le modelé, l'ombre ou la profondeur, peuvent bien avoir sa source chez Hokusai. Van Gogh va de son côté développer une technique analogue, associée aux petits traits de bambou, en particulier dans ses paysages de la campagne arlésienne. Bientôt, dans les années 90, Cross et Signac vont exécuter une très belle série de paysages dessinnés ou aquarellés, en remplissant la page de batonnets plus ou moins sinueux, dont la direction indique l'eau, les feuillages ou les nuages, couvrant la page comme le tissu serré des touches peintes le font pour leurs toiles contemporaines. Alors que les admirables dessins de van Gogh opèrent une fusion entre le dessin japonais et celui des flamands du seizième siècle, comme Brueghel, Signac et Cross sont beaucoup plus délibérément japonisants.

Il est un procédé de l'art de Seurat sur lequel je voudrais m'attarder un peu, c'est celui des bordures peintes sur ses tableaux, et celui de ses cadres peints. C'est une question très complexe, car si l'on sait précisément quand il a commencé ses bordures, pour ses cadres, rien n'est certain; il semble probable que les bordures ont été peintes dès 1886, et les cadres à partir de 1889. Le problème se complique dans la mesure où d'une part, Seurat a sans doute peint des cadres vers 1890 pour ses tableaux antérieurs, et que certains d'entre eux ont même été ajoutés après sa mort. Et pendant quelques années, la plupart des néo-impressionnistes—Signac, par exemple dans *Les Femmes au puits* (1892), ou van Rysselberghe—vont peindre comme lui des cadres foncés, généralement bleu-marine. Or, les bordures peintes apparaissent dans ses paysages de Grand Camp, comme *Le Bec du Hoc*, et l'idée lui en est peut-être venue des bordures d'Hokusai, qui, lui, les faisait par goût occidentalisant. Croyant faire "japonais" ou avoir trouvé dans l'art japonais un procédé qui met en valeur, par un moyen purement pictural, le choix d'une mise en page, c'est par un amusant chassé-croisé que l'idée traditionnelle du cadre européen lui revient, passé déjà de l'extérieur du tableau à l'intérieur de l'image, imprimé qu'il était sur l'estampe même. Quant au cadre peint, il avait déjà été expérimenté par Whistler et Mary Cassatt, par exemple, eux-mêmes japonisants de longue date. Mais je voudrais proposer ici l'idée que l'invention de ces cadres en larges bordures contrastées, mais plus généralement bleu outremer foncé, très particuliers à Seurat et à ses amis, leur serait venue par le charme particulier qu'ils ont trouvé aux bandes d'encrage qu'on remarque presque systématiquement en haut et en bas des estampes d'Hokusai et surtout d'Hiroshige. Ce qui parait aux connaisseurs de l'estampe un détail technique, dû aux imprimeurs et non aux artistes, a dû à l'époque frapper particulièrement, comme un caractère fort décoratif, mettant en valeur la luminosité du paysage. Ils y ont sans doute vu une confirmation de la loi du contraste, comme ils ont vu sans doute, et Seurat le premier, dans les structures claires et géométriques des paysages d'Hokusai et d'Hiroshige, dans leurs compositions très structurées, une confirmation des "lois" de la dynamogénie émises par leur ami Charles Henri, théoricien de l'Esthétique scientifique.

Seurat étant un homme silencieux, jaloux de ses propres recherches, les historiens d'art ont un peu tendance à vouloir chercher des clés cachées. Evidemment, l'art de Seurat doit à tout ce qui stimulait sa curiosité et son intérêt, de l'art

égyptien à Piero della Francesca, Ingres, etc.; et il a trouvé dans l'estampe japonaise des éléments qui confirmaient ses goûts pour la simplification, la géométrie, l'abstraction épurée et qui les ont peut-être même cristallisés, mais la rencontre se fait aussi à un niveau plus profond: un sentiment particulier de la grandeur de la nature, de la lumière, du ciel, des saisons, le paysage traité avec le respect d'une icône, une nature en quelque sorte sacrée, simplifiée, très différente de la simple "prise de vue" instantanée et émotionnelle de l'impressionnisme. Comme chez l'artiste japonais, il y a une sorte de dépersonnalisation devant la nature, que la technique austère, voire ascétique du néo-impressionisme, souligne. C'est pourquoi le vrai rapprochement, à un niveau élevé, est entre Seurat et Hokusai, l'Hokusai des vues du Mont Fuji, plus qu'Hiroshige qui lui a inspiré des éléments plus anecdotiques, tenant plus aux procédés de mise en page.

L'influence de l'art japonais n'est sensible dans la peinture de Signac qu'à partir de 1888–1889, deux ans au moins après Seurat. A l'époque, Félix Fénéon le critique, ami, et "penseur" du groupe depuis 1886, était en train d'écrire un livre sur l'estampe japonaise, qu'il ne terminera d'ailleurs jamais. Il devait en parler très souvent à ses amis, regarder et commenter avec eux estampes et albums, qui remplissaient tous les ateliers d'avant-garde. Son rôle est certainement capital dans l'intérêt qu'ont pris Seurat et surtout Signac aux estampes japonaises. De toute façon, entre 1887 et 1890, des expositions permettaient d'en voir presque constamment à Paris: en mars-avril 1887, au *Tambourin*, faite par van Gogh, avec qui Signac était précisément très lié en 1887–88, puis d'août à décembre, à la 18ème Exposition de l'Union centrale des Arts décoratifs, organisée par Bing, qui l'année suivante, en 1888, expose dans sa propre galerie 160 estampes. En 1889, peu de choses à l'Exposition universelle, une seule manifestation fait découvrir, d'ailleurs avec une certaine horreur, les *bonsai* au public francais. Mais en avril-mai 1890, c'est l'apothéose: 725 estampes à l'Ecole des Beaux-Arts, avec une préface de Bing, dont le rôle devient essentiel grâce à sa revue *Le Japon artistique* qui eut un immense succès, dans le milieu néo-impressionniste, comme dans celui de Pont-Aven autour de Gauguin. Il n'est pas sans intérêt de savoir que S. Bing, promulgateur de l'art japonais à Paris, sera bientôt le marchand attitré des néo-impressionnistes dans sa galerie de l'Art Nouveau.

Devant la large divulgation de cet art auprès de ses amis de l'avant-garde, il était alors dans la nature de Seurat de s'en éloigner quelque peu. C'est le moment où l'influence de Charles Henri va se faire plus forte, et où une sorte de géométrisme plus systématique, curieusement associé à une tendance caricaturale, vont marquer sa peinture. Signac, Cross et Luce en revanche vont fortement "japoniser" à partir de 1889. L'art japonais les a alors intéressés à plus d'un titre: les écrivains et artistes anarchisants qu'étaient Fénéon, Luce et Signac, ne pouvaient qu'être frappés par la réputation—vraie ou fausse, mais telle était l'image que Duret, Ary Renan ou Bing en donnaient—d'artistes-artisans dont l'univers, comme la clientèle, étaient anti-aristocratique, et délibérément populaires. Les artistes de l'*ukiyo-e* passaient—on le voit bien également chez Gauguin et van Gogh—pour former un groupe homogène et uni, échangeant leurs œuvres, une sorte de phalanstère d'artistes populaires anti-académiques. Le phénomème psychologique de projection est ici manifeste. Des photographies

de Signac déguisé en samurai farceur (Figs. 3 et 4) en sont un souvenir humoris-
tique. Ensuite, leur art est ressenti comme un exemple décoratif (le titre de la
revue de Bing est: *Le Japon artistique, documents d'art et d'industrie*) dont les concep-
tions de clarté, d'élégance dans l'élimination du détail sauf s'il est significatif, cor-
respondaient aux besoin de ces artistes qui avaient été, plus que Seurat, formés par
l'Impressionnisme et qui, plus que lui, ressentaient donc le besoin de s'en détacher,
lui reprochant son caractère émotionnel, éphémère, anecdotique. Le génie de la
simplification, qui donne au paysage sa grandeur et au dessin sa vivacité, étaient les
traits de l'art de l'*ukiyo-e* qui les frappait le plus. Ainsi, Fénéon, par exemple, carac-
térise les estampes d'Utamaro: "de vastes et sereines planches vides d'accessoires,"
et décrit dans une estampe d'Hiroshige "trois ou quatre lignes parallèles, souvent
horizontales, et de l'une à l'autre se dégradent des nappes de bleu, de vert,
d'orange, d'encre." Ces nappes horizontales d'encrage ont particulièrement
frappé les néo-impressionnistes, comme en témoigne la toile de Signac *Herblay*,
1889 (Glasgow Art Gallery and Museum), dont le caractère japonisant est
encore plus évident dans l'étude préparatoire, en forme d'éventail, précisément
(Fig. 5).

Fig. 3. Photographie de Paul Signac déguisé
en Samurai, vers 1898–1900. Archives Signac.

Fig. 4. Photographie de Paul Signac déguisé
en Samurai, vers 1898–1900. Archives Signac.

Fig. 5. Paul Signac, Etude pour *Herblay*,
1889. Collection particulière, Paris.

Fig. 6. Paul Signac, *Portrait de Félix Fénéon*, 1890. Huile sur toile. Collection particulière, New York.

Fig. 7. Estampe japonaise anonyme.

Après Degas et Pissarro, Gauguin d'un côté, Signac et ses amis de l'autre, ont en effet souvent peint entre 1889 et 1892 des éventails, comme Maximilien Luce dans *Pins au bord de la mer*, où le japonisme est non seulement sensible dans le format, mais dans la composition, ou comme cette *Vue nocturne de Paris* (Musée d'Orsay) où le pont, la lumière, les silhouettes sombres trouvent de nombreux équivalents dans les estampes de l'*ukiyo-e*.

J'aimerais revenir sur un tableau qui me parait résumer la fascination ambiguë exercée par l'art japonais sur l'avant-garde de l'époque, le *Portrait de Félix Fénéon* (Fig. 6), peint par Signac à l'automne 1890. Abusés,—comme la critique de l'époque—par le titre complet: "sur l'émail d'un fond rythmique de mesures et d'angles, de tons et de teintes," des historiens d'art y ont vu une démonstration des théories scientifiques de la dynamogénie de Charles Henri.[8] Or j'ai eu la chance, il y a quelques années, de trouver dans les papiers de Signac, la clé du tableau[9] un petit album très populaire, imprimé en couleurs, sans doute des modèles de kimonos (Fig. 7). Signac s'en est servi comme emblème de Fénéon, en allusion au goût très prononcé du modèle pour l'art japonais. Ici, japonisme et allégorie se confondent, car les lignes abstraites et élégantes, le maniérisme ajouté par Signac dans la bande en haut et à gauche, sont vraisemblablement une allusion au style même des écrits ultra-précieux de Fénéon, les étoiles sont là pour rappeler, par l'intermédiaire du drapeau américain, la ressemblance bien connue de Fénéon et des images de "l'oncle Sam" yankee.

Il est intéressant que ce soit précisément le Japon qui puisse, seul à l'époque, offrir à Signac un modèle d'abstraction géométrique, un exemple de fantaisie et un tel déploiement de franchise dans la couleur, éléments qu'aucune expérience de l'art occidental ne lui aurait donné. Il a voulu, avec humour naturellement, faire de Fénéon une sorte de saint ou de héros sur un fond emblèmatique d'art dit "scientifique" qu'il défendait dont la vraie beauté ne tient pas au sujet, mais à une harmonie toute abstraite de lignes et de couleurs. Il est bien évident qu'avoir choisi—peut-être avec lui—un motif japonais que le titre camoufle, constituait une sorte de plaisanterie entre eux, et d'ironie sur les exigences excessives de leur ami Charles Henri, puisque spontanément un modeste artisan imprimeur pouvait inventer de telles formes apparemment savantes.

Après y avoir puisé une inspiration décorative, c'est un japonisme plus subtil dont Signac fait preuve, avec la série peinte à Concarneau l'été 1891. Elle est particulièrement riche du point de vue qui nous occupe aujourd'hui. Ces toiles s'offrent aussi comme des démonstration de l'harmonie née d'un système linéaire abstrait, affichée avec moins de provocation que le titre du tableau précédent, mais plus convaincante dans le système d'angulation, destiné à donner une impression de calme. On sait que[10] Signac avait visité longuement la grande exposition d'estampes japonaises de l'hiver précédent et examiné particulièrement celles d'Hiroshige.

Brise, Concarneau (coll. part., Londres) (Fig. 8) et *Barques au soleil* (coll. part., Bruxelles) ne sont des démarquages d'aucune estampe précise mais résument des éléments tirés de certaines estampes de format "ōban" d'Hiroshige de la série *Reisho Tōkaidō*, pour la ligne nette de l'horizon, et les vagues, ou *Vue de Miho* pour le motif des voiles carrées répétées.

Fig. 8. Paul Signac, *Brise, Concarneau*, 1891. Huile sur toile. Collection particulière, Londres.

Fig. 9. Henri-Edmond Cross, *La Ferme*, soir, 1892. Huile sur toile. Collection particulière, Paris.

Fig. 10. Andō Hiroshige, *Pluie nocturne sur Karasaki*. Gravure sur bois en couleurs.

Le japonisme d'Henri-Edmond Cross n'est pas moins évident. Cette même année 1891, qui est l'année de la mort de Seurat, il s'installe dans le Midi de la France où vont venir à leur tour Signac dès 1892, puis van Rysselberghe. Et là, pendant deux ou trois ans, ils vont tous peindre avec émerveillement une nature qui peut à juste titre leur évoquer celle du Japon, avec ses plages, sa côte découpée, ses rochers escarpés plantés de pins, sa lumière vive. Déjà van Gogh, en descendant en 1888 à Arles, dans le Midi de la France, comparait sans cesse les couleurs franches et contrastées du paysage à la nature des estampes japonaises, où les arbres se découpent nets dans le ciel. Toute cette génération a projeté sur cette région, pendant quelques années, une imagerie tirée des estampes passionnément regardées à Paris les deux ou trois années précédentes. Par exemple, dans une toile comme *La Ferme, le soir* (1892) (Fig. 9), Cross retrouve naturellement la découpe du groupe d'arbres d'Hiroshige dans *Pluie nocturne sur Karasaki* (Fig. 10), un vue du lac Biwa.

De même, un tableau comme *Les îles d'or* (Fig. 11) systématise le parti pris souvent par les paysages de l'*ukiyo-e* de monter l'horizon très haut et d'en faire courir la ligne d'un bout à l'autre de la composition (Fig. 12). Dans cette toile, une des plus audacieuses de Cross, tout se passe comme s'il avait extrait des estampes de larges bandes d'encrage et supprimé totalement le sujet.

Fig. 11. Henri-Edmond Cross, *Les Iles d'Or*, 1891–92. Huile sur toile. Musée d'Orsay, Paris.

Fig. 12. Katsushika Hokusai, *Vue du Mont Fuji à Musashino*. Gravure sur bois.

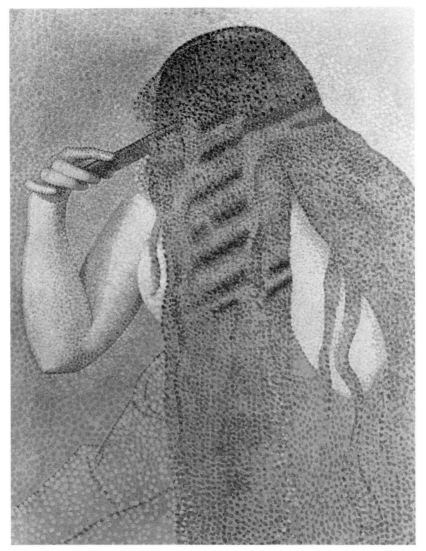

Fig. 13. Henri-Edmond Cross, *La Chevelure*, vers 1892. Huile sur toile. Musée d'Orsay, Paris.

Cette même année 1892, Cross et Signac, un an après Seurat, s'essaient au thème de la Femme à la toilette. Le japonisme de *La Poudreuse* de Seurat me paraît moins évident qu'à certains historiens, comme H. Dorra, et la comparaison avec *Les Femmes au miroir* d'Utamaro et de Kunisada semble surtout en faire sentir les différences. *La Femme à la toilette* (1892) de Signac me paraît japonisant seulement dans la façon de traiter en à-plat de couleurs raffinées tous les motifs du décor, dans le même esprit que Mary Cassatt à la même époque. En revanche, dans *La chevelure* (Fig. 13), Cross exprime un japonisme subtil dans la façon dépouillée dont il décrit un objet comme un des éléments de la nature, comme une algue, comme une vague, avec son rythme et sa vitalité propre. Il n'y a pas là d'allusion, d'anecdote exotique ou de transcription formelle précise: c'est véritablement un certain esprit de l'art japonais qu'il a rencontré.

Un des derniers tableaux franchement japonisants de Signac, *La Place des Lices à Saint-Tropez* (1893) (Museum of Art, Carnegie Institute, Pittsburgh) (Fig. 14) montre une interprétation de la réalité qui développe ce qui se sentait déjà dans le thème des bateaux de Concarneau que nous venons de voir, où le motif répété devient rythme. Mais ici les volutes régulières des branches et du feuillage accusent une vision décorative de la nature, et font bien sentir le glissement progressif du japonisme parisien vers l'art nouveau (Fig. 15).

Ainsi, le japonisme néo-impressionniste aura été, d'une part, un sentiment particulier de la nature, dont le caractère en quelque sorte sacré, serein, la grandeur d'éléments réduits à l'essentiel, peuvent avoir les mêmes accents chez Seurat et chez Hokusai, par exemple. D'autre part, surtout chez Cross et Signac, le sens du rythme, le goût de la simplification japonaise leur a servi d'antidote à l'impressionnisme, en les aidant à exprimer une réalité dépouillée de sentiment et d'impression provisoire, une nature stylisée. C'est-à-dire que leur interprétation, leur sympathie pourrait-on dire, pour l'art de *l'ukiyo-e* a été profonde, et déterminante dans la cristallisation de leur art, autour de 1890. Comme pour Gauguin à la même époque, le Japon a été pour eux un encouragement au style nouveau, et véritablement, pendant quelques années, un modèle de modernité.

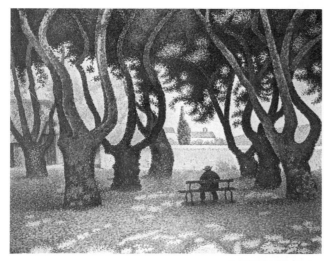

Fig. 14. Paul Signac, *La Place des Lices, Saint-Tropez*, 1893. Huile sur toile. Museum of Art, Carnegie Institute, Pittsburgh.

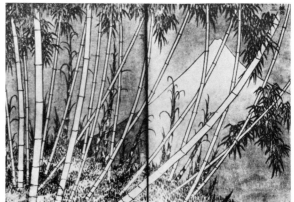

Fig. 15. Katsushika Hokusai, *Vue du Mont Fuji du bois de bambou*. Gravure sur bois.

NOTES

1. K. Clark, *Landscape into Art*, Londres, 1949.
2. H. Dorra et S. Askin, "Seurat's Japonisme," *Gazette des Beaux-Arts*, février 1969, pp. 81–94.
3. P. Signac, *D'Eugène Delacroix au néo-impressionnisme*, 1899, rééd. critique de F. Cachin, Paris: Hermann, 1978, p. 107.
4. Th. Duret, *Les Peintres impressionnistes*, Paris, 1878.
5. E. de Goncourt, *La Maison d'un artiste*, Paris, 1881.
6. E. de Goncourt, *Journal: Mémoires de la vie litteraire*, Paris, 1956–59, t.VI, p. 216 (19 avril 1884).
7. H. Dorra, "Seurat's Dot and the Japanese Stippling Technique," *The Art Quarterly*, n° 33, été 1970, pp. 108–113.
8. J. Arguëlles, "Paul Signac's 'against the Enamel of Background Rythmic with Beats and Angels, Tones and Colors, Portrait of M. Félix Fénéon in 1890, opus 217,'" *Journal of Aesthetic and Art Criticism*, XXVIII, fall 1969.
9. F. Cachin, "Le portrait de Fénéon par P. Signac, une source inédite," *Revue de l'Art*, n° 6, 1969.
10. Arsène Alexandre, source citée par M. T. Lemoine de Forges, in catalogue de l'exposition *Signac*, Paris: Louvre, 1963, p. 49.

QUESTIONS AU JAPONISME

Michel Melot

Quels furent le rôle et la signification du Japonisme dans la société française de la seconde moitié du dix-neuvième siècle? Il faut poser cette question car on ne peut pas continuer de ne voir en lui que le caprice insignifiant d'un groupe d'artistes et d'amateurs provoqué par le hasard de la rencontre de deux civilisations. Je n'ai malheureusement pas l'ambition de répondre à ce très complexe problème; je voudrais néanmoins essayer de formuler les nombreuses questions qu'il soulèverait, en m'appuyant sur un exemple précis: la suite de lithographies *Elles* publiée par Toulouse-Lautrec en 1896.

Quelles sont les questions que les historiens ont posées au Japonisme?

Les historiens de l'art qui se sont penchés sur le Japonisme semblent pour la plupart avoir été avant tout soucieux de montrer qu'il s'est agi d'un phénomène conscient, volontaire, délibéré. La plus grande partie de la littérature sur le Japonisme est en effet consacrée à décrire les références explicites, les sources directes d'inspiration, les lieux de rencontre. Ils ont cherché, en feuilletant les albums, qui a copié quoi. Ces études veulent nous faire croire que, en dehors de ces emprunts précis, le Japonisme n'eut aucune signification plus générale qui en expliquerait la diffusion dans un certain milieu, à une certaine époque. Or, c'est ce problème que nous voudrions voir poser.

Les mêmes historiens se sont montré passionnés aussi par la question de la priorité et des dates qu'on peut assigner aux rapports les plus anciens, jugés par rapport à celle de 1854, qui marque l'ouverture du Japon à l'Occident. Cela pourrait faire croire que cette ouverture historique est une explication suffisante du phénomène dont elle ne fut en réalité que le prétexte, tout au plus la condition, et non la raison. Nous allons étudier une œuvre tardive, de 1896, pour ne pas être troublés par ce problème secondaire.

Les méthodes archéologisantes montrant, pour résoudre ce problème, leur insuffisance, nous serons amenés dans un second temps, à nous tourner vers une histoire "sociale" de l'art qui veut que les formes et les sujets d'un art soient les reflets, ou, dans sa version modernisée, les "manifestations" de l'époque et de la société qui les voient naître. Cette nouvelle approche est inévitable car nul doute que le sujet traité par Lautrec, même s'il reprend un thème familier de l'estampe

japonaise, ne soit solidement et directement ancré dans la réalité française de
la fin du dix-neuvième siècle. Mais il faut alors se méfier d'une déviation de
cette méthode qui chercherait immédiatement, (comme semblent l'avoir fait
spontanément les premiers témoins du Japonisme, Duret ou les Goncourt) la
signification du Japonisme dans l'art japonais. Il serait en effet tentant de con-
clure tout de suite que le Japonisme a reflété à la fois la société française qui
l'adopte et la société japonaise qu'il copie.[1] On en arriverait alors à poser cette
incroyable équation qui démontrerait que deux arts semblables sont le reflet
de deux civilisations identiques, ce qui serait d'un formidable déterminisme!
Nous verrons que cette déviation n'est pas accidentelle, qu'elle a même joué
un rôle fondamental dans ce que nous appellerons "l'idéologie japoniste."

En examinant l'album *Elles*—qui ne servira ici que d'exemple—il sera donc
impossible de limiter l'étude du Japonisme à celle de rapports formels délibérés,
non plus qu'à celle de simples coïncidences historiques. Le lien le plus clair de
cette suite avec celles des estampes japonaises ne tient ni à ses formes ni à sa date,
mais à son iconographie: c'est un album d'images sur la vie des prostituées
dans une maison close célèbre alors à Paris. Y-a-t-il du "Japonisme" dans cette
façon de traiter ce thème et si oui, quel rôle y joue-t-il et quel est son rapport
à l'art japonais?

C'est une suite de onze lithographies en couleurs (Delteil 179 à 189; Adhémar
200 à 210) dont une sert de titre (Fig. 1), formant ainsi un album qui veut avoir
une unité. Cette unité est technique et iconographique. Quant aux couleurs, aux
formes, compositions, elles varient d'une planche à l'autre. Le sujet peut donc
être désigné comme une chronique de la vie quotidienne des filles d'une maison
close. Toulouse-Lautrec passa, depuis 1892, de longs séjours dans cette maison
célèbre, située 5 rue des Moulins, dans l'initimité des pensionnaires. Depuis
1893, il avait présenté dans différentes expositions des tableaux sur ce thème:
*Ces Dames au Réfectoire, La Visite, rue des Moulins, Au Salon de la rue des Moulins,
Rolande de la rue des Moulins*, etc. Il exécuta aussi de nombreux croquis et dessins
dont certains préparent directement les lithographies publiées dans *Elles*. La
publication de l'album à cent exemplaires fut le fait d'un éditeur de 37 ans,
Gustave Pellet, qui tenait boutique 9 quai Voltaire et qui s'était déjà spécialisé
dans les estampes érotiques en éditant des auteurs très appréciés comme Félicien
Rops, Henri Boutet, Charles Maurin (un grand ami de Lautrec,) et surtout
Louis Legrand dont Pellet avait publié en 1893 la série d'eaux-fortes *Les Petites
Filles du Ballet* et publiait encore en 1909 la série *Les Bars*. Pellet exposa l'album
au siège du journal *La Plume*, lors du 20e "Salon des Cents," 31 rue Bonaparte,
le 22 avril 1896.[2]

QUEL RÔLE JOUE L'ANALYSE FORMELLE PUISQU'ELLE NE RÉPOND À AUCUNE DES
QUESTIONS FORMULÉES?

Comme pour la plupart des lithographies de Lautrec, on peut facilement
relever dans *Elles* une démarcation des formes de l'art japonais, par exemple dans
le choix des couleurs. Bien que le Japonisme ne soit pas ici aussi évident qu'il peut
l'être dans les bois d'Henri Rivière ou les aquatintes de Mary Cassatt, on ne
peut éliminer la possibilité d'une référence explicite aux albums japonais (Figs.

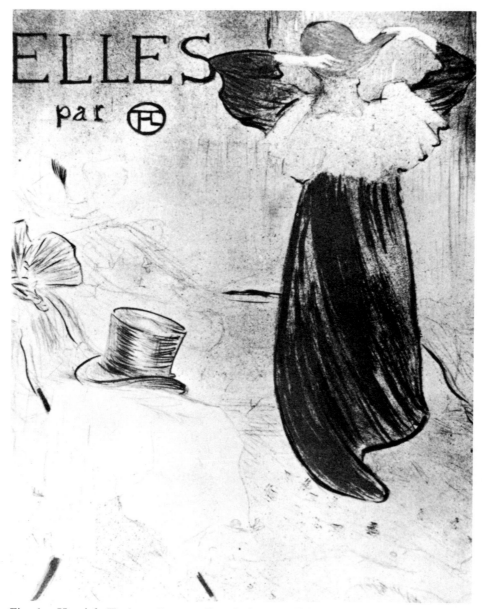

Fig. 1. Henri de Toulouse-Lautrec, Frontispice pour l'album *Elles*, 1896. Lithographie en couleurs (L.D. 179).

2 et 3). Les suites érotiques japonaises étaient composées traditionnellement de douze estampes. Il y en a onze ici mais une douzième[3] (Fig. 4), qu'on catalogue à leur suite, pouvait avoir été prévue pour l'ensemble. De toute façon, dans le choix du sujet comme dans sa présentation, il y a certainement un "clin d'œil" à Utamaro, l'artiste favori de Lautrec, le spécialiste des représentations de courtisanes et des "maisons vertes," auquel les Goncourt avaient consacré une monographie en 1891 et que Durand-Ruel avait exposé en février 1893, date à laquelle Lautrec aborde précisément ce sujet.[4]

Mais le problème de savoir si le Japonisme de Lautrec était ici délibéré ou non semble de bien peu d'importance puisqu'en aucun cas il ne peut suffire à justifier le choix d'un thème très répandu alors dans l'art français et faisant allusion à un problème typiquement parisien. Que dirait-on alors des portraits d'acteurs (Figs. 5 et 6), qui forment la plus grande partie de la production lithographiée de Lautrec ces années là et qui coïncident eux aussi avec un des thèmes privilégiés de l'estampe japonaise sans qu'on puisse pour autant expliquer uniquement l'un par l'autre? Il va de soi que le Japonisme de Lautrec va bien au-delà de la simple volonté japonisante. Peut-on encore parler de "Japonisme"? Ne peut-on voir dans ces coïncidences et ces ambïguités un début d'explication du fait que le Japonisme soit devenu une mode?

Notons d'abord que, même si l'on s'en tient aux rapports formels, les traits qu'on a coutume de baptiser japonisants ne sauraient nullement se réduire à une imitation consciente des modèles japonais. Mais dès qu'on s'aventure un peu loin dans les généralités, c'est-à-dire dès qu'on perd de vue un modèle précis qu'aurait copié l'artiste français, la méthode des rapprochements formels devient inconsistante, car pour autant on parlerait aussi bien du Japonisme des icônes byzantines ou de cette gravure florentine du quinzième siècle dont on trouve le correspondant exact dans la *Manga* de Hokusai (Figs. 7 et 8)! Ben Nicholson,[5] qui a étudié précisément de façon très formaliste les œuvres de Lautrec de cette période, y voit plutôt un renouveau pour le goût charpenté des volumes issus de

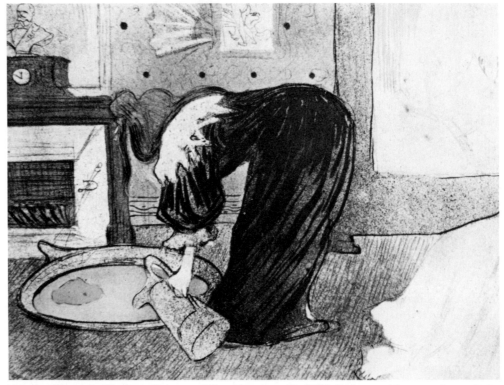

Fig. 2. Henri de Toulouse-Lautrec, *Elles: Femme au tub*, 1896. Lithographie en couleurs (L.D. 183).

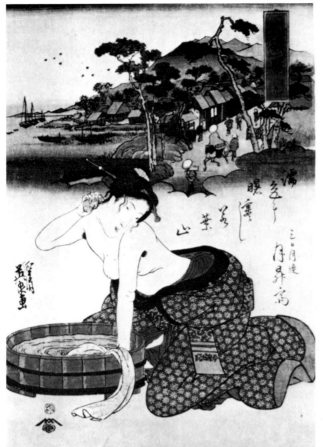

Fig. 3. Keisai Eisen, *Station à Ōiso*. Gravure sur bois en couleurs.

Fig. 4. Henri de Toulouse-Lautrec, *Le Sommeil*, 1896. Lithographie en couleurs (L.D. 190).

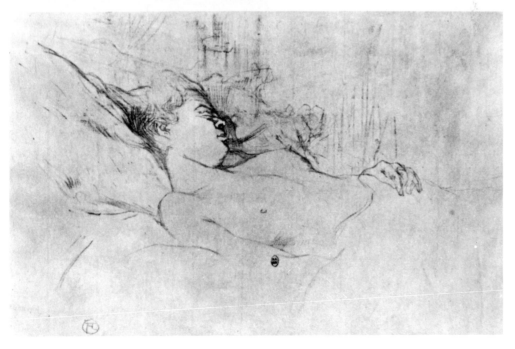

Fig. 5. Henri de Toulouse-Lautrec, *Sarah Bernardt dans Phèdre*, 1897. Lithographie (L.D. 47).

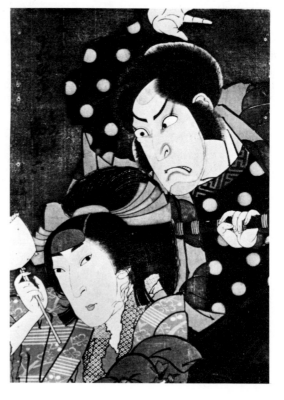

Fig. 6. Hokushū, *Nakamura Utaemon III et Arashi Koroku*, 1821. Gravure sur bois en couleurs.

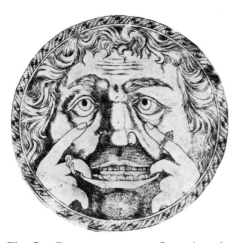

Fig. 7. Gravure anonyme florentine du quinzième siècle de la suite dite des *Otto prints*.

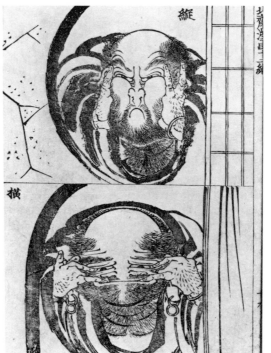

Fig. 8. Katsushika Hokusai, Planche de la *Manga*. Gravure sur bois.

Daumier ou de Cézanne, dont la grande exposition chez Vollard avait eu lieu l'année précédant la publication de *Elles*, en 1895. Tout cela semble plutôt tourner le dos au Japonisme.

Quant à la façon de dessiner de Lautrec, ses compositions disymétriques, ses premiers plans coupés, ses arabesques, ses à-plats, peuvent être tout aussi bien décrits en des termes qui appartiennent à l'esthétique de la photographie, qu'à celle de l'art japonais. Ce que les formes de Lautrec ont d'original peut ressortir aux préoccupations du photographe: effets de cadrage, de profondeur de champ, de vitesse de prise de vue. La question formelle n'épuise donc pas le Japonisme puisqu'en l'occurrence elle ne parvient pas même à le distinguer, au milieu des formes issues de la photographie, de l'art décoratif des affiches et même des recherches de Cézanne. Peut-on prendre, comme le font certains historiens, l'imitation de l'art japonais pour une explication suffisante de sa *Loïe Fuller* de 1893, lorsqu'une photographie de la même époque peut servir, de façon interchangeable au même petit jeu des sources et des "influences" (Figs. 9, 10 et 11)?

Fig. 9. Henri de Toulouse-Lautrec, *Loïe Fuller*, 1893. Lithographie en couleurs (L.D. 39).

Fig. 10. Estampe japonaise anonyme, vers 1770. Bibliothèque Nationale, Paris.

L'analyse iconographique est-elle plus pertinente?

L'iconographie, dans laquelle nous avons vu le caractère japonisant dominant de cette suite est-elle plus pertinente pour y dénoncer le Japonisme?

Le thème des maisons closes était devenu un lieu commun des illustrations de la dernière décennie du dix-neuvième siècle. C'était certainement là le reflet d'un problème qui avait alors pris une ampleur et une notoriété nouvelles. Son ampleur était due à la concentration urbaine qui avait multiplié ce qu'on appe-

lait la "basse prostitution," celle des trottoirs et des fortifications de Paris. Une statistique contemporaine de *Elles* dénombre environ 60,000 prostituées dans la capitale.[6] Sa notoriété est due à son extension ostensible aux hautes classes de la société, à la bourgeoisie d'affaires et au personnel enrichi de la République. C'est cette haute bourgeoisie qui fournit la clientèle de ces maisons réputées, comme celle de la rue de Moulins. Concernant l'extension du phénomène dans les basses classes, on peut la suivre dans les rapports de police et de médecine tel, en 1889 le premier long rapport (636 pages) du Dr Reuss sur *La Prostitution au point de vue de l'hygiène et de l'administration*. En 1896 paraît l'étude de C. Lombroso et G. Ferreo sur *La Femme prostituée et la femme criminelle*. On peut citer encore le livre du Dr Regnault en 1906 sur *L'Evoution de la prostitution*, etc. Quant à l'intérêt qu'y portent les classes plus élevées, il apparaît surtout dans les œuvres d'art qu'elles se font faire, qu'elles achètent et qui font de ce thème le morceau de bravoure de l'école naturaliste. De *La Maison Tellier* de Maupassant (1881) à *La Maison Philibert* de Jean Lorrain (1904) tous les maîtres de l'école s'y sont illustrés, les Goncourt, Zola, Huysmans, et certains écrivains se sont même spécialisés dans le genre comme Oscar Méténier, l'auteur de *La Bohème bourgeoise* (paru la même année que *Elles*) auteur aussi d'une étude sur l'argot des prostituées, de même que Utamaro avait illustré en 1798 le livre de Tatsumi Fugen sur le langage des femmes de Edo; ou encore Charles Virmaître, l'auteur de *Virtuoses du trottoir* (1868), qui a publié en 1891 *Paris impur: les maisons de rendez-vous* et en 1893: *Trottoirs et lupanars*.

Fig. 11. Photographie anonyme de Loïe Fuller, vers 1893.

Ce thème connut le même succès dans les arts graphiques. A côté de Lautrec (Figs. 12 et 13), de nombreux illustrateurs remplissent d'images érotiques les journaux destinés à ce même public bourgeois: Félicien Rops est le plus célèbre (Fig. 14), mais Legrand (Figs. 15 et 16), Maurin, Boutet, Bottini, Grévin ou Guillaume sont alors bien plus connus que Lautrec.[7] Selon les chiffres donnés par Philippe Roberts-Jones dans sa thèse sur les journaux illustrés de Daumier à Lautrec, c'est en 1881—l'année de la grande loi sur la liberté de la presse—que cette production atteignit son comble, à tel point qu'un critique agacé l'avait baptisée "l'année pornographique." Pour mieux faire comprendre les pro-

Fig. 12. Henri de Toulouse-Lautrec, *Elles: Femme au corset*, 1896. Lithographie en couleurs (L.D. 188).

Fig. 13. Henri de Toulouse-Lautrec, *Elles: Femme au plateau*, 1896. Lithographie en couleurs (L.D. 181).

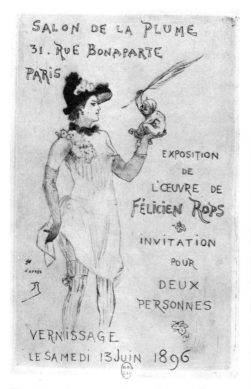

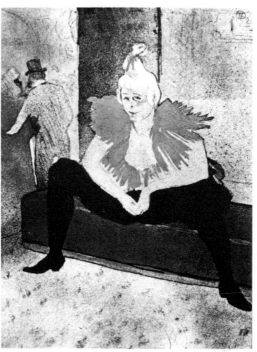

Fig. 14. Armand Rassenfosse, Gravure d'après Félicien Rops pour l'inviation du Salon de *La Plume*, 1896.

Fig. 15. Henri de Toulouse-Lautrec, *Elles: Clownesse assise*, 1896. Lithographie en couleurs (L.D. 180).

Fig. 16. Louis Legrand, *Femme fumant une cigarette*. Gravure de la série *Quelques unes*, éd. par Pellet.

blèmes que pouvait poser cette vogue à la morale traditionnelle, on peut relever que, en 1887, Louis Legrand avait été condamné à la prison pour outrage aux bonnes mœurs à cause d'un dessin paru dans le *Courrier Français* intitulé *Prostitution*. La même année l'avocat de Legrand publiait le catalogue raisonné des estampes du maître de l'art érotique Félicien Rops, qui dès l'année suivante était nommé Chevalier de la Légion d'Honneur![8] En 1896 ces auteurs ont un public bien établi et enrichi qui les célèbre et les collectionne. En 1894 est publiée une luxueuse monographie sur Henri Boutet, en 1895 le supplément au catalogue de Félicien Rops et en 1896 le catalogue de l'œuvre gravé et lithographié de L. Legrand.[9]

Nous sommes ici très loin du Japonisme. La question de l'iconographie de la prostituée à la fin du dix-neuvième siècle le dépasse si largement que les travaux qui ont été consacrés à cette question[10] ont eu comme point de départ l'un la *Phryne* de Gérôme, un autre la *Nana* de Manet, et la thèse la plus récente, la *Rolla* de Gervex, autant d'œuvres qu'on ne saurait suspecter de Japonisme. Cette émergence de la prostitution dans la vie publique française posait un problème qui la distinguait donc radicalement de tout phénomène comparable dans une autre civilisation. Il serait ridicule en tous cas de dire que les mœurs japonaises ont "influencé" les mœurs françaises. Ce problème essentiel est qu'en Occident la prostitution contrevenait à toute la morale chrétienne sur laquelle reposait (du moins officiellement pour quelques temps encore) tout l'édifice éducatif et familial. Néanmoins, sa tolérance et même son encouragement par une clientèle d'un statut social élevé et de plus en plus nombreuse empêchait désormais toute condamnation sommaire, repression ou occultation qui auraient été de rigueur si elle avait été limitée aux basses classes ou à un groupuscule de privilégiés. Il appartenait à cette clientèle de justifier ou du moins de déculpabiliser sa conduite par l'intervention d'une idéologie adéquate qui eût un semblant de naturel ou d'autorité. La collusion avec le Japonisme par le biais de l'art, qui ne touchait directement ni à l'éducation ni à la religion, pouvait, dans ce domaine, être accueillie avec un certain soulagement.

La fortune critique donne-t-elle l'explication "idéologique" du Japonisme ?

Pour que cette collusion fût possible et jouât son rôle, des ajustements, des interprétations étaient nécessaires. Comme on ignorait à peu près tout de l'art japonais, cette projection sur lui de problèmes étrangers était assez facile. C'est là toute l'histoire et ce fut toute la fonction de la littérature de l'époque sur le Japonisme.

L'album de Lautrec fut mis en vente pour 300 F. par l'éditeur Pellet et pour 2,50 F. la feuille aux bureaux du journal *La Plume*. Ce fut un échec commercial. On ne vendit que des planches à l'unité si bien qu'aujourd'hui les albums complets sont rarissimes. Pellet commanda néanmoins à Lautrec l'année suivante deux nouvelles planches isolées sur le même sujet, *Elsa la Viennoise* et *Cha-U-Kao*. Mais dès 1898, Lautrec rompit avec cet éditeur et lui demanda de bien vouloir lui rendre toutes les feuilles qu'il n'avait pas vendues.[11] Quelles sont les raisons

de cet insuccès? Les journaux spécialisés dans l'affiche et "l'art nouveau," en particulier *La Plume* et *Le Courrier Français* ont largement reproduit les planches de *Elles*.

Mais, même dans ces journaux on ne trouve que d'infimes commentaires de cette œuvre. Pas un mot par exemple dans la *Revue Blanche* dont le critique devait pourtant soutenir Lautrec. Cette faveur pour Lautrec n'était d'ailleurs pas unanime même dans le clan des japonisants. Edmond de Goncourt en particulier, bienqu'il paratageât avec Lautrec une passion pour Utamaro, ignora l'album *Elles*. On lit dans l'édition de la correspondance de Lautrec que "bien que Gustave Geffroy avec qui Lautrec avait collaboré à l'album sur Yvette Guilbert ait pressé le doyen des écrivains naturalistes Edmond de Goncourt à assister à la première exposition que celui-ci avait tenue en 1896 (il s'agissait de dessins et peintures présentées le 12 janvier chez Joyant), celui-ci n'y vint pas. Cependant, lorsque Lautrec lui écrivit personnellement, il assista à seconde (une exposition de lithographies chez Joyant tenue quelques jours avant la présentation de *Elles* au Salon des Cents) et même y rencontra l'artiste."[12] Il nota dans son journal à la date du 20 avril: "Exposition chez Jouault (pour Joyant) de lithographies de Lautrec, un homoncule dont la déformation caricaturale semble se reflèter dans chacun de ses dessins."

Beaucoup plus instructive encore est la critique que Vollard prête à Renoir, qu'il interrogeait sur la comparaison entre Lautrec et Degas (Figs. 17 et 18), qui avait vers 1880 exécuté en monotype des scènes de maisons closes que Vollard a publiées pour illustrer *La Maison Tellier*.[13] "Ils ont fait—dit Renoir—tous les deux des femmes de bordel, mais il y a un monde qui les sépare. Lautrec a fait une femme de bordel, chez Degas c'est l'esprit de la femme de bordel, c'est toutes les femmes de bordel réunies en une seule. Et puis celles de Lautrec sont vicieuses,

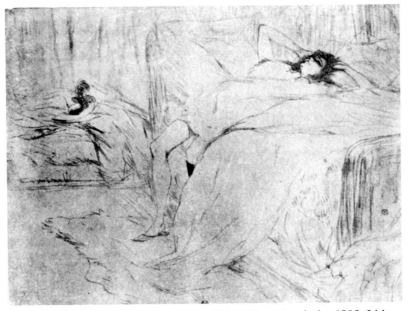

Fig. 17. Henri de Toulouse-Lautrec, *Elles: Femme sur le dos*, 1896. Lithographie en couleurs (L.D. 189).

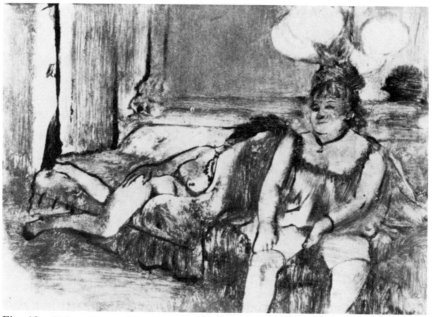

Fig. 18. Edgar Degas, Monotype de la série sur les maisons closes, vers 1880 (Cachin no. 113).

celles de Degas jamais." Renoir considère donc à tort ou à raison que Degas a enveloppé ses scènes—est-ce la technique du monotype?—d'une auréole qui les idéalise en généralisant leur type, alors que Lautrec, en effectuant à la manière d'un photographe son reportage dans la maison de la rue des Moulins a cherché visiblement la particularisation de ses modèles, la banalisation des scènes d'où tout caractère spectaculaire, toute "couleur locale" si facile à évoquer en ces lieux (Figs. 19, 20, 21 et 22), et même tout sous-entendu moral ou satirique est exclu. Par exemple un seul personnage masculin apparaît dans cette suite, et peu de nus à caractère érotique. La maison de la rue des Moulins comportait pourtant une "chambre des tortures" et un "salon oriental" qui auraient tenté plus d'un illustrateur à sensation. On soupçonne alors que certains milieux japonisants aient pu regretter cette absence de pittoresque, d'idéalisation ou de sensualisme et ne pas être séduits par ce constat de la vie des filles d'où l'homme est définitivement exclu même en tant que spectateur. C'est ce qu'un critique de *La Plume*, Henri Degron, traduit en parlant de la "belle série de lithographies de Toulouse-Lautrec, ébauches et croquis d'une cruauté d'exactitude merveilleuse."[14] Ce que Camille Mauclair comprenait lorsqu'il parlait de la "voyoucratie" de Lautrec.[15]

Ce que l'estampe japonaise avait apporté dans de telles représentations ce n'était donc pas le réalisme, mais au contraire l'idéalisation qu'apporte tout exotisme. Par l'aspect conventionnel et quasi-rituel que les images japonaises revêtaient aux yeux des occidentaux, et par l'exotisme qui leur conférait à la fois l'idéalisation de l'étrange et l'autorité du réel, elles avaient eu ce pouvoir de transgresser les interdits iconographiques de la civilisation chrétienne. En choisissant le réalisme à ce qu'on a appelé "l'hyper-irréalisme" des estampes japonaises,

Figs. 19–22 Photographies montrant les chambres de la maison close de la rue des Moulins, où Toulouse-Lautrec exécuta les motifs de la suite *Elles*.

la banalisation du sujet à son exaltation, Lautrec allait au-delà des désirs ou des tolérances du public habituel du Japonisme, qui le rejeta ou l'ignora.

A QUEL NIVEAU SE SITUERAIT UNE EXPLICATION "POLITIQUE" DU JAPONISME?

Il semble alors évident que ce Japonisme-là était, eu égard à l'art japonais, une interprétation pétrie de malentendus et d'ambiguïtés. Ce n'était donc pas de l'art japonais qu'on tirait plaisir et argument mais bien des équivoques auxquelles il pouvait se prêter pour un occidental dans cette situation précise.

Les japonisants ont formé une sorte de clan et le Japonisme n'a pas fourni matière à un véritable mouvement artistique national comme avaient pu le le faire le néo-classicisme par exemple ou même l'orientalisme. Le cercle japonisant était en effet limité à ceux qui, à la fois laïcs et spiritualistes acceptant et même souhaitant le traitement de sujets considérés traditionnellement comme vulgaires ou tabous, n'en acceptaient pas pour autant une représentation non idéalisée. Cela supposait une grande équivoque sur l'idée de "vulgarité," revendiquée et répudiée à la fois. Or, c'est bien à cette équivoque que se prête l'estampe japonaise qui passait auprès des japonisants pour un art populaire mais dont ils appréciaient avant tout le "raffinement" qui était un critère essentiellement bourgeois et aristocratique.

Jean Adhémar nous fait remarquer que les collectionneurs d'estampes japonaises commencèrent par des "crépons," des images grossières . . . et que c'est seulement vers 1900 qu'ils achetèrent les estampes d'Utamaro."[16] Si l'on s'intéressa à Utamaro avant 1900, il est vrai que l'idée d'un art "populaire" était attaché à la perception de l'art japonais et assura une partie de son succès. Il n'est que de lire la préface de Théodore Duret au catalogue de sa collection où l'aspect "populaire," "bon marché" "non artistique" des œuvres est particulièrement mis en valeur comme une qualité et une curiosité.[17] Richard Lane, dans son livre récent, fait justice de ce mythe en ces termes: "L'Ukiyo-e n'a donc nullement été une émanation populaire. Ce sont nos collectionneurs romantiques du dix-neuvième siècle que je soupçonne de cette définition erronée."[18]

Art populaire ou art raffiné, réalisme ou sophistication, culture nouvelle ou décadence, voilà les contradictions vécues par les esthètes de la fin du dix-neuvième siècle en France, qu'ils projettent sur l'art japonais saisi—ou même inventé—comme dépassement de ces contradictions.

Le cas le plus caractéristique de cette contradiction vécue se trouve chez Félix Fénéon dont on connaît le double langage dans la critique d'art: tantôt mallarméen, tantôt savamment vulgaire selon qu'il écrit dans les revues symbolistes ou dans l'anarchiste *Père Peinard*. C'est dans ce dernier qu'il soutient les images sans fards de Lautrec, en ces termes: "Pas rigolote non plus l'existence des fillasses. Les pauvres bougresses triment dur sur le trottoir et sur le plumard, exposées aux mufleries des michés, aux torgnoles des mecs, aux saloperies des roussins, et à une kyrielle de bobos. Toulouse-Lautrec en a peinturluré une floppée et ça a bougrement du caractère."[19]

L'idée de "décadence" est on le sait une notion maîtresse chez les esthètes de cette époque et la seconde "projection" facilitée par l'apparence de l'art japonais. La décadence sociale de la haute bourgeoisie était présente à tous les esprits:

l'année 1896 commença par deux procès retentissants, l'un lié au scandale de Panama, le procès Arton, l'autre, une sordide affaire de mœurs dans une des plus riches familles de la nouvelle bourgeoisie, les magnats de l'industrie sucrière Lebaudy. En même temps qu'il publiait *Elles*, Lautrec produisait plusieurs croquis d'audience de ces deux affaires (Figs. 23 et 24). Cette idée de la société décadente, put elle aussi être plaquée artificiellement sur un art japonais dont l'érotisme apparaissait aux yeux des occidentaux comme un signe de dérèglement. Cette parenté "naturelle" entre l'érotisme japonais et la "décadence" bourgeoise n'était qu'une invention destinée à satisfaire aux problèmes idéologiques de cette bour-

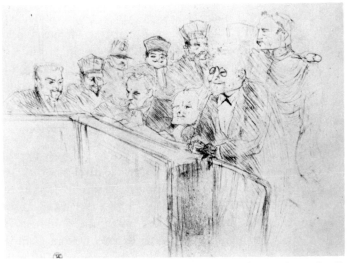

Fig. 23. Henri de Toulouse-Lautrec, *Procès Arton: Arton s'expliquant*. Lithographie publiée dans *Le Rire* du 4 avril 1896. (L.D. 191).

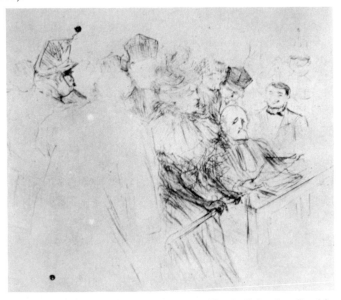

Fig. 24. Henri de Toulouse-Lautrec, *Procès Lebaudy: déposition de Melle Marsy*, 1896. Lithographie inédite (L.D. 194).

geoisie. Un historien de l'art écrivait encore récemment que l'art du dix-neu-
vième siècle était pris entre "un réalisme populaire et un raffinement, une déca-
dence, un symbolisme aristocrate, situation analogue à celle du Japon lors du
développement de l'Ukiyo-e."[20] Cette affirmation globale importe plus par ce
qu'elle suppose que par ce qu'elle affirme. Elle suppose en effet une préoccupation
idéaliste qui est celle de trouver des lois à la vie des formes, valables quelles que
soient les civilisations. Mais elle révèle aussi le souci de ne pas éluder le problème
qui nous reste à résoudre de savoir où réside le rapport objectif, le lieu concret
de la collusion entre l'art japonais et l'art français.

Que le Japonisme ait été une greffe idéologique suscitée par la situation d'une
certaine classe de la société francaise de la fin du dix-neuvième siècle ne nous dit
pas sur quoi cette greffe a pu être faite, comment les formes japonaises ont pu
être copiées et diffusées pour exercer la fascination qu'on attendait d'elles.

Le seul point d'ancrage qu'on puisse établir réside dans les objets produits
alors en France et dans ceux qu'avait produit le Japon. Il faut noter que le
Japonisme est un phénomène qui toucha de façon étrangement privilégiée les
arts plastiques. Si l'art japonais a pu être acclimaté en France pour y jouer le rôle
qu'on a tenté d'évoquer, c'est qu'il coïncide—et très souvent se confond—avec
la vogue des objets d'art "industriel," (ou art décoratif, trouvant son apogée
dans l'affiche et l'art nouveau).[21] Parmi ces objets, l'un d'eux est particulièrement
concerné à la fois par le renouveau économique et par le Japonisme: l'estampe.
Il est clair en effet—cela a été bien étudié—que le succès éclatant de la litho-
graphie en couleurs dans les années 1890 et particulièrement en 1895 et 1896,
fut le résultat de l'enrichissement et de l'élargissement de la grande bourgeoisie,
(comme cela avait été le cas pour toutes les époques où l'estampe connut un
certain essor). Au Japon comme en France, cet objet "intermédiaire" qu'est
l'estampe était destiné surtout aux classes "intermédiaires" de la bourgeoisie.
Citons encore le livre de Richard Lane: "L'Ukiyo-e trouve son expression initiale
à la fin du XVIe siècle. C'est l'époque où une culture et un art bourgeois émer-
gent comme facteurs déterminants de la civilisation japonaise." Ou encore:
"Il s'inscrit dans un développement particulier au Japon, c'est-à-dire une grande
renaissance d'inspiration bourgeoise."[22]

Il n'y a bien entendu aucun rapport historique entre le développement de la
bourgeoisie japonaise et celui de la bourgeoisie française. Mais au jour où la
France apprend l'existence du Japon et où l'art japonais offre aux artistes français
un langage pour traiter leurs propres problèmes idéologiques, il se trouve un
support commun capable de véhiculer cette idéologie qui en facilite l'adaptation.
Or, ce support connaît en France, du fait de l'essor économique de la bourgeoisie
sous le Second Empire, un développement commercial considérable qui sera la
condition objective de la diffusion de cette idéologie.

QUELLE SERAIENT LES MODALITÉS D'UNE EXPLICATION "ÉCONOMIQUE" DU JAPONISME?

Les conditions économiques qui favorisèrent la diffusion du Japonisme se
trouvent donc dans l'essor des art industriels, et en particulier l'estampe. Elles
n'ont qu'un rapport incertain avec les relations économiques franco-japonaises.

Mais nous constatons qu'en 1896, date où le succès de la lithographie en couleurs bat son plein, la vague du Japonisme est en train de se noyer dans la marée de "l'art nouveau." Ce que les rapports économiques franco-japonais peuvent expliquer c'est pourquoi cette forme esthétique n'est pas devenue, comme on aurait pu le supposer devant la poursuite du développement des arts industriels, un art presque "national" qui aurait envahi le marché. Cette autre vogue iconographique que fut l'orientalisme—qui traita en partie des mêmes problèmes à travers le thème du "harem" ou de la femme esclave—se répandait bien davantage mais on soupçonne immédiatement, et la chronologie le confirme, le rôle essentiel que joua dans cette mode l'expansion coloniale.[23] Rien de tel avec le Japon. En 1896 les rapports franco-japonais après avoir suscité des espoirs qui avaient commencé de se concrétiser sous le Second Empire et dans la première décennie de la Troisième République, sont compromis.

Comme on a beaucoup étudié le début de ces relations et jamais leur déclin, il est nécessaire d'apporter ici quelques précisions. Politiquement, tout engageait le Japon vers l'alliance avec l'Allemagne contre la Russie et, symétriquement, la France, en misant tout sur l'alliance russe pour encercler l'Allemagne, s'aliénait le Japon. Sous le Second Empire, le Japon avait fait appel à la France pour mettre sur pied son armée. C'était l'époque où l'armée française jouissait d'un grand prestige. Une seconde mission française envoyée au Japon après la défaite de 1870, en partit définitivement en 1878.[24] Le Japon se tourna alors pour organiser son armée et son administration, vers l'Allemagne, nouvelle grande puissance. On ne s'étonne donc pas de voir les importations françaises au Japon passer de 3 millions de yens en 1877 à 6 millions en 1898, pendant que les importations d'Allemagne passaient de 700,000 yens seulement à plus de 62 millions.[25]

D'autres statistiques nous apprennent qu'entre 1889 et 1893, 391 français résidèrent au Japon, contre 490 allemands et 1,787 anglais; que 57 japonais résidèrent en France dans la même période contre 105 en Allemagne et 116 en Angleterre. Pour cette période encore 15 passeports seulement ont été délivrés à des japonais voulant visiter la France, contre 29 pour l'Allemagne et 299 pour l'Angleterre.[26] Ces chiffres expliquent que l'œuvre volontariste d'un groupe actif de "japonisants" ne pouvait se transformer en mouvement national et était condamné à demeurer sans écho au delà d'un cercle restreint dans la bourgeoisie française qui s'est donné même parfois des allures de conspirateurs.

POURQUOI ÉTUDIONS-NOUS LE JAPONISME?

Si l'utilisation des formes japonaises, contraint dans les limites de l'esthétisme, devint de moins en moins efficient à la fin du siècle, en revanche, il fut relayé dans cette dernière décennie, par une vague d'études scientifiques qui semble résulter de l'intérêt porté au Japon dans les années précédentes. Ces études sont des bilans qui cherchent à théoriser l'expérience en en tirant les conclusions scientifiques, philosophiques ou religieuses. Ces réflexions sont d'un grand intérêt pour nous faire comprendre ce que les français ont retenu du Japonisme à cette époque. Au milieu d'une abondante bibliographie (*Le Japon contemporain*

de Jean Dhasp en 1893, *Le Japon vrai* de Félix Martin en 1898, *Essai sur l'histoire du Japon* de De La Mazelière en 1898, *La Société Japonaise* de André Bellessort en 1902, *Les Japonais, leur pays, leurs mœurs* de Raymond de Dalmas en 1905, etc.) on note deux courants caractéristiques et contraires.

Celui caractérisé par Félix Martin en 1898 traduit le déclin du Japonisme et la dégradation des rapports franco-japonais. Il voit dans le Japon un danger commercial, moral et militaire et le livre se termine sur la prédiction d'une guerre déclanchée par le Japon. Mais ce qui nous intéresse c'est que cette condamnation s'accompagne de jugements idéologiques qui sont ceux de la bourgeoisie française la plus conservatrice: de même que l'auteur reproche au Japon "l'abandon de ses traditions et de sa religion," il met en garde la France de succomber à la même décadence et voit dans cet abandon de la morale et de la religion en France le spectre des "révolutions qui ont bouleversé l'Europe depuis un siècle."

D'une approche totalement différente fut le cours professé à Paris en 1900 par le juriste Michel Revon. Dans le plus pur esprit positiviste il voit dans l'idéologie japonisante un moyen de masquer la faillite des vieilles religions et celui même d'assurer la relève du néo-classicisme lorsqu'il affirme: "Pour l'homme de science, la civilisation japonaise n'est pas moins attachante que celle des Grecs . . . " Pour lui, le Japonisme n'est pas un hasard mais une fatalité puisque toutes les civilisations se retrouvent au sein d'un principe religieux unique. Il préconise donc l'étude des civilisations comparées dans le but d'y trouver les lois qui régissent le monde: "Les vieilles religions perdent leur pouvoir mais l'instinct religieux demeure, la science, qui a détruit l'ancien idéal, doit le remplacer . . . Les phénomènes historiques se reproduisent dans tous les temps et dans tous les pays. L'histoire des civilisations comparées révèle de tous côtés les mêmes rapports nécessaires. Dans une certaine mesure, on pourra prévoir l'avenir."[27]

Voilà ce structuralisme déterministe en marche, la philosophie implicite du japonisme et celle aussi des études qu'il a suscitées, de nos jours encore. Une dernière question se présente alors à nous. En relisant l'abondante bibliographie consacrée eu Japonisme—prenons par exemple la liste dressée dans le catalogue de l'exposition de Baltimore—on constate que cette mode si tapageuse ne provoqua aucune étude après sa retombée en 1900. Il y a, dans l'histoire de l'art, un hiatus de 60 ans. On note un seul livre antérieur à 1960: la thèse d'Ethel Hahn à Chicago et deux articles de 1927 et 1943. En revanche, après la guerre l'intérêt rebondit et une soixantaine de titres apparaissent sur ce sujet avec un apogée qui se situe entre 1968 et 1975. On peut trouver cet écho presque disproportionné avec sa cause, révélant sans doute, comme le Japonisme lui-même, son investissement par des problèmes bien contemporains, très différents de ceux du Japonisme. L'intérêt que suscite aujourd'hui encore, comme un dernier rempart, l'idéologie "structuraliste" que servit le Japonisme, n'y est peut-être pas étranger. Mais de même que l'art japonais ne saurait expliquer à lui seul l'imitation qu'on en a fait, de même, le "Japonisme" ne saurait à lui seul expliquer l'intérêt qu'on lui porte aujourd'hui, et notre présence ici tendrait à prouver que, contrairement à ce qui s'est passé en France voilà un siècle, (—où le Japon ne joua qu'un rôle occasionnel) la situation du Japon dans le monde actuel fournit la première et la principale explication de cet intérêt rétrospectif.

NOTES

1. En fait une seule thèse a risqué, à notre connaissance, une telle explication, celle de Ernst Scheyer, "Far Eastern Art and French Impressionism," dans *The Art Quarterly*, t.VI, 1943, pp. 117–42. En se méfiant des excès et des conclusions générales auxquels pourraient mener le parallèlisme entre deux civilisations—forcément imbu de considérations morales implicites—il faut saluer cet article comme le seul à avoir au moins cherché une explication au phénomène. L'idée a été reprise dans l'article de Karen Van Maur, "Edmond de Goncourt et les artistes de la fin du XIXe siècle," dans *Gazette des Beaux-Arts*, n° 1198, t. LXXII (novembre 1968), p. 209 sqq.

2. Salon des Cents, n° 169–170 du catalogue. Puis réexposées, selon Joyant, en 1897, à la Libre Esthétique de Bruxelles, 25 février- 1er avril, n° 195 à 210 du catalogue. Voir aussi l'exposition de la suite avec catalogue chez Huguette Berès, novembre 1964, préface de A. Dunoyer de Segonzac.

3. *Le Sommeil*, L. Delteil 190, Adhémar 211, 320×205 mm.

4. *Outamaro, peintre des maisons vertes*, Paris, 1891, et *Les Estampes d'Outamaro et d'Hiroshige*, préface de Samuel Bing, Galerie Durand-Ruel, janvier-février 1893. Sur "Le Japonisme des Goncourt," voir la pertinente note de E.-H. Barbier dans *L'Opinion*, 35e année, 10 avril 1942, p. 10.

5. *The Burlington Magazine*, n° 582 (septembre 1951), p. 299.

6. Octave Uzanne, *La Femme à Paris, nos contemporaines*, Paris, 1894. Voir aussi du même auteur: *La Bohême du cœur, souvenirs d'un célibataire*, Paris, 1896.

7. Boutet est l'auteur de l'album *Autour d'Elles* paru en 1898, de *Les Parisiennes d'à présent*, Floury, 1896 et de *Ces Dames*, 50 lithographies originales, Paris, Lahure, 1912, ainsi que de *Filles de joie et de misère*, 1913, etc. Guillaume a souvent traité le sujet (par exemple l'album *Mémoires d'une glace*), on pourrait aussi citer *Les Parisiennes* de Cham et *Les Jolies Parisiennes* de Grévin, etc. La même année que *Elles*, on vit aussi paraître l'album *Etudes de Femmes* par Hermann-Paul, Toulouse-Lautrec et Willette.

8. Erashthène Ramiro, *Catalogue descriptif et analytique de l'œuvre gravé de Félicien Rops*, 1887; avec un *supplément* en 1895.

9. Erasthène Ramiro (pseudonyme de Eugène Rodrigues), *Louis Legrand, catalogue de son œuvre gravé et lithographié*, Paris, Floury, 1896. Léon Maillard, *Henri Boutet graveur et pastelliste*, Paris, Floury, 1894.

10. Sur *Rolla*, voir la thèse, en préparation de Holly Claysson, professeur à l'Université de Wichita (Kansas) sur la représentation de la prostituée en France à la fin du dix-neuvième siècle. Des recherches sur le thème de *Phryne* ont été faite par Joachim Heusinger von Waldegg, à propos du tableau de Gérôme et à l'occasion de l'exposition *Nana* à la Kunsthalle de Hambourg. Sur la *Nana* de Manet on consultera le livre de Werner Hoffman issu de cette exposition. On peut aussi citer les recherches d'Eunice Lipton sur *The Laundress in Late 19th Century French Culture, Imagery, Ideology and Edgar Degas* (à paraître).

11. *Unpublished correspondance of Henri de Toulouse-Lautrec* edited by Lucien Goldschmidt and Herbert Schimmel, with an introduction and notes by Jean Adhémar and Theodore Reff, London, Phaidon Press, 1969, en particulier p. 19 et p. 186.

12. Ibid., lettre 219, p. 197.

13. Ambroise Vollard, *La Vie et l'Oeuvre de P.-A. Renoir*, chez Vollard, 1919, pp. 85–86.

14. Henri Degron, Compte-rendu du 20e Salon des Cents dans *La Plume*, tome 8, n° 169 (1er-15 mai 1896), p. 305.

15. Camille Mauclair, à propos du Salon de la Libre Esthétique à Bruxelles dans le *Mercure de France*, avril 1895.

16. Jean Adhémar, "Le Public de l'estampe," dans *Nouvelles de l'estampe*, n° 37 (janvier-février 1978), p. 19.

17. Bibliothèque nationale, département des Estampes, *Livres et albums illustrés du*

Japon réunis et catalogués par Théodore Duret, Paris, Leroux, 1900.

18. Richard Lane, *L'Estampe japonaise*, Fribourg, Office du Livre, 1979.

19. Félix Fénéon, dans *Le Père Peinard* du 16 avril 1893 reproduit par Joan Halperin, dans *Félix Fénéon, œuvres plus que complètes*, Genève, Droz, tome 1, p. 228.

20. Karen van Maur, op. cit. note 1. Sur l'estampe japonaise comme expression de la décadence d'une civilisation féodale et du réveil du peuple, expliquant son succès en France dans une situation semblable, cf. Ernst Scheyer, op. cit. dans la note 1. On lit aussi chez Goncourt (*Outamaro . . .* , 1891, p. 53): "Et l'école que fondait Outamaro était l'école d'un art sortant de la convention, allant au peuple . . . "

21. On lit dans le *Journal des Goncourt* (13 mai 1892): "L'art industriel français, sous le coup de fouet de l'art japonais de la vie intime, est en train de tuer le grand art."

22. Richard Lane, *L'Estampe japonaise*, op. cit..

23. Petra Dietz, "Sur quelques tableaux orientalistes aux Salons," préface à l'exposition des Orientalistes au Musée de Tours, juin-juillet 1980.

24. P. de Lapeyrière, *Le Japon militaire*, Paris, 1883. Voir aussi Roger Dorient, *Le Japon et la politique française*, Paris, Plon, 1906.

25. Ministère des Finances, *Annuaire financier et économique du Japon*, 1ère année, 1900, Tokyo, Impr. Impériale.

26. Cabinet Impérial, section de la statistique générale. *Résumé statistique de l'Empire du Japon*, 9e année, 1895, Tokyo. Voir aussi: I. Hitomi, *Le Japon essai sur les mœurs et les institutions*, Paris, 1900.

27. Michel Revon, *Histoire de la civilisation japonaise, Introduction*, Paris, A. Colin, 1900.

LES NABIS ET LE JAPON

Ursula Perucchi-Petri

Vers la fin du dix-neuvième siècle, il apparaissait de plus en plus clairement que les moyens d'expression traditionnels de l'art européen étaient usés. La peinture enseignée dans les académies, fondée sur les allusions littéraires et une représentation illusionniste et naturaliste, avait perdu sa force. Une renaissance s'appuyant sur les traditions européennes paraissait impossible.

Pour l'Occident, la confrontation avec l'art japonais fut la révélation d'une toute nouvelle esthétique. Etant donné les caractéristiques des estampes japonaises, à savoir la surface décorative et l'absence de profondeur et de modelé, cet art passa longtemps pour être archaïque et primitif. Ce n'est que plus tard que l'on découvrit la tradition de l'art japonais. Ce malentendu voulut que dans l'art oriental on croyait pouvoir trouver les formes naïves, archaïques et primitives auxquelles on aspirait à cette époque. C'est pourquoi on pouvait l'associer à l'art ancien dans lequel on voyait un exemple d'art intact et vivant, par exemple à l'art égyptien, aux mosaïques byzantines, ou aux vitraux du Moyen Age. Pour les artistes d'alors ce nouveau langage artistique fut aussi une révélation en ce sens qu'ils croyaient découvrir un art symboliste et non-imitatif. Edouard Dujardin a été le premier à établir cette relation entre l'art japonais, l'art primitif et le symbolisme dans son article sur le "Cloisonnisme" de Emile Bernard et Paul Gauguin en 1888 dans *La Revue Indépendante*.[1]

L'histoire montre que les Nabis ont été spécialement réceptifs à l'art japonais. Ils l'ont connu surtout dans l'exposition de Bing en 1888 et dans l'exposition à l'Ecole des Beaux-Arts en 1890 où étaient présentées plus de 700 estampes japonaises. Surtout leurs premières œuvres, créées entre 1890 et 1900, traduisent cette influence de l'art oriental. Les Nabis voulaient rendre l'essence des choses et les émotions qu'elles éveillent, plutôt que donner une copie naturaliste de la réalité. Le contenu littéraire, l'anecdote avaient perdu de leur importance; ce que l'on recherchait, c'était l'expression par la forme. Au lieu de la "fenêtre ouverte sur la nature" des impressionnistes, les peintres Nabis revenaient à l'autonomie des plans de l'image. Mais la technique de la surface plane exigeait de nouveaux moyens artistiques, en mesure de remplacer les moyens traditionnels du trompe-l'œil et du modelé. L'art japonais offrait de nouveaux équivalents plastiques. Bien que ses éléments de base soient la surface plane et la ligne, il ne s'agit pas d'un

art à deux dimensions. Dans la dialectique de l'art oriental, les objets et les figures semblent, d'une part, être sans relief et sans corps mais paraissent avoir, d'autre part, un certain volume et une certaine perspective dont l'effet est obtenu par des moyens artistiques complètement différents des moyens illusionnistes européens. C'est là ce qui impressionnait surtout les Nabis car, malgré leur exigence radicale d'une surface plane, leurs œuvres ne représentent pas seulement les deux dimensions. Leurs images sont des projections du raccourcissement perspectif et du volume sur la surface plane.

L'intérêt des Nabis pour l'art japonais ressort déjà du fait que tous ont collectionné des estampes et des livres japonais. Denis par exemple possédait plus de 70 estampes. Bonnard avait acheté des estampes de Toyokuni, Kunisada, Kuniyoshi, Yoshimura et Hiroshige—presque tous des artistes du dix-neuvième siècle. Vuillard possédait dix peintures sur soie, des estampes de Hiroshige, Harunobu et d'autres et six livres illustrés, entre autre le volume six de la *Manga* de Hokusai et un livre de Kitao Masayoshi. Aussi les Nabis se sont exprimés sur l'influence japonaise. Bonnard par exemple a déclaré: "J'avais compris au contact de ces frustes images populaires, que la couleur pouvait comme ici exprimer toutes choses sans besoin de relief ou de modelé. Il m'apparut qu'il était possible de traduire lumière, formes et caractère rien qu'avec la couleur sans faire appel aux valeurs."[2] Il achetait les estampes dans les grands magasins à Paris. "C'est là que je trouvais pour un ou deux sous des crépons ou des papiers de riz froissés aux couleurs étonnantes. Je remplis les murs de ma chambre de cette imagerie naïve et criarde."[3]

Il est impossible de traiter les multiples aspects de l'influence japonaise sur les Nabis dans le temps limité de cette conférence. Je m'arrêterai donc à deux problèmes essentiels : la représentation de la figure et la représentation de l'espace. Je me concentrerai sur l'œuvre de Pierre Bonnard, Edouard Vuillard et Maurice Denis pour illustrer ces deux aspects.

LA REPRÉSENTATION DE LA FIGURE

L'affiche *France-Champagne* de Pierre Bonnard (Fig. 1),[4] datée de 1891, montre le buste d'une jeune femme à l'air joyeux qui tient un verre de champagne dont la mousse déborde en grandes cascades. On ne peut s'imaginer cette affiche sans les modèles du fameux Jules Chéret dont les femmes joyeuses et exubérantes peuplaient, depuis 1866, les murs et les colonnes d'affiches de Paris. La réalisation de Bonnard, cependant, apporte des éléments inédits dans l'art de l'affiche : la surface plane, la stylisation décorative et la figuration par l'arabesque. Le contour noir et épais fait ressortir la silhouette de la jeune femme et de la mousse du champagne. Bonnard renonce à tout modelé. Malgré cela, la jeune femme, légèrement vue d'en haut, n'est pas une figure purement plane. La position inclinée de son épaule et la superposition de la mousse du champagne créent un certain volume. L'impression de volume est également donnée par la ligne onduleuse, alternativement concave et convexe, qui s'épaissit aux endroits bombés, (par exemple la partie de l'épaule et de la poitrine) et s'amincit le long du bras.

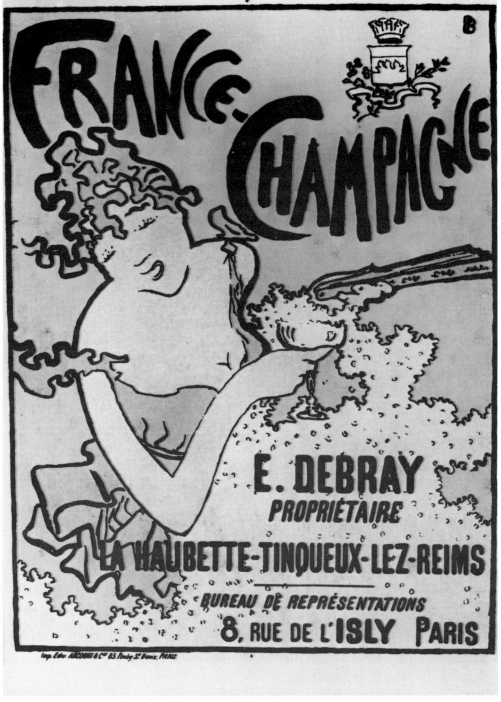

Fig. 1. Pierre Bonnard, *France-Champagne*, 1891. Affiche en trois couleurs.

L'arabesque est un des moyens plastiques les plus importants dans le nouveau langage pictural de Bonnard et des autres Nabis. Pour eux l'arabesque s'oppose aux moyens d'imitation de la nature traditionnels, à savoir le trompe-l'œil et

le modelé, et ils tiennent à souligner sa force d'expression en tant que moyen plastique autonome. La ligne de Bonnard s'inspire directement de l'art de l'Extrême-Orient. Prenons un exemple qu'il a certainement connu : L'esquisse d'un peintre japonais du dix-septième siècle, nommé Shōkadō ou Shōjō (Fig. 2).[5] Cette esquisse était reproduite dans le fameux livre de Louis Gonse *L'Art Japonais*, paru en 1883. La partie de l'épaule et du bras, dont la ligne onduleuse suggère le volume, montre clairement ce qui a influencé Bonnard. Comme dans ses modèles japonais, la ligne onduleuse de Bonnard ne rend pas seulement le modelé mais aussi le mouvement de la personne. C'est ce que montre clairement le contour de la poitrine de la jeune femme. L'épaule, le bras et la poitrine sont réunis en une seule arabesque, qui visualise en même temps la torsion du buste. En schématisant et simplifiant ainsi les éléments plastiques, Bonnard arrive à l'effet d'affiche désiré, lisible à grande distance. Il en va de même pour la figuration décorative de la mousse du champagne. Elle est préfigurée quasi littéralement dans les estampes de Hokusai où l'écume des vagues est représentée par la même ligne irrégulière et dentelée. Bonnard a sûrement connu ces estampes de Hokusai déjà présentées lors de l'exposition de Bing en 1888. On avait pu y voir, entre autres, la fameuse *Vague*. Chéret et ses contemporains s'étaient contentés, dans les affiches publicitaires pour une liqueur ou un apéritif, de montrer une fille avec une bouteille et un verre rempli, où le geste de verser le liquide dans le verre était tout au plus implicite. Bonnard, au contraire, réussit à suggérer le pétillement du champagne par les éléments purement plastiques, éléments dont il s'est inspiré des estampes japonaises. En utilisant des formes analogues pour les cheveux et les bretelles de la jeune femme, il établit une identité entre le charme érotique de la femme et le champagne. La séduction de l'affiche découle de l'interaction de ces deux attraits pétillants. La nouveauté de cette affiche fut tout de suite reconnue par les contemporains. Ce n'est qu'après que le fameux *Moulin Rouge* de Toulouse-Lautrec fut imprimé par le même imprimeur.

C'est d'une manière très semblable que Vuillard a conçu son dessin *Jeunes filles assises* datant d'environ 1891.[6] Les neuf variantes vivent du contour mouvementé. Vuillard évoque la figure en peu de lignes onduleuses qui se gonflent et s'amincissent, traduisant ainsi la dynamique de chaque attitude. Par sa calligraphie ornementale, la ligne revêt une certaine valeur autonome. Ce sont là aussi les caractéristiques de la peinture à l'encre de chine de l'Extrême-Orient. Des modèles de ce genre, Vuillard les trouvait dans sa collection, comme par exemple cette page d'un cahier de croquis de Masayoshi, où les personnages assis présentent des ondulations très semblables.[7] La disposition des neuf variantes de la jeune fille, soit sur une ligne ou superposées, remonte elle aussi à l'influence des cahiers japonais dont Vuillard possédait au moins six exemplaires, entre autres, un volume de la *Manga*, de Hokusai.

Dans chacun des quatre panneaux de son paravent *Femmes au jardin* de 1890–91 (Fig. 3),[8] Bonnard peint une femme debout ou assise. Dans le premier tableau la femme et son chien sont peints d'une manière tout à fait plane, sans aucun modelé. Comme dans l'affiche *France-Champagne*, la ligne onduleuse, alternativement concave et convexe, suggère cependant un certain volume. Le contour tient compte du raccourcissement dû à la torsion du corps et implique le mouvement

Fig. 2. Shōkadō, Esquisse, dans: L. Gonse, *L'Art Japonais*, 1886.

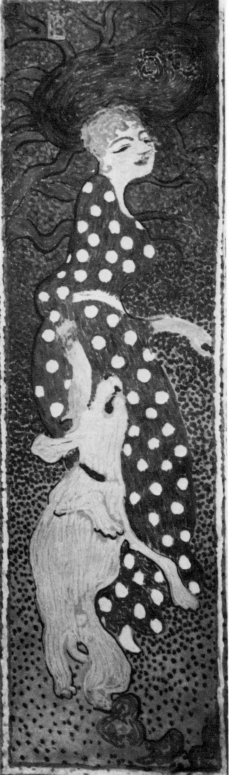

Fig. 3. Pierre Bonnard, *Femmes au jardin*, un de quatre panneaux, 1890–91. Huile sur papier, sur toile. Collection particulière.

compliqué de la figure. Ceci se vérifie surtout dans le bras droit, où le contour et le mouvement du corps se fondent en une seule arabesque. Tout le panneau vit de la ligne en forme de S qui détermine la figure de la femme et du chien et se retrouve partout dans les petits détails.

La ligne en forme de S est une caractéristique essentielle des gravures de femme dans l'art japonais. Elle accentue souvent un mouvement qui rapelle la danse japonaise: comme dans l'estampe d'Utamaro *Le Champ de Musashi*[9] la taille et les genoux sont pliés et le buste incliné vers l'avant. S'y ajoutent des torsions compliquées du corps, où la tête apparaît tournée de presque 90 degrés par rapport au buste et le buste, de son côté, est souvent tourné par rapport à la partie inférieure du corps. Ces torsions permettent à l'artiste japonais de représenter aussi bien le corps que la tête dans un profil de trois quarts et de suggérer ainsi une impression de volume. En même temps, il réussit à augmenter la richesse de contrastes du rythme. Les gravures de femmes japonaises montrent pour la plupart des figures vêtues. Leur mouvement se révèle avant tout par le jeu du vêtement. La ligne en forme de S et les attitudes compliquées contribuent à donner au vêtement un élan charmant et un contour expressif. Celui-ci sert également à exprimer les émotions de la femme idéalisée puisque, dans l'art de l'*ukiyo-e*, l'expression du visage est toujours figée. La ligne—celle des plis, des ourlets et des pans du vêtement—est le seul moyen d'expression utilisé.

En comparaison avec les lignes gracieuses des vêtements dans les estampes japonaises, Bonnard soumet le contour de ses femmes à une forme ornementale où doit s'exprimer non seulement la torsion du corps, mais aussi la joie et la dynamique intérieure de la femme. En même temps, l'arabesque apparaît comme le chiffre d'un mouvement général qui traverse toute la figure et d'un même rythme embrasse la femme, le chien, les branches et les fleurs. Elle révèle la force dynamique de toute chose et montre la grande unité de tout ce qui vit. Elle est un chiffre de vie. C'est ainsi que l'arabesque, inspirée de l'art japonais, n'est pas seulement une solution de remplacement de l'art imitatif, permettant de suggérer le volume et le mouvement dans la surface plane, mais aussi un moyen pour exprimer des forces invisibles.

Les quatre panneaux de Bonnard portent aussi le titre: *Les Quatre Saisons.* Son interprétation de ce sujet ressemble beaucoup aux estampes japonaises dans lesquelles des femmes sont souvent associées avec les quatre saisons ou les douze mois. Chez Bonnard tout comme chez les Japonais, des beautés à la mode incarnent les saisons. Tandis que chez les Japonais, l'évocation des saisons est soulignée uniquement par des fleurs ou plantes caractéristiques (par exemple camélias ou pruniers en fleur pour le printemps, lotus ou saule pour l'été, feuilles d'érable pour l'automne), Bonnard exprime par des moyens picturaux l'essence de chaque saison : la dynamique et l'expansion d'une nature réveillée à une vie nouvelle dans la femme au chien, faisant certainement allusion au printemps; l'introversion et l'attente passive dans la femme au chat, vraisemblablement le symbole de l'hiver. Du fait que les lignes rendent visibles des forces au-delà des figures mêmes, les saisons, elles, concrétisent des formes d'existence.

On peut très bien comparer les figures de Vuillard qui présentent les mêmes caractéristiques. Sa danseuse, *Biahna Duhamel dans Miss Helyett* de 1891 (Fig. 4),[10]

est certainement inspirée des estampes japonaises. Il possédait dans sa propre collection une page de danseuses du cahier de croquis de Kitao Masayoshi portant le titre : *Ryakugashiki* (collection d'esquisses) (Fig. 5).[11] Ces croquis de mouvements souvent grotesques, ont influencé Vuillard. La ligne en forme de S et la torsion du corps, impliquant la dynamique de la danse, en témoignent. Le choix de ces poses, qui déforment le corps humain, s'explique par le refus de se soumettre à la loi des proportions et des mouvements usée par la routine académique, entre autre l'ancien contra-posto. Et pour Vuillard, à la recherche de nouvelles formes d'expression, les modèles que fournit l'art japonais viennent à propos.

Le Peignoir de 1892 (Pl. VIII)[12] est un des tableaux de Bonnard où il "japonise" de manière très évidente : dans le format de *kakemono* d'abord (hauteur—largeur =3 : 1), puis dans l'attitude caractéristique des figures vues de dos. Le mouvement du corps et de la tête est opposé et les genoux sont légèrement pliés. Comparable est une esquisse japonaise prise dans *Le Japon Artistique* que Bonnard a certainement connue.[13]

Fig. 4. Edouard Vuillard, *Biahna Duhamel dans Miss Helyett*, vers 1891. Pastel.

Fig. 5. Kitao Masayoshi, *Danseuses*, page du cahier de croquis *Ryakugashiki*. 1795.

Le Peignoir enveloppe presque complètement la femme et c'est dans son apparence ornementale qu'apparaît le vrai sujet du tableau. La vue de dos et le profil en partie caché font perdre tout caractère propre à la femme et semblent la condamner à la simple fonction de mannequin. Dans cette oeuvre, l'émancipation du vêtement veut que les moyens picturaux de la surface plane et de l'ornementation tendent à l'abstraction. Là aussi on retrouve l'influence japonaise. Les motifs des estampes japonaises tardives depuis Koryūsai et Shigemasa servirent souvent de modèle dans le monde de la mode féminine. Il importait peu aux artistes japonais de rendre l'individualité d'une *geisha* ou d'une courtisane; les élégants kimonos et leurs riches motifs les intéressaient bien davantage. Plus tard, ils se consacrèrent presque exclusivement aux tableaux de mode. Kunisada et Kuniyoshi peignirent en série des acteurs et des beautés féminines, où les vêtements et leur ornementation prirent de plus en plus d'importance. Bonnard possédait une de ces estampes de Kunisada montrant un acteur dans une scène de *kabuki*.[14] La richesse de couleur des estampes tardives apporta sa contribution à une plus grande autonomie du décor au détriment de la réalité de la figure humaine.

Ainsi dans *Le Peignoir* Bonnard renonce à toute personnalité propre de la figure pour mieux laisser la préciosité raffinée du vêtement exprimer la sensualité contenue et l'attrait mystérieux de la femme. C'est ce qui fait de son tableau une œuvre caractéristique de la fin de siècle.

Tandis que pour Bonnard l'influence japonaise était connue depuis longtemps —à l'époque des Nabis on l'appelait déjà "le Nabi japonard"—on n'en a presque jamais parlé à propos de Maurice Denis. La raison réside peut-être dans le fait que dans son œuvre l'inspiration de l'Extrême-Orient est moins évidente, parce que modifiée par d'autres influences, entre autres celles des peintres italiens du Trecento. Mais sa collection de plus de 70 estampes et de plusieurs frontispices de la revue *Le Japon Artistique* témoigne de son grand intérêt pour l'art japonais.

Dans sa représentation de la figure, la ligne devient chez Denis un moyen plastique très personnel. Dans la lithographie *Réponse de la bergère au berger* de 1892,[15] destinée au livre du même titre d'Edouard Dujardin, le traitement ornemental de la figure de femme remonte sûrement à l'estampe japonaise. On retrouve cette même ondulation des ourlets chez Kiyonaga. Comme on l'a vu chez Bonnard, le vêtement et le jeu de ses mouvements est une forme d'expression à laquelle recourt l'art japonais pour caractériser l'émotion de la personne représentée. Dans la feuille de Denis, le tourbillon de la ligne traduit aussi l'excitation qu'éveille chez la femme cette rencontre avec le berger qui pénètre l'image à gauche. L'arabesque semble s'émanciper et mener une vie propre.

Cela devient encore plus clair dans la vignette de *Ecoutez la chanson bien douce* destinée à l'illustration de *Sagesse* de Verlaine.[16] La stylisation ornementale du personnage englobe la torsion du corps dont la courbe en forme de S vient se terminer dans l'ourlet onduleux. De telles figures, qui s'animent grâce à une ligne en forme de S, sont caractéristiques pour beaucoup d'estampes de Harunobu et Utamaro.

Le tableau de Denis, *Avril* de 1892,[17] figure un personnage très semblable agenouillé au bord d'un chemin sinueux. La stylisation du geste et le blanc du

vêtement suggèrent qu'il se réalise là une action hors du quotidien. En effet Denis symbolise ici la Vita Activa qui fait partie de son complexe de pensées religieuses. Au-delà de la balustrade, la sinuosité du fleuve reprend celle du chemin et l'ornementation de grand format revêt une importance toute particulière dans la stylisation décorative de ce tableau. L'idée a été puisée dans l'art japonais. On trouve de très beaux exemples dans la peinture décorative de l'époque Momo-yama et Edo, surtout chez Sōtatsu et plus tard chez Kōrin, très connu vers la fin du siècle à Paris, surtout par son paravent *Pruniers en fleurs*.[18]

Dans le tableau *Procession sous les arbres* de 1892 (Fig. 6),[19] le contour bleu, légère-ment ondulé, encercle complètement les personnages, de sorte que rien ne dépasse cette masse compacte. De cette façon le corps est presque réduit à rien. Le contour n'est plus subordonné aux personnages mais aux longs vêtements à traîne. En outre, les personnages, sans égard aux proportions, sont extrêmement allongés. L'individualité est niée : les femmes n'ont plus de visages. Perdant leur identité propre, elles se trouvent assujetties au groupe par un contour commun. Au moyen de l'allongement des proportions, de la réduction du corps à presque rien, de la suppression de l'individualité, Denis figure des créatures idéales, loin de la réalité. Le contour du vêtement contient à lui tout seul presque toute l'expression psychologique.

Dans beaucoup d'estampes japonaises l'arabesque des vêtements dissimule le corps. Surtout Harunobu, Koryūsai, Shunshō, Kiyonaga et Utamaro ont idéalisé les femmes de cette manière. Et ce sont avant tout ces artistes de la période classique qui ont inspiré Denis. Mais sous l'influence italienne—d'un

Fig. 6. Maurice Denis, *Procession sous les arbres*, 1892. Huile sur toile. Collection A. G. Altschul, New York.

Fig. 7. Pierre Bonnard, *Femmes au chien*, 1891. Huile sur toile. Collection particulière.

Fra Angelico ou d'autres peintres du Trecento et du Quattrocento—les suggestions japonaises sont fortement modifiées.

LA REPRÉSENTATION DE L'ESPACE

Dans le tableau de Bonnard *Femmes au chien* de 1891 (Fig. 7),[20] le groupe principal au premier plan est vu d'en haut, ce qui permet à Bonnard de souligner son volume dans la surface plane. La vue plongeante était déjà un moyen familier dans la peinture du Moyen Age pour représenter l'espace, et les Nabis ont bien étudié les œuvres de l'époque "d'avant la perspective."

Ce qui est nouveau dans le tableau de Bonnard c'est la combinaison de la vue plongeante avec le gros plan et les découpages imprévus. Ces vues insolites et inhabituelles dans la peinture européenne sont inspirées par l'art de l'Extrême-Orient. Cela se trouve déjà dans les tableaux de Degas et des autres impressionnistes inspirés eux aussi par l'art japonais, ce qui montre que l'influence directe des estampes est souvent combinée avec une influence indirecte. Il faut aussi prendre en considération l'influence de la photographie avec ses vues à vol

d'oiseau qui ont renforcé cette tendance. Depuis les *emakimonos* du douzième siècle, les Japonais, ne connaissant pas la perspective centrale européenne, ont représenté l'espace par une vue plongeante, combinée avec une sorte de perspective parallèle. Les estampes japonaises combinent souvent la vue plongeante et les gros plans. Le tableau de Bonnard ressemble beaucoup à une estampe de Kuniyoshi qui se trouvait dans la collection de Maurice Denis et que Bonnard devait connaître.[21]

Dans les *Femmes au chien* Bonnard élimine toute perspective conventionelle. L'œil saute, presque sans transition, du premier plan à l'arrière-plan. On retrouve aussi cette sorte de composition dans les *emakimonos* japonais. De longues bandes, qui peuvent passer pour des nuages ou des bancs de brouillard, marquent la transition de l'un à l'autre. Cette mise en page est reprise dans beaucoup d'estampes japonaises, par exemple par Shunshō, Hokusai et Hiroshige. Je vous montre ici, pour expliquer le principe de la construction, un exemple de Isoda Koryūsai *Temps s'éclaircissant dans un village de montagne*,[22] où le groupe formé par la jeune fille et le jeune homme au premier plan est relié à la chaîne de montagnes de l'arrière-plan par des bandes de nuages.

Bonnard, lui, relie l'avant-plan à l'arrière-plan en intercalant des plantes et des fleurs et un dossier de chaise. Seules les différentes échelles montrent la profondeur, et la succession dans l'espace est exprimée au moyen de superpositions dans la surface et d'intersections. Ce qui est inattendu dans la solution de Bonnard, c'est que la vue plongeante ne vaut pas pour tout le tableau : le petit groupe à l'arrière-plan est vu légèrement d'en-dessous. C'est-à-dire que le tableau n'est plus construit selon la perspective centrale traditionnelle, mais présente différents points de vue. En sautant d'un objet à l'autre, l'œil peut faire naître l'impression d'un chemin parcouru, et par conséquent, de l'espace entre les personnages du tableau.

Cette nouvelle optique de l'espace pictural a été suggérée aux Européens par l'art de l'Extrême-Orient. Une sorte de perspective parallèle, où la troisième dimension est donnée par des lignes de profondeur parallèles, permet aux *emakimonos* japonais, d'enchaîner les différentes scènes de leurs illustrations narratives et de changer, si besoin est, le point de vue. (Comparez une partie du *Kasuga Gongen Kenki Emaki* du XIVe siècle)[23] Il en va de même des paysages en format de *kakemono* dont la composition se développe plutôt verticalement qu'en profondeur. Les *kakemonos* ne sont pas non plus construits selon une perspective centrale, uniforme, mais ont également plusieurs points de vue. (Comparez le paysage dans le style de Kuo Hsi [XIe siècle] de l'époque Ming).[24] Des théoriciens chinois ont développé le schéma des trois vues. La première est celle qui part du bas vers le haut, la deuxième suit les plans obliques en profondeur, et la troisième est celle qui va du haut vers le bas. Un même tableau reprend toujours ces trois vues. Cette conception est tout à fait différente de celle des tableaux européens organisés d'après la perspective centrale. Au lieu de regarder le tableau d'un oeil fixe et d'un point de vue extérieur, le spectateur d'une peinture chinoise est sensé entrer dans la composition même. Il doit s'identifier avec les petits personnages du paysage et se mettre à leur niveau. L'artiste chinois ou japonais ne veut pas simplement représenter un fragment de paysage à partir

d'un certain point de vue, mais pour lui ce fragment fait partie du grand ensemble auquel appartient aussi le spectateur. Ce qui importe aux artistes de l'Extrême-Orient, ce n'est pas l'apparence accidentelle des choses mais leur signification plus profonde. Les objets sont saisis de l'intérieur. Ceci explique l'absence de perspective centrale et la liberté en ce qui concerne le point de vue.

De toute évidence, Bonnard et ses contemporains se sont inspirés de ces possibilités de composition. Ils ont eu l'occasion de les connaître non seulement à travers les estampes japonaises, mais aussi par les rouleaux, les *kakemonos* et les *emakimonos*, déjà montrés en 1883 dans les expositions organisées par Louis Gonse. L'optique à différents points de vue était déjà utilisée dans les tableaux de Gauguin et de Bernard que Bonnard a bien connu. L'influence directe et indirecte se mêle ici de nouveau. Bonnard lui, était très conscient de ce problème: "Représenter, sur une surface plane, des masses et des objets situés dans l'espace, tel est le problème du dessin . . . L'œil du peintre donne aux objets une valeur humaine et reproduit les choses telles que les voit un œil humain. Et cette vision est mobile. Et cette vision est variable."[25] Cela est dit également comme une réaction au "procédé sec de la photographie."

Cette nouvelle optique de l'espace a été si bien accueillie en Europe parce que la tendance voulait que l'on abandonnât le point de vue fixe de la perspective centrale. A la fin du dix-neuvième siècle, on était convaincu que la perspective dans son imitation illusionniste ne pouvait rendre que l'apparence accidentelle des choses, mais jamais l'essence. On ne voulait plus voir le monde à travers l'œil d'un sujet observateur, on voulait annuler la distance entre le spectateur et le tableau et aller au-delà des choses. La rupture avec la perspective traditionnelle et la technique de composition au moyen de plusieurs points de vue sera également adoptée par le cubisme, l'orphisme et le futurisme. Les moyens plastiques étudiés par les Nabis et leurs contemporains préparent donc les solutions de l'art du vingtième siècle.

Vuillard utilise l'ornementation pour figurer l'espace dans la surface plane. Dans son tableau *Atelier* de 1893,[26] la structure géométrique, toute de verticales et d'horizontales, est recouverte d'un décor moucheté et à fleurs. Dans la partie gauche du tableau celui-ci désigne le papier peint de la chambre et un paravent qu'il absorbe presque complètement et, dans la partie droite, occupée par l'embrasure de la fenêtre, l'air en vibration. La structure régulière de l'air l'assimile au papier peint ce qui donne l'impression que la fenêtre se trouve au même plan que la paroi du fond alors que l'entretoise oblique et le mouvement de la femme, penchée en avant, laissent plutôt supposer que la fenêtre est placée sur la paroi latérale. Vuillard utilise l'ornement en tant que moyen pour estomper l'espace réel et cependant le suggérer dans la surface plane.

Là aussi, il a subi l'influence des estampes japonaises. Des artistes comme Harunobu, Koryūsai et Kiyonaga ont souvent disposé leurs personnages devant un écran richement décoré de paravents, de portes coulissantes et de parois. Bonnard possédait dans sa collection une scène de *kabuki* de Kuniyoshi, où le passage de la paroi arrière à la paroi latérale est également très flou. Cela vaut aussie pour une estampe de Yoshinobu qui se trouvait dans la collection Bing à Paris.[27] Il est bien possible que Vuillard ait vu cette estampe. Les Japonais

esquissent l'intérieur par une sorte de perspective parallèle mais n'aspirent nullement à une description exacte de l'espace. C'est pour cela que Vuillard a pu reprendre leurs suggestions et mettre au point un moyen stylistique pour figurer le volume dans la surface plane.

Dans d'autres estampes japonaises, on rencontre le motif du personnage qui passe sa tête derrière un paravent ou une porte à coulisses, par exemple chez Kiyonaga.[28] La servante, à moitié cachée par la porte masque la vue dans la chambre voisine, réduisant par là l'effet d'espace.

Dans le tableau de Vuillard *Atelier de couture* de 1892,[29] les robes richement mouchetées et rayées des femmes se confondent avec le décor du papier peint de la paroi arrière. Elles semblent appartenir à cet ensemble décoratif. Au moyen de l'ornementation, on intègre les personnages à leur milieu tout en atténuant leur réalité.

Les artistes japonais de la fin du dix-neuvième siècle, par exemple Toyokuni, Kunisada, Kuniyoshi et Gakutei aimaient faire vivre l'arrière-plan des estampes grâce à un décor riche et varié qui se confondait avec les figures.[30] Chez eux l'harmonisation de la figure et de l'arrière-plan est plus prononcée qu'au début de l'époque car leurs personnages ressemblent de plus en plus à de simples mannequins, dont les vêtements gagnent souvent une autonomie étonnante. L'effet propre de l'ornement est renforcé par les à-plats des figures et les couleurs éblouissantes et criardes qui, dès l'ouverture du Japon et après l'importation des couleurs d'aniline par l'Europe, ont supplanté les tons délicats des anciennes couleurs naturelles.

Bonnard, lui, trouve encore un autre genre de figuration de l'espace en laissant parler la surface vide. Dans la lithographie *Femme au parapluie* de 1895,[31] la figure est seule sur une surface vide. Mais la silhouette, par l'élan de son contour irrégulier et comme échelonné, pénètre cettte surface créant ainsi un effet d'espace. (On peut comparer cette silhouette d'ailleurs à l'estampe de Kunisada *Neige au Temple Mokumoji*).[32]

Il en est de même pour son paravent *Promenade des nourrices, frise des fiacres* de 1899 (Fig. 8).[33] Là aussi, la surface vide s'anime grâce au groupe du premier plan. Les quatre panneaux du paravent sont concus comme un seul tableau qui, selon l'habitude de l'Extrême-Orient, doit être lu de droite à gauche. Les points de vue pour présenter les divers groupes varient. Des figures au premier plan, vues d'en-haut, le regard glisse sur la surface vide vers les trois figures, vue de face, apparaissant devant la balustrade, puis s'arrête à la frise de fiacres qui dans une file interminable se rejoint elle-même. En sautant d'un groupe à l'autre, l'œil reconstitue la surface vide en espace parcouru. Celui-ci, du fait qu'il n'est pas délimité, semble s'étendre au-delà même du tableau.

Bonnard met au service de sa nouvelle composition l'un des principes de base de l'art de l'Extrême-Orient : la dialectique entre les pleins et les vides. L'artiste chinois ou japonais ne remplit pas la surface avec ses images, il les laisse s'épanouir librement dans la surface vide. Les vides peuvent avoir plusieurs significations : brouillard, eau, ciel ou autre mais avant tout ils incarnent le fond de toute chose et donnent la notion d'espace.[34] En transformant les idées de l'Extrême-Orient, Bonnard réalise une nouvelle conception de l'espace.

Fig. 8. Pierre Bonnard, *Promenade des nourrices, frise des fiacres*, paravent à quatre feuilles, 1899. Lithographie en cinq couleurs.

En ce qui concerne les figures, Bonnard s'inspire, après 1894, plutôt des estampes tardives, où les personnages accusent des positions plus exagérées encore. Ce n'est plus la longue ligne onduleuse qui, comme dans le paravent *Femmes au jardin* de 1890, rend le mouvement des femmes, mais une silhouette par échelons et des contours irréguliers. Les postures sont parfois tellement exagérées que les figures semblent se contorsionner. Dans *Promenade des nourrices*, Bonnard obtient la note presque caricaturale de la femme au premier plan en exagérant l'opposition des mouvements de la partie inférieure et du buste. Il utilise la forme du large col châle pour donner l'impression du buste penché en avant et comme déplacé par rapport aux hanches. On peut établir une comparaison avec la femme de l'estampe de Kuniyoshi (Fig. 9), qui se trouvait dans la possession de Maurice Denis et que Bonnard a certainement connue.[35]

Ce genre de figures domine dans les scènes de rue qui, de 1894 à 1900 environ, comptent parmi les sujets préférés de Bonnard. Reprenant un mot de Baudelaire, Denis avait surnommé Bonnard "le peintre de la vie moderne." La figure, toute de mouvements, dont Bonnard se sert pour rendre la vie dans la grande ville peut être grotesquement exagérée au point de devenir un seul chiffre de mouvement. Il faut voir dans cette apparance grotesque et caricaturale une réaction contre la ressemblance photographique et contre la représentation de l'homme qui, selon les règles académiques, devait être "fidèle" et "belle." Pour les Nabis,

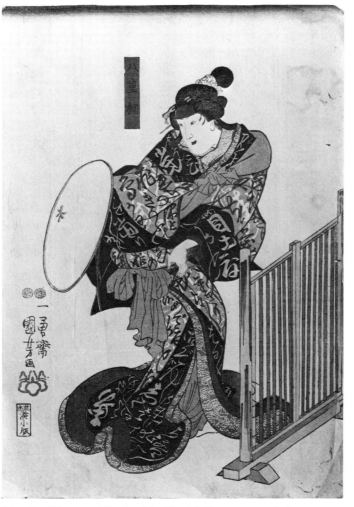

Fig. 9. Utagawa Kuniyoshi, *Yaegiri*. Gravure sur bois en couleurs. Collection Maurice Denis.

la déformation est un équivalent plastique légitime. En se libérant des conventions européennes pour adopter le rythme très différent des modèles japonais, Bonnard s'ouvre de nouvelles possibilités pour exprimer de manière inédite la vie dans les rues et sur les places de Paris.

Pour résumer, on peut affirmer que les influences japonaises entre autres ont aidé les Nabis à élaborer de nouvelles solutions pour la représentation de la figure et la représentation de l'espace, solutions qui étaient à même de remplacer les moyens d'expression traditionnels de l'art européen.

NOTES

1. E. Dujardin, "Aux XX et aux Indépendants: Le cloisonnisme." Dans: *La Revue Indépendante*, mars 1888, p. 489 s.
2. Antoine Terrasse, *Pierre Bonnard*, Paris, 1967, p. 10.
3. Ibid., p. 24.
4. Pierre Bonnard, *France-Champagne*, 1891. Affiche en trois couleurs. 78 × 50 cm. Roger-Marx 1.
5. Shōkadō (Shōjō) (1584–1639), Esquisse. Dans: Louis Gonse, *L'Art Japonais*, 1886, Vol. 1, p. 211. Reproduit dans: Ursula Perucchi-Petri, *Die Nabis und Japon. Das Frühwerk von Bonnard, Vuillard und Denis*, Munich, 1976, Pl. 2, p. 34.
6. Edouard Vuillard, *Jeunes filles assises*, vers 1891. Encre de chine, 36 × 32 cm. Collection particulière, Paris. Reproduit dans: Ursula Perucchi-Petri, op. cit., Pl. 90, p. 134.
7. Kitao Masayoshi (1764–1824), Page du cahier de croquis *Ryakugashiki*, 1795. De la collection d'Edouard Vuillard. Collection particulère, Paris. Reproduit dans: Ursula Perucchi-Petri, op. cit., Pl. 91, p. 135.
8. Pierre Bonnard, *Femmes au jardin*, 1890/91. Deux de quatre panneaux. Huile sur papier, sur toile, chacun 160 × 48 cm. Collection particulière.
9. Kitagawa Utamaro (1753–1806), *Le champ de Musashi*, vers 1796. Du *Ise Monogatari*. Estampe. Reprod. dans: U. Perucchi-Petri, op. cit., Pl. 6, p. 38. Bonnard possédait dans sa collection un crépon de Yoshimura *Jeune femme dans une barque* dans lequel la femme accentue un mouvement comparable à celui dans le paravent de Bonnard (U. Perucchi-Petri, op. cit., Pl. 7).
10. Edouard Vuillard, *Biahna Duhamel dans Miss Helyett*, vers 1891. Pastel, 40 × 25.5 cm. Collection Josef Rosensaft, New York.
11. Kitao Masayoshi, Page du cahier de croquis *Ryakugashiki*, 1795. De la collection Vuillard. Collection particulière, Paris.
12. Pierre Bonnard, *Le Peignoir*, 1892. Huile sur molton, 154 × 54 cm. Dauberville 14. Musée National d'Art Moderne, Paris.
13. Esquisse japonaise. Dans: *Le Japon Artistique*, Vol. II, No. 9, janvier 1889, p. 108. Reprod. dans: U. Perucchi-Petri, op. cit., Pl. 13, p. 50.
14. Utagawa Kunisada, *Nakamura Utaemon dans une scène de Kabuki*. Estampe de la collection de Bonnard. Collection Charles Terrasse, Paris. Reprod. dans: U. Perucchi-Petri, op. cit., Pl. 15, p. 54.
15. Maurice Denis, *Réponse de la bergère au berger*, 1892. Lithographie en couleurs, Cailler 6.
16. Maurice Denis, Vignette de Paul Verlaine, *Sagesse*, 1911, p. 34. Reprod. dans: U. Perucchi-Petri, op. cit., Pl. 114, p. 168.
17. Maurice Denis, *Avril*, 1892. Huile sur toile, 37 × 61 cm. Rijksmuseum Kröller-Müller, Otterlo.
18. Akiyama, Terukazu, *Japanische Malerei*, Genf, 1961, pp. 154–155 et U. Perucchi-Petri, op. cit., p. 221 ss.
19. Maurice Denis, *Procession sous arbres*, 1892. Huile sur toile, 56 × 81 cm. Collection A.G. Altschul, New York.
20. Pierre Bonnard, *Femmes au chien*, 1891. Huile sur toile, 40 × 32 cm. Dauberville 20. Collection particulière.
21. Utagawa Kuniyoshi (1798–1861), *Scène de théâtre*. Estampe de la collection de Maurice Denis. Collection Dominique Denis, St. Germain-en-Laye. Reprod. dans: U. Perucchi-Petri, op. cit., Pl. 17, p. 57.
22. Isoda Koryūsai, *Temps s'éclaircissant dans un village de montagne*, vers 1772. Estampe. Reprod. dans: U. Perucchi-Petri, op. cit., Pl. 18, p. 59.
23. *Kasuga-Gongen-Kenki-Emaki*. Rouleau V. *Scène à la porte de Fujiwara Toshimori*. Début du 14e siècle. Soie, Hauteur environ 41 cm. Reprod. dans: U. Perucchi-Petri, op. cit., Pl. 19, p. 60.

24. Style de Kuo Hsi (vers 1020–1075). Travail de l'époque Ming. Kakemono, Encre de chine sur soie, 188.8 × 109.1 cm. Taichung (Formosa), Collection Impériale. Reprod. dans: U. Perucchi-Petri, op. cit., Pl. 20, p. 61.

25. Cité dans: Charles Terrasse, *Pierre Bonnard*, Paris, 1927, p. 162 ss.

26. Edouard Vuillard, *L'Atelier*, 1893. Huile sur toile, 44 × 51 cm. Smith College Museum of Art, Northampton, Massachusetts. Reprod. dans: U. Perucchi-Petri, op. cit., Pl. 65, p. 109.

27. Yamamoto Yoshinobu (actif vers 1750/60), *Femmes dans une chambre*. Estampe. Ancienne collection Bing, Paris. Reprod. dans: U. Perucchi-Petri, op. cit., Pl. 63, p. 108.

28. Torii Kiyonaga (1752–1815), *Femme assise et servante*. Estampe. Reprod. dans: U. Perucchi-Petri, op. cit., Pl. 64, p. 108.

29. Edouard Vuillard, *Atelier de couture*, 1892. Un panneau de: Panneaux décoratifs pour Paul Desmarais. Huile sur toile, 48.5 × 117 cm. Collection particulière, Paris. Reprod. dans: U. Perucchi-Petri, op. cit., Pl. 68, p. 113.

30. Comparez l'estampe de Kunisada, *Scène de théâtre*. Reprod. dans: U. Perucchi-Petri, op. cit., Pl. 69, p. 113.

31. Pierre Bonnard, *Femme au parapluie*, 1895. Lithographie en deux couleurs, 22 × 14 cm. Roger-Marx 35.

32. Utagawa Kunisada, *Neige au Temple Mokumoji*, Estampe. Reprod. dans: U. Perucchi-Petri, op. cit., Pl. 45, p. 82.

33. Pierre Bonnard, *Promenade des nourrices, frise des fiacres*, 1899. Paravent à quatre feuilles. Lithographie en cinq couleurs, 150 × 200 cm. Roger-Marx 47.

34. Comparez par exemple Ma Yüan (vers 1150–1230), *Pêcheur en bateau*. Encre de chine et couleurs sur soie. Tokyo, Musée National.

35. Utagawa Kuniyoshi, *Yaegiri*. Estampe de la collection de Maurice Denis. Collection de Dominique Denis, St. Germain-en-Laye.

JAPONISME AND THE REVIVAL OF PRINTMAKING
AT THE END OF THE CENTURY

Phillip Dennis Cate[1]

In the late 1850s and early 1860s when Japanese prints first became available to artists in France, a strong kinship with Japanese aesthetics is apparent among the anti-establishment young artists such as Manet, Degas, Whistler and even Félix Bracquemond. The Japanese concern for the depiction of everyday life, for a spontaneity of execution, for simplicity of design, for assymetrical compositions and for the use of pure colors served as a refreshing alternative to the Greco-Roman tradition in French art, and reinforced the French avant-garde's anti-academic tendencies. The similarity of artistic sensibilities found in the art of Japan and in that of the French avant-garde, becomes most apparent in the area of French printmaking. When one compares mid-nineteenth-century French art criticism of Japanese and of French prints, the same descriptive terms are used for both schools. Whether it is Philippe Burty or Ernest Chesneau writing on the art of Japan or whether it is Charles Baudelaire or Théophile Gautier writing on French prints the descriptive terms and phrases used for the woodcuts of Japan and the etchings of France are the following: "spontaneous," "direct," "personal," "ephemeral," "expressive," "everyday-life," "genre," "observer of life."

Thus it may be stated that the "discovery" of Japanese prints by French artists in mid-century was no accident, but rather occurred primarily because the young artists were readily receptive to the Japanese aesthetics and that this receptivity coincided with the revival of artistic printmaking in France, specifically in the medium of etching.

This mid-century renewal of printmaking and the Japanese influence upon it is not, however, the theme of my discussion today. I have mentioned it briefly only to indicate the initial precedent for the much broader revival of printmaking in France at the end of the century. It is within this later revival that one finds not only the culmination of Japanese influences but at the same time the most profound assimilation of Japanese aesthetics in French art.

The revival of French printmaking beginning at the end of the 1880s and continuing throughout the decade of the nineties is characterized by the general renewal of artistic printmaking, this time in various media; lithography, woodcut and etching, in black and white as well as in color. By the early 1890s color

printmaking and color postermaking, became for the first time in France, the dominant aesthetic concern of many artists with lithography as the preferred vehicle of expression. Throughout this approximately twelve-year period of intense activity in French printmaking the Japanese print was an essential stimulus to the stylistic and thematic direction of French art in general—an art which consequently paved the way for the explosion of color and the concern for abstraction which epitomizes much of early twentieth-century Western art. The French print and poster, however, probably more so than painting, most clearly reveal the great debt to Japanese art in the evolution of Western aesthetics at the end of the century.

As I have suggested elsewhere,[2] the revival of printmaking in the 1880s and, in particular, the birth of a color printmaking movement are due to various factors: First, the organization of print societies; second, the involvement of artists in newly developed photo-mechanical commercial printing processes; third, the proliferation of postermaking, the recognition of the color lithographic poster as an art form and the development of print and poster dealers, publishers and printers. In the development of color printmaking none of these factors is more important than the influence of the Japanese print. In fact, it was the

Fig. 1. Auguste-Louis Lepère, *La Convalescente: Mme Lepère,*
1889–92. Color woodcut. Boston Public Library.

Japanese print which at this time gave credibility in France to the concept of the "original color print" where previously color had been reserved almost exclusively for reproductive and commercial printing, i.e. non-artistic purposes. As commercial color printing in the 1880s became more abundant, more popular but also more artful, the impetus for artists to create original color prints became stronger. And as the French had already recognized the aesthetic value of Japanese color prints, they could more easily rationalize creating their own in a Japanese style.

In 1889 Auguste Lepère and Henri Rivière produced the first of their numerous multi-color woodcuts. Lepère's *La Convalescente* and Rivière's *Work Yard of the Eiffel Tower* reveal in style and content a debt to Japanese artists such as Hokusai, Chōki and Hiroshige. This is evident by comparing Lepère's *La Convalescente* (Fig. 1) to Chōki's *Sunrise on New Year's Day* (Fig. 2) where similar compositional devices are used such as a foreground figure against a high horizon, and by comparing Rivière's *Work Yard* to a similar theme by Hokusai from the *Thirty-six Views of Mt. Fuji*. Also significant is the fact that Rivière and Lepère's prints were produced by the Japanese system of carving with a pen knife across the grain of the plank side of soft pear tree wood and then printing from various of

Fig. 2. Eishōsai Chōki, *Sunrise on New Year's Day*, Color woodcut. Mr. and Mrs. Edwin Grabhorn, San Francisco.

these blocks with a water base pigment onto rice paper. However, unlike the Japanese, who divided the labors of the print among the designer, the cutter, and the printer, Lepère and Rivière designed, cut and printed their woodcuts themselves. Of the two artists Rivière certainly was the more prolific color print-maker and the one more decidedly under the spell of Japanese aesthetics. He produced two series of woodcuts using up to twenty-five blocks for each print. *La Mer: Etudes des Vagues*, a series of forty images completed in 1892 and *Paysages Bretons*, a series of forty images completed in 1894, parallel closely the depictions of waves and coastal views by nineteenth-century Japanese woodcut artists specifically in the stylization of the wave motif, in the bold foreshortening and silhouetting of trees, sails and figures, in the use of a high horizon, in the inter-locking pattern of land and sea, in the richness of color, and even in the cartouched monogramme. Rivière, indeed, has orientalized the coast of Brittany, France.

Undoubtedly, Rivière's greatest tribute to the Japanese in his album of thirty-six lithographs entitled *Trente-six Vues de la Tour Eiffel*. The series depicts the various stages of construction and completion of the Eiffel Tower, erected in 1889 as the symbol of modern technology for the Paris Universal Exposition. As Rivière watched the tower gradually rise above the Paris horizon, it became for him comparable in grandeur to Hokusai's Mount Fuji. In typical Japanese manner the tower is viewed from various vantage points, during various times of the day, and under all kinds of weather. The tower is also viewed as an incidental speck in the distant Parisian landscape, as is Mt. Fuji by Hokusai, or as a monu-mental iron grid through which one views the city itself. In fact, the title, the theme and much of the style and format were inspired by Hokusai's *Thirty-six Views of Mount Fuji*. However, Hiroshige's systems for depicting landscapes also influenced Rivière and it is the style of Hiroshige, not Hokusai, which inspired in *Trente-six Vues de la Tour Eiffel* such bold compositions as *Dans la tour* (Figs. 3, 4). In this important French album the Eiffel Tower and Japanese style of depiction serve as dual symbols of European Modernity. Japanese prints were, in fact, synonomous with what was modern in art or the "art nouveau." Deco-rative patterns, curvilinear elements, calligraphy, brilliant primary colors, or even subtle flat tertiary colors as well as embossed and metallic textures are typical Japanese characteristics taken on by the French avant-garde in the 1890s. These elements emphasize the two-dimensional picture plane and negate the traditional European system of producing illusionistic space. It is precisely this planar interest which leads into twentieth-century aesthetics. On the other hand, Hiroshige and Hokusai also revealed to the less radical artists that flat design elements were not necessarily incompatible with the depiction of three-dimensional space. This is especially apparent in the prints of Rivière. For instance, both Hokusai and Rivière often retain the illusion of realistic space within the overall framework of an abstract geometrical interlocking composition. In the 1893 lithograph of *The Wave* for *L'Estampe Originale* Rivière allows a Japanese-like pattern of ocean spray to be frozen against the picture plane acting as a flat screen to an otherwise realistic depiction.

In 1889, Mary Cassatt, the American expatriate and close associate of Degas, had been impressed by the exhibition of Japanese prints at the Ecole Nationale.

Fig. 3. Henri Rivère, *Dans la tour* from the series *Trente-six Vues de la Tour Eiffel*, 1888–1902. Color lithograph. Rutgers University Fine Arts Collection.

Fig. 4. Andō Hiroshige, *Moon Pine at Ueno* from *One Hundred Views of Famous Places in Edo*, 1858. Color woodcut. The Newark Museum.

She visited the show many times and purchased some of the color prints to hang in her home. This contact had an immediate effect on the composition of several of the later works in her 1889–91 series of twelve drypoint prints. These reveal a more intimate involvement with Japanese themes and spatial devices and an overall emphasis on two-dimensional design. As in the work of Rivière, Cassatt combined oriental and Western elements. In the 1891 etching of a *Mother Nursing Her Child*, Cassatt reverted to a reverse perspective system for the table which flattens pictorial space while she maintained a traditional Western system of modeling the figures with shadow and light.

It is Cassatt's color prints that represent the supreme achievement deriving from her contact with Japanese prints. In 1891 she blatantly attempted to imitate the Japanese method of printing in her series of ten color etchings. Using as many as three copper plates and coloring each plate by hand she was able to approximate in texture and in simplicity Japanese color woodcuts. Her composition, color schemes, and juxtaposition of varied color patterns, as well as her themes—of mother and child and of the toilette—reflect especially the influence of the eighteenth-century Japanese masters Harunobu and Utamaro. It is Lepère, Rivière, and Cassatt who substantially instilled the spirit of the Japanese color prints within the general revival of French printmaking at the end of the century. However, it is primarily Vallotton, Toulouse-Lautrec, Bonnard and Vuillard who assimilated and carried the lessons of Japan to extremes, creating the framework from which concepts of twentieth-century abstraction would emerge.

Fig. 5. Félix Vallotton, *La Manifestation*, Woodcut. The Baltimore Museum of Art, Blanche Adler Collection.

Félix Vallotton looked to the Japanese print not for a lesson in color printing but, rather, to understand the relationship of negative and positive spaces within a simple black and white composition. His formal concerns were merged with Japanese themes as early as 1892 in his series of six mountain landscapes. *Glacier du Rhone* with its strong contrasts of black and white and its rhythmic parallel curvilinear cuts, has a Japanese counterpart in Hokusai's woodcut sketch of rock formations found in the second album of Hokusai's *Manga*. Although he often would work in the medium of lithography Vallotton's boldest designs were produced by woodcut. The Japanese motif of figures scurrying across and out of the picture may be found in his *L'Averse*, a zincograph of 1894, and in his woodcut by the same title of the previous year. By the nature of the medium, however, the woodcut print is far more abstract, simplified and daring a composition. *La Manifestation* (Fig. 5), another woodcut, powerfully suggests the turmoil of a rushing mass of people by raising the horizon line, tilting up the perspective and compressing the black shapes of figures into the upper portion of the composition. The relationship between the large area of white paper at the lower half and the dense area of black creates a startling intensity of movement without resorting to detailed realism; yet like the most simplified Japanese compositions, the subject is identifiable. In Vallotton's woodcut print *L'Argent*, of 1898, three quarters of the image is pure black; the figures within a cramped space emerge from this blackness as simplified curved shapes against a more delineated background suggesting strong psychological drama. The dramatic relationship of figure to empty space is an exaggerated application of compositional principles found in pillar prints and actor prints of Japan.

Generally in the 1890s the white of the paper became a positive compositional element in French prints. This was an important step for the French because as the paper itself became an active compositional element the physical reality of the frontal plane became more obvious, and the emphasis of design became more two-dimensional. We saw this in Cassatt's etchings and Vallotton's woodcuts; it is a characteristic which also dominates the graphic work of Bonnard, Toulouse-Lautrec, and Vuillard. In so doing the paper acts as if it were a printed color giving life and substance to a scene by interacting with often calligraphic depictions of figures, animals or landscapes.

The *Mangas* of Hokusai served as strong and often direct examples for the French. Bonnard's figures on horseback typify the series of simple black and white lithographs from his 1898 album, *Small Familiar Scenes*. Bonnard allowed the paper to set off the smooth, rhythmic arrangement of the various stances of horse and rider very much in the manner of Hokusai's woodcut sketch. This active intrusion of the paper into the composition of many of Bonnard's prints emphasizes the frontal plane while his spirited, almost caricature renditions of people and animals create the kind of warmth and liveliness inherent in Japanese prints. Toulouse-Lautrec looked especially to the Japanese as a source for calligraphic simplification of compositions. In his depiction of Jane Avril from the 1893 *Café-Concert* lithographic series, Lautrec uses the white of the paper not only to accent the composition but also to define specific pictorial details such as the bulbs of light, the face and hair of Avril and the underside of her gown.

The white accents in combination with the up-tilted perspective lines of the floor and with the bold black calligraphic contours suggest the grace and movement of the dancer in strongly abstract terms. Lautrec's lithographic illustration of a horse for Jules Renard's *Histoires naturelles* show an even greater abstraction and debt to the Japanese and the *Manga* specifically.

In a poster such as the *Divan Japonais* of 1892 by Toulouse-Lautrec the effect of Japan upon French culture is quite obvious. Not only does the name of the night club imply a Japanese association, but the style of depiction is Japanese inspired. It suggests the subtle yellows and olive greens and the elegant females of Kiyonaga and Utamaro. It is also an extremely two-dimensional composition based upon flat interlocking areas of color. Borrowing from Japanese examples such as work by Kiyomasu, Lautrec avoids illusionistic space by his lack of modeling and by the use of elements going across and off rather than back and into the composition. Less obvious but more significant for Western art, however, is Lautrec's first poster, *La Moulin Rouge* of 1891; Lautrec revolutionized the art of postermaking by borrowing compositional systems from the Japanese woodcut to negate illusionistic space and to unite the pattern of pictorial elements with that of the lettering; the globes of light, "la Goulue," and the audience in top hats are forced onto the frontal plane by the uptilted perspective lines and by the use of pure, flat areas of color outlined in black in a manner similar to that used in the lettering. The calligraphic depiction of the dancer, Valentin, is comparable in form and content to portraits by Sharaku. The Japanese woodcut portraits of Kabuki actors are often boldly silhouetted in profile against a neutral or patterned background; in the eighteenth century, with the work of Sharaku and in the nineteenth century with Kunichika these portraits also emphasized the individual personality of the actor. Lautrec based his 1893 poster of *Bruant* on this very straight forward and elegant format of the Japanese.

So too, it is from the Japanese that the French learned to flatten their compositions by crowding figures onto the frontal plane and by raising the horizon line. We saw this in Lepère's *La Convalescente* of 1889; during the 1890s Pierre Bonnard and Maurice Denis often used this system of depiction as seen in the *Family Scene* by Bonnard from *L'Estampe Originale* and in work from Denis' 1899 Series *Amour*. It was commonly used by numerous artists throughout the last decade of the century. In 1894, one finds this kind of bold composition in the *Mother and Child* (Pl. 9) by Alexandre Charpentier. In addition, however, Charpentier embossed the background in a manner similar to prints by Harunobu.

Giving an actual three-dimensional quality to prints was another major step for French artists. The embossed prints of Charpentier, Pierre Roche and Maurice Dumont helped prepare the way for the concept of "collage" at the turn of the century.

Two other fundamental Japanese systems of depiction adapted by the French were the diagonal orientation of compositions and the birds-eye perspective system. Each, and in combination, greatly negated traditional European methods of producing illusionistic space such as the one-point perspective system, and thus were basic to the development toward greater abstraction. These systems of

depiction are present in the work of each of the artists already discussed. In fact, during the 1890s there were few young French artists whose work does not use these compositional devices. The work of Bonnard and Vuillard indicates well the Western adaption of these Japanese spatial systems. Each of these two artists published in 1899 a series of prints similar in concept to Japanese serial albums. Bonnard's *Quelques Aspects de la Vie de Paris* reflects Hiroshige's *One Hundred Famous Places in Edo* in that they both deal with everyday life in a metropolitan center while Vuillard's *Paysages et Intérieurs* suggests Harunobu's *Eight Views of Indoor Life*. In the works from Bonnard's album the birds-eye view distorts perspective and concentrates figures, ground and architecture towards the frontal plane as does work, for instance, by Kuniyoshi. One also may find a Hiroshige parallel in Bonnard's *Maison dans la cour* (Fig. 6). Bonnard borrows from the Japanese artist the motif of a boldly foreshortened window frame. Ironically, Hiroshige often uses a Western perspective system for exterior views (Fig. 7) while Bonnard flattens the space of his exterior view in a more typical oriental manner with emphasis on pattern. Vuillard's interiors, on the other hand, reflect the awkward birds-eye perspective system and diagonal arrangement of Harunobu.

Fig. 6. Pierre Bonnard, *Maison dans la cour* from *Quelques Aspects de la Vie de Paris*, 1895. Color lithograph. Philadelphia Museum of Art, McIIhenny Fund.

Fig. 7. Andō Hiroshige, *Asakusa Kinryūzan* from *One Hundred Views of Famous Places in Edo*, 1856. Color woodcut. Philadelphia Museum of Art, Gift of Mr. and Mrs. Lessing J. Rosenwald.

In conclusion, it is evident to me that the intense revival of French print-making in the 1890s with the variety of explorations in new areas of aesthetics and techniques was of major consequence to twentieth-century Western art in general. The influence on the part of Japanese prints within this revival was some-times quite obvious and superficial as is apparent in work by Henri Rachou. But most often, as I have endeavored to reveal, and as may be seen in this com-parison of Lautrec's subtle handcolored lithograph of the Dancer Loie Fuller (Fig. 8) with the elegant *Dancer* by Kiyonobu I (Fig. 9), Japanese prints strongly bolstered the embryonic concerns of French artists for abstraction. Each of these two prints, in its own way, tends toward extreme abstraction; remove the heads, for instance, of each dancer and one finds no identifiable human figure but rather flat patterns and shapes. It is this concern for two-dimensional abstrac-tion demonstrated by French artists and inspired in part by the art of Japan which paved the way for a sustained aesthetic change in Western art.

Fig. 8. Henri de Toulouse-Lautrec, *Miss Loie Fuller*, 1894. Handcolored lithograph.

Fig. 9. Torii Kiyonobu I, Theater Poster, 1704, Handcolored print woodcut. The Riet-berg Museum, Willy Boller Collection.

NOTES

1. It is, indeed, a great honor for me to be in Japan, both as a representative of Rutgers University and as a representative of my family. Beginning in 1866, Rutgers had two of the three earliest Japanese exchange students in the United States including Kusa Kabe Taro, who in 1870 was the first Japanese to become a Phi Beta Kappa. And from 1866–1895 out of the total of 500 Japanese students studying in the United States 200 were located at Rutgers.

 As for my family, in 1902, my father was born in Tokyo of missionary parents. Due to the generosity of the Committee for the Year 2001 he has accompanied me on t·· trip which marks his first visit in fifty years.

2. Cate, P ⁙s and Hitchings Sinclair, *The Color Revolution: Color Lithography in Fran* /Exhibition Catalogue published by Rutgers University Art Gallery, Nev. wick, New Jersey, Fall, 1978.

JAPANESE INFLUENCES ON THE GLASGOW BOYS AND CHARLES RENNIE MACKINTOSH

William Buchanan

The great Japanese printmaker Hokusai, one Friday evening, announced his intention of getting married. The great Dutch painter Rembrandt painted a picture to record the occasion showing him seated next to his future wife, Whistler's Butterfly. Part of the reason for this crazy piece of art history is due to the influence of Japanese prints in Scotland.

Hokusai, Rembrandt and many other great masters all appeared on November 28, 1889, at a Grand Fancy Dress Ball run by the Glasgow Art Club. It was the artist E. A. Walton who had taken so much care to go with fan and false forehead to the Ball as Hokusai, for Hokusai was one of the heroes of the group of artists called the Glasgow Boys. Walton's future wife had pinned butterflies to the bodice of her dress as a compliment to another of their heroes, James McNeill Whistler, himself so very interested in Japanese art.

The city of Glasgow where all this took place lies in the industrial center of Scotland, up in the cool, damp, left-hand corner of Europe. On Japanese maps it lies at the very edge of the world. At the turn of the last century, Glasgow was at the height of its prosperity, a prosperity earned by making ships and locomotives, and supplying them and often the men to run them, as well, to customers all over the world. Knowledge of Japanese art came to Glasgow from impeccable sources: from Dresser; Whistler; Bing; and via the art dealer Reid, from Vincent van Gogh.

As a result of Dresser's visit to Japan, the Glasgow Art Gallery received from the Japanese government in 1878 a gift of ceramics, textiles and paper. These items, still safely in the collection, include a porcelain bowl with a thick blue glaze from Aichi prefecture, a stoneware pitcher from Fukuoka prefecture, and a porcelain bowl and cover with a design of *moji* letters by Eiraku Zengorō. Subsequently, an exhibition of Persian and Japanese Decorative Arts was held. Dresser was invited to Glasgow (where he had been born) to give a lecture which he illustrated by using examples from the exhibition. This occurred in 1882, the year that he published his book *Japan, its Architecture, Art and Art Manufactures*.

Soon Glasgow had at least one importer of Oriental art. One of its advertisements appeared with suitable decorations of crane and water lily, boasting a wealth of quasi-oriental type-faces, of a "rare assortment of Imari, Kaga,

Satsuma, Cloisonné and Kioto wares" and of a "fine selection of Japanese screens in gold and silk needlework." These items turned up by the thousand when the households of the generation who purchased them were being sold off. Sale catalogues contain huge lists of Japanese items, some much the worse for the wear and many of doubtful attribution. A brief sample from a sale in 1912 lists: 2 old Japanese brass temple lamps; 2 Satsuma vases (both faulty); petite Japanese inlaid wood cabinet with sliding panels and drawers; Kaga coffee set comprising 12 cups and 12 saucers in lacquered case; Japanese bronze elephant. Not all these items were produced in Japan, however. One Glasgow firm, the Arthurlie Fine Art Coy Ltd, was busily turning out its own cloisonné ware.

One reminiscence of the time[1] states, "Japanese art, too, was the hobby of those years in Glasgow among artists as well as the dilettanti who could not afford to buy Whistlers. If we could not pay for Whistlers, we could at least collect for very little money the Japanese prints of Hokusai, Utamaro, Shigemasa, Hiroshige, *et hoc genus omne* who had so much influenced 'the Butterfly' himself. Local artists, far from wealthy, bought prints, embroideries, bronzes, ivories, vases of China and Japan much oftener than they sold their own paintings; a few years ago it took about a fortnight to disperse by auction the Oriental collection of Mr. R. G. Crawford, an old Glasgow portrait painter."[1]

John Lavery (who went as Rembrandt to the Art Club Ball) states that Whistler's "Ten O'Clock Lecture" was the Boys' gospel. Reading his "Gentle Art of Making Enemies," the Boys would learn that their master found the highest ideals of beauty "hewn in the marbles of the Parthenon and 'broidered with birds upon the fan of Hokusai—at the foot of Fusi-yama [sic.]." The Boys' admiration for Whistler and his ideals went further than respect and occasional imitation, for they persuaded the city in 1891 to purchase his portrait of Carlyle. This was the first official recognition given to that then highly controversial artist. Looking at the Carlyle they could see the profound effect which Japanese art had wrought on Whistler since his first interest in the subject in 1864 with *Purple and Rose: the Lange Lijzen of the Six Marks* (Philadelphia Museum of Art). The *Lange Lijzen* is *Japonaiserie*, the painting of Japanese objects in Western style. The *Carlyle* is an example of *Japonisme*, when the ethos of Japanese art has been understood and used creatively. In the *Carlyle* Whistler's circular butterfly signature, like a heraldic Japanese *mon*, could be admired, as could its placing as an integral part of the composition. Remove it and Carlyle falls over backwards.

A supply of Japanese prints must have come from Paris with Alex Reid who had been sent there to learn the trade of picture-dealing. He worked with Theo van Gogh and met, perhaps even shared rooms with, Vincent. Vincent was painting a series of self-portraits at this time, but he also painted two portraits of his Scottish friend. Reid's gingery beard helped the confusion that his portrait (now in Glasgow Art Gallery) was really one of Vincent's self-portraits. This year, 1887, Vincent became interested in Japanese prints and he organized with Theo an exhibition of prints at the Café du Tambourin, selecting exhibits from the stock held in Siegfried Bing's shop.

Therefore it is not surprising to find, back in Glasgow, Reid in his newly opened

Fig. 1. E. A. Walton. Photograph by Annan.

gallery showing prints "by the most celebrated Japanese artists including numerous examples of Hokusai and his pupils." Some of Reid's own prints, now a little faded, have been traced to a private collection. They include a print from the series *Hinagata no Hatsu-Moyō* (New Patterns for Young Leaves) by Koryūsai; two portraits of courtesans by Eishō; and a print showing the poet Abe no Nakamaro in exile in China gazing at the moon, by Zen-Hokusai I-Itsu (Hokusai).

Walton also had a collection. The photographer Annan used one, a theatrical print by Ichiyūsai Kuniyoshi, as an important element in a carefully contrived composition to photograph Walton in a casual attitude (Fig. 1). Walton had other prints pinned up on the wall of his country studio near Stirling, where the Boys would come to stay and to work. Some of his prints are now in the possession of his grandchildren. There is a print by Utagawa Kunisada of the actor Nakamura Matsue, and an Eisen showing the beautiful fashions of the Capital.

In 1893 there was an exhibition of prints held in a gallery dealing with Japanese curios. The following year the gallery owners presented the Glasgow Art Club

with twelve prints which hang on the staircase of that Club to this day. Among that group are a print by Kikukawa Eizan from the series *Fūryū Ikebana Zukushi* (A Collection of Modern Flower Arrangements) and a portrait of the actor Segawa Rokō (Segawa Kikunojō) by Utagawa Kuniyasu. Another exhibition of Japanese prints in 1894 drew the following response in a newspaper, "The Japanese prints include charming examples of gentlemen whose names are not yet household words—Rukusentia [sic?], Utamaro, Masanobu and Shunkio. Despite their appellations they can—or could, for perhaps they are dead— draw to some effect. Our most pronounced Glasgow School men could get a few wrinkles from them" (i.e. learn from them).

The Glasgow Boys did learn from Japanese printmakers. When Joseph Crawhall saw his first print it is reported that he remained silently staring at it for half an hour, then bought it. Crawhall's *A Trout Rising* (Glasgow University) has cousins among the prints of Andō Hiroshige's *The Large Fishes*.

When the first issue of Bing's magazine *Artistic Japan* reached Glasgow, the local magazine *The Scottish Art Review* praised it and added its own contribution to the subject by publishing articles on sword guards and *kakemono*. It noted the visit of Mortimer Menpes to Japan. By the time that the first issues of the magazine *The Studio* had appeared, with its many articles on Japan, two of the Glasgow Boys had already left for Japan to see it for themselves, namely George Henry (1858–1943) and his close friend E. A. Hornel (1864–1933). Alex Reid put up the money for their trip.

Henry and Hornel were such close friends that they had worked together on *The Druids* (Glasgow Art Gallery), in 1890. It is a rich, gilded, decorative picture, and although on a Celtic theme, to many it may have had a touch of the Orient about it. Each artist had, individually, established his own reputation.

Henry's *Head of the Holy Loch* (Glasgow Art Gallery) is typical of the open-air landscape painting as practiced by the group in the early 1880s. But in 1889 Henry produced *A Galloway Landscape* (Glasgow Art Gallery) showing a very different approach. In it there is no faithful, tonal recording of the scene, but a shimmering evocation of an autumnal mood, with a little stream that looks as if it might have wandered, in its decorative way, into the picture from a Japanese print.

Hornel also concerned himself with the seasons of the year. His painting *Summer* (Walker Art Gallery) has been described as "a studied symbolism, eloquent of summer."[2] Surely this is a familiar motif in Japanese art. The picture shows a girl who has fallen and is crying because she realizes that the prize will not be hers. The other girl hurries after that prize which is, rather disappointingly, a common white cabbage butterfly. What is of great interest is the blouse which this girl wears with red circular patterns on it. It could be a real piece of Japanese clothing.

A Belgian critic singled out Hornel's use of color "in broad and decorative areas in a way which has a relation to Japanese art and is strongly akin to Gauguin."[3] Another critic[4] noted "Mr. Hornel does not servilely imitate Japanese art. It seems rather to have awakened sympathies latent in his aesthetic sense." This is a perceptive thought which might well be extended to the state-

ment that Japanese art awakened sympathies latent in the aesthetic sense of Western artists.

Hornel wrote[5] about the visit to Japan and how he and Henry went to see "a reed shaken by the wind." He continued, "Japanese art rivaling in splendor the greatest art in Europe . . . engenders in the artist the desire to become personally in touch with the people, to live their life and discover the source of their inspiration." It is plain from these words that the two Glasgow artists were setting out on a pilgrimage.[6]

They left Glasgow in February 1893 and arrived, after a stop in Cairo, in Nagasaki in April. Almost exactly forty years had elapsed since the watching *samurai* had growled in rage as the first foreign foot in over two hundred years had touched the sacred soil of Japan.[7]

Henry and Hornel must have expected signs of Westernization. They knew from Reid's print about *shamisen* and the languid lines of a trailing kimono but were they totally prepared for sewing machines producing dresses with bustles, and the playing of Western music—and the harsh, garish prints using aniline dyes which recorded these new facts? No mention of any Westernization occurs in their work whatsoever.

To their credit they did try to live a Japanese life, but it was a very difficult thing to do, for foreigners had to live within the bounds of the Concessions. By bribery they settled in a Japanese house and enjoyed living a Japanese life immensely, until the newspapers discovered them and conducted a fierce campaign for their removal. The question of "Mixed Residences," as this issue was called, was a politically active one, so they were forced to move back into the Concession much to their disappointment.

They sought out Japanese artists, but were not impressed with the work they saw, especially the work by those "foolishly adopting the tricks of Paris and Munich." Hornel summed up the situation by saying that while artists in Europe and America were turning to Japan for inspiration in an effort to free themselves from academic art, Japanese artists were turning to the academies of art in the West. A group of Japanese artists following Western methods were at that very moment protesting about their work being excluded from the Japanese section of the World's Columbian Exposition in Chicago.

It was a difficult time, too, for the artists working in a traditional manner. Hornel quoted Mr. Hyaku-nen (Mr. One Hundred Years) of Kyoto, who thought that young artists were trying to seek the facility with the brush of the old masters, but losing sight of the spirit of these works.

Henry, for his part, produced a series of watercolors recording life around him, although it should be said that his pictures, and those of Hornel's too, suggest that the population of Japan consisted entirely of *geishas*, some *jinrikisha*-runners, a child or two—and not much else. Henry's watercolor *The Koto-player* (Glasgow Art Gallery) was at first exhibited as a *shamisen*-player. He did produce one or two works which go beyond skillful recording. One such is *The Goldfish Bowl* (Gracefield Arts Centre, Dumfries), a genuine artistic expression in its modest way, with the influence of Japanese art in it. He signed the picture vertically.

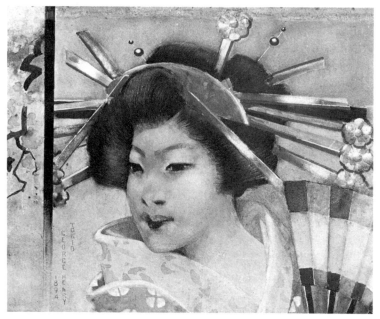

Fig. 2. George Henry, *O-Murasaki san of Shinjuku*, 1894. Watercolor on paperPrivate Collection.

In another of Henry's watercolors he comes to the reworking of one of the finest expressions of the printmakers, the portraits of courtesans. Even the title given to his picture *O-Murasaki san of Shinjuku* (Private Collection) (Fig. 2) echoes Japanese titles, for example, Eishō's *The Courtesan Misayama of Chōji-ya*. Henry records the unchanged hair-style, hair pins and dress, introduces a branch of blossom in the background and signs his name vertically, again.

In *The Geisha Girl, Tokyo* (Kyle and Carrick District Council) he paints in the tonal manner which the Boys took from Bastien-Lepage. Then, on form, he painted with a fine Glasgow flourish *Japanese Lady with a Fan* (Glasgow Art Gallery) with its tight drawing of the turned cheek.

Henry and Hornel had once worked together. Now their styles veered sharply in different directions. Hornel did not like Japanese music, yet he produced *Music in Japan* (Fine Art Society Ltd.) (Fig. 3) and *The Music Party* (Aberdeen Art Gallery). The latter has a hint of Japanese influence in that it is more upright in shape than most Western artists prefer. There is an Utamaro print *Girl Tuning her Shamisen* of exactly the same subject as *Music in Japan*. Side by side these two works demonstrate clearly the different approaches by the Western painter and the Japanese printmaker. Hornel models hands and face. His paint is thick, even blurring the form which it describes. Utamaro says all he has to say in spare, elegant, sinuous line.

If Hornel did not like Japanese music, he did like Japanese dancing, and adored Japanese dancers. Imagine him in his white linen suit mooning, "the giddy thing will dance but a short measure and you sigh as she goes. It is unquestionably costly and you swear you will never do it again, but alas, the bewitching enchantress has more of your hard earned dollars ere the week closes."

Hornel remembered the Japanese "as a large and happy family clattering by in the sunshine with smiling faces and no thought for the 'morrow, to spend the day 'mid plum and cherry blossom." These sentimental words sum up his pictures of Japan. *A Japanese Garden* (Mrs. Ian MacNicol) shows two girls playing shuttlecock. *Kite-flying* (National Gallery of Scotland) and *The Fish Pool* (Glasgow Art Gallery) are Western pictures. If there is any influence of Japanese art on Hornel then it must come, not from the prints, but from the vivid color of cloisonné or the richly patterned cloth. We know that he especially loved the streets where the silk merchants displayed their kimonos and brocades.

Henry and Hornel left Japan in May 1894 to arrive home in mid-July. They had been away 19 months. Henry had been penniless before the trip, and he was penniless again for no one would buy any of his pictures until an exhibition of the work from Japan. This never did materialize. He left Scotland and settled in London to become a successful society portrait-painter.

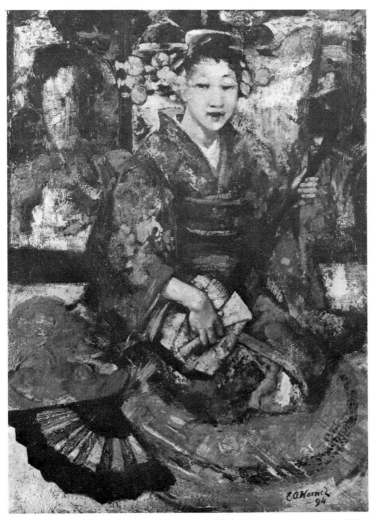

Fig. 3. E. A. Hornel, *Music in Japan*, 1894. Oil on canvas. The Fine Art Society Limited, London.

Hornel had an immensely successful exhibition in Reid's gallery in April 1895. Most of the works were sold. The local newspapers wrote rave reviews. Even *The Studio* was enthusiastic, describing his pictures as of "beautiful and sumptuous color, full in tone, quaint in design," the product of "a romantic mind revelling in the charm of color for color's sake alone."

To advertise the exhibition Henry drew a portrait of his friend. He signed it vertically, of course, and made a little *inkan*, signature seal, out of the initials EH. He drew two large characters to the left of the head, but as these characters are somewhat distorted it now seems impossible to decipher Henry's hidden message if he intended to hide one.[8] Hornel was to grow rich from his paintings. He acquired a fine mansion in his native town of Kirkcudbright. This house is now open to the public. Inspired by his visit to Japan (he made other visits to the East later) Hornel set out part of the lovely garden of the house in the Japanese manner. Although over the years the original design may have faded, this part of the garden is one tangible souvenir of Hornel's interest in Japan. The garden has the inevitable crane standing on a rock in the pool. Hornel, like Monet, was to be inspired by waterlilies and was to use them and the pool as the subject for later paintings.

While the Glasgow Boys were active the young Glasgow architect Charles Rennie Mackintosh (1868–1928) was at his studies. In his room, he, like so many others, pinned up Japanese prints. We cannot identify these prints, but we can read exactly what he read about Japanese art in *The Studio* magazine. He must have read about Holland Park, a house in the Anglo-Japanese style with its billiard room lined with Japanese paintings on silk and with its ceiling panels in red lacquer. The Scottish architect William Leiper had designed a huge house, Colearn Castle, in 1869 with outstanding interiors in this style.

We know that other pages from *The Studio* influenced him: reproductions of *The Three Brides* by the Dutchman Toorop and of the work of Beardsley who had already absorbed qualities from the Japanese print. All these, the Arts and Crafts Movement, The Celtic Revival, simmered together in Mackintosh's fertile, creative, mind to produce architecture, interiors, furnishings which are uniquely his own. A subtle Japanese flavor is one of several flavors which occasionally permeate his work.

If High Victorian interior design is stifling to our eyes, then Mackintosh is one of the people responsible for making it appear so. In doing so he was following a Japanese example. It seems that he had Morse's book *Japanese Homes*[9] where the contrast is well made between the sparse Japanese interior and those in the West, "a labyrinth of varnished furniture . . . with dusty carpets and suffocating wall-papers hot with some frantic designs." Yet the first Japonophile's rooms in Europe were equally crowded with screens and parasols, dotted with bamboo furniture and peppered with potted palms. Groups of fans festooned walls topped with friezes of *Nō* masks. Every single one of these items might have come from Japan, but the total effect was far from Japanese. In Mackintosh's own flat (Fig. 4) every single item was designed by himself, but the spaciousness, the lightness and the calmness which he created comes nearer to a Japanese interior.

Fig. 4. The Mackintosh Flat, 120 Mains Street, Glasgow. Photograph by Annan.

Throughout their flat, Mackintosh and his wife, who was also an artist, paid great attention to flower arrangements. They probably read with great interest the article on Japanese flower arrangements in *The Studio* in 1897, although their own arrangements do not follow Japanese canons. On the mantlepiece was a tight peony or carnation in what looks like a milk bottle contrasted with a sweep of what might be jasmine, the lines of which are so like the lines in Mackintosh's own drawings. In contrast to their white sitting-room, their dining-room was dark and sombre. The flower arrangement reflects that mood in a single bowl of slender dried winter stalks. In his unrealized designs for an Art Lover's House of 1901, Mackintosh created some highly stylized flower arrangements including one in a specially designed vase to stand on the floor.

Mackintosh's masterpiece is the Glasgow School of Art, designed in 1896 with revisions in 1906–07. The School is, with occasional touches of fantasy, a strong, straight, modern building, one of the first of its kind in Europe. Here and there is a hint of a Scottish Castle. Here and there is a Japanese touch in, for example, the decorative motifs reminiscent of *mon* in the circular panels which decorate the railings in the front of the building. They are cut from metal plates like stencils. Perhaps Mackintosh read the article in *The Studio* on Japanese stencils. Perhaps he also knew in the library[10] of the School of Art, where he studied, *The Book of Delightful and Strange Designs, being one hundred Facsimile Illustrations of the Japanese Stencil Cutter.''* This book had a real Japanese stencil plate for a frontispiece.

Mackintosh designed a stenciled banner, on the spot, in Turin in 1902 when he saw that the exhibition of his and his group's work needed visual punctuation marks. The banner is, as it happens, of the same proportions as a *hashira-e* or pillar picture. The girl in Mackintosh's banner is far more stylized than the girl who walks against the wind in Kiyonaga's masterly pillar print. Mackintosh was to carry the stylization of the figure to the borders of abstraction when designing two matching figures on a silver ground for the inside of two doors of a cabinet. He goes much further than Eishi's *Courtesan Itsutome* of 1794 who is certainly elongated and is also shown on a silvery ground (of powdered mica).

Stencils were also used by Mackintosh to decorate the fabric for the seat at the summer end of the drawing-room at Hillhouse in Helensburgh. The proportion of the windows and the subdivision of the panes suggest the *shōji* or sliding screens of a Japanese house. At the winter end of the same room Mackintosh designed a great kite-like fitting to light the area round the fireplace. A number of his designs for lamps do have a Japanese flavor, and they probably would have appealed to the courtesan shown trimming the wick of her lamp in Utagawa Kunisada's delightful print of 1850. She would not have needed to trim their wicks for they were lit by gas or electricity. She would not have found them too unfamiliar until about 1909 when Mackintosh took a leap into the future when he designed some lamps for the center of the Glasgow School of Art Library. He created a group of tiny, glowing, skyscrapers suspended in a galaxy. It is said that while Mackintosh was designing the Library he saw a photograph of a Shintō shrine in an album of photographs of Japanese architecture which was being passed round architects in Glasgow.

Its is strange to think that the travellers shown in Hiroshige's print setting off down the Tōkaidō might have shared an experience with the congregation singing praises on a Sunday morning in a church at Queen's Cross in Glasgow. What both parties might have seen is the construction of the balcony of the old Inn at Mishima, which Mackintosh took from the illustration in Morse's book to use in the construction of the balcony of that Church.

Sadly, Mackintosh was to give up the practice of architecture in later life. He designed fabrics and painted in watercolor. The fine watercolors which he produced after 1900 bear a remarkable resemblance to the Japanese flower drawings which appeared in *The Studio* in 1894. He includes date, initials and place in these watercolors, in a Japanese inspired cartouche.

The most telling evidence of all is that in the middle of Mackintosh's mantle-shelf over the fireplace, at the very center of his home, he displayed what must have been two of his treasures: *surimono* or greeting cards by Kunisada and Shigenobu,[11] placed there for contemplation and inspiration.

Japanese prints were a great stimulus to the Glasgow Boys, and through them, to Scottish Art in general. Japanese art subtly and profoundly influenced Charles Rennie Mackintosh.

NOTES

1. Neil Munro, *The Brave Days*, Porpoise, 1931.
2. Edward Pinnington, "Mr. E.A. Hornel," *The Scots Pictorial*, June 15, 1900.
3. Quoted from Bruce Laughton, "The British and American Contribution to Les XX," *Apollo*, November, 1967.
4. See note 2.
5. The original notes for his lecture on his visit are in his home, Broughton House, Kirkcudbright.
6. An inventory of Japanese pictures by Henry and by Hornel has been published in the catalogue of the exhibition *Mr. Henry and Mr. Hornel visit Japan*, by William Buchanan for the Scottish Arts Council, 1978.
7. That foot had belonged to a certain Captain Buchanan, who by co-incidence, bears the same name as the writer. For a delightful description of the scene see Pat Barr, *The Coming of the Barbarians*, MacMillan, 1967.
8. The portrait appeared in *The Baillie*, Cartoon Supplement, May 1, 1895. The upper character could be taken as *Kei-sei*, a courtesan. The lower, badly distorted, could be taken as *hana*, a flower. Or is the reference to the homonym of *hana*, a nose bearing in mind that Hornel's passport made reference to his large roman nose?
9. Edward S. Morse, *Japanese Homes and their Surroundings*, Ticknor and Co, 1886. Reprint Dover Publications Inc., 1961.
10. The annual report for 1887 notes the purchase for the libarry of a series of books on Japanese Art and Design.
11. Gototei Kunisada, *Girl acting the arigatō part of Asahina Saburō*, c. 1825 and Yanagawa Shigenobu, *Girl Practicing Her Shamisen*, c. 1825. Mackintosh had another print in the room. It has not yet been identified but may be a working out of one of Utamaro's themes by Eisen or Eizan. Mackintosh's American contemporary, Frank Lloyd Wright, had a collection of Japanese prints.

LE JAPONISME ET L'ART NOUVEAU

Yvonne Brunhammer

En 1869, l'exposition organisée à Paris par l'*Union Centrale des Beaux-Arts appliqués à l'Industrie* comporte, à côté des "Oeuvres et produits modernes," une section orientale : trois salles sont consacrées à l'art Chinois et Japonais, une à l'art Indien, une cinquième à l'art Persan, "de l'Asie Mineure et de l'Archipel grec qui dénotent une influence autre que celle que l'on est convenu d'appeler classique."[1] Lorsque l'on sait les buts que se sont donnés les fondateurs de l'Union Centrale,—"entretenir en France la culture des arts qui poursuivent la réalisation du beau dans l'utile"—, l'on réalise l'importance que revêt à leurs yeux l'apport des arts d'Orient et d'Extrême-Orient dans le renouvellement des arts décoratifs.

L'Exposition Universelle de 1851, à Londres, avait sensibilisé les esprits à la nécessité de repenser en termes neufs l'environnement de l'homme occidental, confronté avec les réalisations provenant du monde entier, à l'exception du Japon. Les arts décoratifs qui se transforment en "arts appliqués à l'industrie" sont au premier plan des préoccupations. Paris, à son tour, organise une exposition universelle, en 1855 : deux bâtiments exemplaires, en fer et en verre, sont construits à cette occasion, la Galerie des Machines, et le Palais de l'Industrie qui abritera de nombreuses manifestations dans les décades suivantes, entre autres celles qui émanent de l'Union Centrale.

Absent des deux premières expositions internationales, le Japon fait son entrée à Londres en 1862, puis à Paris en 1867. En 1867, dans une manifestation où les préoccupations sociales sont au premier plan, où l'on se soucie pour la première fois de fabriquer des habitations et un mobilier "à bon marché," de présenter des "objets spécialement exposés en vue d'améliorer la condition physique et morale des populations,"[2] l'art japonais apporte des références : la qualité des maisons individuelles, le sens de l'objet de la vie quotidienne, le plus humble soit-il. Le nouvel art qui cherche son identité au sein du monde industriel rejette les références classiques héritées de la Renaissance: la soumission à la symétrie, la déformation de la nature à travers les canons gréco-latins, l'élitisme attaché aux arts dits nobles, peinture, sculpture, par opposition aux arts décoratifs dits mineurs. L'art japonais, qui se base sur l'observation de la nature et privilégie l'objet, apporte des réponses, d'autant mieux reçues qu'ells coïncident avec des modes contemporaines: "l'Orientalisme" et le "Gothique."

L'insurrection de la Grèce contre les Turcs en 1821, puis le début de la conquête de l'Algérie en 1830 sont à l'origine de la mode orientale et de l'arrivée en France d'objets d'art islamique. L'influence sur les arts décoratifs est sensible dès les années 1840. Les artistes y trouvent des techniques, des formes et des décors neufs, mais aussi une importance accordée à l'objet de terre, de verre, de métal ou de fibres tissées et nouées. Ils sont de ce fait sensibilisés à une conception nouvelle de l'art décoratif lorsque les premiers objets japonais apparaissent en Europe. Les premières traces d'une influence japonaise sur l'œuvre de deux verriers, Emile Gallé et Eugène Rousseau, vont de pair avec l'utilisation d'une technique, d'un procédé de décor islamique—ce que Gallé appelle "les émaux durs des Arabes"— : c'est le cas d'un vase orné d'une carpe d'après Hokusai présenté par Gallé à l'Exposition Universelle de 1878 (Fig. 1) et d'un vase en forme de bambou qui fait partie de l'envoi d'Eugène Rousseau à l'Exposition de l'Union Centrale en 1884 (Fig. 2) (l'un et l'autre au Musée des Arts Décoratifs, Paris).

La rencontre de l'art japonais avec la réhabilitation du Moyen Age Gothique est plus importante encore. Le renouveau de l'époque gothique remonte au Romantisme. Sa connaissance est l'œuvre de l'architecte Viollet-le-Duc, à travers ses restaurations de monuments célèbres—Notre-Dame de Paris, la Cité de Carcassone . . .—et ses écrits. Viollet-le-Duc avait trouvé dans l'étude des monuments et des meubles de l'époque gothique ce goût de la nature la plus modeste, celle du sol français, dont il fit l'une des bases de son enseignement. Il comprit d'emblée la leçon des albums d'Hokusai que M. Marjorin donne en exemple à son jeune élève dans l'*Histoire d'un dessinateur*. " . . . Tiens, voici un livre de gravures japonaises; ne nous gênons pas pour courir le monde, d'autant que les japonais sont d'excellents dessinateurs . . . ils vivent dans un milieu

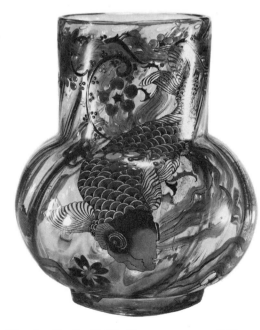

Fig. 1. Emile Gallé, Vase en verre, 1878. Musée des Arts Décoratifs, Paris.

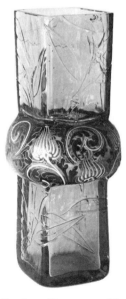

Fig. 2. Eugène Rousseau, Vase en verre, décor émaillé, 1884. Musée des Arts Décoratifs, Paris.

particulier, entourés de races qui ne ressemblent en rien à celles de l'Occident; ils observent la nature, et ainsi sont parvenus à composer des œuvres d'art d'une grande valeur, et dont l'originalité est incontestable. Vois, comme ces artistes sont arrivés à saisir le geste, la pantomime, comme tous ces personnages sont à leur affaire et ne posent pas pour la galerie; quelle sincérité et quel esprit dans ces attitudes! Et comme tout cela est vivant!

"... ce livre qui représente des métiers, des jeux, tous les actes de la vie, est ainsi plein de scènes charmantes, spirituellement indiquées, et qui nous font vivre au milieu de ce peuple comme si nous étions en plein Japon. Penses-tu que nos illustrations aient cette valeur, cet attrait et qu'elles rendent aussi exactement nos mœurs journalières, notre physionomie? Non, n'est-ce pas? C'est qu'il y a toujours chez nous de mauvaises traditions, que nous nous maniérons, surtout quand nous voulons être naïfs.

"L'amour vrai et réfléchi des Japonais pour la nature apparaît dans toutes leurs œuvres d'art. Evidemment il faut qu'ils l'aiment singulièrement pour l'observer avec tant de soin et rendre avec tant d'exactitude ses moindres productions. Pour eux, rien n'est indifférent, et ils étudient aussi bien la forme et l'allure d'un insecte, le port et les détails d'un végétal que le caractère physique de l'homme; ce qui ne les empêche pas de ne voir au besoin que les ensembles et de rendre, en quelques touches de pinceau, ... l'aspect d'un sîte.

"Parcours ces trois cahiers publiés en l'honneur d'un des volcans du pays cahiers qui sont pleins de scènes de toutes sortes et de paysages."[3]

Les modèles que Viollet-le-Duc proposent à son élève sont la *Manga* d'Hokusai et les *Vues du Mont Fuji*, des recueils qui des mains de quelques initiés, Félix Bracquemond et ses amis dans les années 1860, arrivent dans les lieux ouverts à un public plus large : les comptoirs qui s'ouvrent dans les grands magasins et, autour de 1895, peut-être plus tôt, la Bibliothèque du Musée des Arts Décoratifs à Paris. Il s'agit la plupart du temps d'éditions tardives, et de recueils de modèles d'étoffes, de broderies, etc.

Le mouvement est lancé. L'art décoratif réhabilité par ces apports qui se conjuguent, a progressivement droit de cité dans les salons les plus fermés : le Salon de la Société Nationale des Beaux-Arts s'ouvre à eux à partir de 1891. La notion d'un art nouveau s'impose à travers les recherches et les créations des artisans, mais aussi celles des peintres et des sculpteurs qui ne dédaignent plus de s'y consacrer : Paul Gauguin, Lévy-Dhurmer, Rupert Carabin, et bien sûr les Nabis.

Des hommes, des sociétés comme l'*Union Centale des Beaux-Arts appliqués à l'Industrie* et celle du *Musée des Arts Décoratifs*, jouent un rôle essentiel dans la diffusion de l'art japonais ainsi que dans sa compréhension. Adalbert de Beaumont et Eugène Collinot publient en 1859 le premier *Recueil de Dessins pour l'Art et l'Industrie*. Les modèles japonais et chinois, gravés par Beaumont voisinent avec des exemples d'art islamique ainsi que de la Renaissance gravés par Collinot, qui est céramiste. Les planches de Jules Jacquemart qui illustrent l'*Histoire de la Porcelaine* écrite par son père Albert paraissent en 1862. Puis viennent les écrits de Philippe Burty, sur les émaux cloisonnés, et sur le Japonisme dans la *Revue littéraire et artistique* en 1872–1873.

Le rôle de Louis Gonse qui publie en 1883 deux volumes sur *L'Art Japonais* me semble important à plusieurs titres. Directeur de la *Gazette des Beaux-Arts*, l'une des meilleures revues de l'époque, il est aussi collectionneur. En 1883, il organise à la Galerie Georges Petit, rue de Sèze à Paris, une exposition d'art ancien et moderne du Japon qui contribue à rehausser le niveau de la connaissance de l'art japonais. La qualité des œuvres provenant de sa propre collection et des meilleures parmi celles des japonisants dépasse de loin ce que l'on avait vu jusqu'alors dans les expositions et chez les marchands. *L'Art Japonais* est l'œuvre d'un historien et d'un amateur. Il en reprend les termes dans une conférence au Musée des Arts Décoratifs en 1898; c'est l'occasion pour lui de dégager les caractères de l'art japonais et de suivre son influence sur le goût européen :

"Les Japonais sont les premiers décorateurs du monde.

"L'art au Japon est directement et absolument le résultat de l'ambiance. La nature s'y présente comme un véritable décor . . .

"La maison au Japon est l'image même de la race; elle se prête mieux qu'aucune autre au développement de ce goût pour l'art ornemental . . .

"Les Japonais ont tiré de la fleur un parti admirable; ils sont les peintres des fleurs comme ils sont les peintres des animaux . . .

"L'artiste japonais . . . ne fait jamais son dessin d'après nature; il le conçoit et l'exécute toujours de mémoire . . .

"Une autre caractéristique de l'art japonais . . . , c'est l'horreur de la symétrie . . .

" . . . la plus admirable peut-être . . . , celle assurément qui sert le mieux leur génie de décorateur : c'est le sens de la synthèse et du dessin résumé . . . "[4]

L'enthousiasme de Gonse est partagé par les japonisants de l'époque et principalement par Siegfried Bing qui publie de mai 1888 à avril 1891 *Le Japon artistique, documents d'art et d'industrie*. Le but de cette revue à laquelle participent tous les adeptes de l'art japonais, est de faire connaître les artistes japonais et de mettre à la disposition des artistes, des artisans et des industriels occidentaux des documents de qualité. Les planches sont imprimées par Charles Gillot, qui avait réalisé celles des livres de Louis Gonse; Gillot est également collectionneur d'estampes japonaises et d'objets d'art d'Orient et d'Occident. Il n'est pas indifférent de savoir que Bing, qui avait fait commerce d'objets d'Extrême-Orient à Paris et que le gouvernement français avait chargé en 1893 de faire une enquête sur l'art en Amérique, ouvre en décembre 1895 la galerie de "L'Art Nouveau," où sont réunis parmi les meilleurs créateurs contemporains en France et à l'étranger.

L'art japonais pénètre dans l'univers plastique des artistes et des artisans de plusieurs façons : par les œuvres japonaises elles-mêmes—estampes et objets—, par les recueils, les planches de dessins et les études publiés depuis 1859, enfin, à la fin du siècle, à travers les interprétations d'artistes tels qu'Eugène Grasset et P.-M. Verneuil. Son influence s'opère sur le plan des techniques, des formes, des décors—sujets et couleurs—et de leur répartition sur l'objet, mais aussi, plus subtilement, dans une certaine manière d'aborder l'art décoratif. Dans les années 1860, l'influence japonaise sur la céramique se réduit à des ornements. C'est le cas du Service Rousseau, 1866–67, pour lequel Bracquemond grave des animaux,

des fleurs, des plantes copiés des estampes d'Hokusai, d'Hiroshige, d'Isai et d'Hokusen. Mais l'esprit est encore celui du dix-huitième siècle. Dans l'ensemble, les motifs japonais—ou chinois, ou islamiques—, remplacent les scènes de genre et les compositions dont l'esprit remonte à la majolique italienne. La porcelaine et la faïence ne sont encore que les supports d'un décor qui tient plus ou moins compte de la forme et de la matière. Ceci est vrai des vases et des services qui sortent des ateliers d'Eugène Rousseau, de Théodore Deck,[5] d'Ernest Chaplet, d'Albert Dammouse[6] et de l'atelier d'Haviland à Auteuil que Félix Bracquemond dirige de 1872 à 1882. L'œuvre d'une artiste comme Camille Moreau s'inscrit dans une perspective un peu différente. Collectionneuse d'estampes japonaises, elle applique son décor—parfois inspiré des textiles japonais—à la barbotine sur faïence, sur des plats et sur des vases dont la forme rappelle celle de certains bronzes chinois.[7]

Certaines estampes impressionnent vivement l'imagination des artistes contemporains : c'est le cas des *Vues du Mont Fuji*, d'Hokusai. *La Grande Vague* et sa crête échevelée se retrouve sur un vase en grès brun d'Ernest Chaplet (Fig. 3), datant de 1886 (Kunstindustrimeum, Copenhague) et sur le marli d'une assiette de Georges de Feure, réalisée en porcelaine de Limoges pour l'Art Nouveau Bing en 1900.[8] Le Mont Fuji inspire Eugène Rousseau, céramiste et verrier. La même année, en 1884, il envoie à l'exposition organisée par l'Union Centrale un vase en verre doublé où le décor japonais et totalement naturaliste[9]

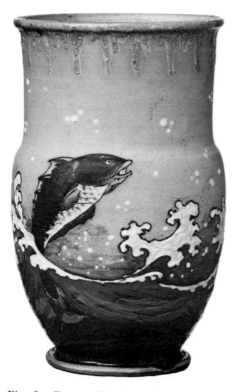

Fig. 3. Ernest Chaplet, Vase en grès brun, 1886. Kunstindustrimeum, Copenhague.

Fig. 4. Eugène Rousseau, Jardinière en verre opaque, jade et corail, modelée à chaud, 1884. Musée des Arts Décoratifs, Paris.

Fig. 5. Jean Carriès, Vase en grès émaillé, vers 1900. Musée des Arts Décoratifs, Paris.

et une jardinière en verre opaque, jade et corail, modelée à chaud (Fig. 4), qui, dans une synthèse d'apports chinois—imitation d'une pierre dure—et japonais—une sorte de paysage abstractisé et assymétrique—aboutit à ce que l'on appelle L'Art Nouveau (Musée des Arts Décoratifs, Paris).

La participation du Japon à l'Exposition Universelle de 1878, à Paris, bouleverse les données de la céramique traditionnelle. Ainsi s'amorce une évolution vers l'objet tourné, ou modelé à la main, dont le décor s'efface devant la matière et l'émail dont l'artiste conduit les hasards en surveillant lui-même la cuisson. A la faïence, à la porcelaine, les nouveaux adeptes préfèrent le grès. Le sculpteur Jean Carriès abandonne son métier pour ouvrir un atelier à Saint-Amand-en-Puisaye, le pays des potiers en grès (Fig. 5).[10] Il est suivi par Georges Hoentschel qui cuit dans les fours de Grittel.[11] A Beauvais, puis à Paris, Auguste Delaherche s'intéresse aux émaux flammés sur grès ou sur porcelaine. La mode de la céramique est telle que Gauguin s'y essaie dans l'atelier de Chaplet, pensant y trouver un rapport financier que sa peinture lui refuse. Des ateliers s'ouvrent un peu partout en France, mais surtout à Paris et sa banlieue, animés par des solitaires ou des artisans qui choisissent la voie semi-industrielle : Emile Muller à Choisy-le-Roi et Alexandre Bigot qui publie un catalogue de sa production où ses propres créations voisinent avec des modèles dessinés par Henri Van de Velde, Henri Sauvage, Hector Guimard.[12]

L'art japonais pénètre dans l'art du métal par la technique des émaux cloisonnés. Reiber, directeur de l'atelier de création de la maison Christofle, utilise un procédé mis au point par un technicien génial, Tard, pour réaliser des meubles et des vases japonisants : tel le cabinet d'angle destiné sans doute à Mme de Païra, exécuté en 1874 et présenté à l'Exposition Universelle de 1878 (actuellement au Musée des Arts Décoratifs, Paris). Les Falize, père et fils, l'appliquent au bijou, avec des motifs tirés des estampes qu'ils achètent chez Mme Desoye ou qu'ils empruntent à Philippe Burty.[13] A la fin du siècle, René Lalique invente le bijou Art Nouveau, rencontre du naturalisme, de la dissymétrie et de la gamme colorée japonais avec son propre répertoire et surtout son génie (Fig. 6). Il est suivi dans cette voie par Henri Vever, dont la collection d'estampes japonaises est

Fig. 6. René Lalique, Boucle de ceinture, cuivre, émaux, verre rose moulé, vers 1902–06. Musée des Arts Décoratifs, Paris.

alors célèbre. Passionné des techniques japonaises et particulièrement des alliages de métaux et des patines, Lucien Gaillard fait venir de Tokyo, après 1900, des ciseleurs, des laqueurs et des bijoutiers qui réalisent d'après ses dessins des bijoux et des peignes où plantes, fleurs et animaux sont reproduits avec le maximum de naturalisme.

Les textiles, les papiers peints empruntent à l'art japonais des combinaisons de formes géométriques, une manière de relier les motifs, flore, faune, par des ondulations inspirées des nuages, des vagues, peut-être aussi de l'écriture cursive. Les recueils de dessins de broderies et d'échantillons de tissus et de papiers sont une mine dans laquelle puisent les industriels. L'architecte Henri Sauvage propose autour de 1900 une série de modèles de papiers peints dont la composition s'inspire de fleurs d'Hiroshige et d'Hokusai (coll. Musée des Arts Décoratifs, Paris).

Mais au-delà des techniques, des formes et des décors, l'art japonais apporte à l'Art Nouveau l'enseignement de la nature qui en est la base. "On n'enseigne pas l'art, disait Hokusai. En copiant la nature, n'importe qui peut devenir un artiste." Ce propos est rapporté par Emile Gallé qui en fait sa religion.[14] Familier des expositions de Londres et de Paris, il connaît bien l'art japonais et en retient ce qui convient à son tempérament, c'est-à-dire la passion de la nature. Il connaît aussi *La Maison d'un artiste* pour avoir lu le livre d'Edmond de Goncourt, mais aussi pour l'avoir visitée et avoir eu le privilège de tenir dans ses mains les objets qui y sont réunis : verres chinois, bronzes du Japon, porcelaines. Il admire en Goncourt l'homme qui au Japon ancien, a préféré celui qu'il jugeait digne d'être aimé des gens de goût, l'art japonais "... *moderne, oui moderne, appartenant au dix-neuvième siècle* ... cet art merveilleux, unique, incomparable doit être attribué à la révolution introduite dans le dessin par l'affranchissement des styles classiques et par un retour à l'observation directe, amoureuse, à la collaboration même de la nature."[15] Amoureux des plantes, horticulteur érudit, Gallé installe à côté de ses ateliers un jardin où poussent les fleurs et les plantes les plus rares mais aussi les plus communes. A Nancy même, Gallé et ses amis, Victor Prouvé, Camille Martin, connaissent Takashima Tokuzō, ce japonais qui suit les cours de l'Ecole forestière de 1885 à 1888. Takashima enseigne aux nancéiens la technique de l'écriture et du dessin japonais.

A la fin du dix-neuvième siècle et au début du vingtième siècle, l'influence de l'art japonais se manifeste à travers l'enseignement de deux hommes : P.-M. Verneuil et Eugène Grasset. A côté de nombreux ouvrages de documents décoratifs, réalisés à partir des plantes, des animaux, Verneuil publie en 1910 un luxueux livre de 80 planches d'*Etoffes japonaises tissées et brochées*, précédé d'une préface de Gaston Migeon, Conservateur au Musée du Louvre. Eugène Grasset qui écrit plusieurs introductions pour les recueils de Verneuil, possède une importante collection d'estampes et d'objets japonais—céramiques, bronzes, bois sculptés, laques, gardes de sabre, pochoirs—dont on connaît la liste par la deuxième vente de sa succession en mars 1918. A l'art japonais, Grasset a emprunté un certain déséquilibre de la mise en page, mais surtout la leçon de l'observation de la nature. Il l'applique à l'ensemble de ses œuvres et l'enseigne à l'Ecole Guérin à Paris. *La Plante et ses applications ornementales*, publié en 1896

Fig. 7. M.-P. Verneuil, *Butome, jonc fleuri*, page de *La Plante et ses applications ornementales*, 1896. Gravure sur bois en couleurs. Musée des Arts Décoratifs, Paris.

(Fig. 7), est en quelque sorte le développement de la *Manga* d'Hokusai. Partant de l'étude des plantes, il propose des modèles de tissus, de papiers peints, de meubles et d'objets. Ainsi l'enseignement du Japon trouve son expression française et se répand parmi les artistes et les artisans.

Un domaine est resté pratiquement indifférent à la vogue japonaise à cette époque en France Il s'agit de l'architecture. La maison d'Hughes Krafft dans la région parisienne est une exception. Elle était en réalité une véritable maison japonaise, construite par des ouvriers japonais dans un jardin dessiné pour elle.[16] Les architectes occidentaux s'intéressent à l'architecture japonaise lorsque leurs propres recherches coïncident avec la syntaxe et le langage nippon. Plus les tendances se diversifient, plus elles se découvrent d'affinités avec l'architecture japonaise. Ce que Frank Lloyd Wright, Charles et Henry Greene aux Etats-Unis au début du siècle lui empruntent—un souci de l'échelle humaine, un respect du matériau—est différent de ce que Mallet-Stevens, Le Corbusier et les architectes du Bauhaus trouveront en elle. Mais comme pour l'objet, l'inspiration se limite à des schémas, et ne pénètre jamais l'idée fondamentale du Japon.

NOTES

1. *Guide du visiteur du Musée Oriental, Exposition des Beaux-Arts appliqués à l'Industrie,* Paris, 1869.

2. *Exposition Universelle de 1867, Rapports du Jury International, Meubles, Vêtements, etc. . . . ,* Paris, 1867, pp. 775–776.

3. Eugène Viollet-le-Duc, *Histoire d'un dessinateur, Comment on apprend à dessiner. Bibliothèque d'Education et de Récréation,* Paris, s.d. En réalité, ce livre a été publié l'année de la mort de Viollet-le-Duc, en 1879. Les " . . . trois cahiers publiés en l'honneur d'un des volcans du pays . . . " sont les *Cent Vues du Mont Fuji,* d'Hokusai, probablement l'édition de 1875, la plus répandue en France.

4. Louis Gonse, "L'Art Japonais et son influence sur le goût Européen, conférence faite à l'Union Centrale des Arts Décoratifs," *La Revue des Arts Décoratifs,* tome XVIII, 1898, pp. 97–116.

5. Cf. cat. de l'exposition *Ukiyo-e Prints and the Impressionist Painters,* Tokyo, 1979, n° III 11 p. 176 et repr. couleurs.

6. Cf. cat. Tokyo, 1979, n°s III 9 et 10, p. 176, et repr. couleurs.

7. Cf. cat. Tokyo, 1979, n°s III 7 et 8, p. 176 et rep. couleurs.

8. Cf. cat. Tokyo, 1979, n° III 14, p. 177.

9. Cf. cat. Tokyo, 1979, n° III 5, p. 176 et rep. couleurs.

10. Cf. cat. Tokyo, 1979, n° III 13, p. 176.

11. Cf. cat. Tokyo, 1979, n°s III 14 et 15, p. 177.

12. Cf. cat. Tokyo, 1979, n° III 18 p. 177.

13. Cf. cat. Tokyo, 1979, n°s III 19 et 20, p. 177 et repr. couleurs.

14. Emile Gallé, *Ecrits pour l'Art,* Paris, 1908, "Goncourt et les métiers d'art," extrait de la *Lorraine artiste,* n° du 26 juillet 1896, consacré à Edmond de Goncourt, mort le 16 juillet, p. 179.

15. Emile Gallé, op. cit., p. 178.

16. Cf. Gonse, op. cit., pp. 101–102. "Du reste la maison japonaise, telle que vous pouvez la concevoir, a été réalisée ici.—Un des membres du Comité de l'Union des Arts décoratifs, que vous connaissez sans doute de nom, M. Krafft, s'est donné le luxe et le plaisir de se faire faire une maison japonaise par des ouvriers japonais qu'il a ramenés du Japon, un charpentier et un jardinier. Il a rapporté du pays, non seulement le bois et les accessoires de la maison japonaise, mais même les ouvriers chargés de la monter. Il l'a établie dans les environs de Paris, et j'ai été à même de la voir plusieurs fois; elle donne précisément cette idée complète de ce que le goût japonais peut chercher dans les satisfactions continuelles de la vie. Cette maison s'ouvre sur un charmant paysage, dans les environs de Versailles; son propriétaire a même choisi, comme un Japonais l'aurait fait, un coin, écarté, solitaire; il l'a entourée d'un jardin délicieux, rempli de plantes bizarres, toutes décoratives, avec les formes spéciales qui font de chaque plante, au Japon, presque un objet d'art. Quand on se trouve au milieu de ce jardin, ou dans cette maison, avec les baies ouvertes, par une belle journée de printemps ou d'automne, on éprouve absolument les sensations que le Japonais peut avoir devant la nature, et l'on comprend immédiatement que celui-ci ait chez lui, dans son âme, dans sa race, un raffinement incomparable de mœurs." Lorsqu'elle écrivait sa thèse sur le Japonisme en 1964, Geneviève Lacambre a cherché trace de cette maison sans la trouver.

WESTERN INFLUENCE AND REVIVAL OF TRADITION
IN "UKIYO-E"

Narasaki Muneshige

I should like to mention here how *ukiyo-e* painters were influenced by Western artistic techniques and at the same time how they revived *Yamato-e*, a purely native style of Japanese painting developed in the Heian period, as a popular art in the Edo period.

Japan's first contacts with the West began in 1543 when a Portuguese ship drifted ashore the island of Tanegashima, south of Kyūshū. By 1600, Western-style paintings had been produced. However, these were not based on any understanding of Western artistic principles and hardly contributed at all to the development of Japanese art. Moreover, as this occurred before *ukiyo-e* appeared, it lies beyond the sphere of my talk. After the fifth national seclusion proclamation of 1639, which strictly enjoined a policy of national isolation, Western influence was slight, but from about the early eighteenth century such influence became visible in Japanese art. This period represents the first phase of Japanese absorption of Western artistic techniques.

In 1720 the ban on the importing of books from the West was removed by the shogun Yoshimune through the influence of scholar-official Arai Hakuseki (books on Christianity, however, were still excluded), and from that time on a certain amount of Western science, thought, and culture was introduced to Japan through trade with the Dutch. Furthermore, Chinese painters visited Japan, including Ch'en Nan-p'in who came to Nagasaki in 1731 and established the Nampin school of Chinese-style realistic bird and flower painting. His illusionistic realism came to be associated with Western-style painting in the Nagasaki area. In 1758 Sung Tzu-shih came to Japan, and he did much to introduce the Nampin school from Nagasaki to Osaka, Kyoto, and Edo. Thus from the early eighteenth century, new artistic styles, including those from the West (especially through Western copperplate prints), the realism of the Ming and Ch'ing periods, and *nanga* (paintings of literary man in the Chinese style) were introduced through the port of Nagasaki.

Let us examine the reaction of the *ukiyo-e* artists of that time to these foreign prints and paintings and artistic techniques. First they attempted to copy or imitate the techniques of perspective, either as introduced directly from Europe or indirectly through China. Among the works of the *ukiyo-e* artists of that time,

however, many used several vanishing points rather than one, as in early *uki-e* prints and paintings imitating the European system of receding perspective. Some, of course, applied perspective with a single vanishing point. Generally speaking, however, they adopted such techniques only partially and superficially.

A graduate student of the University of Washington who visited me in Japan some time ago remarked that he thought Japanese were a "focusless" people. In other words, he was of the impression that they had no concern for focal points and could not, therefore, achieve perspective. This might have some element of truth. It can be said that Japanese do not have a well developed awareness of dimensions or space, nor of the concepts of infinity and eternity.

Following that first phase, characterized by imitation, came a second, of true expression in perspective as artists began to consciously understand the techniques of Western painting. This was made possible by advances in the study of the West. Prominent in this field was Hiraga Gennai (1728–79), who went to Nagasaki in 1752 and eventually became a leading *rangaku* (Dutch, or Western studies) scholar. In 1755 Nakajima Kanbei, a very well established Kyoto Toy merchant, imported from Holland the *vues d'optique*, introducing pictures that demonstrated European techniques of perspective. In 1759 Maruyama Ōkyo (1732–95) painted some Western-style paintings (*vues d'optique*) at the request of Nakajima, including *View of the Ten-Thousand-Year Bridge at Kusu, China*, *Festivities at Shijōgawara* (Fig. 1), *View of the Ōhashi Bridge at Sanjō*, and others. A later work painted in 1767 by Ōkyo called *View of the Pier* shows that he had a clear understanding of Western techniques of painting.

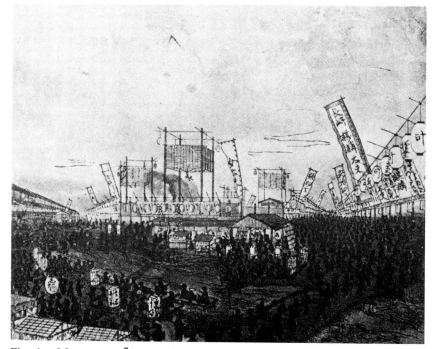

Fig. 1. Maruyama Ōkyo, *Festivities at Shijōgawara*, ca. 1759. Woodcut with colors added.

Meanwhile in 1765, Suzuki Harunobu devised *nishiki-e* or color woodblock printing techniques, and his subsequent work profoundly influenced later portraiture, as I shall describe in greater detail below.

In 1774, Odano Naotake (1749–80) of the Akita Western-style painting school made drawings after the copperplate printed illustrations in the Dutch book on anatomy *Tafel Anatomia* for the famous Japanese translation of it, *Kaitai shinsho*. Naotake's drawings for the Japanese edition were reproduced in woodblock prints. In 1783 Shiba Kōkan (1747–1818) made the first copperplate etching in Japan. Thus Japanese artists had gradually passed the first phase of superficial imitation and begun a phase of understanding based on the study of Western science through the Dutch language.

Leaders among the *ukiyo-e* artists of this period included Utagawa Toyoharu (1735–1814), founder of the Utagawa school, Kitao Shigemasa (1739–1820), Kitao Masayoshi (1764–1824), and others. In *Gohyaku-rakan-zu* by Shigemasa, we can observe the appearance of unified space depicted by the use of perspective with a single viewpoint. *Uki-e: Cool of Evening at Nakasu in the Eastern Capital* by Masayoshi demonstrates not only the understanding of perspective, but also a deep interest in shading and light and dark contrasts.

This process led to a third phase, in which *ukiyo-e* painters had clearly digested Western techniques of expression and turned to incorporating them into traditional Japanese painting. Leading *ukiyo-e* painters such as Hokusai and Hiroshige were active in this phase. Around 1801 Hokusai began to study the three types of painting techniques—Japanese, Chinese and European—and to create

Fig. 2. Katsushika Hokusai, *Ushigafuchi at Kudan*, ca. 1799–1800. Color woodcut.

his own style based on them. One of his works, *Ushigafuchi at Kudan* (Fig. 2) shows a unified space with a single vanishing point, and employing the concepts of light and dark and shading. By the way, the background of many of his works include shapes reminiscent of the thunder clouds often found in Dutch paintings. The Netherlands, being a flat country without mountains or hills, forced its painters to depict variations in the skies. It is not surprising that Hokusai, who probably had chanced to see such paintings, should have been influenced by them. In one of Katsukawa Shunkō's works, *Uki-e: View of Zōjōji Temple in Edo* (Fig. 3) of the same period, there are also elements which seem to show influence from Dutch paintings. He provided his works with sky and clouds overhead, giving the impression that he was himself part of the scheme. Traditional Japanese paintings at that time usually depicted the world very objectively and flatly, without the realistic presence of clouds or rain. About this time, however, *ukiyo-e* painters began, as their works show, to adopt the realism of Western-style paintings.

It is interesting to note that light had hardly been dealt with at all in Japanese, or Far-Eastern, painting traditionally, probably because it was not considered an important aspect of artistic expression. However, under the influence of the West, *ukiyo-e* painters made the effects of light an important element of their works. A leading artist in this endeavor was Kobayashi Kiyochika (1847–1915) who experimented with Western-style prints form 1876 to 1882. Kiyochika learned not only Western techniques of painting, but also about photography, which had been recently introduced to Japan at that time. For this reason his

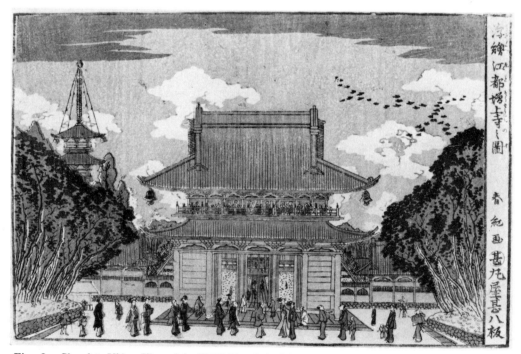

Fig. 3. Shunkō, *Uki-e: View of the Zōjōji Temple in Edo*. Color woodcut. Ota Memorial Museum of Art, Tokyo.

works have a completely new quality with little trace of traditional techniques. Ultimately, the enthusiastic pursuit of light and shade and color began to displace the inherent qualities of *ukiyo-e* and the genre gradually faded out.

Needless to say woodblock prints have limitations in terms of expression, and it is technically very difficult to achieve true realism. However, this was precisely the characteristic that made possible the aesthetic and artistic achievements of *ukiyo-e*. Many *ukiyo-e* masterpieces were created precisely by virtue of their simple forms of expression. Kiyochika himself, who created and developed a new style between 1876 and 1882, ultimately returned to the classical style of *ukiyo-e*.

Let me now turn to a more detailed discussion of the *nishiki-e* of Suzuki Harunobu. Particularly in his prints of woman portraiture (*bijin-ga*), Harunobu achieved remarkable success with his multi-colored woodblock techniques. And he is also known as the artist who revived the traditions of *Yamato-e*, a purely Japanese painting style of the Heian period, incorporating them into *ukiyo-e* of the Edo period.

The connection between *Yamato-e* and *ukiyo-e* can be observed by studying traditional *Yamato-e* of fan-shaped booklets of the sutra *Hoke-kyō*, which were woodblock prints with colors added and with the sutra text superimposed. One example is *Man and Women*, a picture of the fan-shaped booklets of the sutra whose text is said to have been copied in 1188 at Shitennōji temple in Osaka. The black lines in the picture were printed with a woodblock over which the artist later applied color. This example shows two women tucking up their kimono and wading across a garden stream and a young man watching them from a house, a pattern often found later in *ukiyo-e*. There are many other examples among the pictures of the fan-shaped booklets of the sutra *Hoke-kyō* depicting the everyday life of ordinary people of the time such as *Man on the Willow Tree and Woman Crossing the River*, *Boating*, *Siesta*, and *Naruko*. All share a mood which can be found in *ukiyo-e*. Researchers believe that these were made by gathering picture decorated fan papers then sold in the towns and superimposing the text of the sutra *Hoke-kyō*. And the fan-shaped sutra paintings were folded in two, forming a kind of booklet. So to speak, they were based on popular art objects (i.e. decorated fans) developed in the late Heian period. Decorated fans were apparently produced in sufficient quantity to be exported to China, indicating that *Yamato-e* achieved a prominence in the Heian period equivalent to that of the *ukiyo-e* painters in the Edo period, producing a great number of prints which could be distributed cheaply. That tradition of popular art from the Heian period was revived in the eighteenth and nineteenth century by the common people in the form of *ukiyo-e*. In Harunobu's *nishiki-e After the Bath*, there is no apparent influence from the Western concept of perspective, rather it seems an attempt to express the three-dimensional subject two-dimensionally.

However, this flattened, decorative type of painting tends to lose all emotional or psychological depth and can become nothing more than a poster. In fact, after Harunobu, toward the end of the Edo period portraits and *bijin-ga* degenerated in quality, gradually losing richness of emotional expression. Some demonstrated very realistic qualities, but on the whole they lost the aesthetic, poetic and

sentimental dimensions of earlier prints. Two-dimensional portrayal by nature has this latent danger; only as long as the artist himself is moved by profound emotions can be create outstanding works of art. When this depth of human sensitivity is dulled, the paintings become uninteresting and simplistic, ultimately becoming simply decorative designs such as found on kimono fabrics.

It was 1765 when Harunobu created *nishiki-e*, a time when it had become popular to study Western learning (*rangaku*) including the natural sciences, astronomy, zoology, botany and anatomy. In art, too, many Western-style realistic techniques were experimented with such as oil paintings and copper-plate etching. Especially in portraiture, the depiction of the personality and character of individual subjects was much influenced by the realism found in Western painting. In *Osen*, a portrait depicting a courtesan who lived in a tea house in front of the Kasamori Shrine, Harunobu attempted to express her personality, although it has a faint resemblance to his other works.

Fig. 4. Tōshūsai Sharaku, *Ichikawa Ebizō as Takemura Sada-noshin*, 1794. Color woodcut. Ota Memorial Museum of Art, Tokyo.

Another *ukiyo-e* painter of the same period, Katsukawa Shunshō (1726–92) also tried to express the personality of individuals, especially in his portraits of actors and other theatrical prints. The appearance of realism in depiction of human figures in *nishiki-e* was, in a way, a revival of the *nise-e* of traditional *Yamato-e*. However, paintings and prints in this period were strongly influenced by Western realism which emphasized the distinction between man and the outer world, that is, between man and the objects of his cognition. The tradition of portrayal in pursuit of realism set by Shunshō was carried on by Utamaro, the master of *bijin-ga*, Sharaku, known for his outstanding actor prints (e.g. Fig. 4), and others.

While realism was being sought in the expression of human figures, in background space the form of *uki-e* imitating awkwardly or exaggeratedly the Western linear perspective was no longer employed; rather painters depicted scenes naturally as they themselves observed them. In this sense, a new style was being sought which could harmonized Western realism and traditional Japanese style. This tendency is visible in, for example, Kiyonaga's *Nakasu* from the series *Tōsei yūri bijin-awase* (Fig. 5).

Fig. 5. Torii Kiyonaga, *Nakasu*, from the series *Tōsei yūri bijin-awase*, ca. 1781. Color woodcuts. Ota Memorial Museum of Art, Tokyo.

Now let us review the development of landscape *ukiyo-e* prints represented most prominently in the work of Hokusai and Hiroshige. One of the characteristics of Hokusai's works was their geometrical composition, as for example in *Under the Mannen Bridge at Fukagawa, Fine Wind, Clear Morning* (Fig. 6), and *Under the Wave off Kanagawa*. Hokusai's basic principle was that the circle and the triangle were the basic forms of everything. An examination of the above works in terms of combinations of circles, triangles and straight lines bears this out. Hokusai was a man of great insight, with a talent for intellectual treatment of subjects and he reorganized the world in his works in accordance with his own concept of the ideal.

Hiroshige, on the other hand, was a romantic and his works demonstrate a lyrical style as well as mastery and exaggeration of Western techniques, as for example, in *Wagon-wheel on the Beach at Takanawa*, in which foreground objects are enlarged to the extreme. His works have such a bold composition that we might well suspect that he had had a chance to use the camera, which had by then been introduced to Japan. At the same time, compared with Hokusai, Hiroshige's works were more lyrical and literary in inspiration. To properly understand his works like *Eitai Bridge, Tsukuda Island* (Fig. 7), one needs considerable literary knowledge and a poetic nature. Also, a true appreciation of his works necessitates some familiarity with Japanese climate and culture, national character and way of life. These are probably the reasons why it took so long for Hiroshige to achieve his reputation in the outside world, while Hokusai's prints were much

Fig. 6. Katsushika Hokusai, *Fine Wind, Clear Morning*, from the series *Thirty-six Views of Mt. Fuji*, ca. 1829–33. Color woodcut. Ota Memorial Museum of Art, Tokyo.

more popular from an early stage because of their strongly "international" character.

One of Hiroshige's works, *Nihonbashi* is a landscape depicting the bridge of Nihonbashi on a snowy day. A careful look at this print reveals a white space between the indigo of the river and the *sumi* black of the sky. The whiteness expresses the bright, shining surface of the water, demonstrating an attention to light and shadow, and brightness and darkness that could only have been conceived in Japan in the process of exposure to Western art. Hiroshige studied Western art and incorporated it into the Japanese climate and national character, creating a new style.

Fig. 7. Andō Hiroshige, *Eitai Bridge, Tsukuda Island*, 1857. Color woodcut. Ota Memorial Museum of Art, Tokyo.

Above we have looked briefly at the *ukiyo-e* painters of the Edo period; how they passed down the traditions of *Yamato-e* from the Heian period and revived them and how they were influenced by Western artistic techniques. On the other side of the world then, how did Western artists who encountered Japanese *ukiyo-e* react to them? It may be said that for the Impressionists and the Post-Impressionists including van Gogh, Japanese *ukiyo-e* prints were a mere stepping stone to the creation of a new art form. This is clear from van Gogh's *Japonaiserie: The Flowering Plumtree*, a work which he painted after Hiroshige's *Plum Garden, Kameido*. This work is not merely an imitation but a new artistic feeling based on his own firm understanding of art and of nature.

In contrast, when Japanese painters learned Western artistic techniques, they were strongly influenced, but their reaction was neither orthodox nor academic, but sentimental and emotional. In other words, they adopted rather haphazardly, paradoxically creating their own distinctive style in many excellent works.

In concluding, I should like to say that while there are *ukiyo-e* scholars throughout the world pursuing their studies with great care, they are all working in isolation, with very little communication with other another. I have travelled more than twenty times to Europe and the United States but only managed to see a part of the extensive collections of *ukiyo-e* located overseas. In order to establish *ukiyo-e* study as a true science, I believe that we must systematize and catalogue these collections dispersed throughout the world. Without this, no theory can be properly verified.

RESUME

Takashina Shūji

Quelque cent vingt ans après la première découverte par les artistes occidentaux de l'art japonais, le Japon et l'Occident se rencontrent de nouveau ici, à Tokyo; grâce à l'heureuse initiative du Comité de l'An 2001, nous avons pu nous réunir dans cette salle depuis cinq jours et travailler ensemble sur ce phénomène que l'on appelle le Japonisme ou la Japonaiserie. Je ne saurais trop souligner l'importance de cette rencontre internationale même dans un âge dit de "communication développée," car c'est la première fois vraiment, au moins au Japon, que d'éminents spécialistes dans le domaine des études du Japonisme se réunissent. Certes, nous ne sommes plus au temps des découvertes exotiques ou de l'étonnement naïf. Le temps est définitivement révolu où pour faire connaître le Japon aux amateurs occidentaux, il n'y avait à Paris qu'une seule boutique qui ne portait même pas un nom japonais puisqu'elle s'appelait "La Porte Chinoise." Et maintenant, par exemple lors de mon séjour à Paris l'année dernière, un agent de l'Ambassade du Japon à Paris m'a affirmé qu'il existe actuellement à Paris plus de cinquante restaurants japonais, sans compter de nombreux petits et grands magasins qui jouent chacun plus ou moins le rôle de la "Porte Chinoise."

D'ailleurs la contre-partie n'en est guère moins brillante. Je me suis amusé hier soir à relever dans l'annuaire téléphonique de la ville de Tokyo, le nombre des cafés qui portent un nom d'artiste français et sur la base de ce document sûr, je peux vous informer qu'en cette année 1979 il y a à Tokyo au moins quatre cafés Cézanne, sept cafés-bars Toulouse-Lautrec et pas moins de 85 cafés Renoir. Mais le chiffre ne garantie pas toujours la qualité des connaissances mutuelles, et c'est précisément le rôle d'un symposium international scientifique de ce genre d'assurer une véritable communication entre les pays de civilisations différentes. Bien entendu, il est encore bien prématuré de porter un jugement définitif sur ce symposium, d'ailleurs ce n'est nullement mon intention; il faudrait peut-être attendre la publication de ses actes que les organisateurs nous ont gentiment promis. C'est donc une simple réflexion personnelle que je vais vous exposer et par la même occasion je vous présenterai les quelques traits caractéristiques que je crois avoir pu discerner au cours des conférences et discus sions de ces cinq journées. Je me contenterai d'en signaler seulement les trois qui me paraissent les plus essentielles. D'abord la question des documents et des faits, à savoir les dates,

les chronologies et identifications, qui sont, inutile de vous le dire, à la base de toute recherche historique, de tout effort de synthèse et de toute interprétation. Au cours de ces cinq jours de travail, je dois dire que nous avons beaucoup appris. Après une utile mise au point par Madame Geneviève Lacambre qui connaît la question à fond, et qui nous a apporté aussi d'intéressants renseignements nouveaux, nous avons eu des études précises sur un peintre particulier ou sur un mouvement particulier, par exemple sur Whistler par Monsieur Robin Spencer, sur Bracquemond par Monsieur Jean-Paul Bouillon, sur Pissarro par Monsieur Christopher Lloyd, sur Degas et Toulouse-Lautrec par le Professeur Theodore Reff, sur Monet et Renoir par Monsieur Ronald Pickvance, sur Tissot par Monsieur Michael Wentworth, sur Van Gogh par Monsieur Van der Wolk, sur Seurat et les néo-impressionnistes par Madame Françoise Cachin, sur Philippe Burty par Monsieur Gabriel Weisberg, sur Hayashi par Monsieur Segi, et sur les Nabis par Madame Perucchi.

L'art graphique et l'art décoratif n'ont pas été non plus oubliés puisque Monsieur Philippe Dennis Cate, Monsieur Michel Melot, Madame Yvonne Brunhammer et Monsieur William Buchanan nous ont apporté de précieux renseignements sur les estampes de la fin du dix-neuvième siècle, sur l'art nouveau en France et sur le mouvement de l'Ecole Ecossaise. Et beaucoup de documents et des images souvent inédites ou peu faciles à voir ont été présentés. Ainsi nous avons pu avoir le privilège de regarder pour la première fois une photographie inédite de Signac dans un costume japonais présenté par Madame Françoise Cachin et nous avons pu aujourd'hui voir même les photographies de Hokusai et de Rembrandt grâce à Monsieur Buchanan. Tout ceci nous amène, me semble-t-il, à constater que les études sur les documents sont loin d'être épuisées et qu'il y a encore beaucoup à faire dans ce domaine. Surtout, j'ai eu l'impression que du côté japonais, encore de nombreux documents restent inexplorés. Le Professeur Sakamoto nous a judicieusement indiqué la nécessité d'étendre notre champ d'investigations en dehors des estampes d'*ukiyo-e* et le Professeur Ikegami a brillamment démontré qu'il y a encore des faits à découvrir, puisqu'il nous a apporté, grâce à un journal inédit de Tokugawa Akitake, que ce jeune prince de la maison du shōgun était élève de James Tissot. Non seulement les documents proprement dits, mais les oeuvres aussi, surtout les estampes, restent à étudier et à inventorier. Et je trouve tout à fait bienvenue la proposition faite par Monsieur Van der Wolk, après les conférences inaugurales de Monsieur Yamada et de Monsieur Narasaki, de constituer et d'établir une sorte de centre des archives des estampes japonaises du monde entier.

En second lieu, l'un des points essentiels soulevé au cours de ce symposium, me semble être la question de la notion d'influence. On parle souvent d'influence, d'emprunt, d'imitation, d'affinité, d'analogie, d'adaptation, d'assimilation. Mais l'essentiel est de savoir exactement quelle est la nature de l'influence, s'il y en a, et quel était de degré d'influence, par exemple d'une estampe japonaise sur un peintre ou une oeuvre particulière. Le Professeur Reff nous a mis judicieusement en garde contre une interprétation facile ou une conclusion hâtive et nous a montré, en prenant l'exemple du cas de Toulouse-Lautrec, que même si l'on constate une ressemblance formelle entre telle estampe japonaise et telle

oeuvre occidentale, cela ne signifie pas nécessairement une influence directe de l'une sur l'autre. Le même problème a été soulevé sous une forme plus radicale par Monsieur Melot et j'avoue personnellement que je me souscris à son idée que le Japonisme, seul, ne peut pas expliquer tout de la peinture occidentale même japonisante du dix-neuvième siècle. D'autant plus que j'ai, moi-même, exprimé une idée analogue au moment du symposium repris dans le livre édité par le Docteur Yamada *Dailogue in Art*: *Japan and the West* publié en édition anglaise en 1977 suivi par une édition française l'année suivante. Il est certain que l'évolution du style d'un van Gogh ou d'un Gauguin s'inscrit entièrement dans le dévelopment de la peinture occidentale et qu'il ne faudrait pas trop essayer de les japoniser. Et de ce point de vue le parallélisme signalé par Monsieur Bouillon entre l'art japonais et l'art de Bracquemond avant son contact avec l'art japonais me semble être tout à fait intéressant.

Monsieur Lloyd dans son brillant discours sur Pissarro nous a cité une phrase du maître écrite en 1893. En effet Pissarro dit dans sa lettre à son fils: "Ces artistes japonais me confirment dans notre parti-pris visuel." J'ai toujours considéré cette phrase comme la déclaration, sinon de guerre, mais du moins d'indépendance vis-à-vis de cette soi-disante influence japonaise de la part du maître de l'impression-niste. Car il voulait dire par là que sa recherche et les recherches de ses amis ont été faites indépendamment de celles des japonais. Evidemment il faut toujours tenir compte du fait qu'un artiste a plus ou moins tendance à minimiser les ap-ports des autres; néanmoins cette prise de conscience en pleine époque du japon-isme de la part d'un artiste aussi lucide que Pissarro me semble être tout à fait révélatrice. Ainsi, comme il a été signalé par Madame Cachin, Seurat, Signac et les néo-impressionnistes ont trouvé dans l'art japonais, non pas des modèles à suivre, mais des confirmations, des encouragements à leur théorie des couleurs, inspirée, elle, de Charles Henri ou d'autres théoriciens occidentaux. Mais en voulant éviter de tomber dans un piège, il faut faire attention de ne pas tomber dans un autre. Il ne faut pas commettre l'erreur de jeter le bébé avec de l'eau et s'il est vrai que l'art japonais a trouvé dans la peinture occidentale de la seconde moitié du dix-neuvième siècle un terrain propice et fertile pour se faire recevoir, il n'y a pas lieu de nier que l'art des maîtres de l'*ukiyo-e* ou d'autres maîtres japonais aient été aussi parmi les grands qui ont apporté des fruits importants.

Je suis personnellement convaincu et j'espère que notre ami Haga Tōru avec son point de vue comparatiste ne me contredira pas, qu'une influence est toujours une affaire des deux cotés, ce qui rend évidemment la question très complexe, mais ce qui rend également notre étude passionnante.

Et enfin, j'ai constaté qu'une étude du japonisme ne s'arrête pas à un simple constat de faits dans le cadre du japonisme, mais qu'elle déborde largement son cadre et qu'elle nous amène à reconsidérer tout l'art occidental surtout de la seconde moitié du dix-neuvième siècle. Non seulement il est bien évident qu'une nouvelle découverte, un nouveau renseignement qui jetterait une nouvelle lumière sur l'oeuvre d'un grand maître tel que Degas ou Monet ne peut pas ne pas influencer notre image de la peinture du dix-neuvième siècle, mais aussi nous avons vu sur cet écran différentes oeuvres peu connues des maîtres qui n'ont pas, à l'heure actuelle, leur place méritée dans l'histoire. En effet dans notre sympo-

sium, nous avons eu deux conférences entièrement consacrées à James Tissot; Monsieur Pickvance a prononcé à plusieurs reprises les noms des peintres du juste milieu, notamment celui de De Nittis, et d'autres noms comme Stevens, Fantin-Latour, Raphaël Collin sont revenus souvent au cours de notre symposium. Je ne prétends pas qu'ils sont tous de grands maîtres, mais il faut reconnaître qu'ils ont été jusqu'à maintenant plus ou moins oubliés, quelques fois injustement, et qu'ils ont été plus ou moins qualifiés de mauvais goût. Personnellement je me suis réjoui de les voir apparaître sur la scène de notre symposium, car moi-même j'ai le mauvais goût d'aimer le mauvais goût.

Enfin, Monsieur le Président, Mesdames et Messieurs avant de terminer mon court et modeste rapport, je crois interpréter les sentiments de tous les participants en exprimant ici notre profonde reconnaissance envers les organisateurs, le Comité de l'An 2001 et la Société d'Etude du Japonisme et également je voudrais exprimer mon admiration et mes remerciements à tous ceux et à toutes celles qui se sont donnés beaucoup de peine pour préparer le symposium et qui, malgré de nombreux obstacles souvent peu faciles à surmonter, nous ont assuré toutes les conditions matérielles et techniques sans lesquelles évidement notre symposium n'aurait pas été possible.

Et maintenant le moment est venu de nous quitter. Il nous faut clore le symposium, mais nous savons tous que ce n'est qu'une clôture provisoire et que nous ne nous quittons que pour nous retrouver, un jours, quelque part, pour une autre occasion d'échanges de vues, d'opinions, de renseignements et aussi et surtout pour avoir ce plaisir de parler de nos arts, de nos artistes, des oeuvres d'art de nos artistes que nous aimons tous avec une ferveur et une passion toujours grandissante.

SUMMARY

Gabriel P. Weisberg

Studies of the reciprocal relationship between Japan and the West are still in their infancy.[1] Despite thirty years of field investigation, research into the question of "Japonisme" (Japanese influence on French nineteenth-century art) still centers on well-known figures from Edgar Degas to Georges Seurat rather than on investigation of lesser-known artists or critics.[2] Current Japonisme studies remain hampered by a lack of inventiveness and drive; art historians refuse to do the tough, rigorous field research on neglected figures believing that the academic rewards would not be sufficient enough if they chose to study the art critic Louis Gonse rather than Claude Monet.[3] If Japonisme studies are marked by a failure of painstaking new research, the influence of Western art on Japan is almost completely uncharted. Few Western art historians have concerned themselves with this problem and the works by those few Japanese scholars who have attempted to discuss this aspect of art history have remained mostly unknown in the West. Much remains to be done in both fields of research as art historians and curators from East and West should continue to exchange ideas and information as demonstrated by the first international symposium on "Mutual Influences between Japanese and Occidental Arts" held in Tokyo (December 18–22, 1979).[4]

This symposium revealed, in microcosm, the current state of research. The opening lecture by Yamada Chisaburō on "Mutual Influences between Japanese and Occidental Arts" provided a good overview of the questions and suggested that future research could center on the impact of Western influence on the Meiji period. In the search for new dates for the establishment of Japanese influence on the West Mr. Yamada stressed the early period, during the seventeenth century, when first contact was made between Japan and Dutch traders. Through implication Mr. Yamada gave a good outline of where future work could be continued by a younger generation of scholars.

Key to an understanding of the Japanese influence in the West is an appreciation of the *ukiyo-e* print tradition, a topic which was analyzed by Narasaki Muneshige in his "Approach to the Science of Ukiyo-e." Mr. Narasaki carefully noted how Japanese prints borrowed Western perspective and thereby retransmitted to the West a spatial organization that Western artists could understand. Similar

to Mr. Yamada, he emphasized the need to investigate the later phases of the *ukiyo-e* tradition so that it would be possible to see which artists were most strongly influenced by the West.

Once the basic premise of the symposium had been established many of the remaining papers examined the questions of influence from the study of specific cases. Sakamoto Mitsuru in his " 'Vue d'Optique' and the Western Style Paintings at the End of the Edo Era" reiterated the theme first stated by Mr. Narasaki that since Japanese art was influenced by European art it was, in turn, made more acceptable by this influence for the West. By stressing ink painting at the end of the Edo period he also suggested an area that has been little explored by art historians in the West where a calligraphic technique may have influenced painters such as Toulouse-Lautrec and others.[5]

In general, many of the specific studies such as Geneviève Lacambre's investigation of "Japonisme in the Second Half of the Nineteenth Century" reconfirmed the chronology of the influence and showed some examples of Japonisme in ceramics. Although much of this research had been done earlier, her paper redocumented what other art historians had already published.[6] Robin Spencer's analysis of "Whistler and Japonisme" had much the same effect, although the paper did give an excellent and concise history of how Whistler had first reacted to Japanese prints in the 1860s.[7] Among the early figures in Japonisme Félix Bracquemond has always prominently appeared. Mentioning Bracquemond as the first to use Hokusai's *Manga*, Jean-Paul Bouillon tried to situate him in a broader context showing that this artist was reacting to general European interests when he used Japanese motifs in his work. By documenting the dates of Bracquemond's first use of Japanese elements, and giving a well-reasoned approach to his interest, Bouillon did much to move Japonisme away from solely considering questions of influence in an exact one-to-one correlation and toward the necessity of seeing the influence in the context of European art development in the mid-nineteenth century.[8]

With the issues of chronology well established, other participants tried to examine Japanese influence on the major painters of the last part of the nineteenth century. Theodore Reff in his "Degas, Toulouse-Lautrec and Japanese Art" provided a warning to art historians not to read too much into Western paintings by giving a series of unconvincing examples used in the past of how art historians saw the influence of Japanese prints on Degas or Lautrec. Professor Reff also cautioned art historians on the problem of documenting an essentially visual response, noting that the Japanese influence had been often overdone by too facile a use of comparisons. Christopher Lloyd, taking the unusual point of examining Camille Pissarro, showed a strong Japanese print influence in this artist's work. He demonstrated for the first time the impact of *ukiyo-e* prints on this master.

Ronald Pickvance in his "Monet and Renoir in the mid-1870s" carefully demonstrated how Japonisme replaced the cult of the Near East among *pasticheurs* such as Firmin-Girard (*La Toilette*, 1873) and among such Impressionists as Auguste Renoir and Claude Monet. This important discovery, that Japonisme was essentially a late form of Romanticism, was given further credence by

Professor Pickvance's insistence that Renoir knew the art critic Philippe Burty, himself an ardent and devoted Japoniste. In the case of Claude Monet, Burty actually encouraged the painter to use an actor's robe in the painting *La Japonaise* (1876) providing, once again, documentation on how Japonisme was seen as both exotic and bizarre by critics and painters who created a "modern," fashionable composition for a salon audience.

One of the more interesting figures in the study of early Japonisme is James Tissot. Michael Wentworth in his examination of Tissot's career centered him within the context of the major art movements of the 1860s and 1870s, but left room for further research on several mysterious Tissot paintings including *Japonaise au bain* (Dijon) and a *Woman with Japanese Objects* (collection unknown).[9] Further examination of Tissot's role in France during the 1860s was provided by the archival work of Ikegami Chūji whose "James Tissot: Maître of Prince Akitake" raised an important question as to the role of the Japanese in France at the time of the Paris Fair of 1867. If James Tissot actually had been the teacher of Prince Akitake, which Mr. Ikegami carefully suggested, this would be one way in which Tissot could have strengthened his knowledge of Japanese art.

Later artists also utilized Japanese motifs in their work or avidly collected *ukiyo-e* prints. J. van der Wolk carefully elucidated the well-known aspects of Van Gogh's print collection and tried to show that further work could still be done on how Vincent saw Japanese prints early in his career in The Hague, London, or Paris. In the selective use of certain of Van Gogh's paintings (including his direct copies of Japanese prints) the varied influence of Japanese print-makers (from Hiroshige and Hokusai to Toyokuni) was documented. In another way, Mr. van der Wolk tried to enlarge the scope of Japonisme by stating that the idea of Japan—in the mind of the artist—was just as important as the formalistic concepts borrowed or assimilated, thereby stressing the importance of creating an ideological basis for Japonisme studies as well as a purely formalistic one. Françoise Cachin, in her study on "The Neo-Impressionists and Japonisme 1886–1893" took Japonisme into a new, unchartered realm through a sensitive and convincing study of how specific prints owned by Signac, for example, actually influenced a series of his paintings. By opening new territory Mme. Cachin showed that much could still be done in the area of late Japonisme influence on another group of artists.[10]

Philip Dennis Cate in his "Japonisme and the Revival of Printmaking at the End of the Century" essentially provided a broad survey of the influence of Japan on a number of printmakers involved in color-printmaking including Henri Rivière and others; a similar broad survey of the impact of Japonisme on the decorative arts was provided by Yvonne Brunhammer in her "Art Nouveau and Japonisme." Here the influence was most prevalent but individual studies on different artisans are now sorely needed.[11] A similar tendency to provide a survey approach to the Nabis and their use of Japanese devices was provided by Ursula Perucchi-Petri, as many of her visual comparisons were striking and carefully presented to make a convincing argument for strong *ukiyo-e* print influence.

The remaining papers tried to examine unexplored territories. Haga Tōru provided excellent archival material on Sir Rutherford Alcock, an English

diplomat who arrived in Japan in 1859 as Consul General and whose collection was sent to London (1861–62) and provided one of the first exhibitions of Japanese art and industry in the West. Gabriel P. Weisberg, in his discussion of "Philippe Burty and a Critical Assessment of Early 'Japonisme'" provided new information on Burty's role in the promulgation of the tendency in France and characterized much of early Japonisme as being strongly romantic in quality, reiterating a concept stated earlier by Ronald Pickvance. Another mysterious figure in the promotion of Japanese art was also examined—Hayashi Tadamasa. Segi Shinichi developed a full picture of Hayashi's career, and working from Japanese documents showed how he became an important art dealer in France as early as 1884. During the 1890s it was clear that Hayashi had developed a major *ukiyo-e* collection and by 1900 had become one of the most important figures in France, rivaling his friend S. Bing.[12]

Two other papers moved Japonisme into new areas. William Buchanan discussed "The Scottish School," essentially the artists active in Glasgow, and the influence of Japan showing that much material was originally obtained through Christopher Dresser. A final note of caution on the Japonisme movement was sounded by Michel Melot in his heated argument "Questions on Japonisme." Since Japonisme was inspired, on one hand by bourgeois materialism, it is significant that business interests helped promote the taste for things Japanese, and these aspects should be rationally discussed.

The symposium did confirm the fact that Japonisme is a broad theme that awaits detailed examination. If the boundaries of the tendency in the West have been delineated the influence of the West on Japan still awaits further study. Only a future exchange of ideas can bring these new aspects to light by having scholars compare ideas and research with their colleagues in the East and West. This symposium also confirmed that there is a decided need to examine the critics of Japonisme to arrive at a theoretical understanding of what Japonisme meant to those active in the 1860s, 1870s, and later in the century. A systematic assessment of each critic from Ernest Chesneau to Théodore Duret and S. Bing would greatly strengthen the theoretical aspect of a movement and help place it within the context of nineteenth-century French art. Similarly, and in order to combat too facile discussions of the influence of Japanese prints on painting, an effort must be made to reconstruct the collections of Japanese art in France. Those objects owned by Philippe Burty must be differentiated from those collected by S. Bing or Henri Vever. Even the collections of artists should be reconstituted so that one can tell the quality of Japanese art purchased and studied and the differing degrees of Japonisme in France. Once this is begun, the study of Japonisme will be on a stronger foundation and speculative papers will be discouraged at future symposiums.

NOTES

1. Some of the more valuable publications include: Colta Feller Ives, *The Great Wave: The Influence of Japanese Woodcuts on French Prints*, New York, 1974; Gabriel P. Weisberg et al., *Japonisme: Japanese Influence on French Art, 1854–1910*, The Cleveland Museum of Art, 1975; C. F. Yamada, ed., *Dialogue in Art: Japan and the West*, Tokyo, New York, San Francisco: Kodansha International, 1976; and Frank Whitford, *Japanese Prints and Western Painters*, London: Studio Vista, 1977.

2. The major figures of Impressionism and Post-Impressionism were first discussed in Ernst Scheyer, "Far Eastern Art and French Impressionism," *The Art Quarterly*, vol. 6, 1943, pp. 116–143 and Yvonne Thirion, "Le Japonisme en France dans la seconde moitié du XIX^e siècle, à la faveur de la diffusion de l'estampe Japonaise," *Cahiers de l'association internationale des études françaises*, vol. 13, 1961, pp. 117–130.

3. Louis Gonse was a key figure in the development of Japonisme. His collection of oriental objects greatly influenced many nineteenth-century French artists. His descendants should be located so that a proper assessment of his place in the movement can be undertaken. For further information see Louis Gonse, *L'Art Japonais*, 2 vols., Paris, 1883 and "L'Art japonais et son influence sur le goût européen," *Revue des arts décoratifs*, vol. 8, April, 1898, pp. 97–116.

4. There is a need to hold periodic conferences to discuss the newest research being done on the questions of Japonisme.

5. The influence of Japanese ink painting on Western artists has not been adequately explored.

6. The *Japonisme* catalogue (Cleveland, 1975) confirmed much of Geneviève Lacambre's work on the early shops which disseminated Japanese objects and prints in Paris.

7. For further reference to Whistler's use of Japanese prints see John Sandberg, "Japonisme and Whistler," *The Burlington Magazine*, vol. 100, November, 1964, pp. 500–507.

8. This was a well-reasoned argument against one-dimensional research and the necessity of placing Japonisme in a proper European context. For further reference to Bracquemond see Jean-Paul Bouillon, "Félix Bracquemond—Les années d'apprentissage (1849–1859): La genèse d'un réalisme positiviste," *Nouvelles de l'estampe*, no. 48, December, 1979, pp. 12–17.

9. The paintings by Tissot with Japanese themes are not dated. They could be related to events around 1867.

10. For further reference to the Neo-Impressionists and Japonisme see Henri Dorra "Seurat's Dot and the Japanese Stippling Technique," *The Art Quarterly*, vol. 33, Summer, 1970, pp. 108–113.

11. The *Japonisme* catalogue (Cleveland, 1975) remains one of the few accurate studies of Japanese influence on nineteenth-century French decorative arts.

12. Further information on a relationship between S. Bing and Hayashi should be sought.